Fashion

FROM CONCEPT TO CONSUMER

Seventh Edition

■ *GINI STEPHENS FRINGS*

Prentice-Hall

Upper Saddle River, NJ 07458

Library of Congress Cataloging-in-Publication Data

Frings, Gini Stephens.
 Fashion from concept to consumer/Gini Stephens Frings.–7th ed.
 p. cm.
 Includes bibliographical references and index.
 ISBN 0-13-033571-1
 1. Fashion. 2. Clothing trade. 3. Fashion merchandising. I. Title.

TT518 .F74 2001
687–dc21

00-050168

Editor-in-Chief: Stephen Helba
Director of Production and Manufacturing: Bruce Johnson
Executive Editor: Vernon R. Anthony
Associate Editor: Marion Gottlieb
Editorial Assistant: Ann Brunner
Marketing Manager: Ryan DeGrote
Managing Editor: Mary Carnis
Production Liaison: Denise Brown
Production Editor/Full-Service Production: Gail Downey/**TECH**BOOKS
Composition: TECHBOOKS
Design Director: Cheryl Asherman
Senior Design Coordinator: Miguel Ortiz
Manufacturing Manager: Ilene Sanford
Interior Design/Cover Design: Laura Ierardi
Printing and Binding: R.R. Donnelley & Sons
Cover Printer: R.R. Donnelley & Sons

Cover Sketch Courtesy of Gianfranco Ferré

Pearson Education LTD.
Pearson Education Australia PTY, Limited
Pearson Education Singapore, Pte. Ltd.
Pearson Education North Asia Ltd.
Pearson Education Canada, Ltd.
Pearson Educatión de Mexico, S.A. de C.V.
Pearson Education—Japan
Pearson Education Malaysia, Pte. Ltd.
Pearson Education, Upper Saddle River, New Jersey

10 9 8 7 6 5
ISBN: 0-13-033571-1

For Philipp, Peter, and Victoria with love

Contents

2

Influences on Fashion Marketing and Consumer Demand 29

3
Fashion Change and Consumer Acceptance 47

10
Apparel Production 193

11
Accessory and Fur Manufacturing 223

12
Wholesale Marketing and Distribution 251

Part Four

Fashion Retailing 279

13
Retailing 281

14
Retail Fashion Merchandising 303

15
Retail Fashion Marketing 331

Foreword

Everyone has to wear clothes. Clothes are an important part of our lives. The clothing we buy for special occasions—proms, graduations, weddings, and so on—becomes part of our memories. We remember these occasions by what we were wearing.

This is what makes my business special. I enjoy designing those special dresses that my customers will remember. My customer knows what she wants; she wants to look beautiful. She wants to feel nostalgic about her purchase. I design with my customer in mind. My success comes from my strong focus, my point of view. I developed a special style and stuck to it over the years. I adapt current trends to my own style. Buyers know they can find a consistent look from me, and so do my customers. I try every day to make my designs better than yesterday. I am never satisfied with myself. I have always believed that I have a special talent, a special creative force, but aside from that, I'm my own toughest critic.

Fashion design is not work to me, it is my fun, my life. I'm up at six, to work by eight, break half an hour for lunch—usually at my desk to look at fashion magazines so I can keep my eye on what's happening—then spend the rest of the day in the workroom making sure my designs are going the way I want. I create 150 designs a season, five times a year for our seven lines. But it's not enough to be creative. I have to combine my creative ability with a business sense, too. I love my business. No, it's more than that. What I do for a living is exactly the way I want to live.

I have known the author of this book for more than 25 years. In her role as an educator, Gini would bring her students to meet with me to discuss my fashion philosophy and see my current line. Then the students would design and make a sample garment for the next season and bring them back to me for a critique. One of Gini's students later became my assistant.

Because of people like Gini, who has experience in the industry, fashion education is much better today. I am happy to introduce her excellent book, which prepares the student to know how the fashion business operates and what to expect working in it. The book covers the fashion business in logical sequence with complete and realistic information. I hope each student will take advantage of this text and absorb its contents for later use.

As a student, you have to realize that your college education is just the beginning, a time to open your mind to new possibilities. Students want to be successful the minute they graduate and enter the field. But you can't expect to be a success overnight. As a graduate you must be focused and use your first job as a new learning situation and grow in your knowledge day by day.

Best wishes in your fashion career,

Jessica McClintock

Jessica McClintock
San Francisco

Preface

The purpose of this book is to tell the whole story of how the fashion business works, in sequential order from concept to consumer. The fashion business is a series of buying supplies, creating and developing a new product, and marketing the product. The fashion business includes all the processes involved with producing raw materials, apparel, and accessories and the retail stores that sell fashion merchandise to the public. It is important for executives in the fashion industry to know how all of these processes interrelate.

Fashion designers and merchandisers who work for manufacturers must work with textile producers to develop fabrics that they need for their apparel and accessories. Manufacturers must also understand the importance of selling on the retail level. Retail fashion buyers should understand how garments and accessories are designed so that they can be creative merchandisers and make wise buying decisions. They may also have to develop products and source production themselves for private-label merchandise.

Part One concentrates on fashion fundamentals. Chapter 1 traces the development of fashion and the fashion industry as a background to understanding today's business. Chapter 2 shows how consumer demand affects fashion marketing. Chapter 3 explains fashion change and consumer acceptance. Chapter 4 covers market research, fashion analysis, and design resources, information needed by everyone in the fashion business.

Part Two covers the development, production, and marketing of raw materials, including textiles, trimmings, leather, and fur—the supplies needed for fashion manufacturing.

Part Three discusses international fashion centers and traces the fashion manufacturing process from design and merchandising development through production and sales to retailers.

Part Four covers retailing: types of retail organizations, merchandising—the buying and selling process, and marketing.

Each chapter contains a career focus, chapter objectives, review questions, terminology, and projects to aid in reviewing the subject matter. The appendices contain information on career guidelines and a glossary of fashion terminology.

Just as the fashion industry has changed dramatically over the last 20 years, each edition of *Fashion From Concept to Consumer* changes with it. As the industry has become more marketing oriented, so has this book. As the

industry has seen a tremendous growth in men's wear and accessories, this book too has much more information on men's wear and accessories. As computer technology has changed how fashion is produced and distributed, the book describes applications in every area. *Fashion* explains the changes in relationships between levels of the industry; how manufacturers have become retailers and retailers have become manufacturers. *Fashion From Concept to Consumer* describes how these major changes have affected every aspect of the fashion business.

This book completely tells the story of the fashion business and is a valuable tool for any introductory course in fashion: Introduction to Fashion Design, Introduction to the Fashion Industry or Manufacturing, Introduction to Fashion Merchandising or Retailing, or Introduction to the Fashion Business. There is also important information for textile marketing, apparel manufacturing, accessory design, production and marketing, and advertising and promotion. This is a text for specialists as well as for those who are taking only a single course in fashion. In fact, it will interest anyone who wants to know more about fashion and the fashion business.

Acknowledgments

I wish to thank the many friends and business associates who took time to answer questions, make suggestions, review chapters, and donate photographs during the revision of this book. I am particularly indebted to the following persons:

- Gianfranco Ferré, who graciously gave his permission to use his wonderful sketch on the cover.

- Jessica McClintock, whose talent, genuine interest, and cooperation in the training of fashion students makes her Foreword especially meaningful.

- Van Lowry and Tom Cannon, Celanese Acetate; David Link, American Textile Manufacturers Institute; Mark Messura, Cotton Incorporated; Heather Stuart, Tammy Petrasko and Jennifer Morgan, Woolmark; Les Solomon, Fiber dynamics; Maryann Rotella; and Peggy Anstrand for sharing their knowledge of textiles.

- Marian Goodman, Bloomingdale's; Julie Dugoff, Saks Fifth Avenue; Stacey Kaye, Henri Bendel; Rosemary Murphy and Ellen Alpert, Talbots; Jane Messenger, Macy's West; and Gail Cottle, Nordstrom; and Ian Ruddle, Federated Department Stores, and Kay Draisin, Factory Stores; for generously sharing their superior knowledge of retailing.

- Robin Howe, Jones New York; Bob Zane and Carol Charny, Liz Claiborne; Betsey Johnson; Charlotte Neuville, Lerner New York; Trudi Muller, Mervyn's; Dana Peiffer, Esprit; for advice on design and production.

- Abe Chehebar, Accessory Network; Helen Welsh, Liz Claiborne; and Patricia Underwood for updates on accessories.

- Paula Coccimielio, Saks Fifth Avenue; Rachael Arnold, Bloomingdale's; Rob Corder, Mervyn's; Donna Cristina, Dente/Cristina; Jodie Schmidt, Macy's East; and Virginia Meyer, Cato Corporation, for their expertise in fashion marketing.

- Laure du Pavillon, Christian Lacroix; Laurian Davies, UK Fashion Exports; Laurie Belzak, City of Toronto; and Les Kumar-Misir, Industry Canada; for updates on international fashion.

■ My grandmother, Ida Martin, my parents, Ida and Russell Stephens, Elma McCarraher Page, Dolores Quinn, Eleanor Kling Ensign, Hazel Stroth, Debra Smith, and friends and family for encouragement throughout my education and career.

■ Most of all, to my husband, Philipp, and my children, Peter and Victoria, for their patience.

PART *I*

The Fundamentals of Fashion

Part One provides students with the fundamental knowledge they need to understand the workings of the fashion industry. Reading these chapters before reading any other parts of the book is essential.

■ Chapter 1 traces the *development* of fashion and the fashion industry as a background to understanding changes in the industry today.

■ Chapter 2 concerns the importance of the *consumer* and the essentials of *fashion marketing,* which are the very basis of the fashion business.

■ Chapter 3 explains the principles of *fashion change* and theories of consumer acceptance.

■ Chapter 4 covers the market and design *research* necessary for product development.

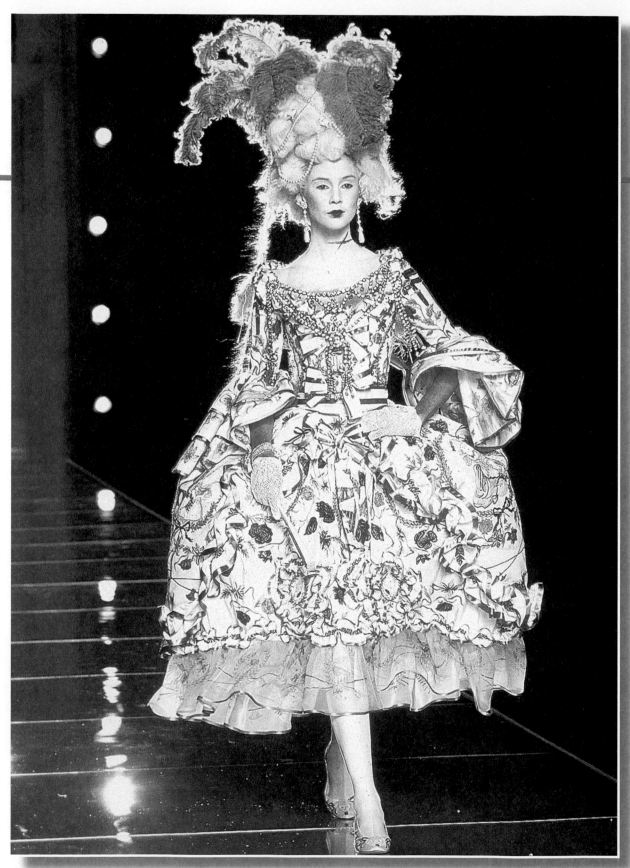

John Galliano created this interpretation of an eighteenth-century costume for Christian Dior. *(Courtesy of Christian Dior)*

1

Fashion Development

■ CAREER FOCUS

Fashion executives at every level of the industry need to understand how the fashion business developed as a basis for their education. Lessons in history help them make decisions for today and for the future. It is also interesting to see how ideas from the past are often reinterpreted for today's fashion.

To preserve this information for us, some fashion professionals work as costume curators for museums or in the archives department of a fashion company.

■ CHAPTER OBJECTIVES

After reading this chapter, you should be able to:

1. List the major changes in American life-styles since the Industrial Revolution and how they have influenced fashion;
2. Explain how fashion has reflected the social, cultural, political, economical, and technological changes since the Industrial Revolution;
3. Outline and discuss major changes in the fashion industry;
4. Name the major designers of the past 100 years.

More than just a designer's whim, fashion is a reflection of the social, political, economic, and artistic forces of any given time. The changing styles that evolve from these forces tell of historical events as poignantly as textbooks, journals, or periodicals. Dressing room mirrors throughout the ages have reflected the trends in how people think, live, and love.

We will examine some of the major influences on fashion in history as a background to understanding contemporary fashion and anticipating future change. Chapter One traces the development of the fashion industry in Europe and America from the seventeenth century to the present, emphasizing the last 100 years. It briefly discusses how fashion innovators, together with society, technology, economics, and politics, change fashion.

Fashion, as we know it, is relatively new. In ancient and medieval times, clothing styles remained practically unchanged for a century at a time. Fashion change began to accelerate during the Renaissance, as Western civilization discovered different cultures, customs, and costumes. As new fabrics and ideas became available, people craved more new things. The pace of fashion change has continued to increase.

■ FRANCE, THE CENTER OF FASHION

France's dominance over international fashion began in the early eighteenth century.

Fashion Dictated by Royalty

Until the industrial revolution, people belonged to one of two main classes: the wealthy landowners or the poor laborers and farmers. Because wealth was concentrated in the landowning class, these people were the only ones who could afford to wear fashionable clothes. Royalty, at the top of both the social and economic ladders, set fashion trends whereas other members of the aristocracy followed their example to gain approval.

At the turn of the eighteenth century, members of King Louis XIV's court became the arbiters of taste, making Paris the fashion capital of Europe. The textile industry grew in Lyons and other French cities, supplying the court with silk fabrics, ribbons, and laces. Dressmakers and tailors, sponsored by the wealthy, developed their skills to a high level using these beautiful materials.

Hand Sewing by Dressmakers and Tailors

The elaborate detail and intricate tailoring and dressmaking at that time required an enormous amount of painstaking hand labor. All clothes were not only handmade but also *custom-made.* Each garment was made to fit the customer's exact measurements. Dresses and suits were individually sewn by dressmakers or tailors to their employers' specifications. The identities of personal dressmakers were secrets guarded by the wealthy. No one wanted to share the talents of clever dressmakers for fear of losing them. Rose Bertin

(Ber-tan') was dressmaker to Queen Marie Antoinette, whose name is known only because she was made the official court minister of fashion.

Poor people wore castoff clothing from the rich or made their own clothing. The very elaborate peasant clothing for special occasions was passed from one generation to another and became the traditional *folk costume,* different in every region. The contrast between the plight of the poor and the extravagancies of the court during the eighteenth century was one cause of the French Revolution, which began in 1789. In response to a general revulsion against excess, fashion changed from elaborately decorated costumes to simpler garments.

Growth of the Couture

France became the center of fashion because of the patronage of the royal court and the development of the silk industry there. In France, the art of dressmaking was known as *couture* (koo-tour'). A male designer was a *couturier* (koo-tu-ree-ay'); his female counterpart was a *couturière* (koo-tu-ree-air').

Charles Worth is considered the father of the couture because he was the first successful independent designer. Born in England, he came to Paris at age 20 in 1846 (the same year that Elias Howe patented his sewing machine). Worth attracted prominent women as clients, culminating in Empress Eugénie, wife of Emperor Napoleon III.

Some couturiers became business forces as well as creative ones, directing salons staffed with seamstresses and tailors. Other couture houses followed Worth, including Paquin, Cheruit, Doucet, Redfern, the Callot sisters, and Jeanne Lanvin. The couture became a bridge between the class-structured fashion of the past and the democratized fashion of today.

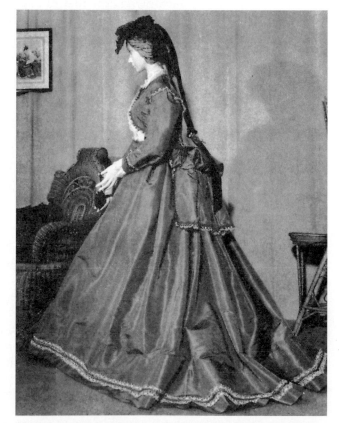

Worth gown typical of the Second Empire period in France, 1852–1860. *(Courtesy of the Union Francaise des Arts du Costume)*

From these beginnings, an international market for Parisian high fashion grew. In 1868, the couturiers of Paris formed a trade association. Other European capitals followed the leadership of Paris; Vienna became the next in importance. Couturiers were the major influence on fashion design for more than 100 years, setting style trends for all of Europe as well as the rest of the Western world.

Fashion dolls, dressed in miniature versions of couture gowns, were sent from France as a convenient means of publicizing fashion. Orders from wealthy women were mailed back to Paris, where the gowns were made to fit the customers' requirements. Some of these dolls made their way to the United States. Most people could not afford couture clothes but managed to copy them to some degree.

■ *EFFECTS OF THE INDUSTRIAL REVOLUTION ON FASHION*

The Industrial Revolution marked the beginning of technological advances in textile and apparel production.

Growth of the Textile Industry

Colonial America had virtually no textile or fashion industry. Most materials were imported from abroad: silks from Italy, France, India, and China; and woolens, calicoes, and cashmeres from Britain.

The modern textile industry, which enabled more fabrics to be produced in less time, began in England with John Kay's development of the flying shuttle in 1733, James Hargreaves' invention of the spinning jenny in 1764, Richard Arkwright's water frame in 1769, and Edmund Cartwright's power loom in 1785. To protect its industry, England passed strict laws preventing textile machines, parts, blueprints, tools, and even the mechanics and inventors themselves from leaving the country. However, Samuel Slater memorized every detail of Arkwright's water frame and other machinery and secretly left England. Within two years of his arrival in New England, he had a new mill built and in operation. Textile mills began to produce cloth in America, and New England became America's first textile center.

In 1814, Francis Cabot Lowell of Boston developed the power loom. His factory was the first to have a vertical operation: complete textile production from raw cotton fiber to finished cloth by one company. By 1847, more Americans worked in textiles than in any other industry.

After the Civil War, the American textile industry began to relocate to the South, the source of cotton. Southern states provided other incentives, such as cheaper labor. Eventually, the South became the center of textile production in the United States.

Growth of the Middle Class

Great economic, social, and fashion changes throughout the Western world accompanied the Industrial Revolution in the late eighteenth century. Burgeoning trade and industry in turn created a middle class with money to spend on the luxuries of life, including better clothing. Money gave the new middle class power, not only in business and society, but also to influence fashion trends. Fashion became a status symbol, a visual means to show off wealth.

Establishment of the Business Suit

Until 1800, men's and women's fashions had equal amounts of decoration. In Louis XIV's time, men's dress was at least as elaborate as women's. As the middle class grew, businessmen wanted to establish an image of respectability and dependability. At that point, "men's garb descended from brilliant finery . . . into bleak conformity." Men adopted the conservative, dignified business suit with long trousers, jacket, vest, shirt, and necktie—"a permanent noose, you might say."[1] Men's business attire remained basically conservative with very few changes.

Men's clothing, as well as women's, was custom-made. The finest tailor shops—such as Henry Poole and Company, established in 1843—were

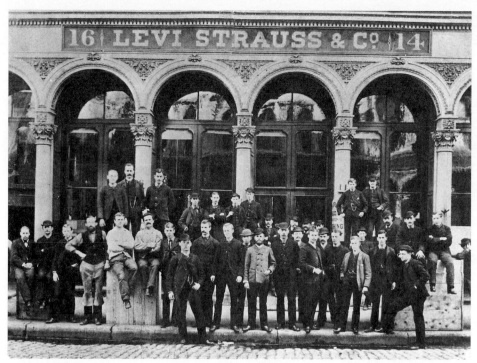

Employees outside the Levi Strauss company headquarters in San Francisco about 1873. *(Courtesy of Levi Strauss & Company)*

on Savile Row in London, which became the international center of men's fashion.

Some ready-made men's clothing was made by hand in France in the late 1700s. In America, some enterprising tailors made the first ready-to-wear suits for sailors so that they would have clothes to wear when they came on land. At first, tailors cut the fabrics, bundled the pieces, and sent them out to homes to be sewn by hand; known as the *cottage industry process*. The tailors also became retailers with factory-shops located in seaport cities, such as New Bedford, Boston, New York, and Philadelphia.

In 1818 in New York, Henry Brooks started the men's clothier business that became Brooks Brothers. Because of his determination to make and deal only in merchandise of the best quality, Brooks helped advance ready-made clothing. There, Abraham Lincoln bought an overcoat for his second inauguration.[2]

■ *MASS PRODUCTION OF CLOTHING*

The mass production of clothing led to accessible fashion for everyone.

Invention of the Sewing Machine

The democratization of fashion began with the invention of the sewing machine, which turned a handicraft into an industry. The sewing machine made the mass production of clothing possible. In 1829, a French tailor named Thimmonier patented a wooden chain-stitch sewing machine, but all existing models were destroyed by rioting tailors who feared for their jobs. Walter Hunt, an American, developed a sewing machine in 1832 but failed to patent it. Thus, the man who is usually credited with its invention is Elias Howe, who patented his in 1846. All of Howe's machines were run by hand.

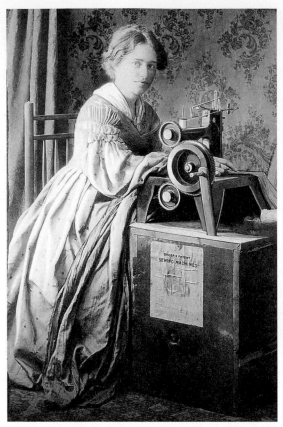

The first Singer sewing machine, 1851.
(Courtesy of the Singer Company)

In 1859, Isaac Singer, whose name has become a household word because of his mass production of the sewing machine. He developed the foot treadle, an improvement that left the hands free to guide the fabric, and mass-produced these machines. Singer spent $1 million a year on sales promotion and, by 1867, was producing a thousand machines per day (Electrically powered models were not available until 1921).[3] To save time and to keep control over production, entrepreneurs brought workers and machinery together in factories. This caused many people in search of work to move to the cities where the factories were located.

In 1849, when the Gold Rush attracted thousands of men to California in search of gold, a 20-year-old Bavarian immigrant by the name of Levi Strauss opened a dry goods store in San Francisco. In 1873, he began to manufacture long-wearing pants with riveted pockets, using a tough cotton fabric called *serge de Nimes* (loomed in Nimes, France), later shortened to *denim.* They are an item of wearing apparel that has remained basically the same for nearly 150 years!

Another early use for sewing machines was to make Civil War uniforms. The Union army recorded the chest and height measurements of more than a million soldiers to come up with the first standardization of sizes. After the war, sewing machines and uniform sizing promoted the mass production of everyday men's wear.

Women's Fashion Reflects Social Changes

Fashion conveyed the rigid differences between the roles of the sexes. Men wore trousers, which became a symbol of dominance, while women wore constraining garments characteristic of their restricted life-styles and obedience to their husbands and fathers. Women did not have the right to own anything except their wardrobes, which is one reason women became so interested in clothes.[4]

Aside from the small number of wealthy women who bought couture, most women had about three basic garments in their wardrobes. Fashionable one-piece fitted dresses were impossible to mass-produce because each dress had to be custom made to fit at least three sets of measurements. Even after the invention of the sewing machine, only hoop skirts and cloaks could be manufactured for women.

Mass Production of Women's Separates

The introduction of separate blouses and skirts in the 1880s made it possible to manufacture ready-to-wear clothes for women. A blouse could be made to fit the shoulder and bust measurements, the skirt to fit the hips. Waistlines and hemlines were easily adjusted and blouses were simply tucked in. This innovation made it possible for the working- or middle-class woman to add variety to her wardrobe simply by mixing separates. The cost of a new ready-made blouse was a mere fraction of the cost of a custom-tailored dress.

Charles Dana Gibson, a popular illustrator in the 1890s, created drawings of young women wearing the new blouses and skirts. His *Gibson Girl* sketches were the personification of the ideal young middle-class American woman and gave style to the the basic high-neck, puffed-sleeve blouse and long-skirt look. The Gibson Girl look paved the way for the simplified, functional dress that typifies American fashion.

Children's Fashion

The wealthy were the only ones who had money to spend on fashionable children's clothes; members of the middle and working classes made their children's clothes at home. Babies and toddlers, both girls and boys, wore dresses. As they grew older, children were supposed to act like adults and they were dressed in miniature versions of adult apparel, usually cut-down remakes of their parents' old clothes. Mothers were particularly grateful for the advent of patterns for children's clothes because previously, home-sewn garments had been cut and fitted by trial and error.

Paper patterns, inspired by French fashions, were made available to American home sewers in 1850 by Ellen and William Demorest.[5] Demorest Patterns, followed by Butterick and McCall's, fostered fashion consciousness at all levels of society. Women on small budgets were especially happy to have patterns to make the clothes that they could never afford to buy.

A young woman dressed in the Gibson Girl style.
(Courtesy of the National Archives, Washington, DC)

■ RETAILING DURING THE NINETEENTH CENTURY

Modern retailing had its roots in the nineteenth century when affordable fashion was first made available to the general public.

Fairs and bazaars were the predecessors of the retail store. The traveling merchant brought clothes to these markets. Expensive goods were shown only to selected wealthy customers. Prices were not marked on the merchandise, so buyer and seller usually bargained.

As large numbers of people settled in towns, the first general stores were established to cater to the desire for wider assortments of merchandise. Also, artisans sold their handmade goods in their own shops. These shops were grouped together by trade and regulated by guilds.

The Industrial Revolution triggered a self-supporting manufacturing and retailing cycle. As more goods were produced, there were more products to sell. This increased business activity gave the growing middle class more money to spend, which created a demand for more products. This growing demand for the variety of goods being produced was the basis for the growth of retailing. Retail stores grew up in the cities, close to production and population centers. As more people clustered in cities to work, stores opened in areas convenient to shoppers.

Two types of stores finally emerged to bring fashion to the public: the specialty store and the department store. Traditional handicraft stores evolved into *specialty stores,* and general stores developed into *department stores,* which carried a wide variety of merchandise. Shopping in department stores became a popular activity, like going to an exhibition. For the first time, people of all incomes could at least enjoy browsing and looking at beautiful things.

The First Department Stores

In 1826, Samuel Lord and George Washington Taylor formed a partnership to open the first Lord and Taylor store in New York City. Jordan Marsh and Company, opening in Boston, claimed they could sell, cut, sew, trim, and furnish a dress in half a day.[6] Edward Filene opened a comparable department store in Boston and John Wanamaker in Philadelphia, Joseph Hudson in Detroit, Morris Rich in Atlanta, and R. H. Macy in New York did the same. Their stores grew to a prominence that lasted 150 years.

Harrod's of London, established by Henry Harrod in 1849, began as a small grocery store. By 1880, it had 100 employees and became the largest department store in Europe. Liberty of London opened its retail store in 1875 and produced its own prints as early as 1878. In France, department stores such as the Bon Marché and Printemps opened in the nineteenth century.

The nineteenth century also saw the beginning of customer service, a major contribution to American retailing. In Chicago, Marshall Field once ad-

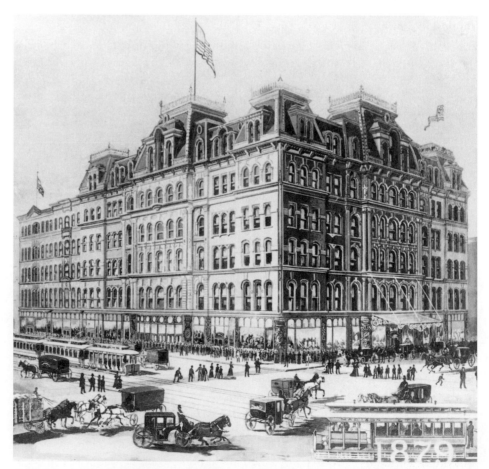

A sketch of Marshall Field's State Street store in 1879. *(Courtesy of Marshall Field)*

monished a store clerk who was arguing with a customer, "Give the lady what she wants." "The customer is always right" has been a principle of American retailing ever since.

Early Mail-Order Merchandising

In the 1800s, nearly three-quarters of the American population lived in rural areas, usually served by only a few general stores with a limited selection. The extension of the railroads to the West Coast and the inauguration of a free rural mail delivery enabled merchants to start reaching these potential consumers with mail-order services.

While working for a wholesaling firm, traveling to country stores by horse and buggy, Aaron Montgomery Ward conceived the idea of selling directly to country people by mail. He opened his business in 1872 with a one-page list of items that cost one dollar each. People could later order goods through a distributed catalog, and the store would ship the merchandise cash on delivery (COD). The idea was slow to catch on because people were suspicious of a strange name. However, in 1875, Ward announced the startling policy of "satisfaction guaranteed or your money back." Contrasting with the former retailing principle of caveat emptor (Latin for "buyer beware"), this policy set off a boom in Ward's business.

In 1886, a Chicago jewelry company erroneously shipped some watches to a jeweler in Richard Sears' hometown in Minnesota. Sears offered to resell them for the jeweler, thereby creating his own watch business. Alvah Roebuck answered Sears' ad for a watchmaker and became Sears' business partner. In 1893, the firm name was changed to Sears, Roebuck and Company. From a modest beginning, they expanded by 1895 to a 507-page catalog including clothing and household goods, often referred to as the "dream book" or "wish book." The mail-order business did more to bring a variety of up-to-date merchandise to rural consumers than any other form of retailing.

■ CHANGES CAUSED BY COMMUNICATIONS, LEISURE, AND INDUSTRY

Communications, leisure activities, labor conditions, and industrial technology have a continuing effect on fashion.

The desire for fashionable clothing was fostered by its increased availability as well as by new communications media such as the mail service, magazines, newspapers, telephones, automobiles, and later airplane travel, radio, motion pictures, television, and computers.

The First Fashion Magazines

During the 1800s, fashion magazines began to be published in France and England. Eighteen fashion magazines were being published in New York and Philadelphia in the late 1800s.[7] Two American magazines that began in the nineteenth century are still published today: *Harper's Bazaar* commenced publication in both New York and Paris in 1867, and *Vogue* started in New York in 1894.

These publications spread the latest fashion ideas from Paris by means of sketches and descriptions. Dressmakers in other countries copied the styles as best they could with available fabrics. As more women became aware of

fashion styles through magazines and other forms of mass communication, their desire to wear these fashions increased. The faster a style was adopted by the public, the greater was the demand for more new looks.

Growth of Leisure Activities

The popularity of sports such as tennis and bicycling created a need for functional sportswear. As early as 1851, Amelia Jenks Bloomer had tried to introduce pants for women. However, they were not accepted until the bicycling craze of the 1890s. Bloomers, full in the leg and gathered at the ankle, were also worn under bathing dresses. Finally, after 1900, swimwear was pared down enough that people could actually swim.

Pants became an acceptable part of the horse-riding habit for women around the turn of the century, when women discovered that riding sidesaddle in a skirt, "often caused one to dismount before the ride was over."[8] As women became more and more involved in sports, pants gave them the mobility for a more active life. However, it was not until the 1920s that pants became fashionable as well as functional for women.

Conditions in the Garment Industry

New York Becomes the Center of the U.S. Fashion Industry

The influx of European immigrants to New York helped establish that city as the center of the industry in the latter part of the century. The immigrants, used to hardship and willing to work for low wages, provided the skilled labor the industry needed to grow. By 1900, the American women's clothing industry consisted of 2701 establishments.[9] They produced mostly cloaks and suits, with some shirtwaists (blouses) and underwear.

Unionization

As more workers crowded into the industry, working conditions became appalling. Tenement workrooms were known as *sweatshops* because of the excessively long hours required of laborers in unsanitary surroundings for extremely low wages.

In 1900, cloak makers, mostly immigrants living in cities in the northern United States, met to discuss working conditions. The result was the formation of the International Ladies' Garment Workers' Union, which tried to protect its members against unfair employers. At first, the union was not very popular, but it did make progress with strikes against the shirtwaist industry in 1909 and the cloak industry in 1910. The men's clothing workers union, which became the Amalgamated Clothing Workers of America in 1914, also had successful strike in 1910 against Hart, Schaffner & Marx in Chicago. It brought working hours *down* to 54 hours per week!

"On March 25, 1911, the nation was stunned by the horror of the Triangle Shirtwaist Company fire in New York City."[10] The factory's main exit door had been bolted, and the lone fire escape was a death trap that ended in midair. The 146 deaths, mostly of girls, aroused Americans' indignation against the plight of the sweatshop workers. Finally, action was taken on demands for regular hours, minimum wages, paid vacations, sick benefits, and better working conditions. Increased labor costs naturally added to the inevitable simplification of fashion.

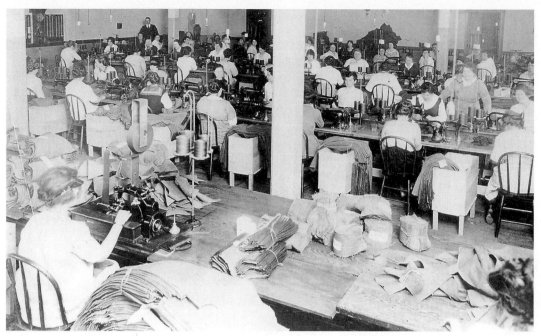

Women working in a Levi Strauss factory. *(Courtesy of Levi Strauss & Company)*

■ *EFFECTS OF WORLD WAR I ON THE STATUS OF WOMEN AND FASHION*

World War I put women in the work force and gave them new rights and practical clothing.

Women in the Work Force

The status of women has hinged firmly on their participation in the working world. Before 1900, very few women worked outside the home. Without a prominent place in business, women had no authority and no rights. At the turn of the century, women began to work in factories, offices, and retail stores. The need for the convenience of ready-made clothing made the apparel industry grow and made ready-to-wear clothing even more acceptable.

In 1914, World War I began in Europe, and the United States entered in 1917. World War I greatly promoted women's rights, because it enabled European and American women to replace men in previously all-male jobs. The functional working clothes worn by these women had a great impact on fashion. "Now that women work," Vogue reported in 1918, "working clothes have acquired a new social status and a new chic."[11]

A trend toward masculinity in women's fashion emerged: decorative details disappeared in favor of a tailored look that imitated businessmen's suits. Corsets were discarded and the curved hourglass silhouette was replaced by the tube. Hemlines rose and skirts widened to permit freedom of movement. No one wanted or had time for complicated dressing. This change coincided with the need to simplify clothing construction because of rising labor costs and resulted in the democratization of fashion. Fashion reflected women's growing independence and, in 1920, women finally won the right to vote in the United States.

Important Trendsetting Designers

While mass production was growing in the American fashion industry, the French couture still concentrated on fashion leadership among the wealthy. Paris was a cultural meeting ground for designers, artists, and writers. The exchange of their ideas created the exceptional atmosphere needed for fashion innovation.

Often one or a few designers became *trendsetters;* they dominated the field because they were able to capture the spirit of their times and translate it into highly accepted fashion. American retailers bought French fashion for their wealthy customers and often worked with American manufacturers to have them copied or adapted for the American market.

Paul Poiret (Pwah-ray'), whose tubular dresses liberated women from corsets, was the first Paris couturier of this century to become a trendsetter.

Coco Chanel, wearing one of the suits she made famous. *(Courtesy of Chanel, Paris, photographed by Hatami)*

Gabrielle Chanel (Sha-nelle'), also known as Coco, was at the forefront of French fashion after World War I. Chanel popularized the "Garçon" (gar-sohn') or boyish style with sweaters and jersey dresses and was the first designer to make high-fashion pants for women.

Jean Patou (Gsahn Pa-Too) created the famous "Flapper" look in 1925 by accentuating the hipline, strengthening a straight silhouette, and making shorter skirts with uneven hemlines. He confirmed that the young, independent woman was the new ideal.

The ready-to-wear apparel industry began to prosper when designers such as Poiret, Vionnet, and Chanel simplified styles and thereby construction. Couture styles were then copied by mass producers for consumers at every price level. Because individual fitting was not so important to their straight silhouettes, the mass production of dresses became practical. As early as the 1920s, designers such as Lucien Lelong in France and Hattie Carnegie in America were adding ready-to-wear lines to their made-to-order collections. Although custom-made clothing remained important, fashionable ready-to-wear was firmly established by the 1920s.

■ *RETAIL EXPANSION IN THE EARLY TWENTIETH CENTURY*

The needs of the growing middle class stimulated both apparel manufacturing and retailing.

Specialty Stores for Quality Fashion

In the early twentieth century, specialty stores emerged with new retailing approaches and offered their customers high-fashion merchandise. Bergdorf Goodman and Saks Fifth Avenue in New York City and Neiman

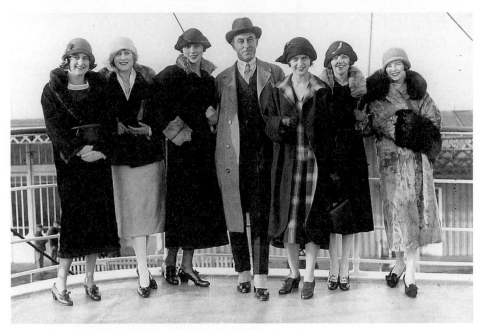

Jean Patou and his American models arriving at Le Havre in 1924. *(Courtesy of the National Archives, Washington, DC)*

Marcus in Dallas concentrated solely on the finest fashion and customer service. By the 1930s, the first women presidents of major retail firms had been installed; Dorothy Shaver at Lord and Taylor and Hortense Odlam at Bonwit Teller. Shaver gave American fashion a boost by mentioning American designers in store ads.

The Expansion of Chain Stores

While great retailing establishments were growing in the big cities, chain stores selling lower-priced merchandise were taking hold elsewhere. James Cash Penney was such an industrious employee at a small Wyoming store that the owners offered him a partnership in their new store in 1902. Called the Golden Rule Store in honor of their belief in high business standards, it proved an immediate success, in part because of Penney's door-to-door advertising campaign. In 1907, the original partners sold their shares to Penney; the store's name was officially changed to J. C. Penney in 1912. When the chain-store concept caught on in the 1920s, Penney opened stores in all parts of the United States. Chain stores became a national phenomenon.

The Advent of Suburban Retail Centers

As more and more people moved to the suburbs and owned cars, personal mobility increased, creating a revolution in retailing. Finding that its mail-order business was dropping off, Sears & Roebuck opened stores not in the city centers but rather near the highways that led to the growing suburbs, where they could offer free parking. It was also the beginning of suburban shopping centers such as The Country Club Plaza in Kansas City, which opened in 1922.

■ *EFFECTS OF THE DEPRESSION ON FASHION*

The experience of the Great Depression of the 1930s still causes manufacturers and retailers to worry at the sign of a recession.

Bursting of the Credit Bubble

In the 1920s, so much credit was extended that eventually there was not enough money to back it up. In the stock market, a person needed to put up only 10 percent of the price to buy stock; when the price rose, the shares could be sold at a profit. So it went until September 3, 1929, when the stock market started a steep decline. In less than a month the market value of all stocks dropped $30 billion. Unemployment rose from 1.5 million to 12.8 million, and business profits fell from $10.3 billion to a net loss of $2 billion. Nearly half of the nation's banks had to close. Industrial production fell to half of what it had been, and many companies went bankrupt. More than one-third of the ready-to-wear manufacturers went out of business. The slump set off a chain reaction that soon put the whole world into a depression.

Hollywood's Influence on Fashion

Americans tried to take their minds off the Depression at the movies. Because people in pre-television days commonly visited the local movie theater once or twice a week, American films brought fashion to every woman. Every young woman wanted to look like her favorite film star. Katharine

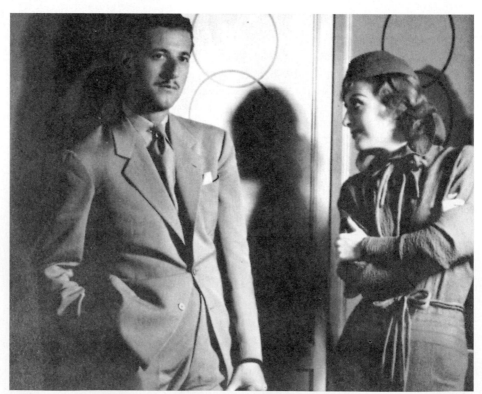

Film star Joan Crawford glances admiringly at Adrian, Hollywood trend-setting designer of the 1930s. *(Courtesy of the Joseph Simms Collection)*

Hepburn and Marlene Dietrich made slacks popular for women; Clark Gable popularized the sport shirt for men. The 1930s were the most glamorous years in film history, a paradoxical contrast with the deprivations of real life.

Gilbert Adrian emerged as the leading Hollywood designer. He was the first American designer to influence fashion throughout the world. Macy's sold half a million copies of one dress he designed for Joan Crawford to wear in *Letty Lynton* in 1932.[12]

Paris's Influence on International Fashion

The influence of Parisian couture designers on international fashion remained.

Elsa Schiaparelli (Ska-pa-rell'-ee) was the trendsetter of European fashion in the 1930s. Schiaparelli moved the center of interest to the shoulders, which she began to widen, accentuating them by pleats, padding, or braid, a silhouette that remained popular through World War II.

James Mainbocher (Main-bow-shay') was the first American designer to be successful in Europe. When King Edward VIII of England abdicated his throne to marry the divorced American Wallis Simpson, Mainbocher designed the wedding dress, which became the most copied dress of the 1930s. Scandals and fashion remain intertwined to this day!

Gown by Schiaparelli. *(Courtesy of Claudy Stoltz)*

■ *EFFECT OF WORLD WAR II ON FASHION*

The American economy did not entirely recover until World War II escalated production.

America's Isolation from Paris Fashion

During the war, the French couture banded together under the leadership of Lucien Lelong, then president of the Paris Couture Syndicale, during the German occupation. Under great restrictions and privation—practically no fabrics to work with, no trimmings, no press coverage, no heat, and little food—most designers barely managed to stay in business. Some were forced to close. Of course, under these circumstances, little was achieved.

Isolated from Paris fashion leadership during the war, Americans had to find their own style direction. The lack of imports from France was actually a boon to the development of American talent. In 1940, *Vogue* reported on the New York collection openings. With Mainbocher as an example of success, other American designers such as Claire McCardell, Hattie Carnegie, and Vera Maxwell gained recognition.

Claire McCardell, considered the top American designer of this time, was credited with originating the "American Look" in practical separates, inspired by the work clothes of farmers, railroad engineers, soldiers, and sportsmen.

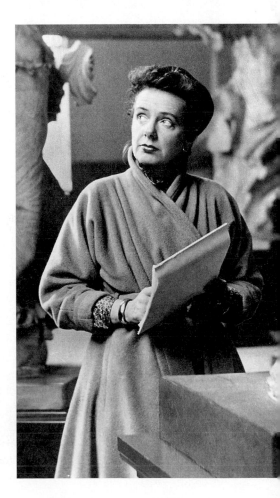

Claire McCardell sketching in a museum.
(Courtesy of the National Archives, Washington, DC)

American designers became especially skilled at and known for their sportswear, reflecting the more casual American life-style, which would eventually influence the rest of the world. Sportswear, with its simpler construction, also suited mass production.

Fashion remained relatively stable during the war years. The U.S. government's wartime regulations restricted the use of fabric and hardware. Functional clothes became a necessity as women doing war work wore uniforms or work clothes. Women's suits were heavily influenced by military uniforms. The result was a masculine silhouette for the women who now shouldered the responsibilities at home.

■ *REACTIONARY POSTWAR FASHION*

The postwar era brought about a suburban life-style and an accent on family life.

In the postwar search for domestic tranquility, American families wanted to escape the deteriorating cities and find a healthy environment in which to raise their children. For many, this meant a move to the suburbs. The informal suburban life-style brought about the popularity of casual sportswear by American designers, new wash-and-wear manufactured fabrics such as nylon, and more convenient shopping centers.

French Fashion Direction

Women were so happy to see men home after the war that most reverted completely to stereotypical feminine roles, leaving jobs open for the returning men. Fashion catered to their feminine ideal. Paris recaptured fashion dominance—almost to the point of dictatorship in Dior's case.

Christian Dior (Chris-tee-ahn' Dee-or') showed his first collection in 1947 and was an instant success. In a reaction against the wartime silhouette, women adopted his "New Look," with longer, fuller skirts; smooth, rounded, sloping shoulders; and tiny fitted waists. Within a few seasons, Dior's name became a household word, and he was doing as much business as the rest of the French couture combined.[13]

Christobal Balenciaga (Bah-lehn'-see-ah'-gah), a Spaniard who worked in Paris, was regarded as the master of tailors. When American stores purchased rights to manufacture *line-for-line* copies, Balenciaga's designs were always the most popular.

American Fashion Innovators

Although Parisian designers set international trends, Americans also enjoyed continued success at home because of the exposure given to them during the war. These women's wear designers included Bonnie Cashin, Oleg Cassini, Ann Fogarty, James Galanos, Charles James, Anne Klein, Norman Norell, Mollie Parnis, Fernando Sarmi, Adele Simpson, Jacques Tiffeau, Pauline Trigere, Sydney Wragge, and Ben Zuckerman.

Movie star Audrey Hepburn and Jacqueline Kennedy, wife of the president, set a new ideal of beauty. They established an impeccable

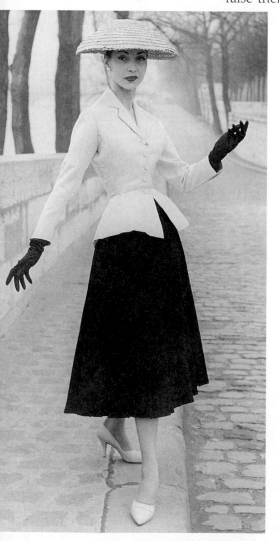

Dior's "New Look." (*Courtesy of Christian Dior*)

look predicated on simplicity that was universally imitated. Jackie practically made a uniform of her two-piece jewel-necked A-line dresses and pillbox hats.

Until the 1950s, the average man's wardrobe had only a few dark suits, white shirts, somber neckties, overcoat, raincoat, and hat. For the first time, designers such as Don Loper and John Weitz developed coordinated sportswear for men.

Some American designers custom-made fashion for the wealthy, but most built their reputation on what Americans did best, ready-to-wear, especially sportswear. The French may have been the high fashion innovators, but Americans developed and excelled at producing fashion looks for everyone.

The late 1940s and 1950s also saw the the biggest increase of births ever; called the post-war baby boom. As these children became teenagers, industry catered to this newly emerging market. Records, cosmetics, magazines, and *junior* fashions were created.

■ THE YOUTH-DIRECTED 1960s

The post-war baby boom had an increasing effect on fashion change. Breaking with convention, young designers created fashions for their own age group.

By 1965, 50 percent of the United States population was under the age of 25. Sheer numbers brought increased buying power and encouraged a youth-oriented market. Reminiscent of the 1920s, young people's tastes were to dominate the fashion scene through the 1970s.

London Emerges as a Leader in Youthful Fashion

Mary Quant and other young British designers such as Zandra Rhodes and Jean Muir set international fashion trends. They were influenced by a group of British youth called the Mods, who put together odd separates and old clothes from flea markets to create individual looks. Miniskirts, which rose above the knee, tights (the first panty hose) and unusual fabrics such as vinyl were characteristic of the "Mod" look.

In the United States, young designers, such as Betsey Johnson, also created youthful fashions. Even the couture designers in Paris, such as André Courrèges, followed the lead of these young designers. This was the first evidence of a reverse in the traditional fashion-adoption process. The popularity of the youthful look made all women want to look young.

Revival of Men's Fashion

The English Mod look affected men's wear as well as women's. Carnaby Street tailors made an attempt to return color and fashion to men's clothing. The initial impact of Carnaby Street did not last, but the general interest in men's fashion did. Men became more concerned with their roles

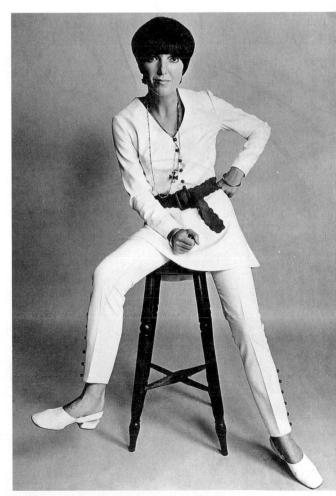

1960s trendsetting designer Mary Quant.
(Courtesy of Mary Quant Limited)

outside work and with leisure dressing. French and Italian designers also became important in men's wear.

Pierre Cardin (Car-dahn′) signed his first contract for men's shirts and ties in 1959 and opened his men's ready-to-wear department in 1961. Dior, St. Laurent, and other women's designers followed his example. The 1960s brought the first designer clothes for men and the first fashion changes since the introduction of the business suit.

Fashion Business Evolution

In the 1960s, the nature of the fashion business began to change. Although some designers such as Pierre Cardin were able to make new successes, the youthful direction in fashion caused financial setbacks for the French couture designers. The 1960s saw the last of elegant fashion for 20 years.

In the United States, the growing population and economy changed the structure of fashion companies. Small, family-owned fashion businesses began to disappear. Some merged or were purchased by large, multi-product corporations. Others, spurred by the flourishing economy, raised money for expansion by selling stocks, to become publicly owned. Public investment gave apparel companies the needed capital to grow and meet rising textile supplier minimums and growing retail distribution.

Boutiques Set Retailing Trends

British shops such as Mary Quant's Bazaar set a new trend in retailing. The French term *boutique* was adopted by Western countries as these small shops gained popularity. Traditional retailing in department and large specialty stores had competition from small boutiques. Following the trend, Yves St. Laurent opened his Rive Gauche (Reev Gosh) boutiques around the world. Henri Bendel's in New York introduced an atmosphere of many boutiques within one store. This idea brought freshness and excitement to retailing.

■ ANTIFASHION OF THE LATE 1960s AND 1970s

Antifashion became the style statement from the late 1960s into the 1970s.

The tumultuous late 1960s—a time of the Vietnam War, assassinations, riots, and civil strife—made people turn away from showy displays of frivolity. In suburban America, the polyester pantsuit became almost a uniform. It even became stylish to look poor. Workmen's Levis became an anti-fashion statement, and the popularity of denim remains today. Some young people, bored with the lack of excitement in retail merchandise, wore vintage clothing purchased at thrift stores.

The Ethnic Look

Society's dropouts, the "hippies," made their anti-fashion statement in tattered jeans, long hair, beads, and old clothes. In their desire to emulate the simple life, they combined their old clothes to simulate ethnic or native American costume.

Eventually, the "Ethnic look" widened to include traditional folk costumes from practically every country. Black people developed pride in their heritage, sporting Afro hairdos and the dashiki, traditional African garb. The resumption of diplomatic relations with China in 1972 created widespread interest in the Chinese people and their traditional costume. Designers incorporated the ethnic idea of layering and combining separates into their collections.

Yves St. Laurent (Eve Sahn'Law-rahn') of Paris emerged as the fashion star of the 1970s because he was able to interpret ethnic and other street looks into high fashion. At that time, he was best known for his blazers, city pants, and ethnic looks. The epitome of reverse fashion adoption was St. Laurent's "Elegant Peasant" collection of 1975: ethnic looks done in silks with high price tags.

Physical Fitness as Fashion

In the 1970s, sports and exercise, such as jogging, became generally popular. Fashion was not lost in the race, and soon everyone had a jogging suit, even if they did not run. By the 1980s, active sportswear was a firmly established fashion category. Designers and manufacturers created clothing for every sport. The newly developed elastic fiber, spandex, was used to give garments the stretch needed for movement.

1970s trendsetting designer Yves St. Laurent and a gabardine pantsuit from his 1969 collection. (*Courtesy of Yves St. Laurent*)

 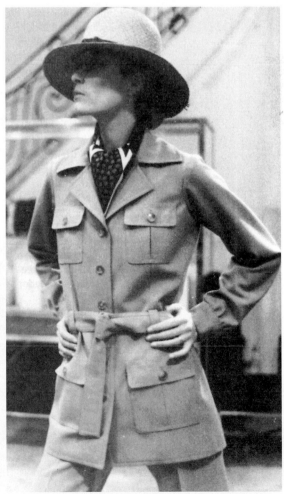

The denim look culminated in "designer jeans" by Calvin Klein and Gloria Vanderbilt. The sexy "Me and My Calvins" advertisements were the most noteworthy example of the growing role of advertising in the fashion business. In the late 1970s, there was a wave of conservative leisure dressing, featuring khaki shorts, penny loafers, polo shirts, button-down shirts, and blazers, called the "Preppy look."

The Women's Movement

The 1970s witnessed women at work, striving for an equal place with men in the business world. Women were trying to make it up the corporate ladder rather than the social one. To fit into a man's world, they adopted the conservative business suit (with skirt) to give themselves a visual business-like credibility. "Dressing for success" became the byword for those who wanted to get ahead. In a somewhat misguided attempt at quality consciousness, *status dressing* became important. The label of the garment became more important then the design. Calvin Klein, Halston, Geoffrey Beene, Ralph Lauren, and Mary McFadden became important designer names. Rolex watches, Gucci shoes, and Louis Vuitton bags became the status accessories.

■ THE ACQUISITIVE 1980s

Overspending and overborrowing in the 1980s caused many of the problems that the fashion business still faces today.

During the 1980s, a trend toward acquisition was manifested in the workplace as well as in fashion. Large manufacturers and retailers got larger by gobbling up small firms. The general public also was primarily interested in climbing the corporate ladder and acquiring money. Many aging baby boomers went back to college to further their careers. More than 60 percent of women ages 18 to 54 worked outside the home, and increasing numbers of them rose to executive-level positions. Their new status was exhibited by the "power suit," a structured but elegant look that dominated fashion.

Globalization

During the 1980s, fashion evolved into a global phenomenon. Both American and European manufacturers and retailers greatly increased imports of textiles, apparel, and accessories.

Giorgio Armani, of Milan, Italy, became the trendsetter of the 1980s because his immaculate tailored look so perfectly suited the career woman. His fashion empire included Emporio Armani and many licenses. Italy became a major international fashion capital; Missoni knits, Armani suits, and Krizia sportswear were in great demand worldwide.

Japan emerged briefly as an important fashion center in the early 1980s led by Kenzo Takada and then Issey Miyake. Japanese designers showed their collections in Paris and influenced world fashion with their oversized silhouettes, wrapping, and layering. In 1981, the eyes of the world were on England where Prince Charles wed Lady Diana Spencer. Copies of her wedding gown were in London shop windows 8 hours after the wedding! In France, Karl Lagerfeld's elegance and Christian Lacroix's flamboyant silhouettes and colors helped rejuvenate the French couture. The 1980s also saw the beginning

1980s international trendsetting designer Giorgio Armani.
(Courtesy of Giorgio Armani SpA)

of international recognition of American designers, led by Calvin Klein. This prompted other American fashion companies to consider exporting.

Domestic Industry Trends

Textiles and Apparel

Textile and apparel manufacturers, faced with increased competition from imports, especially from Asia, began using electronic data interchange to foster cooperation between textile and apparel producers and retailers to react quickly to trends and cut out wasted time in distribution (see Chapter 12).

Growth of Designer and Brand Names

In the mood of acquisitions, well-known designers and brands became even more pervasive by diversifying their product lines. This was often accomplished by *licensing,* a royalty or percentage paid for the use of a designer or brand name, supported by tremendous amounts of advertising. The growth of the Ralph Lauren, Liz Claiborne, and Nike brands, for instance, was astounding (see Chapter 12).

Retailing Trends

Retailing went through an optimistic period, which unfortunately caused over-expansion. The United States became an *over-stored* (industry jargon for too many stores) nation besieged with buyouts and takeovers. Mail-order retailing grew, attracting busy career women who preferred to shop by catalog. Nordstrom, a Seattle-based retailer, built a national reputation for customer service that set a standard for other stores to follow (see Chapters 13 and 14).

■ *THE VALUE-ORIENTED 1990s*

In the last decade of the century, Americans have had to readjust to a less indulgent way of life.

Recession

The biggest impact of the early 1990s was an international recession beginning in the United States and the United Kingdom and finally reaching Japan and continental Europe. This had far-reaching consequences for the fashion industry.

Value Orientation

Consumers, facing job layoffs caused by the poor economy in the early 90s, became value oriented. In 1991, more than half of all apparel sold in the United States was bought on sale.[14] Discount and off-price stores such as Wal-Mart enjoyed success in spite of the recession because their low prices appealed to consumers. Retailers tried to win back customers with various new strategies, including value, customer service, and private label collections.

Retailing

Retail over-expansion in the 1980s, which resulted in overwhelming competition, combined with careful consumer spending, forced bankruptcies and store closures in the 1990s. Many long established retailers, such as I. Magnin, Abraham & Straus, and John Wanamaker, closed or were taken over by large retail groups. Macy's, faced with bankruptcy, was taken over by Federated Stores, but retained its name.

Manufacturing

Naturally, textile and apparel manufacturers were affected by the recession as there were fewer retailers to sell to and imports continued to climb. Textile and apparel producers joined retailers to debate the pros and cons of the North American Free Trade Agreement (see Chapter 2). Textile producers hoped that manufacturers would be able to use U.S. textiles if garments are produced in Mexico instead of Asia.

Information Age

Because of growing imports, there was a shift away from manufacturing to focus on marketing and information. Both strategies were fostered by the great advances made by computer technology in all phases of the fashion industry. As discussed in Chapter 2, the 1990s introduced us to electronic industry partnerships, computer-aided design, high-tech manufacturing, cable TV and computer shopping, infomercials, and the Internet.

Fashion Direction

In the early 90s, the recession in the United States was reflected in the "Grunge Look," an anti-fashion statement. Internationally, Parisian designer Karl Lagerfeld increased his influence and became the foremost international

trendsetter with four major collections: Chanel, Lagerfeld, Fendi, and Chloe. His designs had an impact on many market segments and price ranges, especially with the "conservative chic" look. By the mid-90s, Tom Ford, the American design director of Gucci and Mariuccia Prada, both in Italy, also became global trend-setters with their sleek, minimalist fashions.

The men's wear market grew tremendously during the 1990s. Relaxed corporate dress codes allowed men to wear casual clothing to work, and the men's sportswear market, in turn, thrived. Men's wear designers, first Giorgio Armani, and then Tommy Hilfiger, Tom Ford (for Gucci) and Richard Tyler were so successful that they started women's collections.

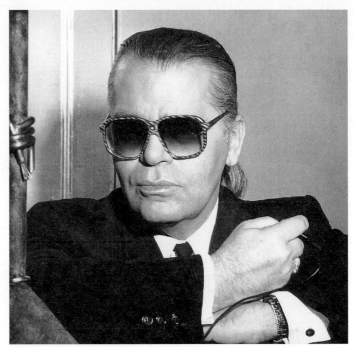

1990s international trendsetting designer Karl Lagerfeld. *(Courtesy of Karl Lagerfeld)*

The Twenty-First Century

The new century got off to a terrific start for the fashion business. Americans enjoyed a vigorous economy and, along with it, a renewed enthusiasm for fashion but with a body-conscious, sexy focus. Consumers are optimistic enough to enjoy color in fashion again. There is more excitement about the international collection showings than ever before. Designers have captured media attention and the public's imagination with their outlandish creations. Anything goes.

The next fourteen chapters tell the whole story of today's fashion business . . . from concept to consumer.

■ SUMMARY

This chapter has briefly covered the growth of the fashion industry. Technological advances, especially the invention of the sewing machine, changed clothing production from custom-made to ready-to-wear. The Industrial Revolution also nourished the growth of a large middle class, which demanded and could afford fashion at every price level. As a result, fashion became available to everyone instead of just the wealthy few.

Fashion has also been influenced by the changing status of women and by the changing roles of both sexes. Fashion leadership originated with and was maintained by the French, except during World War II and in the 1960s and 1970s. The 1980s were the beginning of corporate growth through mergers and acquisitions. Fierce competition and overstoring caused many bankruptcies of former leading companies at all levels of the industry. Competition also drove manufacturers and retailers to seek cheaper labor abroad. Those imports cost many domestic textile and apparel workers their jobs, even more company closures, and forced the industry to streamline production. The information age and globalization brought renewal and the fashion industry into the twenty-first century.

■ CHAPTER REVIEW

Terms and Concepts

Briefly identify and discuss the following terms and concepts:

1. France, the fashion center
2. Royalty as trendsetters
3. Couture
4. Charles Worth
5. Business suit
6. Isaac Singer
7. Levi Strauss
8. The Gibson Girl
9. Department stores
10. Specialty stores
11. Richard Sears
12. Coco Chanel
13. Gilbert Adrian
14. The New Look
15. Claire McCardell
16. The postwar baby boom
17. Mary Quant
18. The Mod Look
19. Antifashion
20. The Ethnic Look
21. Active sportswear
22. Globalization
23. The power suit
24. Giorgio Armani

Questions for Review

1. How did the growth of a middle class affect fashion in the eighteenth and nineteenth centuries?
2. What factors made Paris the center of world fashion?
3. How did the American textile industry get its start?
4. Give two examples of how fashion reflects social or political history.
5. Discuss the growth of mass production in the United States and the technical developments that made it possible.
6. What are the origins of specialty and department stores?
7. How did retail development and expansion in the nineteenth and twentieth centuries reflect social changes?
8. How did the growth of a garment industry encourage the growth of unionism?
9. How did the change in women's status influence fashion in the twentieth century?

Projects for Additional Learning

1. Trace the fashions of one of the designers listed in the Influential Designers Chart by consulting newspapers and magazines from the period in which he or she was best known. Trace the evolution of the designer's styles with sketches or photocopies. Discuss the characteristics that made his or her designs unique. How did the design reflect life-styles?
2. If possible, visit an historic costume collection at a museum and examine costumes from each decade since the turn of the century to compare design details.
3. Start a small costume collection with your class. Canvass your family, friends, and neighbors for attic donations or shop at flea markets and thrift shops. Keep a record of all items as to donor and approximate year made. Examine them for construction methods and design details. These clothes will not only be fun to wear but can be used as inspiration for future design projects.
4. Visit a local sewing machine dealer. Ask the dealer to trace the technical advances in machines as far back as he or she can remember. The dealer may have old catalogs or old machines that you can examine. Discuss the advantages of the old and the new models.

■ NOTES

[1] Phyllis Feldkamp, "Men's Fashion, 1750–1975," *New York Times Magazine,* September 14, 1975, p. 66.

[2] "Bicentennial of American Textiles," *American Fabrics and Fashions,* no. 106 (Winter-Spring 1976), p. 12.

[3] Ishbel Ross, *Crusades and Crinolines* (New York: Harper & Row, 1963), p. 12.

[4] Ibid., p. 99.

[5] Ibid., p. 20.

[6] Ibid., p. 116.

[7] Ibid., p. 220.

[8] "Women's Pants," *L'Officiel USA,* Spring 1977, p. 109.

[9] Florence S. Richards, *The Ready to Wear Industry 1900–1950* (New York: Fairchild Publications, 1951), p. 8.

[10] *Signature of 450,000* (New York: International Ladies' Garment Workers Union, 1965), p. 24.

[11] Quoted by Helen Brockman, *The Theory of Fashion Design* (New York: Wiley, 1965), p. 69.

[12] Ernestine Carter, *The Changing World of Fashion* (London: Weidenfeld & Nicolson, 1977), p. 70.

[13] Charlotte Calasibetta, *Fairchild's Dictionary of Fashion* (New York: Fairchild Publications, 1975), p. 561.

[14] Ira Schneiderman, "A Look at the Future," *Women's Wear Daily,* August 1992, p. 15.

Historical Chart of Influential Designers

Years Most Influential	Designers and International Fashion Directions
1774–1793	Rose Bertin: dressmaker to Marie Antoinette
1790–1815	Hippolyte le Roy: dressmaker for the court of Napoleon, creator of the classic revival Empire style
1860s	Charles Worth (b. England): father of modern couture for women
	London's Savile Row tailors set standards for men's tailoring
Late 1800s	Redfern, Cheruit, Doucet, Paquin
Early 1900s	Madame Gerber (house of Callot Sisters), Jeanne Lanvin
1909–1911	Paul Poiret: his tunics freed women from corsets
1912–1915	Charlotte Premet
Post-World War I	Madelaine Vionnet: first to do bias cut
1916–1921	Coco Chanel: known for the Boyish Look and for using jersey
1922–1929	Jean Patou: known for the Flapper Look
1930–1935	Elsa Schiaparelli (b. Italy): hard chic and unconventional styling
1936–1938	Mainbocher (b. United States) and Molyneux (b. Ireland): understatement and broadening shoulders
	Gilbert Adrian: Hollywood glamour copied in ready-to-wear
1940–1945	Claire McCardle (American): known for American Look of practical sportswear
	The war years made communication with Europe impossible and made Americans begin to appreciate their own designers
1947–1957	Christian Dior: with his New Look, Paris fashion leadership is regained American sportswear for men appears
1950–1960	Balenciaga, Givenchy, St. Laurent, Andre Courreges, Pierre Cardin (France)
	Pucci (Italy)
1960s	Mary Quant: English designers have international influence
	Beginning of young designers creating for young people
	Mini skirts and Mod Look
	Pierre Cardin builds empire for men and women's fashion
1968–1975	Confusion in fashion direction; Paris influence is waning
	Ethnic influence; street fashion
	American jeans became international fashion
1970s	International exchange of fashion
	Major influence from French prêt-à-porter: St. Laurent, Kenzo (b. Japan), Rykiel, Lagerfeld (b. Germany)
	Italian designers important: Armani, Missoni, Krizia (Mandelli), Ferragamo shoes, Gucci handbags
	Geoffrey Beene, Halston, Calvin Klein, Mary McFadden important in American fashion
1980s	Global outlook; acquisition
	Japanese have international influence
	Rise of internationally known, popularly priced sportswear by manufacturers such as Liz Claiborne, Esprit, and Benetton
	Armani (Italy) sets the fashion tone for professional women
	Lagerfeld and Lacroix rejuvenate the French couture
	American fashion designers begin exporting
1990s	Recession followed by value orientation; grunge look
	Karl Lagerfeld is major international trendsetter with five collections
	Gucci and Prada of Italy are major trendsetters; minimalist look
	John Galliano at Dior; Alistair McQueen at Givenchy; outrageous couture
	American designers known worldwide
	Growth of men's designer sportswear; Tommy Hilfiger
2000+	Return of enthusiasm for fashion yet casual clothes prevalent
	Tom Ford, design director for Gucci and Yves St. Laurent ready-to-wear
	Growth of E-commerce for fashion retailing
	Retailers expand globally; international luxury corporations
	Continuing acquisitions; manufacturing and retailing giants

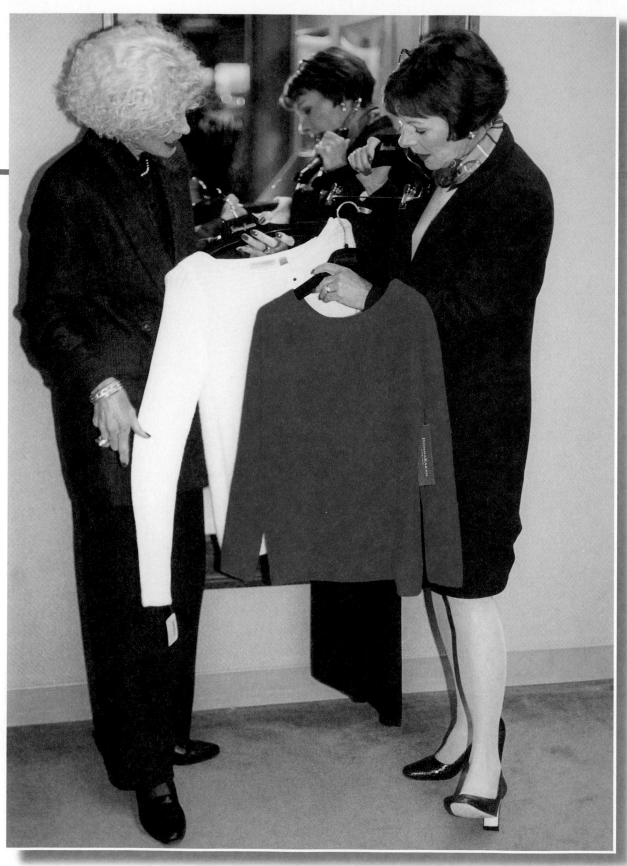

Linda Eller, director of personal shopping at Neiman Marcus, shows apparel to a customer. *(Photo by the author)*

2

Influences on Fashion Marketing and Consumer Demand

■ CAREER FOCUS

Fashion executives, including product managers, merchandisers, designers, buyers, and all the people involved in marketing, continually learn about new developments in consumer demand, economics, world trade, and technology. All product development, production, and marketing decisions are based on this information.

■ CHAPTER OBJECTIVES

After reading this chapter, you should be able to:

1. Understand fashion marketing and the fashion marketing chain;
2. Know the technical, economic, and global influences on fashion marketing;
3. Be aware of the importance of the consumer on fashion marketing and how demographic and psychographic studies help the industry determine target markets.

*F*ashion marketing is the entire process of research, planning, promoting, and distributing the raw materials, apparel, and accessories that consumers want to buy. It involves everyone in the fashion industry and occurs throughout the entire channel of distribution. Marketing is the power behind the product development, production, distribution, retailing, and promotion of fibers, fabrics, leathers, furs, trimmings, apparel, and accessories.

Fashion marketing begins and ends with the consumer. This chapter first discusses the effect of consumer demand on marketing. It begins with a survey of consumer groups, demographic and psychographic trends, and explains how these help define target markets. The chapter goes on to discuss economic, global, and technological influences on consumers and ends with a discussion of the marketing chain.

■ *CONSUMER DEMAND*

Consumers, people who buy and use merchandise, are the primary influence on marketing.

The history of the fashion industry in America is the story of a growing economy that consumed more than it could produce, giving power to the manufacturers. As competition increased, however, the consumer had more choice of products. Consumers now have the income to influence fashion marketing by their buying decisions. In addition to better and cheaper products, consumers also demand constant availability, convenience, and a pleasant shopping experience. As a result, consumers' demands have shifted the industry from a production to a marketing orientation.

With this change in marketing philosophy, the industry now endeavors to find out what consumers will want to buy through research and then tries to develop the products to answer those needs. Fashion industry executives continually read and learn about consumer behavior to get clues as to what products consumers might need or want to buy in the future. Professional analysts have developed sophisticated marketing research methods to determine consumer wants and needs and, in turn, manufacturers and retailers have emphasized product development to answer those needs.

Fashion firms also spend large amounts of money on increased advertising and other marketing activities to *create* consumer demand. The ultimate achievement of advertising is to establish the identity of a particular brand name or store so solidly that it will be preferred over the competition. Consumers are bombarded with million-dollar advertising campaigns (see Chapters 12 and 15). However, there is a limit to which marketing can win acceptance for a fashion. If the public is not ready for a product or is tired of it, no amount of advertising or publicity can gain or hold its acceptance.

■ CONSUMER GROUPS

Fashion executives try to satisfy the wants and needs of particular consumer groups or market segments.

Consumers are not one homogeneous mass. Traditionally, society was divided by income classes. The wealthiest were the most fashionable, because only they could afford to buy expensive clothes. Today, the traditional class systems have broken down. Almost all clothing is mass-produced, and almost everyone can enjoy fashion on some price level.

Demographic Trends

Market research companies, manufacturers, and retailers try to understand consumer needs by studying information about society. Market researchers do sophisticated demographic and psychographic studies to classify the population into consumer groups or *market segments,* based on age, life-style, living area, educational and ethnic backgrounds, and so on. *Demographics* are statistical studies of measurable population characteristics such as birth rate, age distribution, and income. Demographic studies demonstrate that the American population is aging and diversifying.

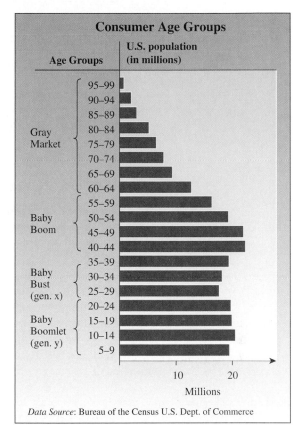

Gray Market

Americans born before 1945 (now over age 55) are the most neglected by the designers, retailers, and the media. In fact, the 55- to 70-year-old group is the second-fastest-growing age segment. This age group tends to feel 10 to 15 years younger than their actual age, but they've been marketed to as if they were 10 to 15 years older. People 50 and older control 77 percent of all financial assets in the United States and 50 percent of all discretionary income.[1] Studies show that mature people have money to spend and enjoy new products as much as anyone. Ten thousand Americans turn 50 every day.[2] By 2010, one-third of the population will be over age 50, indicating that the future will need to cater to a more conservative value-, function-, and quality-oriented customer.

The Postwar Baby Boom

Baby boomers, the age group caused by the increase in the birthrate between 1946 and 1964, are the primary demographic spending group in the United States to influence the apparel market since World War II. In the 1960s, this youth-oriented market fostered the growth of junior sportswear, jeans, T-shirts, and other fashions that fit the needs of baby boomers at that time. In the 1970s, this generation was responsible for the creation of the upscale "Contemporary" style category. By the 1980s, people in this demographic segment were in their 30s and 40s and firmly implanted in both career and family building. Their fashion preferences changed along with their life-styles and

priorities. Some clever manufacturers changed their images as their customers got older. Ellen Tracy, for example, produced junior sportswear in the 1960s, contemporary in the 1970s, and is now a major "bridge" (one price range lower than designer) resource.

One-half of the U.S. population is now over 40 years old and baby boomers account for 32 percent of all Americans.[3] According to Bear Stearns, women age 37 to 55 (41 to 59 in 2005) are the most powerful consumer market.[4] This age group has distinct and firm ideas about what they want. They expect more service, comfort, and quality, but they want the same fashion as young people with appropriate length and fit.

The Baby Busters (Generation X)

The generation born between 1965 and 1979 is referred to as the *baby busters,* because this age bracket is much smaller than the one preceding it. Although this population segment is smaller than its predecessor, these young people are fashion conscious and willing to spend a large percentage of their incomes on fashion. Now in their 20s and 30s, they have become career- and family-oriented, and their spending patterns reflect these interests.

The Echo Boom (Generation Y)

The fastest-growing age segment, and the most sought-after consumer group, is the *echo boom generation,* the children of the baby-boomers, created by the rise in the birthrate that began in 1980. They are a racially diverse group with a global-, sports-, computer-, and entertainment-orientation that will affect their buying decisions in the future. Advertising, television shows, movies, web sites, and magazines are created specifically for this market. The impact of this new generation on fashion will be evident into the twenty-first century. The junior and young men's market is already strong as a result of this age group reaching their teens. By 2010, the nation will be rather polarized, with the postwar boomers over 50 years of age, and the echo boomers under 30.

Ethnic Diversity

Another important demographic trend is the ethnic diversity of the U.S. population. The Immigration and Naturalization Service projects that legal immigration exceeds 700,000 per year. The Census Bureau has determined that the black, Hispanic, Asian, and Native American segments of the population will all grow much faster than the white majority. People of different cultural backgrounds may look for different things in a fashion purchase. With a multicultural society, retailers and manufacturers cater to various ethnic market segments.

Psychographic or Life-Style Trends

People can share the same demographic characteristics and still be very different from each other. Whatever the age group, market researchers try to pinpoint delineations of life-styles, called *psychographics.* These studies use psychological, sociological, and anthropological factors to further separate consumers based on the differences in their life-styles. Manufacturers and retailers often turn to psychographics to further segment and analyze consumer groups and their fashion preferences.

The Working Woman

Today, more than 70 percent of the female population aged 20 to 54 works outside the home. It is of great interest to the industry that working women spend about 35 percent more on apparel than non-working women.[5] For these women, who divide their days between the demands of home and career, time becomes a critical issue. The busy working woman tends to shop less often and favor catalog and convenient, one-stop shopping, which has aided the growth of certain catalogs, web sites, and super stores.

Larger Sizes

Another phenomenon influencing the fashion industry is the increasing number of people wearing larger sizes. As the population has aged, people are getting fatter. Approximately 68 percent of all Americans are overweight. At Haggar, core sizes for its pants used to be sizes 32 to 40; now the core sizes go up to 44.

Other Psychographic Trends

Observers generally believe that the following are also important psychographic or life-style trends:

- Community—People are looking for a connection to the community; for the first time in more than 40 years, cities are gaining in population.
- Travel is more prevalent—People want clothes that are wrinkle-free and packable.
- Renewed interest in family life—People spend more money on the home and family activities than on fashion.
- Work at home—The number of people who work at home is expected to increase from 30% to 50% in the next 15 years.[6]
- Increased at-home use of computers—People are more likely to shop on the Internet.
- Comfort—People want relaxed and casual dressing at home and at work, and activewear for exercise.
- Cocooning—People insulate themselves from crime and world problems by staying home as much as possible, shopping less, or shopping by catalog or on the Internet; they value their privacy.
- Value of time—People are willing to trade money for free time, which makes shopping by catalog or the Internet appealing.
- Overwhelmed consumers—Stressed consumers have busy schedules and are overwhelmed with too much choice of merchandise; they prefer to limit shopping to a few favorite stores, catalogs, or web sites.

Target Marketing

Textile and apparel producers and retailers use demographic and psychographic information in an effort to understand the buying habits and preferences of each market segment. They also use direct customer contact in stores, informal interviews, surveys, consumer focus groups, and point-of-sale data analysis to define their *target market,* the group of consumers that they want to reach. They try to be very specific to find even smaller potential *market niches* within larger markets. Ideally, appropriate consumer goods are then created for each of these groups of people to satisfy their wants and needs.

Database Marketing

Fashion merchants gather data about consumers to strengthen marketing strategies. Through their purchases, consumers unwittingly give manufacturers and retailers information about their shopping habits, size and color preferences, life-styles, age, income, and address, which is recorded and stored in computers. Many retailers are now issuing their own store credit cards or co-branded cards (in partnership with a bank or a major credit card) to build more elaborate marketing databases.

This information is combined with answers to surveys and other sources, such as sweepstake entries, coupon request forms, and public records, and categorized into *databases*, consumer taste profiles for all consumer groups (see Market Research, Chapter 4). A retailer might evaluate credit card purchases by maternity customers, for example, and send those shoppers direct mail advertising on baby goods nine months later.

Mapping Merchants translate sales data and purchasing patterns into geographic maps; visual representations of their markets. Breaking out sales by customer zip codes vividly illustrates primary and secondary markets for each store location and helps management understand traffic flow and sales potential.

Merchants use consumer profiles from databases to:

- Learn about their customers
- Find new customers
- Establish a target market
- Create new products for their target customers
- Find new target markets for existing products
- Help find new ways to advertise to these markets
- Keep them focused on their customer

Manufacturers and retailers in touch with the needs of their target customer are the ones who succeed in an increasingly competitive marketplace. However, in spite of sophisticated research methods, fashion companies still have a problem understanding changing demographics and creating fashion products that consumers want to buy.

■ *ECONOMIC INFLUENCES ON CONSUMER DEMAND AND MARKETING*

Consumer spending, the state of the economy, the international money market, and labor costs have an effect on fashion marketing.

Consumer Spending

The amount of money consumers spend on fashion and other goods depends on their income. Income as it affects spending is measured in three ways: personal income, disposable income, and discretionary income.

Personal income is the gross amount of income from all sources, such as wages and salaries, interest, and dividends.

Disposable income is personal income minus taxes. This amount determines a person's purchasing power.

Discretionary income is income left over after food, lodging, and other necessities have been paid for. This money is available to be spent or saved at will. The increase in discretionary income enjoyed by most people in our society means that more people are able to buy fashion. Young people spend a high proportion of their income on clothes. For baby boomers and the gray market, apparel expenditures have become stagnant. They spend most of their discretionary income on the home, children's education and interests, exercise equipment, health and beauty care, travel, computers, and investments for retirement.

Purchasing Power

Purchasing power is related to the economic situation. Although incomes in the Western world have risen in recent years, so have prices. Thus, income is meaningful only in relation to the amount of goods and services it can buy or its *purchasing power*. Credit, productivity, inflation, recession, and international currency values affect purchasing power.

Credit

The growth of consumer credit and the proliferation of credit cards has greatly extended consumer purchasing power. More and more retailers are offering their own credit cards to obtain consumer information for their databases. Now, there is too much easy credit available. *Kiplinger's Personal Finance Magazine* reported that 65 percent of U.S. households are carrying outstanding credit card debt.[7] A frightening aspect of too much credit is the huge increase in personal bankruptcies with losses to both retailers and banks.

Fashion companies, too, need credit to be able to operate through seasonal peaks and valleys and to finance their businesses through long lead times of buying supplies long before the finished product is paid for. The accumulation of too much corporate debt is one of the factors that led to many manufacturer and retailer bankruptcies and closings during the 1980s and 1990s.

Corporate Ownership

Fashion manufacturers and retailers were traditionally privately owned companies. Now, most of these companies have grown into corporations or have been purchased by other corporations. There has been a steady barrage of mergers and acquisitions, resulting in giant "corporate groups" such as Liz Claiborne, Jones Apparel Group, and LVMH. In addition, many of these corporations sell stock to the public to gain broader access to funding. Their initial public offerings (IPOs) and impressive performance of certain stocks have gained attention from the press. Bottom-lines, instead of hemlines, often dominate the fashion news. These publicly held corporations now have an added responsibility to their shareholders. They are pressured to build sales and profits, increase cost efficiency, and sink millions into advertising to build their brand image (see Chapters 8 and 13 for more information).

Labor Costs

As people receive higher salaries and live better, the cost of making products increases. Rising labor costs have made clothing more expensive and caused many manufacturers to search for cheaper sources of labor in the Far East, the Caribbean Basin, Eastern Europe, and elsewhere. This practice causes controversy among American workers, who believe that their jobs are in jeopardy, and proponents of free trade, who feel that consumers should pay the lowest possible price for merchandise.

Inflation

In an inflationary period such as the United States experienced in the 1980s, people earn more money each year but higher prices and higher taxes result in little or no real increase in purchasing power. The fashion emphasis of the 1980s was the power suit and luxury accessories, which reflected society's obsession with money and achievement.

Recession

A recession, such as we experienced in the early 1990s, is a cycle beginning with a decrease in spending. Many companies are forced to cut back production, which results in unemployment and a drop in the gross national product (GNP). Unemployment furthers the cycle of reduced spending.

When the economic situation is unstable, the fashion picture is also unstable. Not only is money in short supply, but people seem to be confused about what they really want. In an economic upswing, colors are basically cheerful and happy, but they have a grayed palette when the economy is in trouble. The "grunge" look during the recession of the early 1990s and the colorful fashion of the new century's economic boom are perfect examples of this. Also, people are likely to buy conservatively or at least buy fashions that they believe to be of lasting value in a recession but are more willing to pay for fashion in prosperous times.

Foreign Exchange Market

When the dollar is strong against other currencies, American consumers are able to buy foreign-made merchandise more cheaply. At the same time, American industry is hurt because imported merchandise competes with domestic goods. Moreover, American exports become too expensive for other countries to buy.

On the other hand, when the dollar is weak (loses value relative to other currencies), foreign countries can buy American goods more cheaply. This situation encourages American fashion manufacturers to export and is good for business. In this case, however, imported goods are more expensive for Americans to buy.

The Euro In 1999, the Euro became the official common currency of 11 of the 15 members of the European Union (EU). Actual Euro bills and coins will be issued on January 1, 2002. The use of a single currency will boost European industries' ability to compete in world markets, especially against the dollar and yen, and make trade easier by eliminating exchange rate fluctuations within Europe. It will take time, however, to sort out problems and adjust to the new system.

■ *GLOBAL INFLUENCES ON MARKETING*

Fierce competition from imports and a saturated domestic market have led to a new global viewpoint in marketing on all levels of the industry.

A major trend in fashion marketing is globalization. World trade in apparel and accessories is growing despite high tariffs and drastic currency fluctuations. Many countries may be involved in the production of a single garment. For example, a garment could be designed in New York of Italian fabric, made in Hong Kong, and then distributed to retail stores all over the world. Retailers, too, are expanding globally. Stores as diverse as Christian Dior (French), Hennes & Mauritz (H & M - Swedish), and the Gap (American) are opening stores worldwide.

Imports

Imports are goods that are brought in from a foreign country to sell here. The people or firms that import goods are usually called manufacturers or retailers, acting as *importers.* Retailers want to give their customers the best quality products at the lowest prices. Therefore, ever increasing amounts of textiles, apparel, and accessories are being imported into the United States and the European Union (EU) because of the availability of cheaper labor in low-wage countries. United States and European manufacturers compete with labor rates as little as 62 cents per hour in China, 60 cents in India, and $1.12 in the Philippines.[8] There are three types of imports.

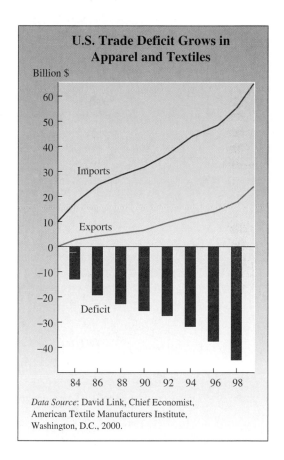

U.S. Trade Deficit Grows in Apparel and Textiles

Data Source: David Link, Chief Economist, American Textile Manufacturers Institute, Washington, D.C., 2000.

Imported Fashion Merchandise

The first type of import is fashion merchandise designed and produced by foreign designers and manufacturers and purchased by retailers at international markets. The United States has long imported fashion from Paris, woolens from the British Isles, sweaters from Scandinavia, and leather goods from Italy. Currently, the European Economic Community, followed by the United States, is the largest importer and consumer of apparel in the world.

Imported Fabrics

Since 1980, U.S. textile imports have increased from 4 billion square meters to 10.7 billion.[9] This corresponds to the enormous growth of the textile industries of China, Korea, Japan, Taiwan, and India. One of the reasons for this is that U.S. manufacturers contracting production overseas tend to use fabrics from the region where production is done, thereby taking sales away from U.S. domestic textile producers (see Chapter 6). As a result, apparel production in Mexico and the Caribbean Basin, where they use U.S. textiles, have become popular.

Imported Apparel or Accessory Production

Many manufacturers and retailers have production (cutting and sewing) done by a contractor in a foreign country where labor is cheaper (see Chapter 10 for a complete discussion of "sourcing"). The huge increase in imports in recent years has stimulated a great deal of controversy. The controversy revolves around two key points: the balance of trade and the loss of jobs at home.

Balance of Trade

The *balance of trade* is the difference in value between a country's exports and its imports. Ideally, the two figures should be about equal. Lately, however, the United States has been importing much more than it exports, sending American dollars abroad to pay for these goods and creating a huge *trade deficit*. Many people believe that we should import fewer goods to balance trade. Others think that the consumer should be given the best merchandise at the best price regardless of the balance of trade.

Labor Versus Free Trade

Another controversy between labor and proponents of free trade concerns the second type of importing: offshore or overseas production. There has been an enormous increase of imported apparel and accessories, especially from China, Mexico, the Caribbean Basin, Taiwan, India, Indonesia, Malaysia, Thailand, Sri Lanka, Bangladesh, and Macao. Labor unions complain that overseas production steals thousands of domestic jobs in textile and apparel production. The textile industry has lost more than 350,000 jobs, and 1000 plants have closed since 1980.[10]

On the other hand, proponents of *free trade* (trade without restrictions) believe that, in the long run, it would be best if world trade were based on specialization; each nation would contribute to the world market what it produces best at the most reasonable cost. In this way, consumers would obtain the most value for their money as well as a wide choice of merchandise from around the world.

Import Tariffs or Duties

Duties or *tariffs* are customs charges imposed on imports in an attempt to protect domestic industry. However, even with duties, imported goods are still usually less expensive. Duties vary according to the type of garment, the fiber content, and whether the fabric is woven or knitted. There are no quotas on silk, flax, and ramie because they are not produced (a small amount of flax is produced in Maine) in the United States and, therefore, are not considered to compete with American industry.

Harmonized Tariff Schedule (HTS) The Harmonized Tariff Schedule is an international system of product classification used since 1988 for international customs clearance and the collection of data on imports and exports. Formerly, every country had its own system of naming or numbering imports and exports. Now a system of 6-digit codes allows participating countries to classify traded goods on a common basis.

Quota Allocations

Many governments also regulate imports by means of *quotas*, regulations that control the quantity of imported merchandise. Quotas are negotiated

agreements between two trading countries and are allocated for a 12-month period. Before considering overseas *sourcing* (finding production), a manufacturer or importer must be sure that there is enough quota to allow the merchandise in question to be produced in that country. Frequently, all the allocations are already "held" (controlled) by manufacturers or by governments in a given country. "Capturing quota" is often a determining factor as to where goods are made.

World Trade Organization

The World Trade Organization (WTO), which governs worldwide trade, is located in Geneva. The organization has members from 124 countries who together account for about 90 percent of world merchandise trade. Its basic objectives are to achieve the expansion and progressive liberalization of world trade. Additional functions of the WTO are to set rules governing trade behavior, set environmental and labor standards, protect intellectual property, resolve disputes between members, and serve as a forum for trade negotiations. In 2000, China was given normal trade status and admission to membership. The WTO now governs the Multifiber Arrangement (MFA), made under the General Agreement on Tariffs and Trade (GATT), created in the United Nations after World War II.

Multifiber Arrangement

Under the jurisdiction of GATT's textile committee, the MFA was negotiated in 1974 as a transitional arrangement to bridge the gap between previous trade restraints and trade liberalization policies. In 1995, approval was reached to phase out the MFA over a 10-year period. During this period, the U.S. has been cutting tariffs on textiles an average of 11.6 percent and apparel, 9.2 percent each year. Worldwide quotas are to be removed from 51 percent of textile

A meeting of the World Trade Organization in Geneva, Switzerland. *(Photo by Tania Tang, courtesy of the WTO)*

and apparel products. American industry does not expect a major impact on trade until 2005, when the phase-out is complete. However, despite reduction, textiles and apparel will remain one of the most heavily protected sectors.

Exports

Because the U.S. market is not growing and to help balance imports, there is a growing trend for American manufacturers to sell their merchandise to foreign retailers either through direct export or by licensing arrangements. Import and export duties and restrictions have kept this business small, but when the U.S. dollar loses value relative to other currencies, exporting becomes especially profitable. As part of the new China Trade Pact, China has agreed to drop high duty rates and other regulations to allow U.S. textile and apparel product imports.

The fastest growing economies in the world are the Southeast Asian countries, Eastern Europe, and Latin America. At its current growth rate, China will have the largest economy in the world in 2025.[11] No longer will these countries be simply a place to source goods, but they will also be attractive new markets because of their growing middle classes.

An increasing number of American manufacturers are exhibiting at industry trade shows in France, Switzerland, Germany, Italy, the United Kingdom, and Japan. Some U.S. manufacturers that are already exporting include Liz Claiborne, Donna Karan, and Levi Strauss. So far, the United States has had the most success exporting to Canada, Mexico, and Japan. Latin America is the fastest growing market for U.S. exports.

North American Free Trade Agreement

In 1994, The North American Free Trade Agreement (NAFTA) created a *free market* (devoid of import duties) including 560 million people in Canada, the United States, and Mexico. The agreement promotes economic growth through the expansion of trade and investment opportunities within the free-trade area. Canada and Mexico are the largest trading partners of the United States and, in turn, the United States accounts for more than two-thirds of their total trade.

Mexico has become a major sourcing spot for the United States under NAFTA and could become even more important to the United States than the Far East. NAFTA gives U.S. textile firms the opportunity to ship their fabric to Mexico to be made into garments. Manufacturers and retailers that have garments produced in Mexico are able to receive shipments much more quickly than shipments from Asia. In 2000, parity was given to the Caribbean Basin countries.

■ *TECHNOLOGICAL INFLUENCES ON MARKETING*

Changes in technology, such as communications, information gathering, and production, have a great effect on the marketing of fashion.

Communications

The development of modern communications has had a huge impact on the fashion industry. Communications that formerly took days or weeks happen instantly. A variety of communication systems provide fashion business

executives and consumers alike with up-to-the-minute fashion information. Accurate, timely, and useful communications are critical to the success of fashion companies.

Business Communications

Fashion industry executives use the latest technology to make communications easier.

- **Computers**—Fashion industry executives are able to communicate with their offices from anywhere in the world on their laptop computers via satellite.
- **Intranet**—Industry executives may use electronic mail (E-mail) on a closed Intranet network system to share information internally, both among departments and with branch offices and stores. These private systems allow people to share information but not worry about data security.
- **Internet**—Executives also use E-mail via the Internet to communicate worldwide with their associates. Manufacturers can communicate with their suppliers and production facilities worldwide and exchange digital design and pattern images.
- **Video**—Video-conferencing provides communications and visuals on products, trends, floor presentations, selling techniques, and electronic staff meetings to retail associates nationwide; the "virtual boardroom."
- **Fax**—A facsimile (fax) machine can send a fashion sketch or list of specifications around the world in seconds.

Communication with Consumers

The Internet, fax machines, and television bring fashion from around the world into our homes instantly.

- **Television**—Television is a vehicle for home shopping, infomercials, and direct-response commercials.
- **Telephone**—The 800 number revolutionized telephone ordering. Now, fiber optic cables carry digital signals to facilitate interactive shopping.
- **Web Sites**—Many manufacturers and retailers have created Web sites to advertise their brands and to give information to consumers. Even small companies can afford to advertise globally.
- **E-commerce**—The Internet opens up global markets. Forecasters predict strong growth for fashion sales on the Internet as more consumers go on-line and more retailers develop "shops" in cyberspace.

Information Technology

Manufacturers and retailers also use computer technology to collect information, or *data*, to help them make accurate marketing decisions.

- **Databases**—As discussed earlier in the chapter, retailers use information gathered from their customers to help them determine target markets and customer preferences and to develop marketing activities and directional selling relevant to that market.

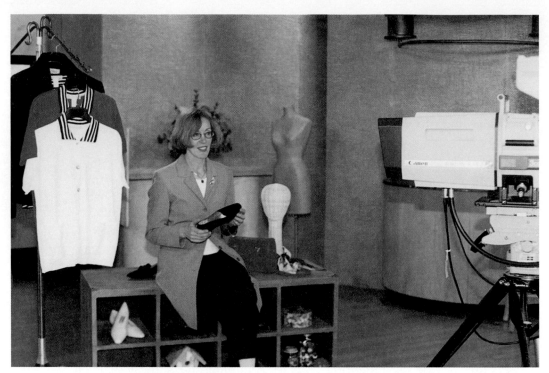

On camera at QVC Cable Shopping Network. *(Photo by the author)*

■ **Research**—Manufacturers and retailers use the Internet to do research on the Web to help them make important merchandising decisions. The Internet can provide fashion industry members with global information on suppliers, fashion services, directories, and libraries.

Merchandise Information Systems (MIS)

Each manufacturer and retailer works with computer experts to develop software programs and systems based on their company's needs. These systems bring order out of chaos by keeping track of and controlling planning, production, inventory, sales, and distribution.

■ In product development, designers and merchandisers rely on consumer statistics and sales data to track trends.

■ Computerized designer worksheets keep track of work-in-progress, specifications, and resources for fabrics and trims.

■ In production, goods are given *universal product codes* (UPC) that identify style, color, size, price, and fabrication.

■ In both manufacturing and retailing, MIS keeps track of inventory so that everyone knows what is on order, in work, or in inventory at all times.

Electronic Data Interchange

In an attempt to reduce waiting time in ordering and distribution, textile producers, apparel manufacturers, and retailers use *electronic data interchange (EDI)*, the exchange of business data between two parties by means of computer. Inventory information is fed through the EDI pipeline from textile producers to manufacturers and retailers.

Automatic Replenishment Agreements between suppliers and retailers allow the manufacturer to ship goods to stores automatically when inventory levels are low. Coded information immediately informs the retail buyer to replenish stock, the apparel manufacturer in turn to issue new cuts, and the fabric producer to send more fabric to the apparel manufacturer.

Value Chain Initiative (VCI) Standardized codes and linkage systems have been developed throughout the industry. A consortium of more than 90 leading software, hardware, transportation, and logistics companies has developed a set of international standards for sharing information among retailers, manufacturers, and suppliers. VCI covers nearly all aspects of the supply chain, including distribution management, electronic data interchange, import/export transportation, inventory control, and warehouse management.

Production Technology

Modern technology makes fashion production more efficient. Computer-aided yarn spinning, fabric design, weaving, knitting, dyeing, and finishing allows our domestic textile industry to compete with imports. Technological research has made manmade fibers possible as well as finishes that change fabric characteristics (see Chapter 5).

The development of modern production machinery, such as power sewing machines and cutting tools, has streamlined the process of manufacturing. Today's power machines can run faster than a car engine, sewing more than 5000 stitches per minute. Modern cutting techniques include the use of computers, water jets, and laser beams. Computer technology has revolutionized manufacturing with computer-aided design (CAD), pattern-making, grading, cutting, unit and modular production systems, pressing and distribution systems (see Chapter 10). Engineers are trying to link all phases of production from design to delivery. In addition, body-scanning technology has been developed to allow mass customization (made-to-measure production).

■ *THE MARKETING CHAIN*

The marketing chain is the flow of product development, production, and distribution from concept to consumer.

The traditional chain of marketing: textiles to apparel manufacturers to retailers to consumers, is no longer clearly divided. The old relationships between suppliers and retailers are disappearing.

Traditional Marketing Chain

This textbook follows the sequential order of the traditional marketing chain. Each level of the industry was formerly clearly separated. The textile industry developed and produced fibers, yarns, and fabrics and sold them to their customers, the apparel and accessory manufacturers. The manufacturers designed and produced the apparel and accessories and sold them to the retailers. The retailers sold it all to consumers. All levels did their own marketing activities, such as advertising, sometimes in cooperation with each other.

Traditional Marketing Chain

FIBERS
Product Development
↓
Production
↓
Sales & Distribution

YARNS
Product Development
↓
Production
↓
Sales & Distribution

FABRICS
Product Development
↓
Weaving & Knitting
↓
Sales & Distribution

APPAREL & ACCESSORIES
Product Development
↓
Production
↓
Sales & Distribution

RETAILERS
↓
Merchandising
↓
Sales

Consumers

Vertical Integration

Today, the old divisions are breaking down. Fierce competition has forced manufacturers and retailers to work together using electronic data interchange to achieve quick and cost-effective "seamless distribution." Alternatively, many companies are combining fabric production and apparel manufacturing or manufacturing and retailing; a strategy called *vertical* merchandising or manufacturing. A completely vertical company produces fabrics, manufactures clothing, and sells the finished apparel in its own stores. Cutting out distribution costs (from manufacturer to retailer) increases profits and keeps prices down for the consumer. Vertical companies also like having total control of the supply, production, and marketing chain.

Manufacturer/Retailer Alliances

To compete with large vertical merchants successfully, many companies who do not have vertical operations form informal partnerships or alliances to integrate the marketing chain (see Chapter 12). Retailers discuss their needs with their manufacturer-partner; they work on product development together, they plan production and shipping timetables together. For this arrangement to work, manufacturers and retailers must have complete trust in each other and open communications.

■ SUMMARY

Consumer demand has caused the fashion industry to convert from a manufacturing to a marketing focus. Manufacturers and retailers study demographic and psychographic trends and databases to learn about consumer preferences and define target markets.

Economics, global trade, and modern technology have a great impact on both consumers and fashion marketing. The traditional marketing chain is no longer made up of totally separate levels. Fashion companies are expanding vertically or forming alliances to strengthen the chain.

■ CHAPTER REVIEW

Terms and Concepts

Briefly identify and discuss the following terms and concepts:

1. Consumer demand
2. Fashion marketing
3. Psychographics
4. Demographics
5. Market segments
6. Disposable income
7. Discretionary income
8. Automatic replenishment
9. Imports
10. Balance of trade
11. Tariffs
12. Quotas
13. World Trade Organization
14. NAFTA
15. Quick Response
16. Marketing chain
17. Vertical or direct marketing

Questions for Review

1. Why has the fashion industry shifted from a manufacturing to a marketing orientation?
2. What impact do demographics and psychographics have on fashion marketing?
3. What factors influence consumer spending?
4. What effect do fashion imports have on prices and jobs?
5. How does a retailer define its target market?
6. How are customer profiles compiled?
7. How does a retailer use databases?
8. Discuss global influences on the fashion industry.
9. Describe merchandise information systems.
10. How does EDI work? What are the advantages of using EDI?
11. What are the benefits of automatic replenishment?
12. What are the advantages of manufacturer/retailer alliances?

Projects for Additional Learning

1. Analyze fashion styles today. Is there one trend that you believe is the result of a social, economic, or technological influence? Briefly explain the reasons for your choice.
2. Prepare a survey addressed to the working woman. Make up at least 10 questions regarding age, job title, income, and clothing preferences and needs. Ask if these women are finding the kinds of clothes they want at the price they want to pay. Ask where they shop. Distribute at least 50 of these surveys to women in offices or at a supermarket. Ask for a mailed reply or complete the survey in person. Compile the answers into a report. This would be a terrific class project as you canvas a larger group of women.
3. Interview a store executive at a local department store or chain store unit. Ask if this store is part of a vertical organization or if it has formed alliances with manufacturers. Who are their major suppliers? Write a report on your findings.

■ NOTES

[1] "Shattering the Stereotypes of the 50+ Shopper, *FGI Bulletin*, Fashion Group International, New York, June/July, 1999, p. 1.

[2] "The Clout of Baby Boomers," *Women's Wear Daily*, August 6, 1998, p. 39.

[3] U.S. Department of Commerce, Bureau of the Census, December, 2000.

[4] "The Clout of Baby Boomers."

[5] NPD Special Industry Services, "Career Smart," DuPont brochure, p. 3.

[6] Janice Suczewski, partner, Deloitte & Touche LLP, as quoted in *FGI*, Fashion Group International newsletter, 1997.

[7] Valerie Seckler, "Staging a Plastic Parade," *Women's Wear Daily*, February 5, 1997, p. 14.

[8] David Link, "Textile Labor Costs," *The U.S. Textile Industry: Scope and Importance*, American Textile Manufacturers Institute, Washington, D.C., 1999, p. 42.

[9] *Textile HiLights*, American Textile Manufacturers Institute, Washington, D.C., December, 1999, p. v.

[10] David Link, Chief Economist, American Textile Manufacturers Institute, Washington, D.C., interview, March, 2000.

[11] "Three Revolutions Shape the Future," *Tracking the Trends Supplement, Women's Wear Daily*, April 1994, p. 6.

New collections herald fashion change; Gianfranco Ferré with his models on the runway at a recent collection showing. *(Courtesy of Gianfranco Ferré)*

3

Fashion Change and Consumer Acceptance

■ CAREER FOCUS

Designers, merchandisers, and marketers at every level of the industry must be aware of fashion change, cycles, and consumer acceptance, and how these concepts will affect product development and marketing. They also have to be aware of all of the categories of apparel, particularly in their specialty area.

■ CHAPTER OBJECTIVES

After reading this chapter, you should be able to:

1. Discuss the dimensions of fashion;
2. Identify the phases and lengths of fashion cycles, and how they relate to consumer acceptance;
3. Explain fashion adoption theories in relation to consumer acceptance;
4. Describe buyer motivation;
5. Demonstrate knowledge of clothing size and price ranges, style categories, and clothing classifications in women's wear, men's wear, and children's wear.

Consumers' wants and needs create a cycle of consumer demand, industry catering to that demand, and finally, consumer acceptance with the purchase of merchandise in the retail market. The first part of this chapter discusses fashion acceptance and rejection, a cycle that creates fashion change. The middle of the chapter covers consumers' connection to fashion cycles, how cycles relate to fashion adoption, and what factors motivate consumers to buy fashion. Last, all of the categories of women's wear, men's wear, and children's wear are described. To set the stage, the chapter begins with terms associated with fashion acceptance.

■ *FASHION TERMS*

All fashion executives use the following terms daily to discuss various aspects of fashion.

Fashion

Fashion is the style or styles most popular at a given time. The term implies three components: style, change, and acceptance.

Style

Style is any particular characteristic or look in apparel or accessories. Designers interpret fashion ideas into new styles and offer them to the public. The manufacturer assigns a *style number* to each new design in each collection, which is used to identify it throughout production, marketing, and retailing.

A style may come and go in fashion, but that specific style always remains that style, whether it is in fashion or not. For example, the polo shirt style will not always be in fashion, yet it will always have variations of the same styling and details, which make it a polo shirt.

Change

What makes fashion interesting is that it is always changing. Designer Karl Lagerfeld said, "What I like about fashion is change. Change means also that what we do today might be worthless tomorrow, but we have to accept that because we are in fashion. There's nothing safe forever in fashion . . . fashion is a train that waits for nobody. Get on it, or it's gone."[1]

Many people criticize the fickleness of fashion, saying that fashion changes only to stimulate buying. And it is true that if fashion never changed, the public would not buy apparel and accessories so often. However, fashion is one way for consumers to visually express their relationship to current events and to life itself.

Fashion changes because

■ It reflects changes in people's life-styles and current events.

■ People's needs change.

■ People get bored with what they have.

As a result of modern communications, the public is quickly made aware of the existence of new styles. Thus, one of the greatest impacts on fashion is the acceleration of change. Consumers are aware of new styles before they reach the stores.

Because fashion is a product of change, a *sense of timing* (the ability to understand the speed of acceptance and change) is an important asset for anyone involved with product development or marketing in the fashion industry. Designers have to decide when their customers will be ready to accept a particular style. Italian designer Valentino remarked, "Timing is the key to a successful idea."[2] When top designers show a new look, designers for mainstream manufacturers have to decide the appropriate timing for including that look in their own lines.

Acceptance

Acceptance implies that consumers must buy and wear a style to make it a fashion. Karl Lagerfeld remarked, "There's no fashion if nobody buys it."[3] It is then up to the public to decide whether these styles will become fashion. Acceptance, i.e., purchases by a large number of people, makes a style into fashion. The degree of acceptance also provides clues to fashion trends for coming seasons (see Chapter 4).

Taste

An individual's preference for one style or another is referred to as *taste*. "Good taste" in fashion implies sensitivity to what is beautiful and appropriate. People who have good taste also understand quality and simplicity. Good taste is developed by extensive exposure to beautiful design.

■ FASHION EVOLUTION

Generally, fashion change evolves gradually, giving consumers time to become accustomed to new looks.

Fashion Cycles

Fashion acceptance is usually described as a fashion cycle. It is difficult to categorize or theorize about fashion without oversimplifying. Even so, the fashion cycle is usually depicted as a bell-shaped curve encompassing five stages: introduction, rise in popularity, peak of popularity, decline in popularity, and rejection. The cycle can reflect the acceptance of a single style from one designer or of a general style, such as the miniskirt.

Introduction of a Style

Most new styles are introduced at a high price level. Designers who are respected for their talent may be given financial backing and allowed to design with very few limitations on creativity, quality of raw materials, or amount of fine workmanship. They create new apparel and accessory styles by changing elements such as line, shape, color, fabric, and details and their relationship to one another. Production costs are high and only a few people can afford the resulting garments. Production in small quantities gives a designer more freedom, flexibility, and room for creativity.

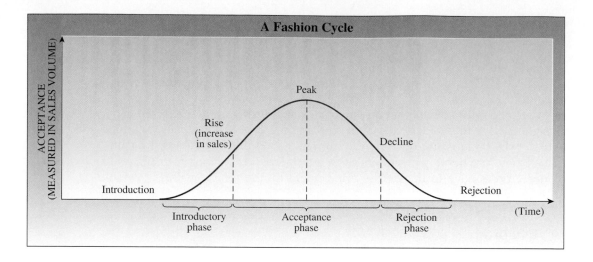

New styles are shown to retail buyers and the press at collection show-ings and market weeks. At this first stage of the cycle, fashion implies only style and newness. Some wealthy people are able to buy these clothes because they want to wear them to important events. Some new styles are loaned to move and TV stars to wear so that they will be seen by many people.

Increase in Popularity

When new styles are seen worn by celebrities on television or photographed in magazines, they attract the attention of the general public. Viewers and readers may wish to buy the new styles but perhaps cannot afford them.

Popular styles are copied by other manufacturers to make them available to the general public. They use less expensive fabric and may modify the design to sell the style at lower prices. Some companies, such as ABS and Victor Costa for Rose Taft, have built successful businesses imitating designer-originals at lower prices. In self-defense, many couture and high-priced designers now have secondary, bridge, and/or diffusion lines, which sell at lower prices, so that they are able to sell adaptations of their original designs in greater quantities.

Peak of Popularity

When a fashion is at the height of popularity, it may be in such demand that more manufacturers copy it or produce adaptations of it at many price levels. Some designers are flattered by copying, and others are resentful. There is a very fine line between adaptations and "knockoffs" (see Chapter 9)! However, volume production requires mass acceptance.

Decline in Popularity

Eventually, so many copies are mass-produced that fashion-conscious peo-ple tire of the style and begin to look for something new. Consumers still wear garments in the style, but they are no longer willing to buy them at regular prices. Retail stores put declining styles on sale racks, hoping to make room for new merchandise.

Rejection of a Style or Obsolescence

In the last phase of the fashion cycle, some consumers have already turned to new looks, thus beginning a new cycle. The rejection or discarding of a style just because it is out of fashion is called *consumer obsolescence.* As early as 1600, Shakespeare wrote that "fashion wears out more apparel than the man."[4]

Length of Cycles

Although all fashions follow the same cyclical pattern, there is no measurable timetable for a fashion cycle. Some fashions take a short time to peak in popularity, others take longer; some decline slowly, others swiftly. Some styles last a single selling season, others last several seasons. Certain fashions fade quickly; others never completely disappear.

Classics

Some styles never become completely obsolete, but instead remain more or less accepted for an extended period. A classic is characterized by simplicity of design, which keeps it from being easily dated. An example is the Chanel suit, which peaked in fashion in the late 1950s and enjoyed popularity again in the 1980s and 1990s. In the interim, the house of Chanel in Paris, as well as other manufacturers, have produced variations of these suits for a dedicated clientele at various price ranges. Other examples of classics include blazer jackets, twin sets, polo shirts, jeans, ballet flats, and loafers.

Fads

Short-lived fashions, or fads, can come and go in a single season. They lack the design strength to hold consumer attention for very long. Fads usually affect only a narrow consumer group, often begin in lower price ranges, are relatively simple and inexpensive to copy, and therefore, flood the market in a very short time. Because of market saturation, the public tires of them quickly and they die out.

Cycles Within Cycles

Design elements (such as color, texture, silhouette, or detail) may change even though the style itself remains popular. Jeans became a fashion item in the late 1960s and remain classics. Therefore, their fashion cycle is very long. However, various details, silhouettes, and other features came and went during that time.

Interrupted Cycles

Consumer buying is often halted prematurely because manufacturers and retailers no longer wish to risk producing or stocking merchandise that will soon decline in popularity. This is obvious to consumers who try to buy summer clothes in August.

Sometimes, the normal progress of a fashion cycle is interrupted or prolonged by social upheaval, economic depression, or war. Consider the large-shouldered, wedge-shaped silhouette in

An updated classic tweed suit from Josh Patner and Bryan Bradley at Tuleh. *(Courtesy of Tuleh)*

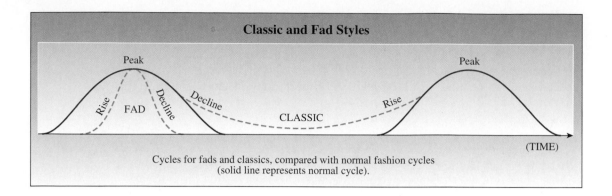

Classic and Fad Styles

Cycles for fads and classics, compared with normal fashion cycles
(solid line represents normal cycle).

women's fashion that began in the 1930s. Because people were concerned with things more important than fashion during World War II, the same silhouette continued, without the normally expected decline, for the duration of the war. The "New Look" of 1947, with its sloping shoulders, tiny waists, and longer skirts, was a radical change because the old cycle had been unnaturally prolonged.

Recurring Cycles

After a fashion dies, it may resurface. Designers often borrow ideas from the past. When a style reappears years later, it is reinterpreted for a new time; a silhouette or proportion may recur, but it is interpreted with a change in fabric and detail. Nothing is ever exactly the same—yet nothing is totally new. Designers may be inspired by nostalgic looks of the last century, but they use different fabrics, colors, and details that make the looks unique to today.

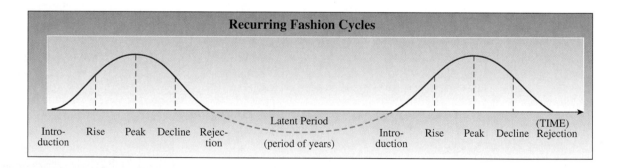

Recurring Fashion Cycles

■ CONSUMER IDENTIFICATION WITH FASHION CYCLES

How the customer relates to the phases of fashion cycles has to do with the consumer group to which they belong.

Consumer Groups

Consumers can be identified with various stages of the fashion cycle. Fashion leaders buy and wear new styles at the beginning of their cycles; others tend to imitate. Manufacturers and retailers may also be identified as fashion leaders or followers, depending on which consumer groups they target.

Fashion Leaders

The people who look for new fashion and wear it before it becomes generally acceptable are often referred to as fashion leaders. Fashion leaders are confident of their own taste or have a stylist advise them. They dare to be different, and they attract the attention of others. Fashion leaders are a very small percentage of the public. They fall into two categories: fashion innovators and fashion role models.

Fashion Innovators Some fashion leaders actually create fashion. They may be designers themselves or just want to express their own individual style. These fashion leaders constantly look for interesting new styles, colors, fabrics, and ways to accessorize their clothes. They try to find unique fashion in small boutiques or vintage clothing stores, or they design their own clothes. They are discerning shoppers who like to wear beautiful or unusual apparel. They may give impetus to a certain style by discovering and wearing it. They may be referred to as *avant garde* (French for "ahead of the pack") or fashion forward. Italian designer Donatella Versace explained, "Many people give us inspiration, the way they put their clothes together, and some have a style that goes beyond the clothes."[5]

225 WEST 39TH STREET, NEW YORK, N.Y. 10018 (212) 575-6400 FAX (212) 354-2548

A sketch of a Vera Wang gown, worn by Charlize Theron to the Academy Awards Ceremony. *(Courtesy of Vera Wang)*

Fashion Motivators or Role Models A few fashion leaders have the beauty, status, and/or wealth to become fashion role models. Designers often lend their new styles to celebrities to get publicity. They are seen at public events, in films, on television, and are photographed by the press. They become role models for everyone who identifies with them and, thereby, influence the way other people dress. Kal Ruttenstein, fashion director of Bloomingdale's, said, "There has been so much interest in what actresses are wearing at the Oscars and customers are emulating them."[6] Because of their influence, fashion motivators are important to designers and to the fashion industry as a whole.

There are fashion leaders for every market segment. They can be anyone featured in the media including royalty, politicians, TV and film stars, rock stars, and supermodels.

Fashion Victims There are also those people with too much money to spend who become slaves to designer brands. Designer Jean-Paul Gaultier remarked, "Fashion victims are people who blindly and stupidly follow a brand without any discernment and without any analysis. As long as it's the latest rage, they buy it without thinking about adapting it to themselves."[7]

Fashion Followers

Fashion needs followers, or it would not exist. Most men and women seek acceptance through conformity and follow world, national, or community fashion leaders to feel confident. Fashion followers emulate others only after they are sure of fashion trends. Consumers become fashion followers for one or more of the following reasons:

- They lack the time, money, and interest to devote to fashion leadership. Dressing fashionably takes time and energy.
- They are busy with their jobs and families and think that fashion is unimportant.
- They need a period of exposure to new styles before accepting them.
- They are insecure about their tastes and, therefore, turn to what others have already approved as acceptable and appropriate.
- They want to fit in with their friends or peer group or to be accepted by them.
- They tend to imitate people whom they admire.

There are various degrees of fashion followers. Some are early adopters, some go with the majority and some lag behind, primarily because they have no interest in fashion. Many busy people want to be judged by their intelligence and not on how they look or what they wear. This is true for many people with a life full of work, children, or other interests.

Because of fashion followers, most manufacturers are copyists or adapters. From a marketing point of view, fashion followers are very important. They make mass production possible, because volume–production of fashion can only be profitable when the same merchandise is sold to many consumers.

Fashion Leadership in Manufacturing and Retailing

Manufacturers and retailers respond to fashion leaders and followers in their product development and merchandising. They try to establish a particular merchandising identity with various consumer groups. Designer collec-

tions provide for the fashion leaders, whereas the majority of manufacturers provide merchandise for fashion followers.

Retailers, too, cater to fashion leaders or followers. Bergdorf Goodman and Saks Fifth Avenue, for example, are stores that identify with and cater to fashion leaders, while Wal-Mart is able to sell volume to the majority of followers. Stores like Macy's and the Gap fall in between. Retailer identification with fashion cycles is discussed fully in Chapter 15.

■ ADOPTION OF FASHION

It is important to understand how new fashion ideas are disseminated, or spread, and how they are adapted to the tastes, life-styles, and budgets of various consumers.

Basically, there are three variations of the fashion adoption process: traditional adoption, reverse adoption, and mass dissemination.

Traditional Fashion Adoption (Trickle-down Theory)

The trickle-down theory is based on the traditional process of copying and adapting trendsetting fashion from Paris, Milan, London, and New York designers. Sometimes it is even difficult to know where an idea began. Did Donna copy Karl? Did Ralph copy Yves? Or vice versa? Because couture or "signature" designer fashion is expensive, it is affordable to only a few people. As the new fashions are worn by publicized fashion leaders or shown in fashion

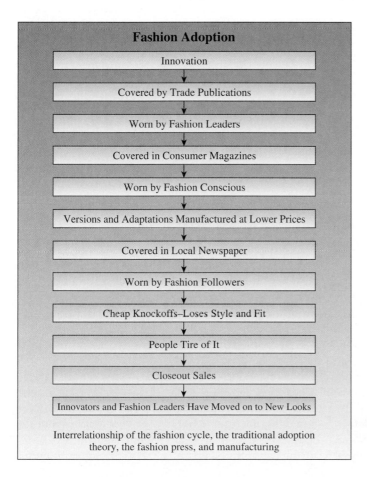

Fashion Adoption

Innovation

↓

Covered by Trade Publications

↓

Worn by Fashion Leaders

↓

Covered in Consumer Magazines

↓

Worn by Fashion Conscious

↓

Versions and Adaptations Manufactured at Lower Prices

↓

Covered in Local Newspaper

↓

Worn by Fashion Followers

↓

Cheap Knockoffs–Loses Style and Fit

↓

People Tire of It

↓

Closeout Sales

↓

Innovators and Fashion Leaders Have Moved on to New Looks

Interrelationship of the fashion cycle, the traditional adoption theory, the fashion press, and manufacturing

A dress from Prada, the much-copied Italian fashion company. (*Courtesy of Prada*)

publications, more consumers are exposed to the new look, and some will desire it for themselves. To appeal to this broader group of consumers, manufacturers produce less expensive versions or adaptations of high fashion. These are copied again and again at lower prices, until they have been seen often enough to become acceptable to the most conservative buyer. The cheapest versions are seen at discount houses soon after. Consumers then tire of the look, and its popularity fades.

The length of this process is influenced by location. If the new look starts in Europe, then people in New York and other large cities will probably be the first to accept it. It may take a year or two for many Americans to fit even a modified version of the look into their life-styles. Fashion implies newness and freshness. Yet as a fashion is copied, modified, and sold at lower and lower prices, it loses its newness, quality, and other essential design elements.

Reverse Adoption (Trickle-Up or Bottom-Up Theories)

Since the 1960s, manufacturers and retailers pay more attention to consumer innovation. They watch people on the streets to find ideas. Some of these ideas eventually reach the designer market. The "Grunge" look of the early 1990s is a good example of a street look that reached the runways. Dancewear and activewear, which began as functional needs of the consumer, also have influenced designer collections. Vintage fashion purchased by young people in thrift shops has influenced recent collections.

Mass Dissemination (Trickle-Across Theory)

Modern communications bring fashion from around the world into our homes instantly. Consumers see the trends and want to look as fashionable as the celebrities. Manufacturers copy hot new styles almost immediately to meet the high demand. Speed of production is of the greatest importance. Mass Dissemination is becoming the prevalent mode of fashion adoption. Oscar de la Renta commented that information is traveling a bit too fast—a denim coat from his collection had been copied and was selling at Bloomingdale's before his original version reached the stores.[8]

There is no longer one channel of fashion dissemination. Many separate markets have developed geared to various age ranges, life-styles, tastes, and pocketbooks. What appeals to a junior customer would probably not appeal to a missy customer. Various designer and manufacturer labels appeal to various market segments at different price points. Increased diversity means that many different styles can be acceptable at the same time. There are many more options.

■ *MOTIVES FOR CONSUMER BUYING*

To help them make styling and merchandising decisions, designers, buyers, and other industry executives try to understand consumer motivation.

In the past, most people bought new clothes only when a need arose, for a very special occasion, or because their old clothes wore out. The average person simply could not afford to buy more than the basic necessities. In Western society today, discretionary income is larger, and people can buy new clothes frequently.

Therefore, buying motives have changed; people are able to buy clothes because they want or like them. Buying motives vary from consumer to consumer and from day to day. Motives are both rational and emotional.

To Be Fashionable People may buy new clothing to make them feel that they are trendy or, at least, in the mainstream of fashion. They may discard clothing that is still wearable only because it is out of fashion.

To Be Attractive Consumers want clothes that are flattering, that make them look their best, or that show off their physical attributes.

To Impress Others People may want to project a successful image or establish unique identities with fashion. They may want to exhibit their level of taste or income through clothing. Expensive brands have even served as status symbols.

To Be Accepted By Friends, Peer Groups, or Colleagues Average Americans have conservative tastes; they do not want to differ from their peers. They may want to identify with a certain life-style. Buying patterns suggest that consumers like some direction or guidance as a framework for their choices.

To Fill an Emotional Need New clothes often help people feel better psychologically. Being secure in the feeling that they are wearing appropriate fashion helps them feel confident and self-assured. This motive, however, may often lead to impulse buying (buying without careful consideration).

Fashion Selection

Buying patterns change continually. To determine the acceptability of fashion, both designers and manufacturers find it helpful to consider the criteria consumers use for its selection.

- Consumers look for their idea of quality at reasonable prices; often referred to as *perceived value*.
- There is a trend toward more selective buying. Consumers may buy only one item, such as a jacket, to update their wardrobes.
- For women, there is renewed interest in glamour and femininity.
- Many consumers look for comfortable, functional, multiple-use clothing.
- People are buying closer to need; often referred to as a "wear now" mentality.

Customers are attracted to a particular garment or accessory by its styling features. There are also practical considerations, including quality and price, that the consumer usually evaluates before making a purchase.

Styling Features

Styling features are the same as the elements of design as discussed in Chapter 9, but considered from the purchaser's point of view rather than the creator's.

Color People relate very personally to color, usually selecting or rejecting a fashion because the color does or does not appeal to them or is or is not flattering.

Texture The surface interest in the fabric of a garment or accessory is called texture. Texture usually gives a clue as to fiber content.

Style The elements that define a style include line, silhouette, and details. A consumer's selection is frequently influenced by his or her opinion of what is currently fashionable.

Practical Considerations

Price Consumers want the best product at the best price. Price is probably the most important practical consideration for the average consumer. They must compare the total perceived worth of a style with the retail price and with their own budgets.

Fit Sizing is not a guarantee of fit. The U.S. Department of Commerce has tried to set sizing standards, but it is difficult to set size ranges and grading rules to fit every figure. Each company tries its sample garments on models whose figures are typical of its target customers, which makes sizing vary from brand to brand.

Fitting a suit at Gieves & Hawkes, London.
(Courtesy of Gieves & Hawkes)

Comfort Obviously, people need clothes to keep warm in cold weather or cool in warm weather. As the population ages and as travel increases, people also want clothes that are comfortable to move in, sit in, travel in, and so on. The increasing desire for comfortable clothes is one of the reasons for the popularity of spandex fiber.

Appropriateness It is important that consumers find suitable or acceptable fashions for specific occasions or to meet the needs of their lifestyles. Consumers consider their clothing needs for job and leisure-time activities as well as what is appropriate for their figure type, personality, coloring, and age.

Brand or Designer Label Brands are a manufacturer's means of product identification. Some consumers buy on the basis of a particular brand's reputation, often as a result of heavy advertising. Designer Giorgio Armani said, "A brand name is important as long as it is combined with a proper relationship of quality and price."[9]

Fabric Performance and Care The durability of a garment or accessory and the ease or difficulty of caring for it are often factors in selection. Many consumers prefer easy-care fabrics because they do not have the time or the interest in ironing or the money to pay for dry cleaning. Consumer concern for easy-care spurned textile industry development of no-iron finishes and the popularity of wash-and-fold cotton garments. To protect the consumer, government regulations now require fiber content and care instruction labels to be sewn into apparel.

Quality Consumer demand for quality has risen in recent years. The designer or bridge customer considers clothing an investment and may not mind spending more for the lasting qualities of fine detailing and workmanship. Some consumers may look for a particular brand or name on the basis of a reputation for quality.

Convenience With time and energy in increasingly short supply, consumers are looking for ways to make shopping easier. Consumers want to find what they need easily and quickly. In response to consumer needs, catalog and Internet shopping has increased. In the stores, consumers are demanding service and in-stock assortments.

■ *FASHION CATEGORIES*

In response to consumer demand and changes in consumer life-styles, manufacturers and retailers have developed various size and price ranges, as well as categories for styling and clothing type.

Variety in dress has resulted from manufacturers' responses to changes in our habits and roles and the increase in consumer purchasing power. There is now clothing for all occasions and life-styles. Manufacturers specialize in clothing type (or have a separate label for each), age of target customer, price range, and often gender. Retailers have separate departments for each category, price range, and size range.

In our value-conscious marketplace, consumers seek multipurpose, multiuse clothing. They look for apparel that is wearable in a variety of settings: office, social activities, gym, home, or vacation. As a result, there is a brakdown of categories: gym wear has become street wear; underwear is outerwear, and so on.

Women's Wear

Clothing Categories

There are many types of women's apparel, including dresses, social apparel, suits, outerwear, sportswear, activewear, and lingerie. There are also specialty categories, such as bridal gowns and maternity clothes, and a huge array of accessories.

Dresses are single garments or two pieces on the same hanger priced as one unit. Styles range from tailored to simple; business to casual. Dresses are easy to wear; no thought is required for coordination.

Social apparel includes special occasion attire, such as long and short cocktail dresses, dressy pant ensembles, and evening or bridal gowns.

Suits are jackets and skirts (or pants) sold together as units. Suits range from casual to tailored. There is a trend to casual dressing at the office but it remains to be seen if professional women will give up their "power" suits.

Outerwear includes coats, capes, and jackets with a primarily protective function. Outerwear can be divided into four categories: traditional wool and wool blends; outdoor-ski anoraks in performance fabrics such as microfibers; leathers; and furs; all are available in both classic and fashion styles.

Sportswear is any combination of tops and bottoms, such as jackets, skirts, pants, shorts, blouses, and shirts, that are priced separately so that the customer can combine them as desired. Sportswear lines are organized as separates or as coordinated sportswear (pieces intended to be mixed and matched). Sportswear is popular because of the variety of looks that can be made by combining separates. American designers have excelled in this category, which suits informal American life-styles.

Activewear is one of the hottest categories of apparel today, fueled by the popularity of fitness. Activewear is subcategorized into two segments: fitness wear, worn by people who actively participate in sports, and active wear, worn for spectator sports or simply as streetwear. Activewear includes bike shorts, leggings, T-shirts, crop tops, jogging sets, unitards, sweatsuits, and jackets. More and more activewear companies are offering as many styles for women as for men. To make their clothing relevant, some manufacturers have the athletes they sponsor help with the designs.

Swimwear includes one-piece suits, bikinis, and cover-ups. Manufacturers are beginning to cater to the baby boom market with bulge-concealers, push-up bras, extra torso length, and other inner construction. Manufacturers are also adding special sizes.

Lingerie, including innerwear, bodywear, sleepwear, and loungewear, is also enjoying increased sales. The popularity of lingerie is partly caused by the fashion of wearing corsets to show, as Karl Lagerfeld introduced under suit jackets, and the marketing style of Victoria's Secret. The more fitted look of today's fashion is also influencing the rise in sales of body slimmers.

Accessories, as discussed in Chapter 11, give consumers an easy way to update their wardrobes with scarves, hats, handbags, footwear, and hosiery. The popularity of particular accessories is cyclical, such as belts with waist interest. Functional accessories, such as backpacks and sun hats, have become fashionable as well.

Active sportswear from Prada Sport.
(Courtesy of Prada, Italy)

Size Ranges

Each size range caters to a different figure type. Generally, today's sizing standards are based on more realistic measurements than in the past. However, each manufacturer has its own interpretation of standardized sizing. Designer clothes may deliberately be labeled one size smaller so that the customer can feel good about being a size 10 instead of a 12. Some manufacturers try to accommodate a variety of body types by using a variety of fit models. Women's size ranges include Junior, Missy, Petite, and Large Sizes.

Junior customers, sizes 1 to 13, have a less-developed figure and a shorter back-waist length (a higher waistline) than missy figures. This figure is usually equated with a slim, young customer.

Missy sizes 6 to 16 (or 4 to 14) are for the mature female figure, usually based on a height of approximately 5 foot 7 inches. For missy separates, some blouses and sweaters are sized 30 to 36 (8 to 14); others may be sized small, medium, or large.

Petite sizes are created for the woman who is less than 5 foot 4 inches tall. Sizes range from 0 to 16. Most manufacturers limit the size range to 4 to 14.

Large or women's sizes range from 14W to 32W but are usually limited to 16W to 26W. Sometimes these sizes are represented as 1X (16 to 18), 2X (20 to 22), and 3X (24 to 26). Large-sized petites are marked WP.

Fashion for petite and large-sized women was virtually ignored by the fashion industry until 1977. Statistics now show that 54 percent of the total female American population wears either petite or large sizes. Among women over 40 years old, 40 percent wear size 14 or larger. Prestigious manufacturers such as Givenchy, Ellen Tracy, and Anne Klein II are now catering to special sizes. There is tremendous growth opportunity for manufacturers in special sizes because there are no extra costs for styling, only for new patterns.

Manufacturers still have to deal with a majority of figures that do not fit sizing standards. One reason that sportswear is so popular is that it gives

Typical Relationship of Style, Size, and Price Ranges in Women's Wear					
Style Range	*Styling*	*Age*	*Size Range*	*Figure*	*Price Range*
Designer	Unique, top-name designer fashion	25 and up	Missy 4–12	Missy: mature, slim	Designer
Bridge	Designer fashion	25 and up	Missy 4–12	Missy: mature, slim	Bridge
Missy	Adaptations of fashion looks	25 and up	Missy 4–14	Missy: mature, 5'7" block	Better to budget
Petites	Same as missy	25 and up	Petite 0–14	Missy: under 5'4"	Better to budget
Women's or large sizes	Same as missy plus some junior looks	18 and up	16–26W or 16–26WP	Missy: large size + some petite	Better to budget
Contemporary	Trendy	20–40	Missy 4–12	Missy: slim	Better to budget
Junior	Youthful, trendy, figure-conscious	13–25	Juniors 3–15	Not fully developed	Better to budget

consumers the opportunity to mix sizes to accommodate their less than perfect figures. Women, too, do not have the benefit of free alterations at retail stores as men do.

Styling and Price Ranges

Apparel is also classified by style range. Style ranges grew out of age groups, price, and size ranges.

Couture This term is reserved for fashion that is made-to-order to fit an individual client's measurements. These clothes are the most luxurious and the most expensive, often between $5000 and $50,000 for a single garment and reserved for a *very* small international clientele. Examples of couturiers include Karl Lagerfeld, Christian Lacroix, Yves St. Laurent, and Valentino (Europeans), and Arnold Scassi and John Anthony (Americans).

Designer This category pertains to ready-to-wear from successful designers who own their own business or have a "signature collection" (with their name on the label). The high prices they charge, $1000 to $5000, allow them to use the best of fabrics and quality mass production. Examples of designer collections include Giorgio Armani, Donna Karan, Ralph Lauren as well as the ready-to-wear collections of the couturiers and all the designers listed in Chapter 8.

A sleeveless dress from designer Yeohlee Teng's signature collection. *(Courtesy of Yeohlee, Inc., photo by Dan Lecca)*

Bridge This styling and price range was created to give consumers a less expensive alternative to designer fashion. Bridge is simply a step down in price from designer, achieved by using less expensive fabric or different production methods. Some designers have secondary lines such as CK from Calvin Klein, Donna Karan's DKNY, Versus from Versace, or Emporio from Armani. Other collections, such as Ellen Tracy or Dana Buchman, cater specifically to the bridge market.

Contemporary This is a revived category aimed at the style-conscious woman who wants more fashion than Missy but does not want to pay designer prices. Again, price ranges vary from Bridge to Budget. Resources include ABS, BCBG, Laundry, Max Studio, Parallel, and Ralph by Ralph Lauren.

Missy This styling category provides more conservative adaptations of proven or accepted designer looks. Missy lines utilize less expensive fabrics and less extreme silhouettes. Missy styling is available in a variety of quality and price ranges: better, moderate, or budget. "Better" vendors include Jones New York, Liz Claiborne, and Sigrid Olsen. Moderate resources are Koret, Sag Harbor, and Alfred Dunner.

Junior The style range grew out of Junior sizing; young styling for a young figure. Styling is heavily influenced by the rock music scene, television, and by street fashion in Europe. It also tends to be body

conscious. The turn of the century is seeing a resurgence of growth in this area as kids from the 1980s echo boom reach their teens. Typical labels include Byer, Esprit, Necessary Objects, and XOXO.

As manufacturers or designer names increase in popularity, they add lines in other categories so that their businesses can grow. Claiborne and Ellen Tracy now make dress lines in addition to sportswear. Claiborne also added men's wear collections. Ralph Lauren, on the other hand, started by designing men's wear and later added women's apparel. Other designers and manufacturers have added children's wear lines. They may also add different price ranges, such as secondary lines at lower prices. Some companies trade up as well. Better manufacturer Liz Claiborne created the Dana Buchman bridge collection.

As women's designers enter the men's wear market and vice versa, and with the popularity of men's sportswear, the production and marketing techniques in men's and women's wear are becoming similar.

Men's Wear

Men's clothing has also changed as a result of changes in their interests and more casual life-styles. Traditionally, men learned to look for quality, fit, and durability. Their wardrobes, formerly limited to suits, slacks, and sport shirts, have expanded along with their activities, and increased clothing choices have made them more fashion conscious.

The electronics and marketing fields have paved the way toward casual dress at the office. Many companies have instituted "casual Fridays," and some have found it to be so popular that they have made it an everyday option. There are many theories as to why this is happening. Some authorities believe that members of the baby boom generation, who are now the business executives, are trying to stay young. Others think that middle-aged men are just more interested in comfort. Also, fewer companies are operating in center city locations, and more and more people are working at home.

As a result of the easing of corporate dress restrictions, the men's wear industry is in a state of flux. Men's suit sales have decreased, whereas sportswear is enjoying tremendous growth. In the past, suits represented half of men's wardrobe purchases; now purchases are divided equally among suits, furnishings and accessories, and sportswear. As tailored clothing becomes more casual, the category distinctions become blurred. There is an intermixing of business and leisure wardrobes: an Armani suit jacket over jeans, or a shirt and tie replaced by a T-shirt.

Casual does not mean sloppy or cheap. By the time a man has purchased all the necessary pieces in a sportswear outfit, it may cost as much as a

Men's classic tweed sportswear from Hickey Freeman.
(Courtesy of the Hartmarx Corporation)

traditional suit, shirt, and tie. Casual looks are also more confusing for the consumer. Men wonder how to present themselves as successful professionals in casual wear. Some companies, such as Hartmarx, are using hang tags and booklets to tell the customer how to wear the new sportswear looks.

Clothing Categories

There are now as many categories available for men as there are for women. Many designers and manufacturers, including Ralph Lauren, Tommy Hilfiger, Hugo Boss, and Nautica, have lines in several men's wear categories. Stores have increased square footage in men's wear areas and use aggressive display and promotional techniques to lure their increasingly fashion-wise male customers. Categories include the following:

Tailored clothing includes suits, tuxedos, overcoats, topcoats, sport coats, and separate trousers for business and evening wear. Tailored clothing requires lengthy, time-consuming, costly production, and retailers need to inventory many sizes.

Furnishings include dress shirts, neckwear, underwear, hosiery, robes, pajamas, shoes, and boots.

Sportswear comprises sport jackets, knit or woven related separates, sweaters, and casual trousers that fill the demand for more leisure and casual wear.

Active sportswear includes all garments needed for sports or exercise, such as windbreakers, ski jackets, jogging suits, and tennis shorts.

Work clothes, such as overalls, work shirts, and pants required by laborers, have become popular for leisure wear.

Accessories include small leather goods such as wallets, shoes, boots, belts, jewelry such as cuff links, scarves, gloves, and eyewear.

Styling

The styling creativity and diversity now apparent in men's wear are a result of men's desire to have appropriate clothing for their leisure acitivities. However, so far, there are not as many styling categories for men's wear as there are for women's wear.

Designer Styling Internationally recognized designers often set fashion directions in men's wear. Giorgio Armani led the way to casual, soft suits that can be worn at the office or for leisure activities. Italian collections, such as Armani, Brioni, Gucci, Kiton, and Zegna are considered fashion forward. Calvin Klein and Richard Tyler are among the prominent American brands. Most designers have both suit and sportswear collections.

Traditional Styling Classic suit makers like Gieves & Hawkes, Oxxford, Hickey-Freeman, Hartmarx, and Brooks Brothers (retail brand) or designer collections like those of Tommy Hilfiger and Ralph Lauren are influenced by traditional tailoring. The styling is somewhat influenced by the less-structured designer looks, but the primary interest is in a wide variety of suiting and shirting fabrications.

Traditional sportswear is also classic in styling. Formerly centered around tennis or golf looks, there is now a wide variety of clothing for every activity from brands such as Polo, LaCoste, and Dockers.

Contemporary This styling is usually less expensive than designer apparel; it is trendier and aimed at a younger customer. Examples include Perry Ellis, KM by Krizia, Nautica, and Gap (a retail brand) sportswear.

Price Ranges

Custom-tailored suits are made with the finest construction and fabrics. Suits from Savile-Row in London, for example, cost more than $3000. Much of the inner, hidden construction is done by hand.

Designer ready-made suits at retail prices run upward from $1000, and sport coats cost upward from $500. Designer suits and sportswear are also made from fine fabrics, but they are not made-to-measure, and the quality varies.

Bridge suits and sportswear, as in women's wear, are a step down in price from designer. This can also mean a step down in fabric quality and workmanship.

Moderate suits have a broad range of prices, usually from $325 to $650, sport coats range from $200 to $450, and slacks cost from $40 to $90. Many large retailers, such as Macy's and Nordstrom, rely heavily on private-label merchandise for this price range to control price.

Popularly priced suits are those less than $325, the most affordable price range. Many discounters and mass merchants also offer private-label merchandise at this price range.

Size Ranges

Men's suits range in size from 36 to 44 (with additional large sizes to 50), originally based on chest measurements. Lengths are designated after the size number: R for regular, S for short, and L for long. European sizes are 46 to 54 (add 10 to each American size). Young men's sizes have a narrower fit in the jacket and hip than regular men's sizes. There has been an attempt to simplify men's sizing because traditional sizing requires a huge inventory of many combinations of chest and length measurements. Men also enjoy free alteration services at most men's stores and in men's clothing departments.

Dress shirts are sized by collar measurement (inches in America and centimeters in Europe) and sleeve length. Sport shirts and sweaters are sized in small, medium, large, and extra large. Trousers are sized by waist and inseam measurements. Dress slacks are left unhemmed to be finished by the store's tailor as a customer service.

Children's Wear

The children's wear business is very complicated because each size range is a separate market. Children's wear is also highly competitive because the consumer is extremely value conscious. Parents do not want to spend much money on clothes that their children will quickly outgrow.

Children's wear manufacturers often produce both dresses and sportswear to protect their businesses from shifts in fashion preferences. Some men's and women's wear companies, such as Esprit and Polo, also produce children's

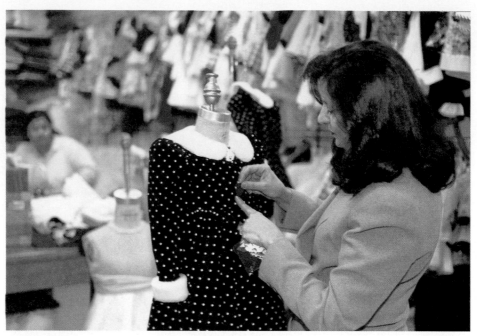

Designer Rosemary Weidman puts the finishing touches on a girl's dress for Castro.
(Photo by the author)

lines, but others have tried and found it a difficult business. Children's manufacturers, too, have had stiff competition from Baby Gap and Kid's Gap and all private-label programs. However, a steady domestic birthrate of around 4 million per year is keeping the children's wear market afloat.

Categories

It is very difficult to categorize children's wear. Categories change with each size and price range. Also, boundaries between categories are becoming increasingly blurred. Some casual dresses fall into sportswear classifications; some dresses fall into tailored clothing classifications. Children's wear, too, has become more casual as today's children lead very active lives.

Girls' dresses are available in all style and price ranges. Holiday and spring are the biggest seasons for special-occasion dresses. Some girls' dresses, jumpers, jackets, and skirts are considered tailored clothing.

Boys' traditional clothing includes blazers, other dress jackets, suits, dress pants, and dress shorts.

Sportswear comprises T-shirts, jeans, pants, shorts, overalls, jumpsuits, leggings, girls' skirts, boys' shirts, sweatshirts, sweatpants, and sweatsuits in knits and wovens, particularly denim and fleece. Boys' wear has become very casual, and tops outsell bottoms.

Swimwear groups swimsuits and beach cover-ups.

Outerwear includes dress coats, all-weather coats, raincoats, ski jackets, windbreakers, and snow suits.

Sleepwear includes layette gowns and sacques, blanket sleepers, pajamas, nightgowns, nightshirts, and robes. A major issue in this category is the

Consumer Product Safety requirement that sleepwear be made of polyester so that it can have a flame-retardant finish. However, many consumers want pure cotton and, therefore, are buying playclothes to use as sleepwear.

Accessories include shoes, hats, gloves, and scarves, hair accessories, sunglasses, jewelry, bags, backpacks, hosiery (tights and socks) and underwear; belts, caps, and ties for boys; and infant accessories, such as bibs and booties. Hats have been particularly strong to protect children from the sun and have become a fashion statement. Some manufacturers are including accessories with their apparel, priced as a unit.

Sizing

Children's wear sizing is separated by age groups.

Newborn sizes are layette (0 to 11 pounds), 3, 6, and 9 months.

Infant sizes are based on "age" in months, usually 12, 18, and 24 months. In Europe, sizes are based on the length of the baby or the height of the child.

Toddler apparel, for the child who has learned to walk, are sized 2T, 3T, and 4T.

At this point, sizes are separate for boys and girls.

Girls' apparel is sized 4 to 6X, 7 to 16 (some companies manufacture sizes 2 to 10 or extra-small to extra-large), preteen sizes are 6 to 14; and the young teen wears young junior sizes 3 to 13.

Boys' sizes are 4 to 7 and 8 to 20.

Styling

The styling of children's wear changes considerably by size range. The only styling differentiation is traditional versus trendy.

Infants, Toddlers, and Young Children In the case of young children, the consumer is a parent, grandparent, or other adult. Parents want their children's clothes to reflect their own taste. "There are still many parents who want people to look at their child and say 'that is the cutest outfit I've ever seen.'"[10] Many parents tend to dress their children more as little adults than as babies.

Ease of dressing, washability, durability, and versatility are important design considerations in clothing for young children. For infants and toddlers who have to be dressed, crotch snaps and generous necklines are important. For the toddler, ease of dressing, such as elastic waistlines, is also important because children want to dress themselves.

Novelty, color, and conversational prints are important in infant, toddler, and young children's wear. Apparel printed with licensed cartoon or television characters has also been a phenomenal success.

Older Children Older children have more definite opinions on what they want to wear, partly because of advertising, television exposure, and peer group pressure. This development has had an effect on styling in that many children's wear manufacturers follow junior trends for girls and young men's trends for boys.

Because styling for older girls is often filtered down from the junior market, junior resources are finding success in the 7- to 14-size range and even in sizes 4 to 6X. In the same way, styling for older boys is influenced by young men's wear. Some men's wear companies, such as Tommy Hilfiger and Ralph Lauren's Polo, are making boys' wear. In this age range, too, printed apparel, with sports teams, celebrities, and brand names, such as Nike or Champion, has been extremely popular.

Price Ranges

In children's wear, price ranges are broader than in women's or men's wear. Also, some manufacturers produce lines in several price ranges and often manufacture for both boys and girls in multiple size ranges. The brand examples are a mixture of all size ranges.

Better resources provide fashion direction, quality fabrics, and workmanship. Vendors include Dorissa, Sylvia Whyte, Monkey Wear, Oilily, Polo, and Tommy Hilfiger.

Moderate includes a wide range of prices and labels at average prices, such as Baby Togs, Eagle's Eye, Esprit, Flap Doodles, Gotcha, Hartstrings, Little Me, Osh Kosh B'Gosh, Quiksilver, Rare Editions, and Youngsport.

Popularly priced merchandise is offered by Byer, Eber, Carter's, Healthtex, and Rampage.

In children's wear, too, retailers often offer private-label merchandise in the moderate and popular-priced ranges.

■ SUMMARY

Fashion has three properties: style, acceptance, and timeliness. Change makes the fashion world go round. New styles are introduced, rise in popularity, then decline into obsolescence. Some styles remain fashionable longer than others. Some come back into fashion after a latent period. Because fashion is a product of change, a sense of timing is an important attribute at all levels of the industry.

Consumers can be identified with stages of the fashion cycle. Fashion leaders, a very small percentage of the population, buy and wear new styles at the beginning of the cycle; other consumers imitate. The majority of consumers are followers, which facilitates the mass marketing of fashion.

Fashions may sift down from the original ideas of high-fashion designers to reappear at lower price levels. Other styles are either adapted "up from the streets" or are disseminated quickly through mass marketing. Consumers buy clothes for many reasons, including the desire to be fashionable, attractive, impressive, accepted, or emotionally fulfilled. Considerations in fashion selection include color, texture, style, price, fit, appropriateness, brand, fabric performance, and workmanship. Consumer acceptance is a major influence on styling and merchandising decisions. The fashion industry responds to consumer needs with a variety of size ranges, price ranges, and style ranges in women's, men's, and children's wear.

■ *CHAPTER REVIEW*

Terms and Concepts

Briefly identify and discuss the following terms and concepts:

1. Fashion
2. Style
3. Acceptance
4. Sense of timing
5. Fashion cycles
6. Classics
7. Fads
8. Fashion leaders
9. Fashion followers
10. Fashion victims
11. Mass-market dissemination
12. Buyer motivation
13. Perceived value

Questions for Review

1. Name and define the three components of fashion.
2. How does fashion acceptance affect the timing of design?
3. Describe the phases of a typical fashion acceptance cycle.
4. Discuss the relationship of consumer acceptance to the fashion cycle.
5. What do consumers consider when buying clothes? How do you make buying decisions?
6. What are the similarities between style ranges and size ranges?

Projects for Additional Learning

1. Is there a well-known movie star or public figure (either male or female) in the news whom you believe to be a fashion leader? Write a short report documented with examples of how this person influences the way others dress. Clip (or photocopy) illustrations from publications.
2. From current fashion magazines, collect five examples of each of the following types of fashion: (a) high fashion; (b) mass fashion; (c) classic; and (d) fad.
3. In a local specialty or department store, compare two dresses of similar price from different manufacturers. Try them on. Which has the better fit? Compare fabric choices in terms of quality and suitability to the design. Compare styling: Which is more innovative? Taking all factors into consideration, which dress is the better buy? Discuss your findings in a written report. Describe or sketch the two garments.
4. In a local specialty or department store, compare the missy and junior departments. List the major manufacturers in each department, and explain the general styling differences.

■ *NOTES*

[1] As quoted in "King Karl," *Women's Wear Daily*, November 20, 1991, p. 7.

[2] As quoted in "Is the Designer Dead?" *Women's Wear Daily*, April 7, 1992, p. 10.

[3] Quoted in "Fall Fashions: Buying the Line," *Time*, April 23, 1984, p. 77.

[4] *Much Ado About Nothing*, Act III, 1598–1600.

[5] As quoted in "Donatella Takes Charge," *Women's Wear Daily*, October 1, 1997, p. 4.

[6] As Quoted in "Dressing for Dollars," *Women's Wear Daily*, March 27, 2000, p. 28.

[7] As quoted in "Les Fashion Victims," *Women's Wear Daily*, January 21, 1992, p. 4.

[8] Review of Fashion Group International meeting, *FGI Bulletin*, May 2000, p. 1.

[9] As quoted in "Europe Design Houses Face a New World," *Women's Wear Daily*, June 15, 1992, p. 6.

[10] Natalie Mallinckrodt, president, Golden Rainbow, as quoted in "The Infant/Toddler Report," *Earnshaw's*, May, 1994, p. 51.

Designer Jessica McClintock working with the fabrics, trims, magazines, and costume books that inspire her. *(Photo by the author)*

4

Fashion Resources

■ CAREER FOCUS

Before work on each new line or collection begins, every designer and merchandiser in the fashion industry is actively involved with fashion research. Market research consultants also study and report on demographics and consumer buying habits. Design services and fashion publications also need experts in fashion research and forecasting for every merchandise category.

■ CHAPTER OBJECTIVES

After reading this chapter, you should be able to:

1. Discuss the importance of research;
2. Explain the need for market studies and fashion forecasting;
3. Discuss and give examples of design resources.

*I*t is not easy to make or sell what people will want to buy in a future selling-season. Awareness, research, and planning are needed for producers and retailers to make, buy, and sell what consumers will want. Fashion executives must be *aware* of what is going on in the world, including economics, politics, demographics, and social change (Chapter 2), and how these events and conditions will affect their business. Without proper research, or with an unexpected turn of events, merchandise ends up on the sale racks, causing losses for producers, manufacturers, and retailers alike. This chapter discusses fashion forecasting, fashion services and resources, and design sources that executives use for product development at every level of the fashion industry.

Research is done before any other design or merchandising activity at every level of the industry. It becomes second nature to every decision-maker in the field of fashion. Because the very term *fashion* implies a state of flux, textile producers, fashion manufacturers, and retailers all need to absorb a constant flow of information to anticipate change and consumer preferences. Donatella Versace explained, "You cannot live in an ivory tower and make fashion or anything artistic . . . You're to live in the real world."[1] Designer Karl Lagerfeld has said, "I want to be informed, to know everything, see everything, read everything. . . . You mix all that, then forget about it and do it your way."[2] Ady Gluck-Frankel, owner and designer of Necessary Objects, explained, "It's the times that set the trends. We are all affected by the same issues: politics, ecology, economy, music, etc. We all just interpret them for our own markets."[3] Often, what seems to be intuition is actually clever assimilation and analysis of careful research.

Every executive, designer, and merchandiser in the fashion industry must be involved with research and analysis. They *continuously* study the life-styles of consumers, shop the market, and read trend and design reports, fashion magazines, and newspapers to understand consumers and what they might want to buy. This research is absolutely necessary to make intelligent planning decisions regarding design, manufacturing, and sales.

■ *FASHION FORECASTING*

Designers, merchandisers, and buyers must learn to predict trends, which are new directions in fashion.

It would be impossible to ask all consumers what they will want to wear a year or two in advance—they would not even know themselves. Because designers, merchandisers, and retailers must work so far ahead of the selling-season to produce or stock the fashions their customers will want, they must learn to anticipate customers' wants and needs—to be fashion forecasters of the future. Fashion forecasting involves the following activities:

- Studying market conditions—how the consumer's buying behavior is influenced by society, economics, technology, and the environment (see Chapter 2)

- Noting the life-styles of the men, women, or children who are the customers (see Chapter 2)

- Researching sales statistics to establish sales trends
- Evaluating the popular designer collections to find fashions (colors, silhouettes, fabrications, lengths) that suggest new directions, or "trends"
- Surveying fashion publications, catalogs, and design services from around the world
- Observing "street fashions" (what people are wearing) and keeping up with current events, the arts, and the mood of the public

Market Research

As discussed in Chapter 2, manufacturers and retailers must constantly research their target market to learn buying habits and preferences.

Consumer Research

Manufacturers and retailers may ask consumers directly about their buying preferences. Consumer reactions are compiled and tabulated to find preferences for certain garments or accessories, colors, or sizes, and so on, or preferences for particular retailers. This information can be used to create new products to fit specific consumer tastes.

Methods of questioning consumers can be formal or informal. Buyers and sales associates may talk with customers in the store. Market research companies may be asked to make inquiries by telephone or mail and to hold consumer focus group meetings.

Surveys, by telephone or mail, are made by publications and market research companies for manufacturers and retailers. These surveys include questions about income, life-styles, fashion preferences, and shopping habits.

Consumer focus groups are meetings of target customers usually selected by a market research firm to meet with manufacturers or retailers. These groups discuss the pros and cons of merchandise or other aspects of shopping satisfaction.

In-store informal interviews can help researchers obtain information by simply asking customers what they would like to buy, what styles they like that are currently available, and what merchandise they want but cannot find. Because of their close contact with their customers, owners of small stores can often do this most effectively.

Shopping

To study what consumers want and need, designers and merchandisers also "shop" retail stores to see what merchandise is selling best. Designers and merchandisers compare the styling, price, fit, and quality of lines that compete with their own. Catalog designers and merchandisers also research competing catalogs and the Internet. Retailers observe competing stores to analyze which merchandise selections and presentation methods are the most successful.

Sales Records

Every manufacturer and retailer researches its own sales records. Rising sales statistics show what fashion trends are developing; declining sales show what styles have passed their peak (see influence of timing and geographic

location as discussed in Chapter 3). Overall weak sales show that a style is not meeting consumer needs for fashion, quality, or fit; it's time to drop it from the line and move on to new styles.

Evaluating the Collections

Traditionally, American manufacturers and retailers turn first to Europe for an indication of the newest fashion ideas. Now, foreign manufacturers and retailers are also interested in American designer collections, especially sportswear. Twice each year, top designers show their collections (see Chapter 12). From all over the world, retail buyers and fashion editors invade Paris, Milan, New York, and London. Editors and buyers try to analyze the collections for outstanding new ideas that might influence fashion direction.

Fashion Trends

Fashion trends are the styling ideas that major collections have in common. They indicate the direction in which fashion is moving. Fashion forecasters look for the styles they think are *prophetic,* ideas that capture the mood of the times and signal a new fashion trend.

Several designers may use a similar fashion idea because they have been inspired by common sources. The trend may appear in a fabrication, a silhouette, or another design element that appears in several collections. Very often, a new trend appears in small doses until it spreads to other collections. As the press notices similarities between collections and highlights them, the media exposure also helps establish the trends.

Evaluating the collections becomes one way a designer, working for a mainstream manufacturer, can research fashion direction. As designers are not invited to the shows, they must evaluate by shopping in major fashion capitals or using design services, magazines, and newspapers.

For retail buyers, it is becoming a huge challenge to figure out which trends will become fashion basics, like capris, and which are only fads, such as pony prints. Buyers have to become very flexible in their buying patterns and cautious about inventory management. If the market becomes flooded with a new trend, consumers may react negatively to the overexposure.

Empowered by the Internet and television, global trends are moving at an accelerating pace. The life-span of a trend is now about five months instead of a year. For the junior market, the span is only three months.

Trends for Target Markets

Too often, manufacturers and retailers get so focused on a single trend that they forget that there are many market segments. Diverse consumer age segments and life-styles create many separate market niches, each with its own trends: trendy, junior, professional, family oriented, and so on. With today's segmented market, a trend may be confined to a single market niche. Designers and merchandisers must decide what trends best suit their own customers based on age range, income level, life-style, and fashion preferences.

■ *FASHION SERVICES AND RESOURCES*

Fashion professionals rely on information sources such as design, color and video services, newsletters, books, magazines, newspapers, and web sites to follow fashion trends.

Fashion Services

Fashion services are resources for fashion reporting, forecasting, and consulting, available to the trade only on a subscription and/or fee basis. These services are very expensive, but many offer education rates. Most of these services can be found on web sites, New York City directories, or through sales reps in major cities. Some of the major fashion services are Carlin International, Dominique Peclers, ESP/Ellen Sideri Partnership, Inc., TFS/The Fashion Service, Promostyl, and Trend Union. These services may provide collection reports, forecasting, slides, consulting, garments to borrow, and/or original designs.

Collection Reports

Fashion services provide reports with the most immediate in-depth source of information about the collections. The services work very quickly, getting their reports out within two weeks after the shows, whereas magazines take months. Fashion reports also analyze the collections in more depth than newspapers or magazines. They may include photographs and/or sketches, slides, fabric swatches, and descriptions. The collections can be so overwhelming in scope that even those who attend the shows may need the assistance of these reports to sort out ideas and identify major trends.

A display of design forecasts and reports from D-cipher, Peclers, Insight, and Jenkins. *(Courtesy of ESP/ Ellen Sideri Partnership, Inc.)*

Trend Reports

Fashion services publish trend reports or "predictives" that include descriptions, sketches, fabric swatches, and color samples of garments they believe are prophetic or that are big-sellers in Europe. They may project color or fabrication tendencies, forecast silhouette or other design elements, and indicate trends for particular target markets, often in separate books. Some include "street photos" of young people in major fashion cities, which are very helpful to junior designers.

Most services offer information on both men's and women's wear. Some reports such as *Bloc Note,* have separate books for children's wear, lingerie, or knits. The *Tobé Report* is aimed at retailers. Each service has its own special approach. Some of them, such as *Insights Footwear, Knit Point,* or *Mudpie Kids,* cater to special niche markets. There are so many of these reports that it is difficult for anyone to decide which ones to order. A German publication called *Styling News* (www.modeinfo.com) was created to make many of them known.

Consulting

Many services also offer personalized services, such as designing, brand development, market research, feasibility studies, customer profile analyses, brand imaging, etc., to help their clients develop products. This can be on an individual consultation basis, or they may actually develop the entire line for a company. Peclers of Paris, for example, designs lingerie for Victoria's Secret.

Staff at the Color Box, New York City, work on color forecasting. *(Photo by the author)*

Color Services

Some services specialize in color forecasting. Fashion and textile industry professionals meet at least twice a year to pool their knowledge of color cycles and preferences to project color trends for the future. Forecasts, including yarn colors or swatches, are sent out by the color services in time for designers and merchandisers to plan their color stories and purchase fabrics. Some fiber companies also supply color forecasts for their customers (see Chapter 6).

Color projection services include the ICA, International Color Authority (British), Essential Colours and Colorace (German), OMS (Austrian), Orizzonti (Italian), L.A. Colours (Dutch), The Color Box, The Color Marketing Group, Concepts in Color, Colorplay, D3 (Doneger), Huepoint, and more.

Color systems are another type of color resource. These companies, such as SCOTDIC (Standard Color of Textile Dictionaire Internationale de la Couleur) and Pantone, keep a permanent library of dyed colors in color families. They distribute color cards to their customers who use the samples as standards for choosing colors for merchandise and dyeing fabrics. SCOTDIC has a library of 6000 colors and Pantone's package has 1701 colors.

Web Sites

There are countless web sites that offer information on fashion. Almost every major manufacturer and retailer has a web site. As the public's craving for fashion information grows, so do the number of web sites. A few key resources (which change frequently) are included on the following list:

■ www.fashioncenter.com The New York City Fashion Center site features an interactive database of over 12,000 apparel-related companies, a map of the garment district, and a trade show calendar.

150 designers, trend analysts, journalists, and photographers prepare 300,000 web pages of current trend information for WGSN in London. *(Courtesy of Worth Global Style Network, Ltd.)*

■ www.fgi.org The Fashion Group International's web site lists events and business information for members. The site's "student center" gives information on fashion schools, internships, and jobs. Their newsletters and meetings are another good source of information on current developments in the fashion industry.

■ www.firstview.com *First View* is a fashion publication available on a fee basis with photos of latest fashion collections from Paris, Milan, London, and New York.

■ www.vogue.com *Vogue Magazine's* web site covers the designer collections, with celebrity and behind-the-scenes features.

■ www.wgsn.com Worth Global Style Network provides on-line fashion news, trade show calendars and reports, ready-to-wear and couture collections, and trend forecasts to businesses on a subscription basis.

■ www.wwd.com The on-line version of *Women's Wear Daily*, the daily fashion industry newspaper.

Video Services and Television

A CD-Rom called Fashion INK, which covers major fashion events, is available by subscription. Video is another ideal medium for fashion reporting. Videofashion News Service sends subscribers video-cassette highlights of the collections and designer profiles monthly. Video-fashion News also appears weekly on the E! Entertainment channel.

The E! Channel created a separate "Style Channel" to showcase their continuous fashion programming. "Style with Elsa Klensch" on CNN also features collection coverage and behind-the-scenes designer interviews.

Fashion Magazines and Newspapers

Fashion trend research also depends on a variety of trade and consumer publications. *Trade* magazines and newspapers are intended for people working in the fashion industry; *consumer* publications are created for the general public. Each fashion journalist edits fashion trends from a different perspective. Their collective editing can make or break the success of a designer and reinforce trends.

Fashion Editing

The role of the fashion editor is to educate the public; to provide fashion information from all phases of the industry in all parts of the world; to make the industry or the consumer aware of all that is available; and to help the consumer make wise and suitable styling and/or buying decisions.

Fashion editors, together with journalists, stylists, and photographers, act as the eyes and ears of the consumer. They let the nation or the community know where to find the fashions that are currently on the market, and they report on how new fashions should be worn and accessorized.

The fashion editors of prominent newspapers and fashion magazines attend the collection openings, take notes on what they like best, and report on what directions they believe are important. They may request sketches or photographs of their favorite garments to use in their articles.

In between openings, fashion editors write articles on topics that they think are noteworthy. They sift through the news releases that come into their offices to help them write a story. Editors may ask to borrow samples from manufacturers and have them photographed to illustrate the text or they may simply use a photo sent to them in a publicity release. Sometimes sketched illustrations are used, depending on the mood or effect to be achieved. Garment and fabric descriptions may be included as well as a list of stores that carry the merchandise described in the article.

Trade Publications

Trade publications in the form of newspapers, journals, or magazines offer readers information on fashion trends and developments in the textile and fashion industries and retailing. Most specialize in a particular branch of the industry. Busy executives have time to read only a few of these, so they need to look for those publications that provide information relevant to their market. Fashion executives read these publications *daily*. The following are some examples:

Women's wear *Women's Wear Daily*, the major American fashion industry newspaper, is published five days a week. Each day features different topics and there are often special supplements on subjects such as accessories, sportswear, swimwear, or technology. *WWD* also publishes *W*, a monthly magazine. *Style* is Canada's trade magazine, *Gap* is published in France, and *Fashion Folio* and *Draper's Record* in England.

Men's wear *DNR, Daily News Record*, the men's wear industry newspaper.

Children's wear *Earnshaw's, Children's Business*

Sportswear *Sportswear International*

Accessories *Footwear News Magazine* and *Accessories Magazine*

Textiles *ATI (America's Textiles International), Bobbin, Textile World*, and *Textiles Suisse*

Apparel industry *Apparel Industry Magazine, Apparel Manufacturer*, and *Bobbin*

Advertising and marketing *Advertising Age, Brandweek, American Demographics, Direct Marketing, Retail Ad-Week*, and *Sales & Marketing Management*

Retailing *Stores* (National Retail Merchants Association), *Chain Store Age, Discount Merchandiser, Journal of Retailing, Retail Store Image, Retail Intelligence*, and *Inside Retailing*

Visual presentation *Artweek, Communication Arts, Display & Design Ideas, Graphis, Inspiration, Lighting Dimensions, Views & Reviews*, and *Visual Merchandising & Store Design*

International Consumer Fashion Magazines

These publications are aimed at the consumer and show fashion that is already available in the retail stores. Americans find foreign magazines helpful for forecasting because European designers often create these trends. Some of these magazines are published only two or four times a year to

report on the collections. Many German and Japanese magazines have patterns included.

Magazines are very important resources for designers, particularly when budget cuts eliminate design services. Designers buy only the magazines that provide suitable ideas for their specific product. For example, jeanswear designers buy contemporary and junior magazines that have ideas for that specific category. International magazines may be ordered through Overseas Publishers Representatives in New York City. The following is only a partial list of the hundreds of magazines on fashion:

Women's wear *Collections, L'Officiel de la Couture et de la Mode de Paris, Jardin des Modes,* and *Vogue* (France); *Line a Italiana, Donna, Moda, Harper's Bazaar Italia,* and *Vogue* (Italy); *Harper's and Queen,* and *British Vogue* (England); *Burda International, Madam, Fashion Guide,* and *Vogue* (Germany); *Élégance* and *Rendez-vous* (Switzerland); *Fashion Yearbook, Hi Fashion, Mode et Mode, Mrs.,* and *Madam* (Japan); *Flare* (Canada)

Contemporary and junior (trendy) *Dazed and Confuzed, Options* (UK), *Elle, Dépêché Mode, Jeune et Jolie* (France); *Moda In, Moda Viva, Amica* (Italy); *Brigitte, Miss Vogue, Carina* (Germany); *Non-no, 25 ans,* and *McSister* (Japan)

Children's wear *Vogue Bambini, Donna Bambini,* and *Moda Bimbi* (Italy); *Sesame* and *Baby Fashion* (Japan). (Junior fashions are also a good source of ideas for children's wear.)

Men's wear *L'Officiel Hommes, Vogue Hommes* (France); *L'Uomo Vogue, Linea Italiana Uomo, Mondo Uomo,* and *Uomo Harper's Bazaar* (Italy); *Männer Vogue* (Germany); *Men's Club, Mr.,* and *Dansen* (Japan)

Bridal *Mariages* (France) and *Sposa* (Italy)

American Consumer Fashion Magazines

Many established magazines are undergoing extensive facelifts, and there is a continuing influx of foreign publishers and editors into the United States. Some magazines have vanished, but there are always new attempts to reach new markets. American magazines as resources are best used to analyze appropriate fashion for specific target markets, to examine American designer collections, and to see what fashion is currently available in the stores. Each designer has his or her own favorites. Keep in mind that advertising comprises 50 to 75 percent of the magazine!

Women's *Ebony, Essence, Harper's Bazaar, Vogue*

Trendy *InStyle, Elle* (American Edition), *Glamour, In Fashion, Mademoiselle, Sassy, Marie Claire, Jane*

Junior *Seventeen, YM (Young and Modern), Jump*

Men's *GQ (Gentleman's Quarterly), Esquire Gentleman, EM (Ebony men)*

Bridal *Bride's, Modern Bride,* and *Bridal Guide*

Children *Kids Fashion*

Catalogs

Designers also use catalogs as resources for ideas. Catalogs are essentially free magazines. A leather jacket shown in a sportswear catalog might be the inspiration for a corduroy nylon jacket for another fashion company, even another catalog business.

■ *DESIGN SOURCES*

Historic and ethnic costume, the arts, and travel are sources of inspiration for designers.

Where do ideas come from? Ideas do not simply materialize out of thin air. First, the designer does careful research, but what makes a designer's line special is his or her unique interpretation of design sources.

Historic and Ethnic Costume

Designers often turn to the past (recent or distant) or to folk costume for ideas and themes. Costume falls into two categories: *historic* costume, the fashion of a certain historical period; and *folk* or *ethnic* costume, traditional national or regional dress. Both are inspirational sources of design.

Historic Inspiration

Designers usually are sensitive to the combinations of colors, motifs, lines, shapes, and spaces in each historical period of costume. Some are inspired to use these in their collections. Recent Cerruti and Theyskens collections showed obvious references to Grecian costume. Nostalgic looks are often used in today's fashion, reinterpreted for today. A recent collection from Prada had a very 1940s feeling. Other examples are Jeremy Scott, who was inspired by the 1930s and 1940s; and Michael Kors, whose collection for Céline was reminiscent of the 1980s.

Folk Influences

Designers find the same inspirational blend of colors, motifs, lines, shapes, and spaces in folk costume. A recent Yamamoto collection blended Native American and Tibetan influences. Jean Paul Gaultier found inspiration in Japan for a collection of exquisite kimonos layered over floral printed underskirts.

Vintage Clothing Shops and Services

Designers shop vintage clothing stores, flea markets, thrift shops, auctions, and on-line for old garments and fabrics to interpret for today's fashion. There are also services that search for inspirational old clothes for manufacturers. For example, Stacey Lee, owner of Vintage in New York, shops for manufacturers such as Liz Claiborne.

A designer might use these garments to round out a group theme. For example, a designer might find old ski sweaters in thrift shops and use the knit patterns for sweaters in a "Nordic" theme sportswear group.

Museums

Museum costume collections offer the unique opportunity of seeing actual preserved garments displayed on mannequins. Designers such as Yves St. Laurent occasionally sponsor historic costume exhibits. A popular exhibit can

The French Foreign Legion was an inspiration for John Galliano's design at Christian Dior. *(Courtesy of Christian Dior, Paris)*

influence many designers. The following museums and galleries house important costume collections:

Costume Institute, Metropolitan Museum of Art, 5th Avenue and 82nd Street, New York, New York 10028

Costume Gallery, Brooklyn Museum, 188 Eastern Parkway, Brooklyn, New York 11238

Costume Gallery, Los Angeles County Museum of Art, 5905 Wilshire Boulevard, Los Angeles, California 90036

Costume Institute, McCord Museum, 690 Sherbrooke Street West, Montreal, Canada

Fashion Institute of Technology (FIT) Costume Library and Gallery, 27th Street, New York City

Musée du Costume de la Ville de Paris, 14 avenue New York, 75016 Paris, France

Musée de la Mode, Pavillon de Marsan, Louvre, rue de Rivoli, 75001 Paris, France

Victoria and Albert Museum, Brompton Road, London S.W. 7, England (including costumes, old fabrics, and embroideries)

Museum of Costume, Assembly Rooms, Alfred Street, Bath, England
Rijksmuseum, Stadhouderskade 42, 020 Amsterdam, the Netherlands

Kostümforschungs Institut (Costume Research Institute), Kemnatenstrasse 50, 8 Munich 19, Germany

Centro Internazionale Arti e del Costume, 3231 Palazzo Grassi, 30124 Venice, Italy

Many regional museums have fashion collections, and almost every national museum of folklore includes ethnic costumes. Costume can also be studied in paintings in every museum.

Libraries and Bookstores

Costume can also be studied in books. Museum bookstores and libraries are excellent sources of costume references. Many libraries also have collections of old fashion magazines, including *Godey's Lady's Book* (from the 1830s to the 1890s), *Harper's Bazaar* (from 1867), and *Vogue* (from 1894). Many fashion designers have their own libraries of books on historic and ethnic costume, films, sports, artists, designers, and textiles. Some colleges have historical costume and print libraries.

The Arts

Film, video, television, art, architecture, music, and theater are also inspirational sources for fashion design. Designers flock to large cities to soak up the creativity centered there. They are influenced by what other designers and artists are creating. Excitement about a new idea acts as a catalyst for more creativity.

Art exhibitions often have an impact on design collections. After seeing an exhibition of Eugene Delacroix's paintings, Gérard Pipart, designer for Nina Ricci, paid homage to Delacroix with multicolored caftans and exotic harem pants like those found in the paintings. Both British and American designers attended the recent "Portraits by Ingres" exhibit in London and New York.

Films often influence fashion. *Costume design* refers to the specialized field of creating apparel for film and theater. Although the costume designers of contemporary films are influenced by current fashion, it usually works the other way around. Apparel designers are inspired by both new and old movies. Sometimes it is just a mood that captures their imagination, but most often it is the clothes. Geoffrey Beene loves "any film that used costume designer Adrian, who supplied glamour, great fabrics, backless dresses and sensuality to films."[4] Anna Sui said that she was influenced by two films about gypsy culture for her spring, 2000, collection.[5] Occasionally, Seventh Avenue apparel designers are asked to design for contemporary films, such as when Donna Karan designed the costumes for Gwyneth Paltrow in *Great Expectations.*

Music and the exposure that video gives singers and musicians have made a significant impact on young people. Teens look to see what rock stars are wearing; therefore, junior designers emulate these entertainers so that their clothes will be popular with their customers.

Television gives broad exposure to fashion as seen on programs. These clothes are either designed specifically for the show or are chosen from ready-to-wear collections. Many programs targeted to viewers under 30. The clothes worn by the stars of popular TV programs, such as Sabrina, Party of Five, or Dawson's Creek, disseminate youthful fashion trends.

Fabrics

Fabrics are the most important inspiration and resource for designers. However, mainstream apparel and accessory designers are limited to the fabrics that are currently available in their price range. Designers shop at international textile markets or fabric showrooms in New York and Los Angeles to see the current fabric lines. The selection of fabrics in the apparel design process is discussed in Chapter 9.

Fabric designers do the same market and trend research as do apparel and accessory designers. They also have the same sources of inspiration, especially in fabric and costume collections, old or new interior decoration, or at the fabric market fairs. There are even textile swatch services that specialize in vintage fabrics. Designers such as Martin Margiela and Miguel Adrover even use recycled fabrics and parts of old garments in their new designs. Fabric design is covered in Chapter 6.

Flowing chiffon fabric was a major inspiration for this romantic gown from John Galliano for Dior. *(Courtesy of Christian Dior, Paris)*

Travel and Nature

Travel influences designers' collections. Designers like to visit visually and culturally stimulating places. Designers take working vacations because they are always using their awareness skills to absorb new stimuli. Travel exposes them to new ideas, but these ideas are not always obvious in their collections. The accumulated ideas may be as subtle as a fresh color palette, a pattern for a fabric, or just a different way of looking at things.

Designers can be inspired by nature both at home and abroad. Natural forms and patterns can suggest a design for apparel or accessories. The colors of flowers or fall leaves might inspire a color story. Donatella Versace, for example, covered an entire dress with leaves cut from green-dyed python skin.

Form Follows Function

To borrow a phrase from architect Louis Sullivan, apparel designers, too, are inspired by necessity. The long-term demand for denim made jeans fashionable. When consumers became active, the fashion industry created activewear. As activewear became popular, it became fashion. The popularity of practical backpacks made them stylish. The desire for comfort and flexibility made spandex so successful. The use of spandex, in turn, led to body-conscious styling. Often, the need creates the fashion. Some designers also like to predict the future of fashion in their designs.

The Street Scene

Designers get ideas just watching people in the streets: people on their way to work, the trendy young people out and about, or the kids on their skateboards. They look in the shop windows. They take photos or make sketches of clothing that appeals to them. A designer at Levi Strauss made videos of "street fashion" to show to her colleagues to stimulate ideas. Photos of what the general public is wearing are often featured in *Women's Wear Daily* and fashion trend books.

Awareness

Designers surround themselves with photographs of ideas, fabric swatches, and anything else that will stimulate creativity. They leave their studios to shop, visit museums, study nature, attend the theater, or people-watch. They watch fashion on the Internet, videos, and television. Designers usually carry sketchbooks to jot down ideas whenever and wherever they find them. They hunger for information, letting ideas mingle and shape themselves into new forms.

Awareness is the key to creativity. Designers must learn most of all to keep their eyes open, to develop their skills of observation, to absorb visual ideas, blend them, and translate them into clothes that their customers will like. It is impossible to predict where an idea will come from or which idea may inspire a whole group or line. Some people are more sensitive to good composition than others, but practice and observation make a person more aware, sensitive, and confident. Exposure to beautiful things helps a designer or buyer distinguish genuine beauty and quality from fads and mediocrity.

■ SUMMARY

Research and observation are critically important in the fashion business. By observing and researching consumer buying habits, watching for directions in designer collections, reading the most appropriate fashion publications, observing fashion trends, and being aware of the arts, manufacturers and retailers try to predict what the majority of their customers will want in the foreseeable future. To keep up with the changing world of fashion, fashion awareness should become second nature.

■ *CHAPTER REVIEW*

Terms and Concepts

Briefly identify and discuss the following terms and concepts:

1. Fashion editing
2. Fashion forecasting
3. Fashion trends
4. Target market
5. Evaluating collections
6. Fashion services
7. Trade publications
8. Consumer publications
9. Awareness
10. Design sources

Questions for Review

1. Explain what factors are involved in fashion forecasting.
2. How do designers use trend and information services?
3. Why is market research important for textile and apparel manufacturers and retailers?
4. Explain the difference between trade and consumer fashion publications.
5. What role does historic or folk costume play in today's fashion?
6. Give an example of how films have influenced fashion.

Projects for Additional Learning

1. Trend research: Make a survey of fashion resources available to you. Read the latest issues of fashion magazines and compare the contents with fashion looks six months ago and a year ago. From the information that you find, try to analyze the fashion direction for the future. Organize your ideas into a few basic trend forecasts for color, fabrics, silhouette, and line.
2. Fashion magazine evaluation: Examine and compare the content of four different fashion magazines. How many pages are devoted to paid advertisements? How many pages are devoted to editorial fashion reporting? What do these magazines have in common?

How would a fashion forecaster use this information?
3. Look through costume books for pictures of ethnic dress. Using these as inspiration, design a garment using the line, shapes, colors, and details from these garments in a new combination for today's life-style.
4. Develop a consumer survey. Type up questions you would like to ask. Be as specific as possible, such as "What length skirt do you prefer to wear?" Go to a local shopping mall and ask customers to answer your survey (explain that you are working on a student project). Tabulate your findings in a brief written report.

■ *NOTES*

[1] As quoted in "Donatella Takes Charge," *Women's Wear Daily,* October 1, 1997, p. 4.

[2] As quoted in "King Karl," *Women's Wear Daily,* November 20, 1991, p. 7.

[3] As quoted in "Juniors, a Trend Ahead," *Women's Wear Daily,* December 1, 1994, p. 6.

[4] As quoted in "They Lost It at the Movies," *New York Times Magazine,* February 20, 2000, p. 119.

[5] Ibid.

The Raw Materials of Fashion

Before we can even begin to think of fashion apparel or accessories, we must consider the raw materials from which they are made. Collectively, the producers of these raw materials—fibers, fabrics, leathers, furs, and trimmings—are the suppliers to the apparel and accessories industries and the first level of the fashion industry.

- Chapter 5 covers the *production of fibers and fabrics* for those students who do not have a background in textiles.

- Chapter 6 describes the *marketing of these fibers and fabrics;* basic knowledge needed by anyone working in textiles or manufacturing.

- Chapter 7 surveys *leathers and furs,* which are also raw materials for clothing, and *trimmings,* the necessary secondary supplies to finish apparel and accessories.

A field of flax. *(Courtesy of the International Linen Promotion Commission)*

5

Textile Fiber and Fabric Production

■ CAREER FOCUS

Careers in textile production require a technical education in textiles and/or engineering. Since most mills in the United States are located in the Southeast, this is the area where most jobs are found. Other opportunities exist in New York City and the Los Angeles area. There are technical career opportunities in research and development, styling, plant technology, engineering, and management.

■ CHAPTER OBJECTIVES

After reading this chapter, you should be able to:

1. List the sources of fibers;
2. Explain the processes involved in the production of fibers and fabrics;
3. Describe the roles of mills and converters.

*T*extiles is a broad term referring to any material that can be made into fabric by any method. Occasionally, the term *textile industry* is used to cover the whole apparel industry: the production and marketing of textile merchandise from raw materials to the product in the retail store.

More precisely, the textile industry encompasses the production and marketing of fibers, yarns, and fabrics, including trimmings and findings. This production and marketing chain includes the following steps: fiber production, yarn production, fabric production, dyeing, printing, and finishing. Defined in this way, the textile industry represents the first level of the fashion industry. Textile production will be discussed in this chapter, followed by textile marketing in Chapter 6 and trimmings in Chapter 7.

■ *FIBERS*

Before the textile industry can supply fabrics to apparel manufacturers, it must first develop and produce both natural and manmade fibers.

Fibers are hair-like materials, either natural or manufactured, that form the basic element of fabrics and other textiles. They can be spun into yarn and then made into fabric by various methods, such as weaving and knitting. Fiber characteristics such as fineness, moisture regain, elasticity, luster, or crimp are inherent and, therefore, affect the properties of the yarns and fabrics made from them.

Total world fiber production is continually growing. Production is now 41.2 billion kilograms per year as compared with 22 billion in 1970 (only one-half of worldwide fiber production is for apparel).[1]

The vast differences between the *natural* and *manmade* fiber industries have resulted in markedly different operational and organizational forms, even though the final goal of both groups is the same: to produce fibers that fill consumer needs.

■ *NATURAL FIBER PRODUCTION*

Used for thousands of years, natural fibers are derived from either animals or plants.

Natural Fiber Producers

The natural fiber industry is dependent on animals and living plants. Thus, the production of natural fibers depends on climate and geography, and, in most countries, the majority of crops are produced by thousands of small farmers. For thousands of years, farmers around the world have worked independently to raise and harvest crops or to raise and shear animals to obtain fibers. They sell their fibers at local markets or auctions to wholesalers, who, in turn, sell the fibers at central markets or directly to textile mills.

The most widely used natural fibers for apparel are animal, such as wool or silk, and vegetable, such as cotton and flax. Others include ramie, jute, sisal,

hemp, and even corn. There is a trend toward blending natural fibers to create new textures, such as linen with cotton, cotton with wool, or silk with linen or cashmere.

Cotton

Cotton has long been the world's major textile fiber. It comprises about 41% of world fiber production or approximately 19 billion kilograms (or million metric tons) annually, but this amount fluctuates.[2] A vegetable fiber, it grows best in tropical and subtropical climates. The leading cotton-growing country is China, followed by the United States. Uzbekistan, India, and Pakistan also produce large cotton crops. In the United States, 17 states in the South make up what is known as the Cotton Belt, stretching from the Southeast through the Mississippi Delta to Arizona and California.

The cotton plant has blossoms that wither and fall off, leaving green pods called *bolls.* Inside each boll, moist fibers push out from newly formed seeds. The boll ripens and splits apart, causing the fluffy cotton fibers to burst forth.

There are many steps in manufacturing cotton yarn based on the production system used and the quality of the yarn desired. Basically, the cotton is picked and *ginned,* an operation that separates the fiber from the seed. Then the fibers are cleaned and, afterwards, straightened by the *carding* process.

Cotton fiber may be processed on a *combing* machine that removes short fibers, resulting in a smooth, uniform yarn. The quality of cotton depends on length, strength, fineness, maturity, and color. The combination of these factors determines the overall quality, price, and end use of the cotton.

Cotton is washable and durable, holding up well after many launderings. Wrinkle-resistant finishes have recently been created that make cotton care easier. Cotton absorbs dyestuffs easily to produce a wide range of vivid colors. It also absorbs moisture, which makes it feel cool against the skin in hot, humid weather. For this reason, cotton has traditionally been a summer fabric. Yet cotton is very versatile and can be made in both light weights for summer and heavier weights for winter. Cotton fabrics range from the light and sheer

Cotton harvesting. *(Courtesy of the Cotton Council)*

(such as voile and batiste) to the heavy and thick (corduroy, flannel, and chenille) to the strong and sturdy (denim).

Flax

Flax is made from the fibrous material in the stem of the flax plant. Flax is harvested by pulling up the plants to preserve the full length of the fibers. Extracting the fibers from the flax plant is a lengthy and complex process. Flax seeds and adhesive substances that bind the fibers together must be removed by a process called *retting*. Then, in the *scutching* process, the fibers are separated from the outer bark and the woody inner core of the stem. Further processing can include *hacking* or *combing* and drawing the flax into a continuous ribbon of parallel fibers ready for spinning into yarn to make the fabric called *linen*.

Linen is the oldest known textile, dating back as far as the Stone Age. At one time, linen was used extensively for bedding; this explains why we still call sheets, towels, and tablecloths collectively "linens." Flax was an important crop in the United States until the invention of the cotton gin in 1792 made cotton cheaper to produce.

Today, flax makes up only 2 percent of world fiber production or approximately 600 million kilograms annually. Eighty percent of the world's flax is grown in Russia; France is the largest producer of flax in the Western world. France and Belgium have the reputation for growing the best quality. Because the United States no longer grows flax, there have been no quotas on its importation. However, farmers are again growing some flax in Maine.

The cool, crisp qualities of linen make it especially suited for summer clothing. Renewed interest in texture and natural fibers has repopularized linen and linen blends as well as linen look-alikes in the form of rayon and other fiber blends.

The scutching process to separate flax fibers from the bark and stem.
(Courtesy of the International Linen Promotion Commission)

Ramie

Ramie is a formerly rare fiber that is now being used for apparel because its importation into the United States is not restricted, because there are no domestic commercial growers. A vegetable fiber similar to flax, it comes from the 5- to 6-foot stems of a nettle-like shrub. Ramie grows best in a semi-tropical climate, and is imported primarily from India, China, and the Philippines.

Ramie is even stronger than flax and has a smooth, lustrous appearance. The fibers dye easily but are brittle and more difficult to spin and weave than other fibers. Therefore, it is most often combined with cotton to soften it.

Wool

Wool fiber is a natural and renewable resource from the fleece of animals, most commonly, sheep. The *fleece* is removed by the use of shears or clippers in the *shearing process.* Shearing takes place at various times throughout the year, depending on fiber-length requirements. Although wool is commonly understood to be fiber from the fleece of sheep, some other animal fibers are also classified as wool specialty fibers. They include angora, camel's hair, cashmere, mohair, llama, alpaca, and vicuna. With fashion's focus on texture, specialty fibers have renewed popularity.

Wool fiber has an unusual ability to absorb and evaporate up to 30% of its weight in moisture. The crimp structure of wool fibers allows it to return to its natural position after stretching, which gives it resiliency. When woven or knitted, the crimp structure creates air pockets, which give it insulating properties. Resiliency also makes wool fabrics resistant to wrinkling, and the softness of wool makes it comfortable to wear. Because of its thermal properties, wool has traditionally been used for fall and winter suits and coats. However, new developments in microfibers, as well as lightweight woven and knitted fabrics, make wool a fiber that can be worn in spring and summer. Wool fibers also absorb dye easily, allowing bright and clear colors to be produced.

Shearing a sheep to obtain wool fiber. *(Courtesy of Judith Winthrop)*

Raw wool is scoured to clean the wool, then *carded to* separate and lay the fibers parallel, and *combed* to separate short fibers from long ones. The long fibers are spun into smooth, compact *worsted* yarns used for fabrics such as gabardine or crepe; short fibers make up the soft, dense *woolen* yarns used in textured tweeds and flannel.

Australia is by far the world's largest wool producer, followed by New Zealand and then by China. Although more than 1,392,044 tons of clean wool are processed each year, this represents only 3 percent of world textile fiber production.[3] The supply of wool changes yearly; sometimes there is a stockpile and other times a shortage.

Silk

Silk is the only natural fiber that comes in continuous *filament* form as opposed to short staple lengths. *Silk* is the protein filament secreted by a silkworm to make its cocoon. A silkworm uses the cocoon as a shell to protect itself during its transformation from caterpillar to moth. A typical cocoon will produce 600 to 2000 meters of continuous fiber, making silk the only natural filament fiber. Nevertheless, it takes over 500 silkworm cocoons to make a blouse.

Silk harvesters unwind the filament from the cocoon onto silk reels. The silk fiber is steeped and boiled in soap baths to remove the *sericin* or silk glue. The time and labor needed to cultivate silk make it a rare and, therefore, expensive fiber. World production of silk fiber is a mere 0.2 percent or only 60 million kilograms annually. Asia produces nearly all of the world's raw silk filament fiber. Asia has decreased exports of raw silk and increased production and exports of finished silk fabrics. The most famous quality silk fabric mills are in Como, Italy, and Lyons, France, but the Koreans have learned their techniques.

There are four kinds of silk fibers. *Cultivated silk* comes from the domesticated silkworm. The filaments are almost even in size, their fineness indicated by a unit called *denier* (the weight in grams of 9000 meters of yarn). Cultivated silk is used for the finest silk fabrics, such as crepes, taffetas, and satins. *Wild* or *tussah silk* comes from the wild silkworm. Less secure environmental conditions cause the filaments to be coarser and more uneven. Therefore, fabric made from wild silk is not as smooth as that made from domesticated silk. *Douppioni silk* is the result of the filament sticking together at intervals while wrapped as a cocoon, causing slubs (lumps) and uneven yarn used to make shantung fabric. *Schappe* and *bourette (waste) silk* are composed of short fibers from damaged cocoons that are not strong or long enough to be used on their own. Yarn spun from waste silk also has irregular slubs from the joinings and is used in rough-textured silks.

Silk has always been used for the finest garments. The silk fiber is triangular and reflects light, giving silk its unique luster. Because it takes dyes with exceptional depth and clarity and has a luxurious feel, it adds elegance to any garment. Silk also has insulation properties, making the wearer feel cool in summer and warm in winter. Silk drapes exceptionally well, is very strong yet lightweight, and is comfortable as well as beautiful.

PLA

The newest fiber development is called PLA (poly-lactic acid), a corn-based polymer created by Cargill Dow Polymers. It is a cross between a natural and a manmade fiber. Although a polymer, it is made from the natural source of corn. It is biodegradable like other natural fibers but with the performance of synthetics. PLA is still in the developmental stage; a few mills are experimenting with it alone and in blends with cotton or polyester. This is another example of exciting textile products created by new technology.

■ MANMADE FIBERS

The phenomenal growth of the textile fiber industry was made possible by the development of manmade fibers.

Chemists began to experiment with synthetic fibers as early as 1850. In 1884, a Frenchman named Hilaire de Chardonnet patented a fabric he called "artificial silk," which is known today as *rayon* (or *viscose* in Europe). He dis-

covered that silkworms use cellulose from mulberry leaves to make real silk, so he reproduced the process chemically. Rayon was first produced chemically in the United States in 1910, but not until 1939 was the first completely chemical fiber, *nylon,* introduced by DuPont.

Originally, the term synthetics was used to denote all chemically produced fibers. In the world market today, however, the term *synthetic* covers only the non-cellulosic fibers. A true synthetic is made from the carbon atom of oil or coal whereas viscose and acetate are regenerated cellulose. The textile industry refers to all chemically produced fibers together as *manmade* or *manufactured* fibers.

Manmade Fiber Producers

Large chemical companies, such as BASF (Badische Anilin und Soda Fabrik), DuPont, and Celanese, pioneered the development of manmade fibers. The fiber divisions of these companies do extensive research and development of both fibers and fabrics; they work closely with their customers, the textile mills, and provide technical services to manufacturers and retailers.

Strong competitive pressures from imports forced the U.S. textile industry to reorganize, consolidate, and focus on those things that they do best. This specialization has led to international mergers and acquisitions. For example, Lensing of Austria bought the rayon division of BASF and is now the world's largest rayon producer. DuPont bought Zeneca's nylon facilities and, in turn, Zeneca purchased DuPont's acrylic division.

In contrast with natural fibers, manmade fibers are produced by a few chemical companies whose huge facilities enable them to take full advantage of mass production. These plants are located in areas where the combined cost of raw materials, labor, energy, and transportation is the lowest possible. Manmade fiber production depends mainly on the supply of petroleum products; therefore, it is subject to shortages and ever-increasing prices.

In 1960, manmade fiber production was only 22 percent of world fiber production as compared with more than 50 percent today (about one-third of this amount is used for apparel). The growth rate of manmade fibers is the result of many factors: fiber research and development by chemical companies, new technical developments in making new varieties of fibers, the scarcity and expense of some natural fibers, increased high-tech production, and increased demand.

China leads the world in manmade fiber production. China's production, combined with that of Taiwan, Japan, and Korea makes Asia by far the largest producer, followed by the United States and then the European Union (primarily Germany and Italy) and Russia.[4]

Of utmost importance is the use of manmade fibers in blends, either with each other or with natural fibers. Blends capitalize on the best qualities of each fiber. For example, spandex is often blended with a variety of fibers to add stretch. Polyester can be blended with cotton to give it easy-care properties. Continual experimenting with fiber combinations makes exciting new fabrics.

Regenerated Cellulose Fibers

Derived chiefly from the pulp of wood, cellulosic fibers create a *hand* (the feel, body, and fall of a fabric) similar to natural fibers, as compared with chemical synthetic fibers. Cellulosic fibers include rayon, acetate, and triacetate.

Rayon (Viscose)

The first manmade fiber to be developed, *rayon* is composed of regenerated cellulose derived from wood pulp, cotton linters, or other vegetable matter. The cellulose is dissolved into a viscose solution and spun into fiber. Rayon has become very popular because it is a soft, lustrous, versatile fiber that can be treated and finished to produce a wide range of characteristics.

Soaring wood prices and the expense required to clean up the environment have made rayon very expensive to produce. The caustic materials needed for rayon's wet-spinning process cause pollution. The rayon fiber industry has had to incur heavy costs to conform to more stringent environmental standards.

Lyocell

Lyocell is the generic designation for a new type of solvent-spun cellulosic fiber produced by Tencel, Inc., a division of Acordis Fibers, and Lenzing of Austria. Lyocell is almost twice as strong as rayon, both wet and dry, is a good blending partner with many other fibers, and takes color well. Tencel A100 has been developed for use in knits.

Like rayon, Lyocell is produced from wood pulp. However, Lyocell is manufactured using a solvent spinning technique in which the dissolving agent is recycled, thus reducing waste that is harmful to the environment.

Acetate and Triacetate

Cellulose acetate fiber was first produced commercially in 1921 and advertised as a synthetic silk. Acetate (diacetate) and triacetate have been adopted as alternatives to rayon although they are not quite as strong. Triacetate can be heat-set to give it easy-care properties, but it requires such strong solvents that it is no longer produced in the United States. Diacetate can be dissolved in solvents that are easier to handle and, therefore, it is more widely produced.

Acetate has a soft, silk-like hand, excellent drape qualities, and takes dye well. Acetate can be used alone or in combination with other manmade or natural fibers. It is used primarily in women's dressy apparel, bridal wear, and linings.

Synthetic Fibers

Made from chemical derivatives of petroleum, coal, and natural gas, *synthetic fibers* (also sometimes referred to as *non-cellulosic* fibers) used in apparel include nylon, polyester, acrylic, spandex, and polypropylene. Synthetic fibers, particularly microfibers, have risen in popularity with the demand for lightweight, high-tech fabrics.

Nylon

One of the strongest and most durable manmade fibers, nylon is made of a long-chain synthetic polymer. Nylon filaments usually have an even, silky hand but can also be textured to be soft and supple. Nylon is not only strong but also flexible, washable, and colorfast. In apparel, it has been traditionally used in hosiery, lingerie, bathing suits, and active sportswear. However, the Italian designer Miuccia Prada has made nylon fabric fashionable for all apparel.

New uses for nylon include this quilted suit from Prada.
(Courtesy of Prada, Italy)

Polyester

Another kind of long-chain synthetic polymer, *polyester* is the most widely used manmade fiber in the world. Chemical companies can produce polyester fiber in the forms of filament, staple, or tow (short or broken fiber).

Polyester is highly wrinkle resistant and easy to care for. It was one of the first fibers to be developed in fabrics with permanent-press features. Polyester is used in many types of apparel, including textured knits and wovens, permanent-press blend fabrics, shirtings, suitings, and sleepwear. It is often blended with natural fibers to lend easy-care properties to them. The development of microfibers has made polyester even more adaptable and popular.

Acrylic

Acrylic is yet another long-chain synthetic polymer. Because of the composition and cross-section of the fiber, fabrics made of acrylic have a high bulk-to-weight ratio. This provides warmth in fabrics that are lightweight, soft, and resilient. End uses of acrylics include knitwear, fleece activewear, suits, coats, and fake furs.

Spandex

A long-chain synthetic polymer comprised of segmented polyurethane, *spandex* can stretch 300 to 400 percent without breaking and return to its original length. Its elastic properties are unequaled by any other fiber, and it does not deteriorate as rubber does. Because of its tremendous stretch, spandex is generally added to other fibers, such as cotton, nylon, rayon, or wool, in small quantities of 2 to 20 percent, to create stretch fabrics. This stretch characteristic makes it an excellent fiber for use in swimwear, hosiery, and active sportswear. Because of its comfort and fit properties, spandex is now widely used in many fabrics. It is used in stretch-wovens as well as knits and has even been used in stretch-satin for evening wear!

Polypropylene

An olefin fiber made from polymers, *polypropylene* is very strong and resilient. It provides greater coverage per pound than any other fiber, yet it is so light that it actually floats. Although the major uses of polypropylene are in industrial and carpet applications, its good insulative properties make it useful in some high-tech activewear where moisture transport is important.

Modern man-made fibers, such as nylon, spandex, and polypropylene, help keep skiwear flexible, warm, and dry. *(Courtesy of Fila, Inc.)*

Generic and Brand Identification

When a completely new fiber is developed, the U.S. Federal Trade Commission assigns it a generic name, such as "polyester." Many companies produce polyester but they each call it by a different name in order to promote

it independently. A *brand name* or *trademark* (identifiable symbol) is registered and is owned by the manufacturer. For example, Lycra is Dupont's brand name for spandex and Dacron is its brand name for polyester. The Textile Fibers Products Identification Act requires that end-products carry labels listing the generic names of the fibers used and the percentage of each.

It is possible to work within the basic generic composition of an existing generic fiber and modify it, both chemically and physically, to change the properties of the fiber to create variants. *Variants* are specialty fibers for special applications. Some variants are intended to imitate natural fibers. Some are blended with natural fibers to add easy-care properties to them. Others are engineered to add stretch, moisture wicking, or other comfort properties. Each fiber producer creates its own variants and gives them a *brand* name. Thermax, for example, is DuPont's brand name for its insulating hollow-core polyester, whereas Coolmax is its moisture-wicking polyester. There are many variants of other manmade fibers. Each producer gives them its own brand names.

Manmade Fiber Production

In very simple terms, all manmade fibers are extruded from a viscous solution of cellulose (purified wood pulp) or from chemical raw material. Originally, the chemical substances exist as solids and, therefore, must be first converted into a liquid state. The raw materials are converted into flakes, chips, crumbs, or pellets, which are then dissolved in a solvent, melted with heat, or chemically converted into a syrupy liquid and pumped through the tiny holes of a spinneret to form continuous filaments. The process of extrusion and hardening is called *spinning,* not to be confused with the textile yarn operation of the same name.

Unlike natural fibers, the manmade fibers can be extruded in various cross-sections (solid or hollow, for example) and thicknesses, called *denier.* These long fibers can be left as continuous filaments or cut into *staple* (short, uniform lengths) to be blended with other fibers.

Manmade fibers were first created to imitate the texture of natural fibers, duplicating their crimp, length, and thickness. Since then, scientists have learned how to vary the shape, composition, and size of fibers to achieve pleasing esthetic effects and higher levels of performance.

One of the most successful manmade fiber developments is that of *microfibers,* which contain individual filaments that are less than one denier thick, twice as fine as silk. Used primarily in polyester, this luxury fiber is giving polyester a renaissance. It can be used alone or combined with silk, worsted wool, or other fibers.

■ TEXTILE YARN AND FABRIC PRODUCERS

Textile mills use fibers to produce yarns and fabrics. Converters may also finish fabrics. Both textile mills and converters are the suppliers to the apparel industry.

There are about 4000 apparel-related textile plants (yarn, fabric, and finishing) dispersed throughout the United States and approximately 554,000 people are employed in domestic textile production.[5] The industry originally located in the southeast to be close to the source of cotton and to take ad-

vantage of less expensive labor. The Carolinas and Georgia together still account for more than half of all industry employment and production, although textile mills now exist in almost every state. In addition, because New York City is the nation's fashion capital, most textile companies have offices there as well as sales representatives all over the country (see Chapter 6).

Textile Mills

Mills are the producers of yarns and fabrics. Some mills produce only yarns; others knit and weave fabric from their own yarns or from purchased yarns. Certain mills produce unfinished fabrics called *greige* (pronounced "gray") *goods,* which are sold to converters to be finished, or they may produce both greige goods and finished fabrics. Small mills usually specialize in one type of fabric, such as velveteen or corduroy. Large companies create separate divisions to do the same thing, grouping similar fabrics under one division.

The various stages in textile production may or may not be handled by firms under common ownership. Firms have tended to grow either forward or backward into the production or marketing chain to form large *vertical mills,* which perform all processes, from "top to bottom" (fiber to fabric). However, these operations are separated in specialized facilities. Milliken and Burlington are examples of vertical mills.

Mills have had increased capital expenditures to purchase the latest technology to offset the low labor cost advantage of imports. Because of the huge investment needed for machinery and technology and the expense of changing it, the large mills tend to serve the mass market with volume fabrics. In domestic mills, most processes are computerized: the spinning and texturing of fibers and yarns; high-speed weaving and knitting; and automated material handling, dyeing, and finishing. The size of most U.S. mills is suited to high volume production but in recent years, as a result of competition from imports, they have begun to accommodate small runs and more design changes. Also, due to NAFTA, many U.S. mills are building factories in Mexico or forming partnerships with Mexican companies.

Textile companies are investing heavily in new technology. They believe that technological advances will guide the future of fabric development in the twenty-first century. This is particularly true with the popularity of lightweight, *performance fabrics,* those that are easy to care for and move with the body.

Converters

Converters do only the finishing stages of production. They can be a division of a vertically integrated textile company or independent, such as Abraham, Brittany, Channel, Charter, and Pressman-Gutman. There are fewer and fewer independent converters today because the industry has tried to cut costs by becoming vertical or forming alliances between levels of the industry. Therefore, most large textile mills now do their own converting.

Converters *source* (find the best quality goods at the best price) greige goods from worldwide mills. The few independent, domestic converters that remain in business are sourcing most of their fabrics offshore, from Korea, China, Taiwan, or Mexico. They usually contract out all printing, dyeing, and finishing processes to specialized factories rather than owning production facilities. This gives them the flexibility to change methods or products to keep up with changing fashion. The vertical mills are now trying to fill this role.

■ *YARN PRODUCTION*

Once a fiber is produced, yarn production is the next step in creating a fabric.

Textile manufacturers choose a yarn-making technique that can best achieve the texture or hand desired. Yarn can be made as coarse as rug yarn or finer than sewing thread. Finished yarn is then sold to fabric producers to be used for weaving and knitting.

Filament Yarn Processing

A *filament* is a continuous strand of fiber. Single monofilament, direct from the fiber producer, may be used as a yarn and knitted or woven into fabric. Multifilaments may also be brought together, with or without a twist, to create yarn. Filament yarns are smoother, have more sheen, and are more uniform than spun yarns.

Silk filament is twisted in a specialized silk spinning process. It is then ready for weaving or knitting.

Synthetic filament, on the other hand, is generally textured to provide bulk, loft, or elasticity. *Texturing* is a process used on filament yarn to change the shape or characteristics into some form of crimp, loop, curl, or coil. These characteristics are given to the fibers to make them suitable for specific end uses. After texturing, manmade filament yarn is ready for dyeing and weaving or knitting.

Spinning Staple Fibers

Spun yarns can be made from natural fibers and manmade fibers that have been cut into *staple* (short lengths that emulate raw natural fiber).

Natural fibers, such as cotton, flax, and wool, must go through a long and expensive series of processes to become yarn. Each fiber has its own special spinning system: the linen system, the cotton system, the woolen system, or the worsted system. To explain the systems in a very simple way, there are first several processes to clean, refine, parallel, and blend the raw fibers. Next, the fibers are drawn out into a fine strand and twisted to keep them together. This process gives them strength to withstand the spinning process.

Manmade fibers are cut into staple and spun on the same conventional spinning system used for cotton or on a new high-speed system to make yarn. The resulting yarns have characteristics similar to those of spun natural fiber. Both natural fibers and manmade fibers are blended to give yarn consistency as not all the fibers have the same quality. Natural and manmade fibers may also be blended together. In fact, most manmade fibers that are cut into staple are used to mix with natural fibers.

■ *FABRIC PRODUCTION*

After spinning, the yarns are ready for weaving or knitting.

Fabric is material or cloth made from natural or manmade yarns by any of the following methods: weaving, knitting, bonding, crocheting, felting, knotting, or laminating. Most apparel fabrics are woven or knitted. Fashion preference for one or the other is usually cyclical.

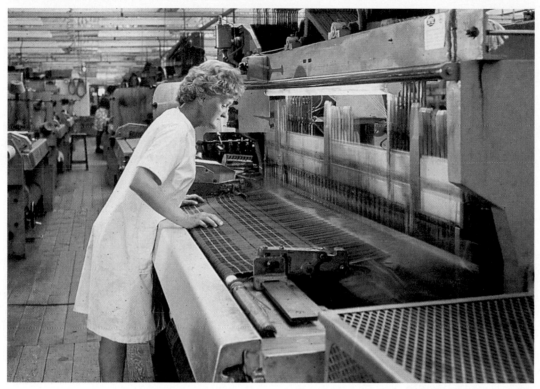

Weaving cloth on an automatic loom. *(Courtesy of the Woolmark Company)*

Weaving

Woven fabrics are made by interlacing *warp yarn* and *filling yarn* (called *weft* in England and in handweaving) at right angles. Weaving begins with a process called *warping* during which yarns are wound onto a beam. The beams are combined via a "slashing" process to put 4000 to 12,000 yarn-ends onto a loom beam.

In the conventional method of weaving, filling (weft) yarns are fed into the loom by a shuttle carrying yarn wound on a bobbin. Originally, the shuttle was fed by hand. Modern technology has developed faster methods of weaving such as the *rapier* loom that carries the filling yarns through the warp on steel bands. Faster speeds are obtained on air-jet and water-jet looms, which use a blast of air or water to propel the filling yarn across the warp. These looms operate at four to seven times the speed of shuttle looms and produce seven to eight times the amount of fabric at wider widths. However, loom speed and weave complexity are inversely related. The more elaborate the pattern, the slower the loom speed must be.

The warp yarns separate alternately (called *shedding*) to allow the filling yarns to interlace with them as they pass through the warp. The next step is *beating* the last row of yarns into the cloth.

Kinds of Weaves

There are three basic weaves: plain, twill, and satin.

Plain weave is the simplest, most common weave. The warp and filling yarns alternately pass over and under each other, creating both horizontal and vertical surface interest. Fabrics woven by this method include a wide range of weights from broadcloth to duck.

Twill weave is created by passing the warp yarn over a number of filling yarns before going under one. The same pattern is repeated row after row, but each time the repetition begins on the next warp yarn, creating a diagonal weave that gives the cloth added strength and a diagonal surface interest. Denim is the most popular twill fabric.

Satin weave is achieved by one warp yarn crossing over the most possible filling yarns (or vice versa), creating floats on the face side of the fabric. The floats give the fabric luster and smoothness. But because they are caught into the fabric only at comparatively wide intervals, a satin weave does not have the same durability as the other weaves.

Pattern Created by Weaving

Pattern can be introduced by using yarns of different colors in the warp, the filling, or both, to create plaids, checks, or stripes. These *yarn-dye patterns* can be distinguished from prints because the patterns appear on both sides of the fabric. Woven patterns may also be produced by reversing the direction of the weave in certain areas or in alternate rows, as in herringbones. Many variations of the three basic weaves are used to create unusual designs or patterns in fabrics, which are called *novelty weaves*.

Types of Looms

Weaves can be created on cam, dobby, or jacquard looms. Cam looms are the fastest because they produce simple weaves. Dobby looms are used to do simple patterns. More complex patterns require more complicated yarn feeding and set-up and, therefore, slow down the speed of the loom.

Fancy woven patterns, such as brocade, damask, and tapestry, may be created on a *Jacquard* (jah-kard') loom. The pattern is programmed on a computer, which controls every yarn individually, creating the desired pattern. The Jacquard loom is the most flexible, but is therefore more expensive and slower.

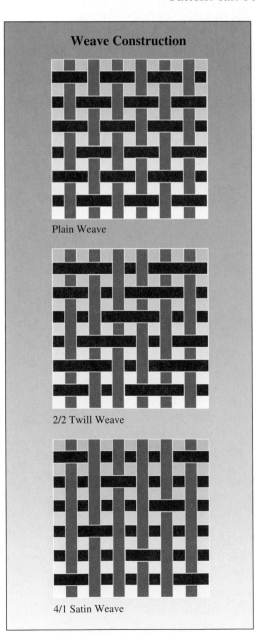

Weave Construction

Plain Weave

2/2 Twill Weave

4/1 Satin Weave

Weave construction.

Knitting

Knitted fabrics are made from one continuous yarn or a combination of yarns formed into successive rows of loops drawn through another series of loops to make cloth. The amount of stretch in the final product depends on the fiber and yarn construction, the density and the type of knit, and the presence of spandex yarns. Various types of stitches in combination with several ways of knitting produce a wide variety of knit fabrics from very bulky to fine-gauge. Designs can be transferred to a computer tape, which operates electronic knitting machines automatically. A modern knitting machine can knit 1 million loops per minute.

Gauge or *cut* refers to the number of needles per inch in the knitting machine; a 10-cut machine has 10 needles per inch. However, the number of *stitches* per inch on the finished fabric may have more or less stitches than the number of needles per inch!

A 5-cut machine with five needles is the most commonly used for bulky knits. However, the resulting knit fabric can have as few as three stitches per inch or as many as nine stitches depending on the amount and size of yarn fed into the machine. The more needles, the finer and closer the knit loops are. A fine jersey might be made on a 28-cut machine. The most common cut-and-sew jerseys and double knits are made on 18- to 24-cut machines.

Weft and warp knitting are the two basic methods of knitting fabric.

Weft Knitting

When the loops run horizontally across the width of the fabric, the process is called *weft knitting.* Weft knits can be made on either flatbed or circular machines, and circular knits may be either single or double knit. In single knits, all the stitches in a given *course,* or row, are made with a single yarn. In double knits, the stitches in a given row may be made by interlocking two different yarn feeds. Weft knits are made in a wide variety of single and double knits and generally have more stretch than warp knits.

Jersey Jersey is the basic construction of all weft knits. The front and the back of the fabric are different in appearance. The rows of stitches running vertically (parallel with the edges, like warp) are called *wales* and the rows of stitches running across the fabric are called *courses.*

Jersey is the most common construction used in fine-gauge fabrics and stretches equally in length and width. Popular uses include pantyhose, underwear, and full-fashioned sweaters (see Chapter 10 for sweater and knitwear production). There are many variations on the jersey construction that are made by differing needle arrangements.

Circular (left foreground) and flat (right background) knitting machines.
(Courtesy of the Woolmark Company)

- **Purl knit** is actually the reverse side of jersey and used primarily for sweater knits.
- **Rib knit** fabrics have a distinctive lengthwise rib on both sides of the fabric for added stretch in the width. A combination of jersey and purl stitches, it is most often used in sweaters, socks, knit accessories, or trims, such as neckbands or cuffs.
- **Interlock** knit looks like jersey on both sides of the fabric. The stitches alternate a half movement up or down to create a zigzag horizontally across the fabric.
- **Knit and welt** uses the front and back beds of the knitting machine to create a welt.
- **Float jacquard** knits have a pattern on the face side. Yarns not being used on the pattern float on the back until they are needed again.
- **Full jacquard** knits also have a pattern on the face side but there is another simple pattern on the back instead of floats. This requires the use of both the front and back knitting beds and makes a double fabric, which is heavier.
- **Novelties,** including *tuck* stitches, *miss* stitches, and *pointelles,* can be created with other needle arrangements.

Warp Knitting

In *warp knitting,* multiple yarns are used, and the loops run vertically and zigzag across each other to form the fabric. Each stitch in a row is made by a different yarn that is fed from a sheet of yarns wound on a beam. Patterns and inlays can be introduced by various needle arrangements. The Missonis in Italy are famous for their beautiful warp knits. Warp knits include tricot and raschel.

Tricot knit fabrics are usually made with fine-denier filament yarns. They are soft, drape well, and are somewhat elastic. Popular uses include women's lingerie and uniforms for nurses.

Raschel is the most complex warp-knit structure, capable of making lacy open stitches. Yarns may be heavily twisted filament yarns or spun yarns. Uses of this knit include thermal underwear, swimwear, shapewear, knitted lace, and crochet.

Nonwoven Fabrics

Nonwoven (or *engineered*) fabrics are made by bonding or interlocking fibers, filaments, or yarns into a web or sheet by mechanical (pressure, needle punch, or needle-tufting), chemical, thermal (heat), hydro, or solvent means. Examples of such fabrics include nonwoven interfacings and nonwoven felt. Nonwoven fabric production usually includes four stages: (1) fiber preparation, (2) web formation, (3) web bonding, and (4) post-treatment. Nonwoven fabrics constitute one of the fastest growing segments of the textile industry.

Production Centers

China produces the most woven woolen apparel fabrics followed by Italy. Hong Kong produces the most woolen knitwear, followed by Thailand, China, or Italy (varies from year to year).[6] Better cottons come from Italy and Switzerland. The United States produces more denim than any other country.

However, the largest cotton fabric producer is China, followed by Eastern Europe, and then India and the United States. Linen fabrics are produced in Italy, Belgium, Northern Ireland, France, China, and Poland. Italy produces the most printed silks, but only one-third of the total world silk fabrics. The other two-thirds are produced in Korea using Chinese silk.

It is difficult to calculate the production of fabrics from manmade fibers because so many are blends, and most industry and trade associations calculate production only in their own countries. The three major global centers of manmade and blend fabrics are Asia, Europe, and the United States.

■ *DYEING*

Dyeing can be done at any stage of fiber, yarn, or fabric production.

Some of the most important methods of dyeing are the following:

■ **Producer colored**—The producer or solution dyeing process, used for manmade fibers, adds the pigment or color when the fibers are still in solution before the filaments are formed.

■ **Stock dyeing**—This method is used to dye loose fibers before yarn processing.

■ **Yarn dyeing**—This is the quality method used to dye certain woven patterns such as stripes, plaids, and checks. It is done after the yarn is spun, but before weaving or knitting. It is most often used in shirts.

■ **Piece dyeing**—Dyeing a piece of fabric after weaving or knitting is called piece dyeing. It is the least expensive and most widely used method of dyeing solid colors.

Piece dyeing cloth. (*Courtesy of the Woolmark Company*)

- **Cross dyeing**—This type of piece dyeing achieves a simple, less expensive two-color pattern. The cloth must be made of fibers having affinities with different dyes so that the cross dyeing can achieve varied color effects in one dyebath.
- **Garment dyeing**—Greige goods are preshrunk and sewn into garments. The whole garments are dyed after they have been sewn. This method ensures quick delivery of needed colors as well as tops and bottoms that match.

Computers have been enlisted to help regulate dye mixing so that colors match from lot to lot.

If apparel manufacturers want a fabric in a color that is not regularly available, their order must meet a minimum yardage requirement. Solution-dyed fabrics require the largest orders and longest lead-times.

Although domestic fabric producers are trying to be more flexible about minimums, mass production requires keeping machines and employees busy. Large domestic mills are most suited to servicing a large manufacturer, such as Levi Strauss or the Gap. Smaller manufacturers are often forced to seek fabrics outside the United States where minimums are lower.

■ *PRINTING*

Printing is used to apply design or pattern to fabrics. There are two basic printing techniques: wet printing and dry printing.

Wet Printing

In both engraved-roller printing and screen printing, dyestuffs are applied wet for optimum color penetration. In pigment printing, another method of wet printing, the pigment is attached to the fabric surface with a resin. Other wet prints use dyestuffs that have a chemical affinity to the cloth fiber and do not require resin. With wet printing, it is possible to achieve a soft, drapable hand.

Engraved-roller Printing

In this technique, a separate roller engraving is used for each color in the pattern. The design is rolled onto the fabric as it passes through the printing machine.

Screen Printing

Flat-bed screen printing uses a screen spread over a frame. The portions of the design to be printed are made of porous nylon fabric that allows the color to pass through the screen. The areas that are not to be printed are covered or coated. Color is poured into the frame shell and is forced through the nylon by means of a squeegee worked back and forth. Flat-bed screen printing is versatile but expensive. The most expensive silk scarves require as many as 50 silk screens with separate colors to be printed in perfect registration.

Rotary screen printing is a mechanized version of flat-bed screen printing. In this method, the roller itself is porous in the areas to be printed. Dye is forced into the roller cylinder and through its porous screen as it rolls over

the cloth. This method is much faster than flat-bed screen printing and is continuous, leaving no breaks between screens.

Dry Printing

Heat-Transfer or Paper Printing

In this process, rotary screens or rollers first print dyestuffs onto paper. The paper can be kept for use at any time. This process helps keep converters' fabric inventories lean inasmuch as greige goods are printed against orders and not for stockpiling.

To print on fabric, the paper and fabric are put through hot rollers; the dyestuffs sublimate into a gas, which moves from the paper base onto the fabric. The advantages of this method are that it gives a clean, fine line on knits with no mistakes or waste, and paper is a smaller investment than the elaborate equipment needed for the other methods. However, this method can cause the hand of the goods to become stiff and the printed pattern transfers only to the fabric surface, with little penetration, creating potential *grin-through* (fabric showing through) problems.

The demand for prints as well as developments in low-sublimation dyes, deeper-penetrating dyes, and better inks for a variety of fiber types has given dry printing wider acceptance. There is relatively little waste water or few harmful discharges with this method.

Digital Printing

Used widely in offices and graphic arts, digital printing is an emerging process for the textile industry. A design on a CAD file can be downloaded directly onto cloth, thus eliminating the need to prepare screens. It is even

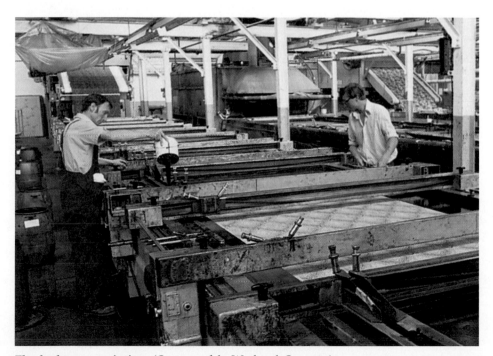

Flat-bed screen printing. *(Courtesy of the Woolmark Company)*

possible to engineer a print design according to the shape of garment pieces. Digital printing is a flexible process that provides the opportunity for quick response changes in color or design as demand changes. This method is increasingly used for creating samples, short run production, and customization.

■ *FINISHING*

Finishes can radically alter fiber and fabric characteristics, performance, or hand.

Finishing is the term used to encompass all the processes used to enhance a fabric (usually after dyeing or printing). Finishes can be accomplished by chemical or physical change:

Physical Means of Finishing

Calendering—A mechanical process of passing fabric between heavy rollers. By using different combinations of heat, pressure, and rollers, it is possible to produce a wide assortment of effects, such as glaze, watermark, or moiré. Calendering is usually done on synthetics, because it is not permanent on fabrics made of natural fibers.

Heat setting—This is a final finish created by heating thermoplastic manmade fabrics (usually polyester) to just below their melting point. This treatment stabilizes the fabric so that there will be no further change in its size or shape and, therefore, improves the fabric's resilience.

Napping—Fabric surfaces are raised and plucked with needles on rotating drums to create a woolly or flannel surface.

Shearing—Fabrics are usually sheared to give the surface a uniform pile or to take off fuzz.

Sanding (or sueding)—The process of mechanically rubbing the fabric with rollers coated with fine-grit sandpaper to create a soft surface.

Shrink control—The preshrinking of cotton cloth so that it will not shrink during laundering; also known as Sanforizing or compacting.

Chemical Means of Finishing

Caustic reduction—A process usually done on polyester to give it a silk-like feel. The surface of the fibers is eaten away in a caustic bath, which reduces the weight of the fabric.

Decatizing—The stabilizing of wool fabrics with the use of heat and moisture.

Durable press—The application of certain resins to cotton or cellulosic fabrics so that they require little or no ironing (also called permanent press, although it is rarely permanent).

Mercerizing—The treatment of cotton with a cold, strongly caustic chemical solution to achieve a lustrous silk-like finish.

Water repellency—Yarns or fabrics treated with chemicals and then woven to create cloth that permits air and vapor to pass through the fabric while keeping rain and snow out.

Other finishes can make fabrics flame retardant, UV resistant, fade resistant, mildew resistant, bacteria resistant, or stain resistant. Also, see Chapter 10 for information on garment finishing.

When production is complete, fabrics are measured and rolled onto tubes. Each finished roll, called a *piece,* may have 40 to 100 yards on it, depending on the weight of the goods (heavier knits and wools have less yardage on a piece, to make them easier to handle). Multiple pieces are shipped to manufacturers to fill production orders that can amount to thousands of yards. Smaller quantities, in the form of 3- to 10-yard sample cuts, may be ordered for designer styling, or *duplicate yardage* (perhaps 100 yards) can be ordered for multiple sales representatives' samples.

■ *ENVIRONMENTAL CONCERNS*

The growing demand for more environmentally friendly products has generated a new awareness and ingenuity at each level of the textile industry.

The American Textile Manufacturers Institute has established an Encouraging Environmental Excellence (E3) program to urge producers to protect the environment. This includes environmental targets and audits to encourage recycling and environmentally efficient manufacturing and finishing processes. As a result, many textile firms now budget and plan for environmental improvements.

Alternatives in Cotton Growing

New standards are being set for the growing, processing, printing, and dying of natural cotton fabrics. New strains of cotton are being developed that are insect- and water-resistant and require little if any chemical insecticides or fertilizers. Organic farmers are striving for chemical-free cotton fibers.

Recycled Polyester

Developments in recycled products include fabrics made from recycled soda bottles and polyester manufacturing waste that are cleaned, chopped, melted, and spun into fiber and used mostly in fleece for outerwear.

Alternatives in Fiber and Fabric Production and Finishing

Various companies are working to develop nontoxic pesticides, environmentally friendly alternatives to PVA and finishing detergents; citric-acid cleaners to replace phosphate and chlorine, natural oils to supplant petroleum lubricants, fiber-reactive dyes to decrease water use and chemical waste, resins to replace formaldehyde; and enzymes to replace acid washes.

"Green" Jeans

Formerly, the textile industry was dumping approximately 70 million pounds of scrap denim a year into American landfills. North Carolina State University, in conjunction with Burlington Industries, has developed a method

to reclaim cotton waste and convert it into yarn for reweaving. The material, called Reused Denim, is made of 50% reclaimed denim yarn and 50% virgin cotton yarn. Companies are also making efforts to reclaim other scrap.

Costs of Environmental Improvements

Some American textile producers are against environmental improvements because of the expense. The costs to American and European textile companies to maintain health, safety, and clean air and water are astronomical. It is very difficult, therefore, for environmentally responsible producers to compete with the low prices from mills in Taiwan and China where producers do not pay to clean up their environment.

American textile manufacturers want to require imported textile products to be made under the same environmental, health, and safety standards to ensure fair competition as well as a clean environment throughout the world.

■ SUMMARY

Textile producers are the suppliers of fabric to apparel and accessory manufacturers. Textile fibers are the basis for fabrics. They are classified as natural (cotton, flax, wool, or silk) or manmade (cellulosic or synthetic). Yarns are made from staple fibers or filaments and are usually woven or knitted into fabrics. The fabrics are then dyed or printed and finished in preparation for shipment to manufacturers.

The phenomenal growth of the textile industry would not have been possible without the development of manmade fibers. These fibers have revolutionized the industry, especially in the areas of yarn and knit production and fabric printing. The industry is making advances in the development of environmentally friendly production. The textile industry is now dominated by a few large companies for only they have the capital for the modern technology needed to survive in today's competitive international textile market (see Chapter 6).

■ CHAPTER REVIEW

Terms and Concepts

Briefly identify and discuss the following terms and concepts:

1. Textiles
2. Natural fibers
3. Flax
4. Ramie
5. Worsted yarns
6. Synthetic fibers
7. Manmade fibers
8. Cellulosic fibers
9. Lyocell
10. Microfibers
11. Generic fiber names
12. Manmade fiber spinning methods
13. Spun yarns
14. Filament-yarn texturing
15. Plain weave
16. Twill weave
17. Warp knitting
18. Types of dyeing
19. Printing techniques
20. Finishing methods
21. Mills
22. Converters

Questions for Review

1. Why is a study of textiles important to someone working in apparel production?
2. What determines the quality of cotton?
3. What are the two basic ways of making fabric?
4. How is knit yardage made?
5. Give examples of textile dyeing methods that can be used at three different levels of fabric production.
6. Why were specialization and consolidation important in the textile industry?
7. What is the difference between a mill and a converter?

Projects for Additional Learning

1. Examine the fiber-content labels in the clothes in your wardrobe. How many garments are made from natural fibers? How many from manmade fibers? How many from blends? How does the fiber content affect the care of the garment?

2. Visit a local fabric store and find examples of a plain weave, a twill weave, a satin weave, a novelty weave, a warp knit, a circular knit, and a nonwoven fabric. Ask for tiny swatches of each or purchase the smallest amount possible to illustrate your findings.

■ *NOTES*

[1] Mark Messura, Senior Director, Corporate Planning and Program Development, Cotton Incorporated, letter, March 7, 2000.

[2] David Link, Chief Economist, American Textile Manufacturers Institute, Washington, D.C., fax, March 23, 2000.

[3] Jennifer Morgan, The Woolmark Company, letter, March 10, 2000.

[4] David Link, ATMI.

[5] Henry Holzer, Chief Economist, U.S. Department of Labor, October 11, 1999.

[6] Jennifer Morgan, The Woolmark Company.

A Cotton Incorporated color and trend presentation.
(Courtesy of Cotton Incorporated)

6

Textile Product Development and Marketing

■ CAREER FOCUS

In textile product development, there are career opportunities in research, design, and merchandising. In marketing, positions range from entry-level junior sales representative to account manager, sales manager, marketing manager, and director of marketing. There are also the support areas of advertising and public relations to consider. Most of these opportunities are in New York City, Los Angeles, Atlanta, or other international textile centers.

It is also essential for manufacturers and retailers to understand the marketing forces that transform fibers into fabrics and then move these fabrics into the hands of the apparel designers and manufacturers.

■ CHAPTER OBJECTIVES

After reading this chapter, you should be able to:

1. Discuss the impact of imports on the domestic textile industry;
2. Explain the importance of product development for both fibers and fabrics;
3. Identify the promotional tools of the textile industry.

extile producers respond to consumer demand through their product development and marketing efforts. Textile consumers include the fabric manufacturers who use fibers, the apparel manufacturers who use fabrics, and the end users who buy apparel. *Product development* covers the research, merchandising, and styling involved in creating new and updating existing products. *Marketing* incorporates the entire process of planning, promoting, and selling of goods, in this case, textiles.

This chapter discusses the impact that foreign competition and consumer demand have on the industry. It also describes how the industry is reacting with product development, new technologies, and new marketing strategies for fibers and fabrics. Product development, design, and marketing activities are centered in textile and fashion capitals such as Paris, Milan, Como, Lyon, London, Tokyo, Hong Kong, New York, and Los Angeles.

■ THE GLOBAL TEXTILE MARKET

Globalization has made a huge impact on the textile industry.

As discussed in Chapter 2, globalization is a major trend in the textile and apparel industries. Ever-increasing numbers of textile products are being imported into the United States because of the availability of cheaper labor abroad. American manufacturers compete with labor rates of as little as 60 cents per hour in India, 62 cents in China, and $1.12 in the Philippines.[1] As a result, imported fabrics are much cheaper than domestically produced fabrics.

Imports Cause Trade Imbalance and Loss of Jobs

Fierce competition from imports has caused the American industry to lose more than 50 percent of its domestic market and has resulted in buyouts, takeovers, and consolidations to salvage the business that was left. Textile imports have increased to $12.9 billion; the textile trade deficit has increased from $1.5 billion in 1990 to $3.9 billion in 2000; the industry has lost more than 350,000 jobs; and more than 1000 domestic plants have closed.[2] This corresponds to the enormous growth of the textile industries of Japan, China, Taiwan, Korea, India, and Mexico.

Even American textile companies are joining the stampede to import, as they find that fabrics produced and finished overseas are sometimes 25 to 30 percent cheaper than those produced domestically. American textile companies may complete styling domestically; they may orchestrate the purchase of greige goods, dyeing, and finishing from here; and then they instruct agents to ship the fabric directly to the apparel factory. Importers, however, must allow for the longer lead-times required for shipping and the risks associated with trying to control quality and production from so far away.

Exports and Overseas Investment

American textile producers find that one way to compete in the global economy is to export (see Chapter 2). In addition, just as foreign producers have opened facilities here, some U.S. textile companies, such as Burlington,

Table 6.1 Timing of Product Development in the Textile and Apparel Industries (The industry constantly strives to shorten lead times.)	
Activity	*Length of Time Before Retail Selling Season*
Development of new fibers and variants	Several years
Fabric development (fiber firms working with mills to research and develop new fabrics)	1 to 2 years
Color predictions (fiber level)	18 to 20 months
Presentation of new fabric lines by fabric producers (Interstoff, Premier Vision, Ideacomo, etc.)	1 year
Shopping fabric lines (by designers and merchandisers)	8 months to 1 year
Apparel design and line development	6 to 9 months
Apparel collection openings, market weeks, showing lines to retail buyers, taking orders	4 to 6 months
Apparel production	1 to 5 months
Shipping to retail stores	1 week to 1 month
Apparel for sale in retail store	0

Cone Mills, Dan River, and Guilford Mills, are among those that are investing in Mexico and other areas of Central and South America.

■ *NEW MARKETING STRATEGIES*

To compete with imports, textile producers have developed new marketing strategies.

The American textile industry was built on producing large volume, streamlining the product to be efficient, and offering quality at a reasonable price. In the past, companies were able to dictate products, prices, minimums, and production schedules. Now, with fierce competition from imports, over-supply, and so many market niches, textile firms realize that they have to be market driven (responding to market or consumer needs) rather than manufacturing driven. In response to consumer demand for a variety of fibers and fabrics, textile producers have had to overhaul their marketing strategies completely.

The new strategies are more difficult and more expensive. Textile manufacturers are trying to provide innovative styling, improve quality, offer flexibility, and respond more quickly to the market. To be fashionable and flexible, however, it is necessary to produce smaller quantities, which costs more per yard. Innovation, which requires creativity and not just improved technology, has become an important part of the business.

Performance Fabrics

In response to consumer demand for lightweight fabrics that move with the body, textile producers have developed "performance" fabrics. These fabrics use innovative fiber blends, technical advances, such as microfibers and

other variants with unique characteristics, and special finishes improve performance (durability, flexibility, etc). These high-tech fabrics are the most important feature of today's fashion.

Garment Packages

Many retailers have asked textile producers to supply them with "finished garment packages." Retailers want to cut the cost of finished garments by eliminating middle-men and distribution charges. To meet this demand, many textile mills have extended their vertical operations to make finished garments. Although the mills do not want to alienate their apparel-manufacturing customers by competing with them, they also want to sell textiles. Burlington, for example, makes jeans at its manufacturing plant in Mexico; Galey & Lord produces khakis. Finished garment packages have become a popular way to compete against low-cost imports.[3]

■ *FIBER PRODUCT DEVELOPMENT AND MARKETING*

To meet consumer demand, fiber producers do extensive research and product development. Textile marketers then promote and sell these fibers to yarn or fabric producers.

In the past, the marketing role of the natural-fiber producer was relatively simple. The crops or animals were raised, harvested or sheared, and the fibers sold at local markets to wholesalers who, in turn, sold the fibers at central markets. Sheep farmers and cotton growers did not have to be concerned with fabric and garment promotion.

Manmade Fibers The development of manmade fibers and new marketing strategies changed all that. The giant chemical companies that produce manmade fibers invest a great deal of time and money in the research and development of new fibers and variants. This process may take several years (see Table 6-1). Several fiber companies may research the same problem simultaneously and might develop similar, competitive fibers. Then these chemical companies try to *create* a demand for the new fibers among yarn and fabric producers and apparel manufacturers with sales promotion and advertising, and to educate the consumer on the value and uses of these fibers.

Natural Fibers The need to compete with manmade fibers forced natural fiber producers to form associations to promote their own fibers. Supported by growers, they include Cotton Incorporated, the Woolmark Company, the Silk Institute, and the International Linen Promotion.

Cotton Incorporated has a research and development center at its world headquarters in North Carolina and a marketing division in New York City where it utilizes advertising and promotion to build demand for cotton. The Woolmark Company, based in Australia, has a research facility in Ilkley, England, and offices globally. Because wool represents less than 4% of global fiber production, the Woolmark Company's promotional activities are limited to research, development, and product innovation. All the natural fiber associations work to improve fiber quality and processing, support fabric development, and promote their fibers to the trade and consumers but they have had to cut back

dramatically because their small market shares (other than cotton) do not support high marketing costs.

Blends Natural and manmade fiber producers also work together to research and develop fiber blends. Textile engineers find the best properties of both manmade and natural fibers and combine them in satisfactory proportions to maximize their best characteristics. For example, cotton may be blended with polyester for easy care, with rayon for softness, or with spandex for stretch. In turn, these fibers will create new and interesting fabrics.

To foster sales, fiber producers create marketing campaigns to promote public recognition of their products. The manmade fiber industry has concentrated on consumer brand recognition; to explain what a new fiber or variant is and what uses it has. Natural fiber associations also want the public to be aware of the attributes of their fibers. Both use *trademarks* or *logos* for identification, such as the Woolmark Company's ball of yarn symbol.

To prepare for international textile trade shows such as Première Vision, fiber producers may have sample fabrics and garments made up to display. These samples show yarn and fabric producers how the fiber may be used effectively in a fabric.

Researching new fiber finishes in a textile laboratory. *(Courtesy of the Woolmark Company)*

Advertising and Publicity

The goal of advertising is to make consumers aware of natural fibers or manmade brands. *Advertising* pays the media to run announcements about a product. Not only does media itself cost a great deal, but it is very expensive to have an ad produced. Ad production involves design, artwork, photography, copy for print media or scripting, casting, rehearsals, photography, etc., for television. As a result, advertising is very selective and usually is done only to stimulate interest in a new fiber or product. Fiber producers may use *cooperative advertising;* sharing the cost of advertising with fabric producers, manufacturers, and retailers that use their fibers. Tencel, Inc., for example, does cooperative advertising with Nordstrom and Bloomingdale's.

Fiber producers may advertise to fabric and apparel manufacturers in trade. However, they usually advertise their brands directly to consumers in magazines or on television. Cotton Incorporated's "Fabric of Our Lives" is an example of a national fiber advertising campaign. Television and magazine ads appeal to consumers' emotional association with the product by showing people wearing cotton in real-life situations. The ads run in conjunction with an interactive web site. The aim of the campaign is to raise consumer awareness and demand for cotton.

Publicity is another way of sending a message to the consumer. In this case, a company cannot buy media time or space. Fiber companies or public relations agencies send written information about fibers to media news departments. The media chose what information they want to use and interpret the information to appeal to their readers. Fiber producers and trade associations continually provide the press with newsworthy material and photographs in hope of an editorial mention.

Cotton Incorporated's new trade advertising campaign featuring silicone caricatures, specific benefits of cotton, and the Cotton Seal. *(Courtesy of Cotton Incorporated)*

Customer Services

Fiber producers provide many services to their customers at both the manufacturing and retailing levels to promote sales:

Consumer Education　Fiber producers continually provide information on their products to apparel manufacturers, schools, and the general public in the form of brochures, exhibits, lectures, audiovisual aids, and videos. This information covers every aspect of fibers and fabrics, including history, production, use, care, and benefits to the consumer.

Technical Advice　Fiber producers offer advice to yarn and textile mills as well as to garment manufacturers. Fiber producers often commission fabric designers to work up new ideas for them. Samples of these ideas are woven or knitted in short runs, and swatches are sent to the mills. The fiber producers are also able to offer production advice to the mills.

Hangtags　Some fiber producers provide apparel manufacturers with printed hangtags listing fiber properties and, perhaps, care instructions. Hangtags can be a useful form of publicity as well as information for the consumer.

Fashion Presentations Fiber producers have been the major source for styling and color directions. Based on their research, fiber producers make trend direction information available to mills, converters, and manufacturers, usually on a semiannual basis. A stylist representing the fiber producer may make presentations to manufacturers showing garments, new and experimental fabrics, and color charts. Presentations are often targeted to specific needs, such as coat ideas for coat manufacturers or men's wear ideas for men's wear manufacturers. Market research and sourcing information may be included. Some companies also produce fashion styling reports.

Color Forecasts Color directions based on color cycles, the economy, the arts, and international fashion trends are researched at the fiber level. These are combined with basics and seasonal colors to round out the color story. Companies decide on the colors that they think will be the most popular and dye yarn or fabric swatches to present to their customers. These are usually made available to fabric producers, converters, and apparel manufacturers to help them plan their color stories.

Fabric Libraries An important service of the fiber producers is their fabric libraries, located in major fashion centers, such as Paris, London, New York, and Los Angeles. Fabric libraries keep samples of fabrics from every mill or converter using their fibers. A designer can visit the library for an overall picture of what is available. If a designer is looking for a specific fabric, the library can help locate a mill or converter that makes it. Some libraries now bar-code the fabric samples. A scanner automatically reads and prints out the name and address of the mill and the contact person. At the same time, the designer's name is sent to the mill or converter so they know of potential customers.

A selection of wool color cards and yarn forecasts. *(Courtesy of the Woolmark Company)*

Fiber Distribution

Natural Fibers

Fibers are sold to mills for yarn spinning and weaving or knitting. The farmers who produce natural fibers sell their goods at the markets organized by their various trade associations. The major markets in the United States are Dallas, Houston, Memphis, and New Orleans for cotton and Boston for wool. Farmers have no control over prices, which are set in the marketplace by supply and demand.

Manmade Fibers

The large chemical companies that produce manmade fibers have their own sales forces and set prices based on their costs. In some cases in the Far East, when fiber producers and mills are vertically integrated into one large company, the producing company becomes its own market.

Fibers are often sold under certain obligations so quality standards may be controlled. After spending a great deal on advertising to build a good

reputation for a fiber's performance, the producer wants to preserve that good name. Restrictions on standards, therefore, are imposed when the fiber is sold under a brand name or a licensing agreement. There are no restrictions if the fiber is sold without the use of a brand name.

■ *FABRIC PRODUCT DEVELOPMENT AND MARKETING*

The next step in the textile marketing chain is the development and marketing of yarns and fabrics.

Fabric is becoming the driving force of change within the fashion industry. Karl Lagerfeld commented, "Fabrics bring the big changes now. Lycra, stretch and all that really made things possible that you could not do before, except in couture with 20 fittings."[4] Exciting innovations in fabrics, especially in blends, create interesting new textures.

Textile Design

Specialization

To focus on a specific target market, fabric producers usually specialize in one or a few types of fabrics. For example, their collection may center on only one fiber or fiber blend, a certain quality level, only knits, or only prints. Within that specialty, they offer a well-balanced line of fabrics and prices. Textile designers, too, tend to specialize in print, woven, or knitted design. They may work as full-time employees of mills, converters, or design studios, or they may sell their designs to textile companies.

Market and Technical Research

Fabric merchandisers and designers try to anticipate consumers' needs by doing intensive market research. They also study international fashion and fabric trends and work to develop fashionable products having desirable fiber blends, finishes, and other properties. Merchandisers and designers must understand the physical attributes of fibers, the effects that can be achieved with the yarns that they are using, as well as the capabilities and limitations of the weaving looms or knitting machines to be used. They work hand in hand with textile engineers and have to understand textile processes to know if their ideas will work.

Focusing on End Use

It is very important for product managers, merchandisers, and designers to consider the fabric's end use:

- Fiber content and yarn sizes that are appropriate for the season and type of garment to be made
- Fabrics and prints that are appropriate for men's wear, women's wear, or children's wear
- Fabric prices that will fit into the price ranges of finished apparel

Concerned primarily with texture, textile designers may use computer-aided design (CAD) systems to help them experiment with visual representations of weave and pattern designs. A well-balanced collection of fabrics is created within the company's product line. Then a color story is chosen for the entire collection or for various groups within it.

Print Design

Print design ideas come from worldwide influences, including historic and folkloric motifs, wallpapers, old fabrics, architecture, nature, cartoons, and people's hobbies and interests. Designers may shop worldwide for fabrics or garments as a source of new ideas. Many fabric companies maintain fabric archives to supply designers with ideas from the past for new prints. Print designers must consider the essential elements of color, texture, line, shape, and space. The *motifs* (repeated designs) for a print should have interesting shapes, a pleasing rhythmic pattern, and a harmonious relationship to one another.

Designers are concerned primarily with a two-dimensional surface, the flat fabric. Yet they must keep the three-dimensional end use of the fabric in mind if they are to create usable designs. Because print design is a continuous repetition of motifs, the designer must consider how cutting will affect the pattern.

Different types of prints may be designed for particular segments of the apparel industry. For example, florals and feminine motifs may be aimed at women's apparel, traditional geometrics at men's wear, and small, whimsical prints at children's wear. However, the use of prints is also cyclical; some kinds of prints are more popular than others at a given time.

Mills or converters may have their own design studios, or they may purchase original designs from independent print studios in Milan, Paris, London,

Designer Marc Grant paints one of his original textile designs. *(Photo by the author)*

Tokyo, or New York. Large print studios may also bring their design collections to New York and other textile centers for trade exposure. The original *croquis* (paintings) are then converted into a repeat design for fabric application. Variations, repeat work, restyling, and coloring may be done by the converter's own studio or by an independent studio. CAD systems are sometimes used to make the original design and most often are used for repeat work. CAD systems also transfer licensed artwork to be printed on T-shirts and sweatshirts, such as the Disney or Warner characters.

Coloring

A print is usually offered in several colorways. For a new color combination, a croquis is made by the textile firm's design department or by computer. If that is approved, a *strike-off* is run as a test on a short piece of fabric. Minimum yardage requirements for custom colors vary with the printing method.

The Fabric Collection

The textile industry must develop fabrics early enough to allow apparel designers time to find and test suitable goods. Timing is very important. Every season, fabric producers prepare a new line or collection of fabrics to show to their customers, the apparel designers and manufacturers. Designers at Abraham AG, a trendsetting converter in Zurich, for example, create collections of more than 300 fabric designs twice a year.

It is very important for fabric merchandisers and designers to work directly with apparel manufacturers while developing the line. Cathy Valent, women's apparel merchandiser at Burlington Performancewear, explained, "One can make the most beautiful collection; however, if one doesn't have distribution or the ability to place a product in the appropriate market, [the beauty] doesn't really matter."[5]

It is important for each fabric collection to be unique so that customers will not be tempted to buy something cheaper from another producer. Fabric producers have to be careful not to give swatches away because piracy is widespread. Fabric producers also offer their expertise to apparel manufacturers and sell sample cuts of fabrics for test garments.

Marketing

Fabric producers compete for the business of apparel manufacturers and for retail-level acceptance of products made of their goods. Marketing usually focuses on brand building. Textile companies educate the consumer about their product's characteristics to create consumer demand. The consumer learns to equate the brand name with those characteristics and to look for it. Fabric producers use advertising, publicity, and customer service to make their products known to their customers.

Advertising

Large fabric producers advertise the brand names of their products. Like the fiber producers—and often in cooperation with them—they use television, newspapers, and magazines to reach national audiences. They also join apparel manufacturers and retail stores in cooperative advertising nationally or locally.

Publicity

Many fabric producers also provide educational materials to consumer groups, schools and colleges, and the general public. They also supply information on fabric fashions and developments to the press in hope of editorial coverage.

Customer Services

Like fiber producers, fabric companies provide services to their customers on both the manufacturing and retailing levels to promote sales.

Fashion Presentations A few large fabric producers also employ merchandising and marketing experts who analyze trends and pass the information on to manufacturers and retailers. They may invite customers to fashion presentations where they present photographs, fabrics, and/or garments from Europe as well as the new fabrics from their own company and ideas on how to use them. Fabric presentations, and the fabrics they promote, exert a great influence on apparel design.

Other Services Other services might include printed or visual materials, hangtags, brochures, in-store fashion shows, sales training sessions for retailers, and consumer education.

Fabric Markets

Twice a year, textile producers from all over the world display their lines at the following important international yarn and fabric shows:

Major Yarn Fairs

Pitti Filati ("Pitti Yarns" originally shown at the Pitti Palace) fairs are held twice each year in Florence, Italy, and is the foremost international yarn show.

Expofil is held each June and December at Villepinte, Paris, featuring approximately 220 exhibitors.

Major Fabric Fairs

Tissu Premiere—A new fabric fair with approximately 285 exhibitors, this market is held each winter and summer in Lille, France.

Moda In—An Italian fabric fair, this is held each February and July in Milan.

Prato Expo—This is a consortium of 140 local textile companies that show their fabrics in winter and summer at Prato, near Florence, Italy.

Ideabiella—This is another Italian fabric fair that is held in March and October in Cernobbio, Italy.

Première Vision ("First Look")—With approximately 650 exhibitors and 40,000 visitors, this market is held in March and October in Paris.

Eurotuch ("Euro-fabrics")—This fabric market, with approximately 100 exhibitors, is held each March and October in Düsseldorf, Germany.

The denim–corduroy exhibits at Première Vision Fabric Fair in Paris.
(Courtesy of Sophie Xuereb Communications)

Ideacomo ("Ideas from Como")—Primarily an exhibit of Italian silks, this market takes place in April and November in Como, Italy.

Interstoff Asia—One of several international Interstoff fairs, this one is held in Hong Kong each April and October.

International Fashion Fabric Exhibition (IFFE)—Showing fabrics from about 380 fabric producers, IFFE is held in New York in spring and fall following the European shows.

Material World—Approximately 300 fiber manufacturers, yarn spinners, mills, and converters exhibit each September and March at the Miami Beach Convention Center.

Los Angeles International Textile Show (TALA)—Sponsored by the California Mart and the Textile Association of Los Angeles, TALA shows fabrics from approximately 140 producers each spring and fall.

Fabric shows are also held in other major cities. Textile trade organizers often try new shows to try to make buying convenient and make joint efforts to plan cohesive fair schedules. Textile producers visit these shows to see the latest directions in fabrics. Manufacturers and their designers visit the shows to buy fabrics and gather ideas about how to use them.

Trimmings and Supplies Fairs

Mod'Amont—This trimmings and supplies fair is held at the same time as Première Vision in Paris.

Bobbin Americas—Held every September/October in Orlando, Florida, Bobbin Americas' 2,000 exhibitors show trims, embroidery, machinery, and information on sourcing and technology. Every three years, the fair includes large machinery and is called Bobbin World.

Selling

Five times each year, fabric producers present their new lines to their customers. To get reaction to the line, fabrics are first shown to key customers. Then, market weeks are held in the fabric producers' showrooms, usually in January, March or April, June, August, and October. However, the market is becoming increasingly seasonless, and new fabrics are continually being developed. Producers also have "open line" fabrics that they can dye and ship quickly to customers (custom prints and weaves take longer to develop and produce).

Worldwide fabric producers have showrooms in major fashion centers, such as New York, London, Paris, Milan, and Los Angeles. In New York City, these showrooms are on Sixth Avenue or in the Seventh Avenue garment district area. Designers and merchandisers from apparel companies across the country come to these showrooms to see the new lines. Textile companies also work directly with "private label" retailers, those who produce their own merchandise.

Sales Representatives

Each fabric company also has sales representatives who visit manufacturers and their designers, showing them suitcases full of *headers*, head ends of fabrics. Most salespeople in the textile industry, especially for large companies,

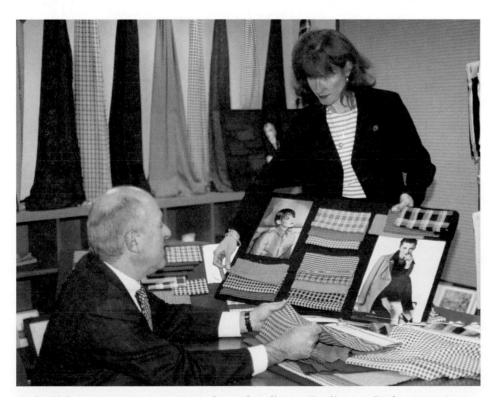

Cathy Valent, women's wear apparel merchandiser at Burlington Performancewear, shows her new fabric line. *(Photo by the author)*

are salaried employees of the firms they represent. Independent sales agents or representatives may handle several textile lines and are paid by commission. They try to make contacts to gain new accounts as well as showing and selling fabrics to regular customers.

Jobbers

Jobbers are independent agents who purchase leftover fabrics and "seconds" (damaged goods) at considerable discounts from textile producers and resell them at low prices. They may buy from several sources and put together their own line, or they may buy goods in hope of selling them later at a good markup during a period of peak demand. Buying leftover fabrics clears warehouse space and gives operating cash to the textile producer. Another role of jobbers is to buy up unsold goods for resale to discount stores or other outlets.

Brokers

Textile brokers are also independent agents and act on behalf of apparel manufacturers. When there is a need for a particular kind of fabric at a certain price, brokers try to find it. They may first have to find the greige goods and then have a converter finish it to order. Brokers work on a commission, usually 1%, based on the volume of fabrics sold.

■ SUMMARY

The tremendous growth of the Asian textile industry and its low production costs resulting from cheap labor have caused keen competition for the U.S. textile industry. The United States is fighting imports with new marketing strategies to meet consumer demand and new technology such as Quick Response to speed distribution in the marketing chain. Product development has become very important, and the industry is striving for innovation and flexibility. The industry promotes fibers and fabrics with brand-recognition advertising and customer services. International fabric markets and sales representatives provide the link to the apparel manufacturer, the next level of the fashion industry.

■ CHAPTER REVIEW

Terms and Concepts

Briefly identify and discuss the following terms and concepts:

1. Imports
2. Marketing strategies
3. Logos
4. Cooperative advertising
5. Consumer education
6. Hangtags
7. CAD systems
8. Motifs
9. Strike-off
10. Brand recognition
11. Customer services
12. Premier Vision
13. Headers
14. Jobbers
15. Brokers

Questions for Review

1. Why have textile imports taken such a big market share in the United States?
2. What has been the textile industry's response to imports?
3. How does modern marketing differ from textile marketing in the past, when only natural fabrics were available?
4. How do natural fiber producers compete with the giant chemical companies?
5. What types of advertising do fiber producers use?
6. How are styling and color direction influenced by fiber producers?
7. What influences print design?
8. What are the major fabric markets in the world?
9. What function do jobbers and brokers perform?

Projects for Additional Learning

1. Select a print that you like from a book on historic costume or art. Trace (or modify to update, if necessary) and recolor the print in the current season's fashion colors.
2. Shop a local department store to compare fabrics used in designer or contemporary fashions.
 a. What fabrics look the freshest and most exciting?
 b. What kinds of fabrics (knits, wovens, prints, solids) are used the most?
 c. What are the predominant colors?
 d. Examine hangtags and labels for fiber content. What kind of fiber is used more frequently in the garments—natural or manmade?
 e. Can you identify the fiber brand names and generic names on the labels?
 f. Can you identify fabric producers by information on the labels?
 g. Is enough information provided for the consumer about the fibers and fabrics?
 h. Summarize your findings in a written report.
3. Shop a local department or specialty store and examine country-of-origin and fiber content labels in 20 garments.
 a. Among the garments made of cotton, what country of fabric origin predominates? Where is each garment made?
 b. Find the same information for garments made of wool, silk, ramie, and manmade fibers.
 c. Make a chart showing fiber content, country of fabric origin, and country where made. Make separate sections for (1) foreign fabric and labor, (2) imported fabric but American labor, and (3) American fabric and labor.
 d. Do you see a pattern forming? What conclusions can you draw from these data?
 e. Are all garments adequately labeled?
 f. How do prices compare between garments made overseas and those made in the United States? How do quality and detailing compare?

■ *NOTES*

[1] "Textile Labor Costs," *The U.S. Textile Industry: Scope and Importance*, American Textile Manufacturers Institute, Washington, D.C, 1999, p. 42.

[2] Ibid, p. 34.

[3] Don Vidler, Commercial Director, Tencel, Inc., interview, March, 2000.

[4] As quoted in "King Karl," *Women's Wear Daily*, November 20, 1991, p. 8.

[5] Cathy Valent, Women's Apparel Merchandiser, Burlington Performancewear, interview, March, 2000.

Lace trimmings are important to the Jessica McClintock look.
(Courtesy of Jessica McClintock)

Trims, Leather, and Fur

■ *CAREER FOCUS*

Job possibilities for stylists, merchandisers, technicians, and marketers in the trims industries are very similar to those in the textile industry. Apparel manufacturers also need trim buyers. Much of the domestic leather and fur industry has been lost to imports, but there are still opportunities in marketing.

■ *CHAPTER OBJECTIVES*

After reading this chapter, you should be able to:

1. Explain how threads, interfacings, narrow fabrics, zippers, buttons, and belts are produced and used;
2. Identify the sources of fur and leather and the steps in processing them.

*T*o complete our discussion of the raw materials of fashion, this chapter presents a survey of trims, leather, and fur.

Trims, covered in the first half of this chapter, are the secondary supplies necessary to complete a garment. The category of trimmings is very diversified, comprising both textile and non-textile areas. Thread, interfacing, and narrow-fabric manufacturing are extensions of the textile industry that have similar production and marketing procedures. Zipper and button manufacturing, however, are entirely separate industries with their own resources and production methods.

Leather and fur sources and treatments are explored in the second part of the chapter. Leather and fur were used for clothing long before textiles were developed. Even today, leather and fur are important materials for the fashion industry. Leather is used for jackets and coats as well as for fashion accessories—shoes, handbags, gloves, and belts—whereas fur is primarily a garment material.

■ *TRIMS*

Designers and trimmings buyers need to know the best uses of a wide array of available trims.

Trims are the necessary supplies used to finish and adorn both garments and accessories. The huge array of decorative trimmings includes buttons, buckles, frog closures, belts, braids, ribbons, fringe, bows, laces, emblems, and sequins. Often, functional trimmings such as threads, elastics, tapes, fasteners, interfacings, and shoulder pads are classified as *notions.* The combination of trims and notions is sometimes referred to as *sundries.*

Use of trimmings varies with each segment of the industry. For example, men's wear manufacturers use more interfacings, construction tapes, and basic buttons, whereas activewear, swimwear, and underwear manufacturers use the most elastics. Women's wear designers use a wider variety of decorative embroidery, ribbons, laces, and buttons.

Threads

Thread is manufactured from fibers supplied by the fiber producers. Formed by spinning and twisting textile fibers or filaments together into a continuous strand, thread holds a garment together, and its quality is vital to the durability of apparel construction.

Previously, cotton and other natural fiber threads met requirements of durability, appearance, and sewability because the majority of fabrics available were also made of natural fibers. However, the advent of manmade fibers brought about the development of many new fabrics, including knits. Because of their new characteristics, these fabrics demanded a stronger, more elastic thread. To meet these requirements, polyester, nylon, and lyocel threads were developed.

The following thread choices are available today:

Cotton, used in cotton and garment-dyed apparel, is offered in soft, mercerized, and glace finishes.

Core spun is produced by spinning a staple polyester sheath cover around a core of filament polyester. This thread is strong, yet fine and is used in better apparel.

Spun polyester is strong, suitable for synthetic fabrics, able to withstand chemical and heat treatments, and inexpensive.

Continuous filament can be made from nylon or polyester fibers.

Multifilament is made from high tenacity nylon or polyester filaments that are twisted and used for stitching tough materials. Polyester multifilament threads can be mechanically "textured" and heat-set to ensure bulk retention. Multifilaments can also be bonded with very little twist to create a monocord.

Monofilament is produced from a single continuous synthetic filament but tends to be stiff and is not usually used for apparel.

Silk is used in silk garments and some men's wear.

Embroidery thread, made of rayon or polyester, is used for specific decorative sewing.

Threads are wound on cones in 1,200- to 30,000-yard lengths for factory use. The Thread Institute has suggested metric conversions that approximate current yard lengths that will eventually replace the numbering systems used now.

Manufacturers use various thread sizes, or thicknesses, according to fabric and quality needs. A metric system called tex has been suggested for measuring thread size. Based on the weight of 1,000 meters of gray yarn, the tex number increases as the size increases; average thread sizes range from 10 to 500.

Although a small part of the cost of manufacturing, thread quality is critical to the durability of a garment. In choosing a thread's weight, twist, or fiber content for apparel construction, consideration must be given to sewability, strength, shrinkage, abrasion resistance, colorfastness, and resistance to heat and chemicals. Thread selection is also based on strength requirements, stitch type and number of stitches per inch, the type of fabric being used, the kind of sewing machines being used, performance and quality expectations, and cost-effectiveness.

Elastics

Elastic is used often in today's clothes, in swimwear, underwear, activewear, pull-on pants and skirts, and stretch cuffs. It affords an ease of dressing and comfort that many people appreciate.

Elastic is made from a manmade rubber called elastomer or from spandex. Elastic strands are covered (wrapped) with polyester, cotton, or acetate. They can be woven, braided, knitted, cut into flat strands, or made into thread.

Elastics are available in widths from 1/8 to 5 inches to fit manufacturers' needs. Types of elastic include the following:

Knitted elastics are the most commonly used because they are the least expensive and retain their width when stretched. They are widely used for waistband tunneling.

Knitted spandex is used in swimwear and dry-clean-only garments because it holds up in chorine and dry-cleaning solvents.

Narrow braided elastic is usually used for wrist and neck gathers but the width gets narrowed when stretched.

Webbed elastic wrapped in colored thread is used for decorative purposes such as stretch belts.

Woven elastic, the highest quality and most expensive product, is popular for exposed applications, such as logos woven into the elastic, such as boxer short waistbands.

Elastic thread (a strand of elastic wrapped in cotton, rayon, or polyester) is sewn into fabric to add stretch, as in shirring or smocking.

Interfacings

Interfacing is a layer of fabric placed directly under the garment fabric for structuring and support in tailored jackets, coats, and to reinforce details such as collars, lapels, cuffs, pocket flaps, buttoning areas, and waistbands. Formerly, interfacings were made primarily of linen, burlap, or horsehair. Now, natural and manmade fibers and blends are used to make interfacings.

Types of Interfacings

Nonwoven interfacings are made of fibers held together by chemical, thermal, or spun bonding. They are the most widely used types of interfacing because they cost less to produce. Nonwovens are used in men's, women's, and children's wear; underwear; outerwear; and other garments.

Knit interfacings have been developed for use under soft fabrics in designs that require flexibility.

Woven interfacings are made by interweaving yarns, the same as most fabrics. These are used infrequently, mostly in tailored garments.

Interfacings are available in a wide variety of weights. Selection depends on the weight of the garment fabric as well as the support and effect desired. Ideally, interfacing is never heavier than the actual garment fabric. Interfacings are also available in both sew-in and fusible forms. Fusibles, which are heat-bonded to fabrics, add body, make a smooth surface, and replace old-fashioned hand tailoring.

Narrow Fabrics

Narrow fabrics include narrow laces, ribbons, braids, other woven and knit decorative bands, piping, and cording. Woven, knit, and braid trims are produced by narrow fabric manufacturers. Previously, most of the trims sold in the United States were imported from Europe. Now the imports come from Asia, but the domestic narrow fabrics industry has been able to compete. Narrow fabric manufacturers are small companies heavily concentrated in Pennsylvania and New York.

Narrow fabrics are either functional or decorative. The decorative trims industry is a fashion-oriented business, although there are really no seasonal lines. The fashion for trims is cyclical, like any other fashion. For example, when ethnic looks are popular, decorative trims are in great demand.

Types of Narrow Fabrics

Narrow fabrics vary greatly and are specially made for different uses and methods of application.

Banding—Narrow fabric having two straight or decorative edges that make it ideal for borders, edging, insertion, or accenting a design line

Beading—Openwork trim, usually lace or embroidery, through which a ribbon may be threaded (this beading is not to be confused with beads used to create banding or edging for evening wear)

Binding—Prefolded trim that encloses a raw edge, finishing and decorating it at the same time

Edging—A trim having one decorative edge and one straight edge

Galloon—Lace, embroidery, or braid having two shaped and finished edges; it can be used as a banding, border, or design-line accent or can be applied like insertion

Insertion—A trim with two straight edges (also a method of applying trim by inserting and sewing it between two cut edges of fabric)

A narrow fabric weaving machine. *(Courtesy of Jakob Müller Ag, Switzerland)*

Medallions—A chain of trims with individual motifs that can be used continuously as banding, edging, or galloons or clipped apart and used as appliqués

Laces

The popularity of handmade laces led to the invention of lace-making machines. Although narrow-textile manufacturers primarily produce bands of lace, their methods can be applied as well to the production of lace fabric. Laces are used primarily for lingerie or bridal gowns, but like other decorative trims, they recurrently play an important role in fashion. Today, there are basically four types of machine-made lace.

Barmen lace has its roots in Germany and Cluny, France. The Barmen machine runs on a Jacquard system. *Jacquard* is a weaving system that uses a highly versatile pattern mechanism to produce intricate designs. Yarns are plaited together to resemble heavy, crocheted lace.

Leaver lace, named after Englishman John Leaver who developed the machine, is sheer bobbin lace. Also Jacquard programmed, the Leaver machine twists threads into a giant web that can have up to 180 bands, each connected by auxiliary threads. To separate the bands, auxiliary threads can be hand-pulled (as is usually done in Europe) or dissolved in an acetone solution.

Raschel knitted lace is less expensive than Leaver because of the high speeds at which it can be produced. This lace is also made in a giant web, formed by linking chains of yarn. The bands are separated by pulling drawstrings.

A computer-automated shuttle embroidery machine. *(Courtesy of Saurer Textile Systems, Switzerland)*

Venice lace is made on Schiffli (see the following section) embroidery machines. The Schiffli machines are also controlled by a Jacquard system.

Embroidery

Although embroidery is not confined to narrow fabrics, it seems appropriate to discuss its production after that of laces. As an allover or as a trim, embroidery has been used most often in lingerie and blouses. Although imports offer some competition, several hundred domestic embroidery companies, located primarily in northern New Jersey, are still successful.

Schiffli is continuous embroidery on fabrics or trims. Manufacturers can send out fabric panels to have them embroidered and then insert them into garments, as on a blouse front. The newest Schiffli machines are huge and highly automated but require some labor to operate, including cutting and fastening threads. Schiffli machines are also used to make embroidered eyelet (cut-work embroidery) and lace.

Framework embroidery is used when a single motif is needed on a garment. Multi-head machines operated by a computer embroider up to 20 pieces, such as a pocket, at one time. These pieces are cut apart and attached as decoration.

Ribbons

Ribbons are another category of narrow fabrics. Many ribbons are woven at one time on looms with 2, 4, 6, 8, 16, 24, or 48 spaces. The width of the ribbon and the volume of production determine the size of the machine to be used. Satin and velvet ribbons are made much like their fabric counterparts. Grosgrain is woven on a belting or dobby loom.

Throwaway or *craft ribbon* is woven on a broadloom and cut into bands. This type of ribbon is usually reserved for the gift-wrapping market because it frays and fades. However, polyester ribbons can be cut because they don't fray or fade.

Solid color ribbons can be piece dyed after weaving to match manufacturers' color specifications. Patterns such as stripes or plaids may be woven with pre-dyed yarns. For intricate patterns, Jacquard looms are used. Some motifs, such as company logos, are printed on the woven, dyed ribbons.

Although most ribbons are produced domestically, fine ribbons are imported from Europe: velvet from France, Germany, and Switzerland, and plaids from England. Offray is the largest manufacturer of ribbons in the United States but is opening a factory in Asia to compete with low Asian prices. Jobbers buy up huge quantities of ribbon and novelties from manufacturers to have them available for small manufacturers whenever needed.

Passementerie (Braids and Cords)

This category includes braided trims as well as woven and knitted decorative trims that are heavier than ribbons. Uniform and costume manufacturers use the most braids. Braided trims are made by interlacing three or more yarns to form a flat, narrow fabric. They include soutache, middy braid, braided cord edging, and rickrack.

Knitted braids, made by a few needles on a warp-knitting machine, include both flat and foldover braids.

Woven braids, made on textile looms, include flat and foldover braids and piping made with bias strips.

Patterned braids, like ribbons, are produced on Jacquard looms.

Fasteners

Zippers

Whitcomb Judson, a Chicago inventor, first introduced a metal "slide fastener" in 1891. However, it was not until 1912 that Gideon Sundback developed a practical fastener made on narrow woven fabric. These zippers were made by the Hookless Fastener Company in Pennsylvania, which later became

Automatic braiding machines making rick-rack. (*Courtesy of Trimtex, William E. Wright Co.*)

Talon, Inc. In 1923, the B. F. Goodrich Company first used the term zipper to describe the fastener, and manufacturers began to use the device in fashionable garments. In 1960, the nylon zipper was introduced, which provided the industry with an alternative lightweight zipper that could be dyed to match any garment fabric.

Today, the three basic types, depending on the materials used, are metal, polyester coil, and plastic molded zippers.

Metal zippers are made by clamping interlocking metal scoops (teeth) onto narrow fabric tapes.

Polyester coil zippers are manufactured from a continuous polyester monofilament that is either first formed into a coil and then sewn or woven onto a tape, or formed directly from the monofilament state into a zipper.

Molded zippers are made by injecting molded plastic teeth onto tape.

Zippers are sold in three basic forms: continuous chain (in long lengths), regular (closed end), or separating (open end). *Continuous chain,* sold on reels by the yard, can be cut by the apparel manufacturers and made into zippers. *Closed end* zippers are cut to specified lengths and then metal staples are attached to the bottom and top. *Separating* zippers are also cut to length, then sliders, separating end components, and top stops are attached. Zipper thickness sizes range from a very fine size 02 to a large size 10. In lengths, 7 to 9 inches and 22 to 24 inches are the most common for use in skirts, pants, jackets, and dresses. Usually, zipper application is hidden under a placket-fold or at a seam. Sometimes, fashion prescribes that zippers be displayed as garment decoration. In this case, the zipper color, size, and type become part of the design.

The zipper industry is extremely competitive because of fierce foreign competition and an increase in finished garment imports.

Buttons

Buttons are an important aspect of a garment both for functional purposes and for fashion interest. When fashion emphasizes detailing, the market becomes stronger for buttons. Most button producers follow fashion trends in both color and styling.

Originally, shirting buttons were made from real pearl, so button production centers grew up in New York, near the Hudson River, and in Muscatine, Iowa, on the Mississippi River, both sources of freshwater pearls. Metal button production originated in Connecticut. Button manufacturing centers are also located in New Jersey, Virginia, and Kentucky. Many button companies have their merchandising and marketing headquarters in New York City.

Button production is also scattered around the world, particularly in Third World countries where labor is cheap. China, Thailand, and Taiwan are big areas of production. "The Italians continue to make the most beautiful buttons, but they are quickly knocked off by the Asians."

Buttons can be made of natural materials, metal, polyester, plastic, glass, or nylon:

Natural Traditionally, buttons were made from natural materials such as pearl, shell, wood, leather, porcelain, and bone. Manufacturers concerned with the environment are again promoting the renewable resources of natural materials. Tagua (also called Corozo) buttons, made from a nut that grows in Ecuador, have been popular and their harvest helps protect the rainforests. Mother-of-pearl, trocca, and mussel buttons are made from natural shells

found in the waters around Japan, the Philippines, and Australia. However, most of these natural sources are expensive and, therefore, are copied in plastic. Because of technological advances and the wide use of synthetics, less than 10 percent of all buttons sold in the United States are constructed of natural materials.

Metal Metal buttons, which can be made from brass, stainless steel, or pewter, are either stamped or cast. Casting is more expensive and constitutes only a small portion of the business. Stamped metal buttons (front and back are stamped separately and joined together), as well as metal rivets and snaps, are in great demand for jeans. Some environmentally concerned manufacturers are using buttons made from nonrusting alloys to avoid the hazardous sludge that is a byproduct of electroplating.

Plastic Most buttons are now made of various types of plastics (melamine, urea, polyester, or nylon) because they can be made to imitate natural materials inexpensively, and they can be dyed to match fabric. These buttons can be cut out of plastic sheets, line cast, or molded. In the case of nylon, liquid nylon is poured into button-molds to create unusual shapes, such as those used on children's wear.

Button style and size chart.

Sew-through buttons have two or four holes that are sewn through for application. Shank buttons are sewn through a hole in the shank back. Two-part metal buttons, as used on jeans, require special machinery for application.

Buttons are purchased by the gross (144), and all sizes are expressed in terms of *lignes* (one ligne equals 0.025 inch or 0.635 millimeter). For example, a 1-inch button is the same as a 40-ligne button. Self-covered buttons are made to order by contractors for apparel manufacturers.

Other metal and plastic fasteners include buckles, slide locks, snaps, and hooks and eyes.

Hook-and-Loop Fasteners

Hook-and-loop fasteners can be used to fasten apparel and shoes, to secure shoulder pads, and for many other applications. In the 1940s, the Swiss inventor George de Mestral came home from hiking with cockleburs on his trousers. His microscope showed that cockleburs were covered with hundreds of tiny hooks and that his trousers were made of hundreds of tiny loops. De Mestral decided to turn his discovery into a practical fastener. He offered his new product under the trademark Velcro from the French words *velour* (velvet) and *crochet.* The first application in apparel was in skiwear.

In the apparel industry, most *hook-and-loop* (or *touch*) fasteners are made of woven or knitted nylon. The hook-and-loop tapes come in many stock colors or can be custom-dyed. They are sold in 50- or 100-yard rolls in a variety of widths, 5/8 and 3/4 inch being the most common for apparel. A wide variety of shapes are now available, including linear tapes and cut pieces, straps,

and custom forms. For example, to eliminate sharp edges for children's wear, the fasteners are often dye cut with rounded corners and applied by sewing.

Belts

There are two types of belt manufacturers. The *rack trade* (see Chapter 11) sells to retailers, and the *cut-up* producers sell less expensive belts to apparel manufacturers to be used on dresses, jackets, skirts, or pants.

Garment belts are usually made of inexpensive materials such as bonded leather, vinyl, or ribbon. The belt material is either glued or sewn onto a stiff interfacing or backing. Novelty belts can be made of any material needed to meet fashion requirements: webbing, plastic, braid, chain, rope, or even rubber.

Belts can also be made "in house" by the garment manufacturer with buckles from the button supplier. Most of these belts are made from garment fabrics. Self-belts can also be made to order by a contractor.

Marketing

The major trim exhibition is the Bobbin Americas Show, which is held in Orlando, Florida, each September and May. Every three years, the show is expanded into Bobbin World with added exhibitions of manufacturing and information technology and machinery. Both trim and apparel manufacturers attend these shows to see the newest products and to learn about sourcing and technology. The Trimmings Expo is held each November in New York for designers and manufacturers to see the newest in this important market.

Manufacturers often buy their trimmings through distributors and/or jobbers. These people buy trims from trim manufacturers to have large inventories available when their customers, apparel and accessory manufacturers, need them. Manufacturers, distributors, and jobbers have sales representatives who call on manufacturers to show them their lines and cater to their needs.

The trimmings industries are also cooperating with Quick Response initiatives to speed up ordering, production, and distribution to apparel and accessory manufacturers. The Sundries Apparel Findings Linkage Council (SAFLINC) has established universal codes and linkage systems throughout the industry.

Bobbin World. (*Courtesy of Bobbin Blenheim*)

■ *THE LEATHER INDUSTRY*

Designers, merchandisers, and manufacturers of leather apparel and accessories must know the sources, properties, and best uses of leather. Retailers, too, are interested in the quality of the leather products they sell.

Although much older than the production of fiber and fabrics, the processing of leather is not as sophisticated—and it takes much longer. Lately, however, production methods have improved, greatly increasing the supply and variety of leather. However, as in textiles, the domestic industry has shrunk considerably because of competition from imports.

Leathers are preserved animal hides and skins, byproducts of the meat industry. Cattle hides provide the most leathers, but deer-, goat-, pig-, and sheepskins are also widely used. The world's largest exporter of cattle hides is the United States, most goatskins come from India and China, and most sheepskins come from Australia. Developing countries, particularly those with abundant raw material supplies such as Argentina, Brazil, and India, impose export controls or taxes to encourage the growth of their own tanning and leather products industries.

Hides and skins are differentiated by weight. Skins come from smaller animals such as goats, deer, pigs, and calves and weigh less than 25 pounds. Hides come from large animals such as steers, cows, buffaloes, and horses and weigh more than 25 pounds each.

Leather Processing

Tanneries purchase and process skins and hides and sell the leather as their finished product. Companies usually specialize because processing methods depend on the nature of the skins treated and the end use of the leather. New equipment and technology have made the U.S. tanning industry more productive than any in the world. However, because of competition from cheap labor in developing countries, the tanning industry in the United States has shrunk to only 110 facilities clustered in New York, Massachusetts, California, Wisconsin, Pennsylvania, New Jersey, Texas, and Tennessee.

The process by which hides and skins are made into leather can take up to six months and requires extensive equipment and skilled labor. The three basic steps in leather processing are pretanning, tanning, and finishing.

Leather dress from Ralph Lauren.
(Courtesy of Ralph Lauren)

Pretanning

Pretanning is basically a cleaning process. Skins and hides are cured to prevent them from rotting by applying salt, soaking them in brine, or just drying them. Then they are soaked in water to rehydrate them and to remove dirt, salt, and some proteins. Hides and skins must also have hair and fat removed by additional treatments, which differ with each type of skin.

Tanning

Tanning involves the application of various agents that protect the hide or skin against decomposition. Treatment methods include soaking and powdering. The choice of agents depends largely on the end use of the leather. Tanning agents include vegetable products, oils, minerals, and chemicals.

Vegetable tanning is generally done in large vats filled with tanning solutions made from water and tannin. Tannin is a bitter substance obtained from the roots, bark, wood, leaves, or fruits of various trees and shrubs and produces a firm, heavy leather.

Oil tanning, using codfish oil that is rubbed into the skin, produces relatively soft and pliable leathers, such as chamois.

Mineral tanning is performed with a tanning solution of chrome salts. Chrome tanning is much faster and is also more resistant to heat and scratching.

Chemical tanning, a newer method, uses agents such as sulfonic acid.

Combination tanning is the use of a combination of agents to obtain the desired effect. For example, many leathers are pretanned with chrome and then retanned with vegetable tannins.

Finishing

Finishing produces the desired thickness, moisture, and aesthetic appeal. After excess water and wrinkles are removed from the tanned leather, it is shaved or split into uniform thickness.

Color is applied to leather by brushing or by tray, drum, spray, solvent, vacuum, or tank dyeing. Special effects may be created by dabbing color on with a sponge, applying color through stencils, sprinkling, spraying, or tie-dyeing.

The dyed leather is treated with oils and fats, which provide lubrication, softness, strength, and waterproofing. The leather is then dried to fix the dyes and oils permanently. Dried leather is conditioned with damp sawdust to obtain uniform moisture content and then stretched for softness. Finally, the leather is coated with a seasoning or finish that improves its properties or character. For example, urethanes are used to add shine for patent leather. Leathers may be further treated with buffers, rollers, or presses to achieve glazed, matte, and embossed effects. Tanners in China and Korea add distressed finishes to less expensive pigskin and goatskin to make them look richer so as to compete with the more supple lambskin or calfskin.

Environmental Concerns

The Environmental Protection Agency (EPA) has established standards to control the polluting wastes that tanners discharge, such as sulfides, chromium, and acid. Control of these wastes requires expensive primary and secondary treatment facilities. The industry is developing and adopting new tanning systems that will use nontoxic metal salts and other organic tanning materials to replace the chromium. The industry is also encouraged to adopt low-solvent or solvent-free finishes.

Leather Marketing

Like the fiber and fabric producers, leather producers market their products to apparel manufacturers, fashion editors, retailers, and consumers. Marketing is done by the individual companies or through trade associations such as the Tanners Council.

Leather markets are concentrated in Western countries. The United States imports more processed leather than it exports. It exports leather, but for non-apparel use, to more than 80 countries, primarily Japan and Hong Kong. It imports leather primarily from Argentina and Italy. The major importers of

finished leathers are Europe and South America. Major exporters are Japan and China. International trade in leather is more than $1 billion per year. The footwear industry is the tanning industry's largest market.

Rising world population and incomes, along with new fashions for leather, have contributed to an ever-increasing demand for leather. To protect and expand their markets, leather producers must constantly strive to develop new leather finishes and colors.

■ THE FUR INDUSTRY

The fur industry is another supplier of raw material for the fashion industry. Many apparel designers also design collections for fur manufacturers.

Fur is the hairy coat of a mammal. However, except in the case of lamb, fur is not a byproduct of the meat industry. From prehistoric times, people have used animal fur for both its warmth and its attractive appearance. Because fur has long been associated with wealth and prestige, the demand for luxury has played a major role in the development of the fur industry. Recently, however, an organization called the People for the Ethical Treatment of Animals (PETA) has raised the American public's consciousness against the use of fur in fashionable clothing. Still, the use of shearling lamb is acceptable to many because lambskin is a byproduct of the meat industry.

This section discusses the characteristics of various furs, the processes involved in preparing fur pelts for their use in the manufacture of fur garments, and the marketing of furs. The fur industry consists of three major groups: pelt producers or trappers, fur processors, and companies that produce fur garments for consumers (fur garment production is discussed in Chapter 11).

Fur Sources

The international fur market is focused mainly on mink production. Scandinavia produces more than half of the world's mink supply, followed by the United States, Holland, and Russia. The major animals raised or trapped for the United States fur business are (in descending order of importance) mink, mostly bred; fox, trapped and bred; and sable, imported from Russia and Canada, where it is trapped. Other furs used in smaller quantities include muskrat, skunk, opossum, lamb, and rabbit. The industry obtains the pelts or skins of fur-bearing animals from the wild or, more often, from fur farms or ranches.

Wild Furs

Wild furs for commercial use come from more than 80 countries on all six continents, but mainly from North America, which has the greatest variety (40 different types).

Endangered Species In the late 1960s, individuals, international organizations, and governments became concerned about the possible extinction of endangered species. As a result, some countries enacted legislation restricting or prohibiting the commercial use of particular animals, including certain monkeys, seals, and leopards.

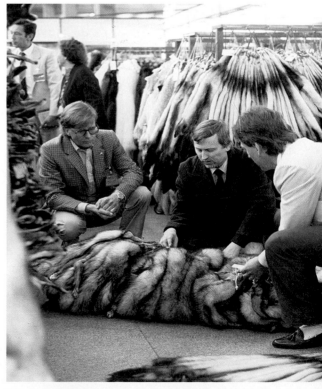

Inspecting fur pelts. *(Courtesy of the Deutsches Pelz Institut, Germany)*

Trapping Wild fur-bearing animals are usually caught in baited traps. There is public concern about the agony animals suffer in this slow, painful death. Legislation against certain kinds of traps has been enacted to try to make trapping more humane. In some areas, seals were clubbed to death, a practice that caused protests and efforts to prohibit the commercial use of wild seal fur.

Fur Farming

Fur farming has greatly increased the supply of fur. General livestock methods are adapted to the keeping and breeding of animals for their pelts. Research in management, feeding, and breeding techniques has resulted in the production of quality furs in thousands of mutations. Mink has become the most popular fur, accounting for approximately 60 to 70 percent of today's fur trade. Silver foxes are also raised mainly on farms.

Fur Processing

After manufacturers purchase pelts at auctions or from wholesale pelt merchants, they usually contract with fur dressing and dyeing firms to process them. New York City is the largest fur-processing center in the United States.

Dressing

Fur skins are dressed to make them soft, pliable, and lighter weight, as well as to preserve their natural luster. Dressing processes vary with the nature and condition of the skin, but there are usually at least four distinct steps.

Preliminary cleaning and softening of the pelt

Fleshing (cleaning) and stretching

Leathering, a tanning process using oils or other solutions

Finishing, to condition and bring out the natural beauty of the fur

Dyeing

The modern use of chemical compounds known as fur bases has enabled fur dyers to produce a wider variety of colors. Although not all furs are dyed, dyeing has led to the use of many skins that were unattractive in their natural colors. New colors are an important selling point among fur retailers. Dyers often keep their techniques secret from competitors to maintain a market edge. As in the leather industry, an effort is being made to control the polluting wastes from dressing and dyeing processes.

Marketing

Fur farmers and ranchers sell their pelts at public auction directly to the wholesale pelt merchants, manufacturers, or commission brokers (who buy for merchants or manufacturers). Major fur auction centers are located in New York City, Frankfurt, St. Petersburg, and Montreal. Pelt prices can fluctuate sharply, because price is dictated by supply and demand.

Trappers normally sell their catches to collecting agents, who in turn sell them at auctions or to wholesale merchants. These merchants maintain stocks of furs, selling them to manufacturers as they are needed. Both sources of pelts are used to produce coats, a manufacturing process covered in Chapter 11.

■ SUMMARY

Trimmings are the materials needed to finish and decorate apparel and accessories. Decorative trims include buttons, ribbons, laces, braids, and belts. Functional trimmings include thread, interfacing, zippers, tapes, and elastic. Thread, interfacing, and narrow fabrics are an extension of the textile industry. Each of these trims is a separate industry with its own resources and markets and is a study in itself.

Leather and fur, the oldest body coverings, are still important to the fashion industry. Animals, either wild or raised on farms, are the sources of both leather and fur. Tanning (for leather) and dressing (for fur) are similar treatments: they clean, preserve, and bring out the natural beauty of the skin, hide, or pelt. Although modern technology has speeded processing and made it somewhat easier, leather and fur production are still basically time-consuming craft industries.

■ CHAPTER REVIEW

Terms and Concepts

Briefly identify and discuss the following terms and concepts:

1. Trimmings	5. Narrow fabrics	9. Cut-up belt trade
2. Sundries	6. Jacquard system	10. Leather types
3. Notions	7. Schiffli	11. Tanneries
4. Interfacing	8. Passementerie	12. Fur dressing

Questions for Review

1. Briefly explain the difference between decorative and functional trimmings.
2. Discuss the various types of interfacings and their uses.
3. What categories are included in narrow fabrics?
4. Describe the four basic kinds of machine lace.
5. Describe the three basic types of zippers and their construction.
6. Discuss the various natural and manmade materials used to make buttons.
7. Explain how belts are produced for the cut-up trade.
8. Briefly discuss the basic steps in leather processing.
9. Discuss the animal rights controversy and how it affects the fur industry.
10. Discuss the steps in the dressing of furs.

Projects for Additional Learning

1. Select one category of trim (lace, for example) and find a variety of samples at fabric stores. Ask if you may have or purchase just a small piece of each. Describe the pattern or construction of each type. Show examples (photos or actual garments) of their end use.
2. At the library, trace the origin and development of a specific trim. Explain the differences between how it was made by hand originally and how it is mass-produced today.
3. Visit a local department or specialty store and find five garments that use decorative and functional trimmings. List every trim on each garment. Discuss how the trims affect the total design of the garment.

How do you think the manufacturers balanced the added cost of the trimmings with fabric and labor costs?
4. Write to a national animal protection agency such as API (Animal Protection Institute) or PETA (People for the Ethical Treatment of Animals). Find out what members are doing to promote animal rights. What impact do prevailing political attitudes and economic conditions have on the sale of furs?
5. Visit a furrier or fur dealer. Learn to identify various furs by their characteristics.

PART III

The Manufacturing of Fashion

Part Three concentrates on the core of the fashion industry, the manufacturing sector.

- Chapter 8 gives an overall picture of the international centers of design and manufacturing as well as a brief discussion of major designers.

- Chapter 9 discusses product development, merchandising, and the entire process of design and sample development.

- Chapter 10 takes the reader through the process of apparel production.

- Chapter 11 covers the design, production, and marketing of accessories and furs.

- Chapter 12 deals with the wholesale markets, sales, and distribution of fashion merchandise, the meeting ground of manufacturers and retailers.

The Christian Dior salon on the corner of rue François Premier and avenue Montaigne, Paris. (*Courtesy of Christian Dior*)

International Fashion Centers

■ *CAREER FOCUS*

Every professional in the fashion business wants to be informed about what is happening in the fashion capitals of the world. Most designers, their business partners, other manufacturing executives, and promotional organizations are located in these major fashion centers where creative inspiration and suppliers are found and major business decisions are made.

■ *CHAPTER OBJECTIVES*

After reading this chapter, you should be able to:

1. Name the well-known international fashion creators;
2. Explain the reasons for French fashion leadership;
3. Discuss the growth in importance of the prêt-à-porter;
4. List the reasons for the importance of New York as a fashion center;
5. Discuss the role of international and domestic fashion centers.

*T*his chapter introduces the major fashion capitals of the world, the centers that are most influential in creating, manufacturing, and marketing new fashion. You will read about the specialties of each and about the creators who have made them into fashion centers. Fashion centers develop as a result of concentrations of resources, supplies, skilled labor, and creative people. Designers are influenced by what other designers and artists are creating. Excitement about a new idea acts as a catalyst for more creativity. This is why many creative people gravitate to major cities.

■ GLOBAL NATURE OF FASHION

It becomes more and more difficult to discuss fashion by individual city or country.

Four cities have emerged as major fashion capitals: Paris, Milan, London, and New York City. Other noteworthy but less influential centers include Düsseldorf and Munich, Montreal, Toronto, Hong Kong, and Los Angeles. American designers and brands score high when it comes to marketing savvy and making salable clothes that appeal to the whole U.S. population and have influenced the world with their approach to sportswear.

However, it is increasingly difficult to describe the characteristics of fashion by country or fashion capital. A clear division no longer exists between what is foreign and what is domestic; the fashion industry is becoming a worldwide exchange of ideas, talent, material, and products. Ideas come from all over the world, textiles are exported from one country to another, production is done almost everywhere, and nearly every country contributes in some way. Each company seeks to expand its markets through exports and that makes them known internationally.

Designers move to other countries to work. Karl Lagerfeld, a German, works in Paris. Should we consider him a German designer or a French designer? John Galliano, an Englishman, designs the Dior couture collection in Paris. Tom Ford, an American, is the designer for Gucci in Italy and the Yves St. Laurent ready-to-wear collection in Paris. Helmut Lang, an Austrian, moved his business to New York. The list is endless.

The job of the international designer is not an easy one. Lagerfeld designs three major collections: his own signature line, Chanel couture, and the Italian Fendi collection. Tom Ford commutes between design studios in Milan, Paris, London, and New York. Oscar de la Renta commutes between New York, where he designs his signature collection; Paris, where he designs Balmain's couture collection; and his home in Santo Domingo. Some designers have time for little else than designing or promoting their designs. They supervise large design teams for several collections, visit factories, attend store openings, and make worldwide public appearances.

Promotion and Licensing

Designer names become famous because of extensive press coverage, their own advertising and promotional efforts, and success in the marketplace. With fame come requests for *licensing,* a process through which manufacturers are

given permission to use a designer's name (see Chapter 12), and joint ventures. Fashion empires grow to the point that successful international designers have become stars.

Business Partners

A successful fashion business is not built on a good designer alone. The top designers have astute business partners like Pierre Bergé at St. Laurent, Domenico De Sole at Gucci, Giancarlo Giametti at Valentino, or Peter Strom at Ralph Lauren. These people manage the finances, operations, and marketing sides of the business to enable the designer to concentrate on creativity.

Company Ownership

One trend in the fashion business is to try to build powerful, complex conglomerates or corporate groups. The manufacturing business is controlled by fewer, bigger companies. The consolidation of retailers forces manufacturers to do the same to be able to supply all of their stores. Large conglomerates develop in an effort to have the financial power to control image, sourcing, product, production, and distribution worldwide. Mega-corporations have greater negotiating power with suppliers, retailers, and advertising venues. Corporate executives also believe that it's important for them to diversify so that when one brand is weak, others might sell well as a balance. They also argue that growth is necessary to sustain and increase the worth of their stock and to have the strength to compete with other large corporations.

The French company LVMH Moët Hennessy Louis Vuitton, for example, owns Dior, Givenchy, Galliano, Kenzo, Celine, Louis Vuitton, Loewe, Christian Lacroix, Thomas Pink, Joseph, and many more brands, Guerlain perfumes, and Sephora cosmetic stores, Duty Free Shops (DFS), Le Bon Marché and Franck & Fils stores. Prada purchased Jill Sander and 51% of Helmut Lang. Conglomerates like these aggressively vie for prestigious luxury brands.

However, these large corporations must preserve the identity and autonomy of each brand. Some private or family-run businesses, such as Ferragamo, believe that remaining independent allows them to be more flexible and focused on creating a quality product.

■ *FRANCE*

Paris has long been the foremost city in the world for fashion, but it now has fierce competition from Milan and New York City.

Paris is the capital of France and is the Hollywood of the fashion world. Designer Tom Ford says, "Paris is particularly interesting at this moment. I always find great inspiration in Paris. The French have amazing style. It's in their blood."[1] Karl Lagerfeld concurred, "Paris is more exciting, even if there's more business in Milan."[2] Fashion is one of France's top three export industries. It is also the second most important in employment with 120,000 workers in the apparel sector (less than half of what it was in 1983) and approximately 500,000 employees in the combined textile, apparel, and related industries.[3]

Paris became the capital of fashion because it had the necessary resources and a creative atmosphere. There is tremendous cooperation among the French design firms; fabric mills; and the auxiliary shoe, hat, fur, trimmings,

findings, and embroidery industries. Designers eagerly seek out artisans who use both traditional and experimental techniques to create unique embroidery, paintings-on-fabric, hand knits, and other special effects. Designers who want distinctive fabrics find the mills willing to weave or print just a few meters as a test run. Shoe manufacturers plan designs to complement designer garments, and button and trim manufacturers will create items for the exclusive use of one designer. Oscar de la Renta said that it is "the extraordinary support system and all the little artisans that make Paris special."[4] The French government has always supported and encouraged "les mains de France" (the hands of France), giving the needle trades much-deserved respect. Having such an atmosphere, Paris is understandably looked to for fashion leadership.

Recognizing Paris as a fashion center, many fiber and fabric associations, promotion agencies, and information sources have established their main fashion offices there. Among the designers from other countries who are now showing their collections in Paris are Valentino from Rome, Kansai Yamamoto and Issey Miyake from Japan, and Dries van Noten from Belgium. Paris attracts talent from around the world, which, in turn, keeps Paris the center of fashion.

French exports are rising, primarily to Germany, followed by the Benelux countries, Japan, and the United States. However, as Didier Grumbach, president of the Chambre Syndicale, said, "We think less and less in terms of France and what is produced here and more in terms of European exports."[5]

The Couture

"Fashion is a very important economic sector for our country, and couture is the flagship of French fashion," explained Dominique Strauss-Kahn, the former French minister of industry.[6] *Couture* is simply the French word for fine, custom dress design, made to measure for a particular customer. A *couturier* is a male couture designer; a *couturière* is his female counterpart. Haute couture (the most exclusive couture) is reserved for the very best design and highest quality of fabrics and workmanship. A couture business is called a *maison* (house). When the founding designer retires, former assistants or other designers may take over design responsibilities. Some houses have one designer for the couture collection and another for the prêt-à-porter line.

The couture houses and adjacent *boutiques* (retail shops for ready-to-wear and accessories) center in the avenue Montaigne and the Faubourg Saint-Honoré in Paris. Private clients come to the salon, an elegant showroom in the same building as the design studio, to see sample garments in the collection. When a client orders a dress or suit, it is made up in her exact measurements, with several fittings. Construction usually takes weeks. Fewer than a thousand women in the world can afford to buy couture, which costs from $10,000 to $20,000 for a suit or up to $50,000 for an elaborate gown! Most couturiers are happy if they sell 200 garments a season.

Publicity It costs approximately $1 to $2 million a year for a large house to produce its couture collections. Collection costs include fabrics, labor, specially made accessories, and the expenses of the show itself: models, catwalk, sound systems, rent of a theater, and dinners for buyers. However, these costs are more than compensated for by government support and free publicity. This publicity is especially important because it generates sales of ready-to-wear, perfume, and licensing businesses (see Chapter 12 for more information).

Creativity The couture is regarded as offering the opportunity for the purest form of creativity in fashion, providing the research and development for the French fashion industry. The clothes of some couturiers, like those of John Galliano for Dior and Alexander McQueen, are audacious and extreme on the runway, but their very boldness attracts valuable attention and huge amounts of free publicity for the entire couture. Other couturiers, such as Yves St. Laurent and Oscar de la Renta for Balmain, feel that it is their responsibility to make pretty clothes that are flattering and salable. Even the daring designers have tamer garments in their showrooms to show their clients.

Parisian Couturiers

Oscar de la Renta for Balmain, a well-known American designer, has joined the ranks of the international commuter designers to design couture in Paris (see the section on New York).

Karl Lagerfeld for Chanel (Shah-nell') brought international attention back to the couture when he took over as artistic director for the house in 1983. He also designs the Karl Lagerfeld collection, as well as designing for Fendi of Italy. Lagerfeld won the International Wool Secretariat design competition in 1954 at age 16 and was hired by Pierre Balmain as an assistant. He was designer for Chloé for 19 years before Bidermann Industries offered to back him in his own line.

John Galliano for Dior, who was born in Gibraltar in 1960, moved to London in 1966, and later studied at St. Martin's School of Art. He presented his first signature collection in 1985, showing in London until 1990 when he began to show in Paris. In 1995, he was chosen to be the new designer for the House of Givenchy but was soon transferred to Dior, also owned by

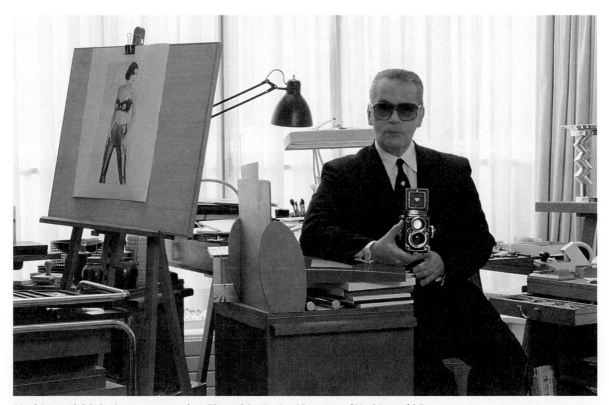

Karl Lagerfeld designs couture for Chanel in Paris. *(Courtesy of Karl Lagerfeld)*

LVMH, where he presented his first collection in January, 1997. He has won many fashion awards including the British Designer of the Year Award three times.

Yves Saint Laurent (Eve Sahn' Law-rahn') is still considered a master of couture. He is a steady, major influence in the fashion world, setting trends in a restrained, sophisticated way with a good sense of timing. He began his career by winning the wool design competition at age 17 and a post as assistant to Dior. He opened his own business with Pierre Bergé in 1962 at the age of 26 and now has over 200 licenses. The Metropolitan Museum presented a retrospective of his work in 1984.

Emanuel Ungaro was born in 1933 and learned his trade in his father's tailor shop. At 22, Ungaro left for Paris and eventually spent four years with Balenciaga and a year with Courrèges. He opened his own salon in 1965 and added a men's wear collection in the late 1970s. Parallele is his luxury prêt-à-porter collection, and Emanuel is a bridge collection designed especially for the American market.

Other couturiers include Jean-Paul Gaultier, Lecoanet Hemant, Oliver Lapidus for Ted Lapidus, Yvan Mispelaere for Féraud, Thierry Mugler, Christian Lacroix, Torrenté, Valentino (Italian), and Versace (Italian). The current novice members to watch are Adeline André, Dominique Sirop, Franck Sorbier, and Pascal Humbert.

Fédération Française de la Couture

In France, only those on the selective Couture-Creation list of the Fédération Française de la Couture are considered members of the haute couture; membership is based on high standards of excellence and special requirements. Of the 20 current couture members, only about 13 are commercially successful. They now allow foreign companies, such as Valentino and Versace, to become correspondent members. The federation includes three branches: couture, women's ready-to-wear, and men's wear. The Chambre Syndicale de la Couture Parisienne, the managing body of the federation, dictates rules about workrooms and collections.

Ateliers

To qualify for the Couture-Creation list of the Chambre Syndicale de la Couture Parisienne, a house is required to have at least one *atelier* (workroom) in Paris with a minimum technical staff of 15 (20 for established houses), not including the director. A couturier may have anywhere from 20 to 400 employees in one or a combination of several ateliers. To get established, novice couturiers are allowed a two-year transition period during which they need have only 10 employees.

In large houses, where there is much work to be done, *modelistes* work under the head designer, executing the individual designs. The modelistes are the liaison with the ateliers, where they supervise construction of the *toile*, or sample garment.

Ateliers are separated into *flou*, where they make dresses, and *tailleur*, where they specialize in the tailoring of suits and coats. Each atelier is headed by a production manager or chief technician called the *premier d'atelier* (pre-me-ay' dah-tel-yay'). Working under the manager are the shop assistant(s), fitters, *midinettes* (seamstresses), and apprentices.

To encourage young people in the fashion business, the Chambre Syndicale has chosen 20 young designers whom they believe deserve support. SOFARIS,

a government agency, now guarantees 50 percent of any bank loans to these designers, and the Finance Ministry provides grants. The Chambre also chooses two young designers each season who are permitted to show their collections rent-free at the Carrousel du Louvre (see Chapter 12 for a discussion of collection showings).

Prêt-à-Porter

Prêt-à-porter (pret-a-por-tay') is French for "ready-to-wear." Most French fashion is mass-produced, as it is in other countries. Mass production makes fashion less expensive. In this case, identical garments are manufactured in various sizes and colors. A customer needs only to try on a garment in a store to check fit and appearance, purchase it, and take it home immediately.

As couture garments became more expensive, mass-produced garments became more and more fashionable. By the 1960s, designer ready-to-wear became as influential as couture. The couturiers suffered from the competition and were no longer financially successful. Therefore, the couturiers began to produce their own prêt-à-porter collections.

Today, designer prêt-à-porter creations cost as much as couture used to. Whereas a couture creation might now cost from $5,000 to $50,000, the upper-end prêt-à-porter range is roughly $1,000 to $5,000. However, despite its price, a prêt-à-porter garment brings no exclusivity with it. There is the same experimentation involved in creating original sample garments for ready-to-wear as there is for couture. However, it is the mass production of these original samples that makes ready-to-wear a profitable business.

Designers

All of the couturiers also have prêt-à-porter collections. Karl Lagerfeld, for example, is a major ready-to-wear trendsetter. Additional prêt-à-porter designers (some from other countries who work in Paris) include Azzedine Alaia, Nicolas Ghesquiere for Balenciaga, Gilles Dufour for Balmain, Eric Bergere, Véronique Branquinho (Belgian), Jean-Charles de Castelbajac, Michael Kors (American) for Céline, Phoebe Philo for Chloé, Jean Colonna, Ennio Capasa for Costume national, Pablo for Gerard Darel, Ann Demeulemeester (Belgian), Jerome Dreyfuss, Alber Elbaz, Marithe and Francois Girbaud, Andrew Gn, Martin Margiella for Hermès, Jerome l'Huillier, Naoki Akizawa for Issey Miyake, Gilles Rossier for Kenzo, Michel Klein, Jean-Paul Knott, Christina Ortiz for Lanvin, Herve Léger, Lolita Lempicka, Marcel Marongiu, Nathalie Gervais for Nina Ricci, Lucien Pellat-Finet, Stefano Pilati for

Updated classic tweeds by Veronique Branquino, a young Belgian designer who works in Paris. *(Courtesy of Veronique Branquino, photo by Houbrechts-Daniels)*

YSL ready-to-wear, Myrene de Premonville, Sonia Rykiel, Jeremy Scott (American), Martine Sitbon, Sophie Sitbon, Hedi Slimane for Dior men's wear, Frank Sorbier, Olivier Theyskens (Dutch), Josephus Thimister, Dries Van Noten (Belgian), Yohji Yamamoto, Viktor (Horsting) & Rolf (Snoeren), and Tom Ford for Yves St. Laurent.

To reach a wider audience, most designers also have a less expensive *diffusion line,* such as Prada's Miu Miu. Also, many less expensive prêt-à-porter lines are shown in group exhibitions at the Porte de Versailles. Some of these brands have become world famous and influential.

■ *ITALY*

Italian fashion is very popular with Americans, for it suits our casual lifestyle better than the more extreme French fashion.

The Italian fashion industry and its influence on the world have grown enormously. Around 1940, only 30 fashion manufacturers operated in Italy, their production limited basically to men's wear. Since then, the Italians have built an international fashion reputation on creativity, beautiful fabrics, knitwear, leather goods, tailoring, and quality production. The Italian fashion industry is primarily devoted to ready-to-wear and accessories. Fashion is now Italy's second biggest industry, next to tourism.

To expand its markets, Italy's fashion industry is export driven. Clothing and textiles have become Italy's biggest export after shoes. Italian fashion is very popular in the United States and exports to the U.S. are growing every year.

Milano (Milan) has become the center for *moda pronta* (ready-to-wear) because it is close to the fabric sources of Como, Biella, and Torino. Italy also has a smaller fashion center in Florence, as well as fashion and accessory companies scattered around the country.

Designers, manufacturers, and fabric companies work cooperatively, often as integral parts of a large vertical company. Some of these fashion companies are part of large textile firms. These companies are able to invest heavily in the newest technology and spacious, modern factories that help Italy maintain its reputation for high-quality production. As a result, 39 percent of European Union (EU) apparel production is done in Italy.

Designers

Giorgio Armani, born in 1934, became assistant men's wear buyer for Rinascente, an Italian department store. Later he was hired by Nino Cerruti to choose fabrics, where he learned apparel production. In 1974, he created his first col-

Giorgio Armani checking the fit of one of his designs. *(Courtesy of Giorgio Armani, Milan, Italy)*

lection under the Armani label with partner Sergio Galeotti; he added women's wear in 1975. His multimillion-dollar empire includes Emporio Armani (stores and a less expensive collection), A/X Armani Exchange (basics and jeans), Mani (Italy only), and licenses. He has received many international awards including a CFDA Lifetime Achievement Award. His tailored style set international trends in the 1980s and is still considered elegant.

Domenico Dolce and **Stefano Gabbana** began working together in 1982. Dolce learned his craft working in his family's clothing factory in Sicily. Gabbana studied graphics in design school. They met in 1980 while working for a Milanese designer. In 1985, they presented their first women's collection under the Dolce & Gabbana label and have since added men's wear, knitwear, lingerie, and swimwear.

Gianfranco Ferré, born in 1944, studied architecture and today is considered the architect of Italian fashion. He gave up architecture to design accessories and later presented his first collection of ready-to-wear for Baila in 1974. His first women's collection under the Ferré name was shown in 1978, and his men's collection was introduced in 1982. He also designed couture for Dior in Paris from 1989 to 1996.

Romeo Gigli (Ro meh' o Gee lee), known for his minimalistic style, first studied architecture in Italy and then learned tailoring in New York City. He

Italian designer Gianfranco Ferré, with his assistants, fitting a gown. *(Courtesy of Gianfranco Ferré, photo by Sylvie Lancrenon)*

presented his first collection in 1983 and has since added men's wear. He now has a diffusion line called G. Gigli and has chosen to show his women's wear collection in Paris.

Tom Ford for Gucci, received a fine arts degree from Parsons, in New York City, in 1986. He began his career with Chloé in Paris as a design assistant. He joined Gucci in 1990 and became creative director in 1994. He is responsible for the design of all 11 product categories including men's and women's ready-to-wear, footwear, handbags, scarves, and neckties, as well as advertising, image, and visual merchandising. Now he is also creative director for the Yves St. Laurent ready-to-wear collection and accessories in Paris. He has received numerous fashion awards including the Council of Fashion Designers of America's (CFDA) International Designer of the Year award.

Julien MacDonald is the newest designer for Givenchy in Paris. Born in 1973, he was originally a textile designer. He worked with Karl Lagerfeld designing knitwear for Chanel couture. MacDonald continues to design his signature collection in London in addition to designing for Givenchy.

Stella McCartney, daughter of Beatle Paul, graduated from Central St. Martin's design college in 1995 and started a small apparel business. From 1997 to 2001, she was the designer for Chloe in Paris. Now she concentrates on her signature collection, financially sponsored by the Gucci Group.

Alexander McQueen was born in 1969 and began his career working for Savile Row tailors. In 1992, after graduating from St. Martin's School of Art, he started his signature collection. In 1996, he was given the British Designer of the Year Award and was chosen to design couture for Givenchy in Paris. Now he is again concentrating on his signature collection, financed by the Gucci Group.

Miuccia Prada revitalized the leather goods business begun by her grandfather Mario Prada in 1913. In addition to bags and accessories, she also began designing shoes in 1985 and launched a women's clothing collection in 1989. By the mid-1990s, her clothing and accessories were global trendsetters. In the 1990s, Prada launched a men's wear collection and a secondary line called Miu Miu. With her husband Patrizio Bertelli, she oversees their vertical business from Milan: production in Tuscany and company-owned boutiques worldwide.

Paul Smith, Britain's most successful designer, was born in 1947. He is known for his expert tailoring and thirty years as a men's wear designer. In 1995 he added a women's collection. Currently he is expanding his business to include accessories and retail stores in Milan, Paris, and New York.

Valentino (Garavani), who uses only his first name professionally, was born in 1932 and, at age 17, started to work for Guy Laroche and then Jean Desses in Paris. He opened his own house in Rome in 1960, and shortly thereafter Giancarlo Giametti became his business partner. Because he is Italy's most successful couturier, Valentino has been considered the main link with Paris and now shows his collections there. Oliver is his primary ready-to-wear line. He is a fastidious worker and is known for his elegant collections.

Donatella Versace. Started in 1978 by her brother Gianni, Versace became a very successful women's wear business. The company added men's wear in 1979 and started a couture collection in the 1990s, which is shown in Paris. Gianni Versace's death in Miami in 1997 was a great shock and loss to the industry. Donatella now heads the design team, and brother Santo runs the business. Versace secondary collections include Versus and Istante.

Although most Italian designers have built their reputations in ready-to-wear, Valentino and Versace both have couture collections that they show in Paris with the French couturiers.

Other internationally known designers and manufacturers in Italy to look for in fashion magazines and newspapers include Laura Biagiotti; Anna Molinari for Blumarine; Bottega Veneta; Peter Speliopoulos for Nino Cerruti, who put Italian men's wear on the map; Piero & Miriam Cividini; Alessandro Dell'Acqua; Veronica Etro; Sefano Guerriero for Les Copains and Antonio Marras for Trend Les Copains; Extempore by Itlierre; the Fendi sisters—Anna, Franca, Alda, Paola, and Carla—who produce both furs and apparel; Salvatore Ferragamo's sons and daughters—Ferruccio, Fiamma, Massimo, Giovanna, Fulvia, and Leonardo—who have added other accessories and Marc Audibet's ready-to-wear designs to the original shoe business; Alberta Ferretti; Antonio Fusco; Josephus Thimister (Dutch) for Genny; Keith Haring for Iceberg; Luca Orlandi for Luca Luca; Mariuccia Mandelli, who owns Krizia; Laura Lusuardi for Max Mara; Consuela Castiglione for Marni; the Missoni family, who designs elegant knitwear; Piazza Sempione; Neil Barrett for Samsonite; Sportmax; Lawrence Steele; Trussardi; and Luciano Barbera, Brioni, Campagna, Kiton, and Zegna men's wear.

■ *ENGLAND, UNITED KINGDOM*

London, the capital of England, is also the center of its fashion industry.

London enjoys a diversified international reputation for men's tailoring, classic woolen and cashmere apparel for women, and innovative young fashion.

Savile Row

London has long been the respected world center for classic men's business attire and tailored country-wear because of its famous Savile Row tailors and shirtmakers. Long-established tailors include Anderson & Sheppard, Ozwald Boateng, French & Stanbury, Gieves & Hawkes, William Hunt, H. Huntsman & Sons, Richard James, Kilgour, Henry Poole & Co. (the oldest Savile Row firm), Strickland & Sons, Turnbull & Asser, and Bernard Weatherill. A *bespoke* (custom-tailored) suit requires two to three fittings, takes up to six weeks to complete, and may cost between £2,000 and £5,000. Many are now offering tailored suits and tweeds for women.

Sales for bespoke suits, however, have decreased by half during the past few years. To contend with sluggish sales and a stodgy image, some Savile Row tailors are trying to appeal to younger customers and to women. Therefore, they are adopting newer marketing and advertising tactics, selling branded goods such as ties and watches, and licensing their names abroad.

In addition, some of Britain's best-known men's ready-to-wear lines include Chester Barrie, Duffer of St. George, Timothy Everest, Richard James, and Paul Smith.

Gieves & Hawkes tailors at No. 1 Savile Row, London. *(Courtesy of Gieves & Hawkes)*

Women's Apparel

The young designers of the 1960s, such as Mary Quant, Jean Muir, and Zandra Rhodes, made London a fashion capital. The 1970s gave the junior fashion world the "Punk" look, and London designers are again setting fashion trends for the young. Many of them have small, undercapitalized operations but their witty, wacky collections are good sources of ideas for others. A few of them have gone on to design collections in other countries.

The most internationally known of the London ready-to-wear designers include Antonio Berardi, Roberto Menichetti for Burberry Prorsum, Hussein Chalayan (who also designs for TSE New York), Clements-Ribeiro (also designs for Cacharel, Paris), Nicole Farhi, Bella Freud, John Galliano (who also designs couture for Dior in Paris), Ghost, José Levy, Betty Jackson, Joseph (Ettedgui), Markus Lupfer, Rifat Ozbek, Paul Smith, Tomasz Starzewski, Vivienne Westwood, and Ronit Zilkha. The British Fashion Council, which runs the exhibition and shows for London Fashion Week, has assisted in strengthening the United Kingdom's position in the market. Yet some of these de-

signers show their collections in Paris, Milan, or New York because they think they get better exposure there.

Couture designers include Bellville-Sassoon, Lindka Cierach, Anouska Hempel, Alexander McQueen, Bruce Oldfield, and Samantha Shaw. Jon Moore for Hardy Amies continues as the Queen's couturier.

The British also have an international reputation for classic apparel, woolen country clothing, trench coats, and cardigans from such companies as Aquascutum, Austin Reed, Burberry, Daks-Simpson, Jaeger, Mulberry, and Laura Ashley. McGeorge, Pringle, and Johnstons of Elgin are well-known names in cashmere sweaters.

Britain's apparel industry employs approximately 240,000 people. North of Oxford Street in London, in the area around Margaret Street, lies the West End "rag trade" district, which supports a conglomeration of fashion suppliers, studios, and showrooms. Actual manufacturing, originally confined to London's East End, has now spread all over England, Scotland, Wales, and Northern Ireland, with a concentration of high-quality cashmere and wool knitters to be found near Hawick in Scotland. As in other countries, many manufacturers have garments produced in Italy, Eastern Europe, or Asia.

■ *GERMANY*

Germany has an international reputation for quality manufacturing.

Unlike France, Germany's fashion industry is decentralized. Apparel companies are located all over the country, with large centers in Munich, Berlin, Krefeld, Düsseldorf, and Hamburg. The industry employs more than 200,000 workers, the largest group of employees in the German consumer goods industry, in more than 2,500 firms.

Werner Baldessarini, design director at Hugo Boss, makes a guest appearance at Saks Fifth Avenue. *(Photo by the author)*

Internationally known designers and fashion brands include Iris von Arnim, Bassler, Willi Bogner, Werner Baldessarini (men's wear) and Grit Seymour (women's wear, located in Milan) for Hugo Boss, Marc Cain, Comma, Brian Rennie (Scottish) for Escada, Jim Buckley (American) for Escada Sport, Esprit Europe, Hauber, Wolfgang Joop, Rena Lange, Rene Lezard, Caren Pfleger, Uta Raasch, Jil Sander, Uli Schneider, Klaus Steilmann (the largest women's clothing manufacturer in Europe), Street One, Strenesse, Tom Tailor, Susanne Wiebe, and Windsor.

Germany is also the home of international trade fairs such as CPD, as discussed in Chapter 12.

■ *CANADA*

Canadian designers blend the European and American approaches to fashion and export many of their products to the United States.

According to Statistics Canada and Industry Canada, the Canadian apparel industry is the tenth largest manufacturing industry in Canada, employing more than 84,000 people and comprising an estimated 1,600 to 2,000 apparel manufacturing firms.[7] Apparel is produced in every province and territory of Canada but is most highly concentrated in Quebec, Ontario, Manitoba, and British Columbia.

Although quite diversified, Canada's apparel industry is particularly known for exports of men's clothing, outerwear, furs, leather goods, women's sportswear, and children's wear. With a stagnant market, Canadian manufacturers export 30 percent of all apparel, primarily to the United States, followed by the United Kingdom and Japan. Since the implementation of the 1988 Canada-U.S. Free Trade Agreement (now part of NAFTA), exports to the United States have increased 550 percent and are still rising. In turn, the U.S. has become the main import supplier of raw material for Canadian apparel.

Montréal, Québec

Québec is Canada's largest fashion-producing province, with approximately 1,100 manufacturers, 57 percent of the apparel workforce, and 62 percent of total Canadian production. A large portion of the Québec fashion industry and fur industry is centered in Montréal. In fact, the apparel industry is the island of Montréal's largest employer. Showrooms and buyer's weeks are found in the Chabanel Street and the Place Bonaventure area.

Well-known Montréal area designers and brands include Jean Airoldi, Helene Barbeau, Dina Merulla for Boz, Arnold Brant, Angela Bucaro, Lino Catalano, Simon Chang, Denomme & Vincent, Michel Desjardins, Philippe Dubuc, FFI Apparel, Dita Martin, Marisa Minicucci, Christian Chenail for Muse, Peerless, Jean Claude Poitras, Hilary Radley, Marie Saint Pierre, Samuelson, Simon Sebag, Debbie Shuchat, Nadya Toto, and Jack Victor.

Toronto, Ontario

Ontario is Canada's second largest fashion center with more than 27 percent of the workforce. Textile and fashion manufacturing companies in Ontario employ 23,000 people. In Toronto itself, more than 11,000 people work for approximately 750 apparel manufacturing companies located primarily in the King-Spadina fashion district. Toronto also plays host to two Exhibitor Markets

Montréal designer Jean-Claude Poitras in his studio.
(Courtesy of Jean-Claude Poitras)

per year, as well as two Toronto Fashion designer ready-to-wear runway shows, in February and September/October.

Top Toronto-area ready-to-wear designers and collections include Lida Baday, Brian Bailey, Dominic Bellissimo, Marilyn Brooks, Mimi Bizjak, Joeffer Caoc for Misura, Sunny Choi, Wayne Clark, Judy Cornish and Joyce Gunhouse for Comrags, David Dixon, Jim Searle and Chris Tyrell for Hoax Couture, Paula Lishman, Linda Lundstrom, Mariola Mayer, Ross Mayer, Pat McDonagh, Franco Mirabelli, Crystal Siemens, Alfred Sung (Algo Group), Umi Eto, and Olena Zylak. Internationally successful Toronto-based manufacturer/retailers include Club Monaco (now owned by Ralph Lauren Inc.), M.A.C., and Roots.

Winnipeg, Manitoba, ranks as the third largest apparel production center in Canada with about 10 percent of total manufacturing, employing about 8,000 people. The largest Canadian women's manufacturer, Nygard International, is headquartered there.

The Vancouver area in British Columbia has about 400 apparel manufacturers that employ approximately 7,000 people. Well-known fashion companies in British Columbia include Arabesque Design Ltd. (Patricia Fieldwalker), Jax, TAG (The Apparel Group by Ron Leal), and Feizal Virani.

■ *THE UNITED STATES*

American manufacturers are largely headquartered in New York City followed by California and other smaller regional manufacturing centers.

New York

American designers and manufacturers naturally understand the domestic market best. American fashion blossomed during World War II, when communications to Paris were cut off. Since then, an American style developed, especially for sportswear, which is now appreciated around the world.

New York became the American garment center because creative talent, supplies, and skilled labor were concentrated there. At least two-thirds of American fashion manufacturing is still located in New York: fabric showrooms, designing, manufacturing headquarters, major markets, and apparel showrooms.

The Seventh Avenue Garment District

Seventh Avenue gives its name to the whole garment district, which runs north to south from Fortieth to Thirty-fourth Streets and east to west from Fifth to Ninth Avenues, on Manhattan Island in New York City. Inside art deco buildings, built in the 1920s, design studios, showrooms, and offices crowd each building on every block. There is a sharp contrast between the plush showroom in front, for the outside world to see, and the cluttered design rooms in back. Many buildings in the garment district are known for certain apparel specialties. For example, 550 Seventh Avenue has traditionally housed high-fashion companies, one on each floor. Enterprises such as the Garment Industry Development Corporation and the Fashion Center Business Improvement District (FCBID) have been working to create incentives, in the form of tax breaks, to upgrade or expand manufacturing facilities and to clean up the garment district, to make it more pleasant to work in and more attractive to out-of-town buyers. The FCBID has installed bronze plaques honoring designers on the sidewalks of Seventh Avenue.

Crowded into this area are approximately 2,000 manufacturers and contractors. However, advertising and media technology companies are moving into the area, driving up rents, and forcing many apparel firms to move to side streets or other areas of the city with lower rents. To preserve manufacturing in the city, owners of these buildings are now blocked from converting more than half of their space from manufacturing to offices.

Despite the advantages of proximity to the marketplace, over the past 30 years, New York City has lost apparel jobs to countries with cheaper labor. Fashion industry employment in Manhattan, New York City, has dropped to approximately 80,000 people working in design, manufacturing, distribution, and related activities.[8] However, fashion is still the largest manufacturing industry in New York City. There are an estimated 4,000 factories located primarily in Chinatown, Manhattan, and Sunset Park, Brooklyn.

Internal Growth

Companies can expand their businesses by broadening their product lines to include other style categories, sizes, or price ranges. Liz Claiborne started with women's sportswear and later added new divisions for dresses, suits, accessories, and men's wear. They also created new sportswear divisions such as Lizwear and Lizsport, Elizabeth for large sizes, Liz Claiborne petites, and Dana Buchman to get into the bridge market. Many manufacturers have expanded to produce both men's and women's fashion. Ralph Lauren started in men's wear and added women's; Liz Claiborne did the opposite. Most sportswear and outerwear companies now produce for both sexes (see Building a Brand in Chapter 12).

Company Size and Ownership

Traditionally, fashion businesses were small and family owned and operated. Their small size allowed flexibility in both design and production, which is needed to respond quickly to market needs. Today, however, the sizable advertising and marketing budgets of the large companies make it difficult for small companies to compete. As a result, small companies have been bought up by larger ones so that the number of apparel firms has decreased. Jones New York, for example, purchased Evan Picone to cover the market in a slightly lower price range. The Jones Apparel Group now comprises Jones New York, Evan Picone, Rena Rowan for Seville, Sun Apparel, Nine West, and has the li-

cense to produce Lauren by Ralph Lauren and Ralph by Ralph Lauren. Another example is Liz Claiborne, Inc., which encompasses Liz Claiborne, Lizsport, Lizwear, Liz & Co., Elizabeth, Dana Buchman, Sigrid Olsen, Russ, and the licenses for Kenneth Cole women's wear and DKNY Jeans.

Globalization

American designers and brands have become very well known abroad. Their fashions are sold in stores in all the major cities of the world. Increasingly, American designers are working for European and Japanese companies. Examples include Tom Ford for Gucci in Italy, Oscar de la Renta for Balmain, and Michael Kors for Céline in Paris. In addition, many foreign companies have invested in the United States, purchasing companies or production facilities. Takihyo, a Japanese firm, backed Donna Karan so that she could start her own business. The industry is full of similar examples.

Designers

In companies that produce moderate- or low-priced clothing, the designer's name is usually unknown to the public. The company may use a fictitious name, such as "Ellen Tracy." Designers who have proven themselves may have their names added to the company's label, such as "Linda Allard for Ellen Tracy."

Some designers are able to start their own businesses under their own names, called a "signature collection." They may start small as Ralph Lauren did with neckties, or, if they have a good reputation working for a manufacturer, a financier might offer to back them in their own business. If their collections are successful, and if they have skillful business and financial partners, quality production, and clever advertising, their names become well known.

As in show business, however, designers are only as good as their last production. A designer is often a star today and forgotten tomorrow; the picture changes every season. It is increasingly difficult to name the most important American designers because they change from year to year. Reading fashion publications regularly is the only way to keep informed about current designer favorites and best-selling styles.

Internationally Known American Designers

Geoffrey Beene—Born in Louisiana in 1927. Beene is a consistently innovative designer. He began his career in the display department of I. Magnin in Los Angeles. In the 1940s, he studied fashion in New York and with Molyneux in Paris. He designed for Teal Traina from 1958 until he started his own collection in 1963 with partner Leo Orlandi. He later added men's wear and Beene Bag sportswear. One of the first American designers to show in Europe (in 1975), he has over 30 licenses.

Lars Nilsson for Bill Blass—New York's senior designer, Bill Blass (retired in 2000), had the longest continuing success of any American designer and is a hard act to follow. Lars Nilsson has been chosen to take over the design helm at the firm. Born in Sweden in 1968, Nilsson studied in Paris and went on to be Christian Lacroix's assistant for nine years. In 1995, he became coordinator of the couture studio at Dior and, in 1999, a design director at Ralph Lauren.

Tommy Hilfiger—In 1969, Tommy began his business with a small store in Elmira, New York, his hometown, with a $150 investment. In 1980, he moved

to New York City and designed for Seventh Avenue companies. In 1985, he was backed to manufacture his own men's wear collection. His company has enjoyed tremendous growth in men's tailored clothing, sportswear, and boys' wear since then.

Marc Jacobs—Born in New York City in 1963, Jacobs attended the High School of Art and Design and Parsons School of Design. With his partner, Robert Duffy, he designed his first signature collection in 1986. After a stint at Perry Ellis beginning in 1989, he and Duffy launched Marc Jacobs International Company in 1993. He introduced his Men's Collection in 1996 and, since 1997, is also artistic director for Louis Vuitton in Paris. He won the CFDA Women's Designer of the Year Award in 1992 and 1997 and the Accessory Designer of the Year Award in 1999. He has recently moved to Paris.

Donna Karan—Born in 1948 in New York to parents in the "rag trade," Donna (Faske) Karan left Parsons to become Anne Klein's assistant. After Anne Klein's death in 1974, Karan became head designer with Louis Dell' Olio. This was the first time that an American fashion company was able to continue successfully without the original designer. In 1985, Tomio Taki offered to back Karan in her own business featuring luxury sportswear. Her bridge collection called DKNY (Donna Karan New York) has been extremely successful.

Calvin Klein—Born in New York City in 1942, Klein always wanted to design clothes. He studied at the Fashion Institute of Technology and worked

American designer Donna Karan at her collection opening. *(Courtesy of Donna Karan)*

at Millstein sport and suit company on Seventh Avenue. In 1968, he and his friend Barry Schwartz opened a coat business and got their first order when a buyer from Bonwit Teller accidentally got off the elevator on the wrong floor. Calvin Klein expanded into sportswear, men's wear, jeans, and accessories. He was the first American designer to open his own shops in London and Milan. His designs consistently represent the clean all-American look.

Michael Kors—Raised in Merrick, Long Island, New York, he enjoyed acting as a child but later studied fashion at FIT. He worked at Lothar's boutique before opening his own business in 1982. He designs his own signature collection, the Kors by Michael Kors line, and he commutes to Paris to design for Céline (owned by LVMH). He won the CFDA Women's Wear Designer of the Year Award in 1999.

Helmut Lang—Actually an Austrian, Lang presented his first international collection in Paris in 1986. In 1997, he moved his entire business from Vienna to New York City where he now manufactures men's, women's, and accessories collections. The Prada Group recently purchased 51 percent of Lang's business. He won the CFDA Award for Best International Designer in 1996 and the Pitti Immagine Award for Best Designer of the Nineties in 1998.

Ralph Lauren—Lauren was born in New York City in 1940 and began his career as a salesclerk at Brooks Brothers. In 1967, he started to design ties and, by 1968, had established Polo men's wear with backing from Norman Hilton. The Polo name is perfect for his classic, Ivy League look in expensive fabrics. Lauren built the rest of his multimillion-dollar business on licenses for

American designer Ralph Lauren at a collection opening. *(Courtesy of Ralph Lauren, photo by Corina Lecca)*

women's wear, a less expensive men's wear collection called Chaps, boys' wear, girls' wear accessories, and home furnishings. In 1986, he opened a $14 million retail store on Madison Avenue and has Polo shops in stores across the country. He is the perfect example of a designer who was able to build an empire on a life-style.

Oscar de la Renta—Born in 1933 in the Dominican Republic, de la Renta studied painting, sketched for Balenciaga in Madrid, and afterward became assistant to Castillo at Lanvin. In 1962, he designed for Elizabeth Arden in New York and, in 1965, became partner at Jane Derby where he took over the business in 1966. His work, which enjoys a reputation for elegance, includes evening wear, suits and dresses, sportswear, men's wear, accessories, and the less expensive Miss O collection. Now he also designs couture for Balmain in Paris, the second American to do couture in Paris.

Narciso Rodriguez—A Cuban-American, Rodriguez graduated from Parsons School of Design in New York City in 1982. He began his career by designing accessories for Anne Klein and became Calvin Klein's assistant. Later, he designed for Tse in New York and Cerruti in Paris. Rodriguez's signature collection is manufactured by the Italian company AEFFE and shown in Milan. He also designs a collection for Loewe (low-ay' -vay), a Spanish company (part of LVMH), which is shown in Paris.

Vera Wang—Born in 1950 in New York City, Vera was an art history major at Sarah Lawrence College and also studied at the Sorbonne in Paris. At age 23, she was named an editor at American Vogue. Later, she spent a year as director of accessories for Ralph Lauren. She established her bridal business in 1990 and later added evening wear, ready-to-wear, furs, and footwear collections. Her designs are worn by many actresses for public appearances.

Other successful designers in both men's and women's wear include Joseph Abboud, Katayone Adeli, Victor Alfaro, Linda Allard for Ellen Tracy, John Bartlett, Badgley Mischka (Mark Badgley and James Mischka), Julie Caiken, David Chu for Nautica, Kenneth Cole, Daryl K (Kerrigan), Han Feng, Eileen Fisher, Carolina Herrera, Betsey Johnson, Mary McFadden, Nicole Miller, Josie Natori, Maggie Norris, Cynthia Rowley, Cynthia Steffe, Anna Sui, Vivienne Tam, Rebecca Shafer (women's wear) and Hussein Chalayan for Tse (men's wear), Josh Patner and Bryan Bradley for Tuleh, Joan Vass, John Varvatos, Yeohlee, and Gabriella Zanzani.

Moderately priced brand names have increased in importance. Major brands, such as Liz Claiborne, Jones New York, or Kenar, are recognized nationally and have grown into multimillion- and even billion-dollar enterprises. They all have talented design staffs who are specialists in their field, and many graduate to having their name on a label, such as Rena Rowan for Seville (Jones New York) or Linda Allard for Ellen Tracy.

Regional Fashion Centers

The United States has approximately 20,000 apparel manufacturers employing approximately 650,000 people.[9] Although New York City remains the largest fashion marketing center, the trend toward decentralization is increasing. Some manufacturers have left New York City in search of more space. Other companies have started up in regional locations. The result is the growth of regional fashion centers. California is now the largest employer in apparel manufacturing, followed by New York, Texas, North Carolina, and Pennsylvania.[10]

California

California has approximately 6,300 manufacturers, contractors, and textile companies and one-fourth of the nation's apparel production. It employs approximately 145,000 directly in manufacturing, more than the state of New York.[11] The California clothing industry has a reputation for innovative styling, involvement with the entertainment industry, and the advantage of close proximity to sourcing in Mexico.

Los Angeles—About 4,300 fashion companies are headquartered in Los Angeles Country, making it the second largest U.S. apparel manufacturing center and the largest manufacturing sector in Los Angeles.

Successful designers in the Los Angeles area include Max Azria for BCBG, Michele Bohbot for Bisou Bisou, David Dart, Karen Kane, Carole Little, Jonathan Martin (Harkham Industries), Leon Max, Mossimo (Giannulli), Serge Azria for Parallel, Dorothy Schoelen for Platinum, Allen Schwartz for ABS, Laundry by Shelli Segal, and Richard Tyler. Nationally known brands from Southern California include Authentic Fitness (Catalina, Cole of California, and Speedo), Bebe, Bugle Boy, Cherokee, Guess, Lucky Brand, Rampage, St. John Knits, Sketchers, and XOXO.

San Francisco—The nation's third largest fashion city is home to approximately 200 apparel companies and 300 contractors. The garment industry is San Francisco's second biggest industry and its biggest source of manufacturing jobs.

San Francisco is headquarters for the world's largest apparel manufacturer, Levi Strauss. The bay area is also home to other manufacturers such as Esprit, the Gap (actually a private-label retailer) and its subsidiary Banana Republic, Byer, and Koret (now part of Kellwood Co.). Recognized local designers include Isda Funari, Nick Graham for

California designer Richard Tyler accepting a CFDA award. *(Courtesy of the Council of Fashion Designers of America)*

Joe Boxer, Jessica McClintock, Lat Naylor, Celia Tejada, and Eileen West.

Much of the success of California designers is based on their ability to promote a certain life-style approach to fashion. California is especially known for sportswear, swimwear, and contemporary dresses. Sales of the California look keep growing as Americans become more leisure conscious, and as population shifts toward the Sunbelt.

Other Regional Centers

Other important apparel manufacturing and design centers are scattered throughout the country.

Miami, Florida, is now the third largest apparel manufacturing center. The Miami area has a large number of children's wear, swimwear, sportswear, and activewear manufacturers. The city of Miami is producing its own official line of swimwear and apparel called "Tropicool."

Dallas, Texas, the fourth largest center, is home to designers and companies such as Michael Faircloth (designer for First Lady Laura Bush), Haggar, and Jerrel. There are approximately 1,800 textile, apparel, footwear, and accessory manufacturers and wholesale businesses in the state of Texas.

Seattle, Washington, has become the fourth largest apparel manufacturing center. Manufacturers include Union Bay, Pacific Trail (now owned by London Fog), and Helly Hansen. Eddie Bauer produces sportswear and outerwear for its own catalog and stores in the metropolitan area.

Portland, Oregon, area manufacturers include Nike, Jantzen, Pendleton, Hanna Anderson, and Columbia Sportswear. Philadelphia, Pennsylvania, is the headquarters of Jones New York, J.G. Hook, and has some children's wear manufacturers. Chicago, Illinois, the home of Hartmarx, and Rochester, New York, headquarters for Hickey-Freeman, have long been known for men's wear. St. Louis and Boston are smaller centers for apparel and accessory manufacturing. Osh Kosh and Jockey are located in Wisconsin, Lee jeans and sportswear in Kansas, London Fog in Maryland, and Wrangler in North Carolina.

As regional manufacturing develops, each center becomes less and less specialized. The spreading of fashion centers throughout the United States and the world is helping to balance fashion influence and to diversify styling. Many large corporations own manufacturing operations located around the country. VF Corporation, for example, is based in Pennsylvania but owns Wrangler of North Carolina, Jantzen of Oregon, Lee of Kansas, and Vanity Fair of Pennsylvania.

Other well-known brand names such as Jaclyn Smith (Kmart) or Kathie Lee (Wal-Mart) are actually private-label names belonging to retailers. The line is getting blurry between manufacturers and retailers because so many retailers are producing their own merchandise, and many designers are opening their own stores. Private label is discussed with retailing in Chapter 13.

■ SUMMARY

Fashion has become a global phenomenon. Because of a concentration of resources, supplies, skilled labor, and creativity, Paris grew to be the fashion capital of the world. It built its reputation with the couture, but profits now come from prêt-à-porter. Today, Paris shares the European spotlight with Milan, whose designers and fashion brands have achieved similar international success. London, the focus of youthful fashion of the 1960s, remains noteworthy for its Savile Row tailoring. Also in Europe, German designers are gaining global respect. Canada has its style centers in Montreal and Toronto. New York, especially the area around Seventh Avenue, is the fashion capital of the United States and continually gains international recognition. Los Angeles and San Francisco make California the second largest U.S. center. Fashion has become big business and the top designers are the fashion stars.

■ *CHAPTER REVIEW*

Terms and Concepts

Briefly identify and discuss the following terms and concepts:

1. Paris as a fashion capital
2. Couture
3. Prêt-à-porter
4. Atelier
5. Toile
6. Salon
7. Milan as a fashion center
8. Savile Row
9. London as a fashion center
10. Tokyo as a fashion center
11. Seventh Avenue

Questions for Review

1. Why does Paris continue as a fashion capital?
2. What are the requirements for membership in the Chambre Syndicale de la Couture?
3. Explain the two classifications of ateliers and discuss the organization of a typical atelier.
4. What are the differences between the couture and the prêt-à-porter?
5. Discuss decentralization of fashion centers in Germany and Spain versus centralization in England and France.
6. What are the fashion centers in Canada? How are Canadian designers affected by the trade agreement with the United States?
7. What name is used to refer to New York's garment district? Explain why that name is used.
8. Discuss the growth of regional fashion centers in the United States.

Projects for Additional Learning

1. In a fashion magazine, find a photograph of a garment that you particularly like. Find the name of the designer in the description. Trace that designer's name through older issues of fashion magazines until you have found 10 examples (in 10 separate issues) of his or her work. Analyze the unique characteristics of the designer's style.
2. Shop a store that carries Italian or French fashions. Find five of the names mentioned in this chapter on garment labels. Discuss the style characteristics of each garment in a written report. If possible, illustrate with sketches. If a store is unavailable, find your examples in magazines.
3. Shop an exclusive specialty store and ask to see their most expensive evening dress or suit ($1,000 and up). Then go to a department store and examine an evening dress or suit in the $400 to $600 range. Finally, go to a discount store and look at an evening dress or suit in the $100 to $200 range. Make a written comparison of the quality of fabric, construction, and styling. Document your report with descriptions or sketches.

■ *NOTES*

[1] As quoted in "Is Paris Burning Again," *Women's Wear Daily*, July 13, 2000, p. 10.

[2] Ibid.

[3] French Embassy, October 13, 1997.

[4] As quoted in "The Concorde Couturier," *Women's Wear Daily*, November 17, 1992, p. 24.

[5] As quoted in "War on the Floor," *Women's Wear Daily*, September 8, 1999, p. 4.

[6] As quoted in "Couture Rule Changes Lead," *Women's Wear Daily*, October 21, 1992, p. 33.

[7] Conflicting statistics from Industry Canada and Statistics Canada. Les Kumar-Misir, Apparel Network, Consumer Products, Industry Canada, fax, April, 2000 and "Canada: Heading South," *Women's Wear Daily/Global*, January, 2000, p. 22.

[8] "Is Zoning Change in Fashion's Future?" *Women's Wear Daily*, February 22, 2000, p. 5. Conflicting statistics from several sources.

[9] *Textile HiLights*, American Textile Manufacturers Institute, December, 1999, p. iv.

[10] Conflicting statistics from "Textiles and Apparel," *The U.S. Textile Industry: Scope and Importance*, American Textile Manufacturers Institute, Washington, D.C., 1999, p. 23 (160,000) and Fact Sheet, California Fashion Association, January, 2000, p. 3 (154,000).

[11] California Fashion Association.

Designer Tommy Hilfiger presiding at a styling meeting.
(Courtesy of Tommy Hilfiger)

9

Product and Design Development

■ CAREER FOCUS

The creative side of manufacturing offers highly competitive positions as designers, merchandisers, product managers, and patternmakers. In a large company, a designer, a merchandiser or product manager, and their assistants are assigned to each product group. A recent college graduate may obtain employment as an assistant in one of these areas.

■ CHAPTER OBJECTIVES

After reading this chapter, you should be able to:

1. Describe line development by item or by group;
2. Explain the important elements and principles of design and their application to line development;
3. Describe the process of creating a sample garment.

A manufacturer's design or product-development department plans and creates new styles within the company's image or identity. This chapter begins by explaining how a manufacturer's line is developed. To prepare for this, it is very important to first read Chapters 2, 3, and 4 to understand target customers, design influences, and resources. This chapter then goes on to discuss fashion design elements and principles, including color and fabrication and the creation of a sample line.

■ *PRODUCT DEVELOPMENT*

Merchandisers or product managers, designers, and their assistants are all involved in the development of a line or collection of the fashion manufacturer's product.

Appealing to a Target Market

Each apparel manufacturer is defined by its customer and identified by its particular style. This involves finding a market niche around a particular lifestyle or need—ideally a part of the market that is not served adequately or successfully by another manufacturer. Hedi Slimane, men's wear designer for Christian Dior, reflected on his creative approach, "I'm interested in [my cus-

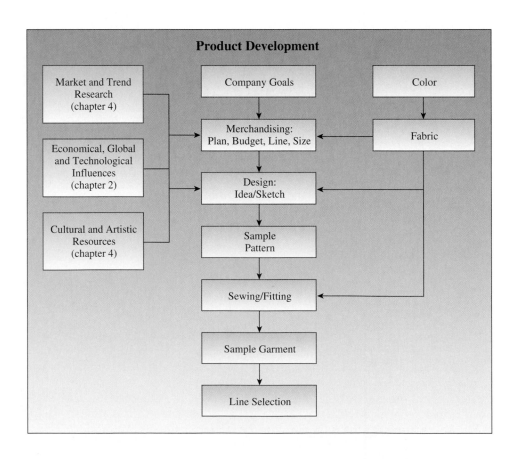

tomer] in the sense of where he lives, what sort of house [he lives in], what kind of car he drives, where he goes to eat . . . In America, you call it lifestyle."[1] Manufacturers identify their customers as a group, develop a product that fits that identity, and stay with it.

Maintaining an Identity

A designer or manufacturer that develops and is recognized for a particular style, yet incorporates current trends into that style, attracts buyers year after year. Ralph Lauren and Jessica McClintock are excellent examples of designers with a distinctive style. Lauren himself said, "It's the most important thing for designers . . . to have an identity. . . ."[2]

Traditionally, manufacturers specialize in a particular styling category, price range, gender, and size range of apparel. As a company grows, it expands by adding diversified lines. Many manufacturers have broadened their product lines to include other style categories or size and price ranges, but they have separate divisions and/or label names for each. For example, Liz Claiborne started with women's sportswear and later branched out to include dresses, suits, accessories, and men's wear. Both Ralph Lauren and Giorgio Armani began with men's wear and later added women's wear collections. The addition of large-size and petite divisions offers manufacturers tremendous growth opportunity because no new design is necessary, just additional patterns. As manufacturers diversify, however, they must maintain a consistent identity oriented toward their customers. Giorgio Armani reiterated, "Coherence is always the secret, I believe, behind a great company. There is an underlying philosophy to my designs that never changes."[3]

The Product Development Team

Responsibilities for product development, design, and merchandising vary from manufacturer to manufacturer. Product development is the process of market and trend research, merchandising, design, and development of the final product. In a large company, a designer, a merchandiser, perhaps a product manager, and their assistants are assigned to each division.

When the designer is president of the company, the designer is obviously in charge. Manufacturers that are design driven, such as Liz Claiborne or Ellen Tracy, have designers in charge of product development. In companies that are merchandising or marketing driven, such as Levi Strauss, merchandisers, brand, or product managers direct development of the line. But in either case, in most companies, it is a team effort among managers, designers, and merchandisers.

Merchandising

Merchandising is planning to have the right merchandise at the right time in the right quantity and at the right price to meet the needs of the company's target customers. It is also the manner in which a group or line of garments is presented to the public; the way the line will look in the stores.

The merchandiser or product manager is basically a process manager, developing the blueprint of the line. Merchandising activities, which vary from company to company, usually include setting financial goals, budgets, and price points; making the merchandising plans; planning line size; planning fabric purchases; sourcing; scheduling production and deliveries; controlling product

flow; presenting the finished line to the sales staff; and sometimes preplanning assortments for stores.

Scheduling

Merchandising is responsible for integrating all the phases of product development, including design and production. The merchandiser, or product manager, sets up a schedule of deadlines for styling, finished samples, and production to meet the required shipping dates. These dates are, of course, coordinated with the production department. Merchandisers meet regularly with designers, the sales staff, and production managers to discuss company goals, budget requirements, line size, delivery dates, sizes, and so on. Merchandisers and designers have to plan production based on how they think the line will sell by group, color, and size in the stores.

Seasons

Each season, the design and merchandising departments of each division are responsible for creating a new line, the seasonal collection, that the manufacturer will sell to retail store buyers. The terms are synonymous: *Collection* is used primarily in Europe and for high-priced apparel in the United States. *Line* is used more often in the United States for moderately and popularly priced fashion.

Work on a new line begins approximately eight months before the selling season (a velvet dress to be worn in December must be designed in May). Sportswear design may begin a year in advance of the selling season. For example, a sportswear firm usually begins work in February for the spring line of the following year. The design/merchandising team has about two and a half months to complete line development. At Jones New York, for example, designers and merchandisers research fabrics in February, work on the merchandise plan and group concepts in March, select fabrics and prints, work on sweater samples, and design bodies in April, and make final line selections in May. Yet, the spring *line release* (when samples are shown to retail buyers) isn't until September 1st.[4] That same line will be in the stores in late winter, to be worn in spring.

Designers and merchandisers also work on two or more lines at once, designing a future collection while checking samples from the one that is about to be produced. They are finishing work on the spring line while beginning fabric research for summer. It is a continual process of creating new merchandise, a "seamless" product development.

Most women's wear companies produce four or five seasonal lines a year: spring, summer, transitional, fall, and holiday or resort. Men's sportswear firms also have four line releases a year as compared to men's suits that have just two. Children's wear firms have three or four, depending on the product focus. Most manufacturers have staggered delivery dates for each group within the line. Managing delivery dates in this way means that manufacturers are shipping to stores monthly, providing them with continual fresh merchandise. European companies that traditionally have shown two collections per year have also caught on to the need for fresh merchandise year round.

Some manufacturers are now trying to fit their lines into the financial calendar of the retail stores with a line per quarter: January to March for spring, for example. This makes it easier for the retailer to plan buying and deliveries. Manufacturers that have their own catalogs also do not follow traditional seasons. Instead, they plan their lines around planned catalog mailing dates.

Vice President of Design, Charlotte Neuville, in a merchandising meeting with her staff at Lerner New York. *(Photo by the author)*

The Merchandise Plan

Each season, merchandisers have to develop a merchandise plan or business plan. They must decide how many apparel or accessory groups are needed to meet both the demands of retailers and consumers and the financial goals of the manufacturer. The previous year's actual sales are used as a basis for projected sales goals for each group. Spreadsheets are created to show what needs to be produced and sold per month to reach sales and profit goals.

The merchandiser has to determine the number of groups, fabrics, and styles required to meet those sales goals. This includes the number of styles in each group, styles in each fabric (wovens, knits, yarn dyes, prints, novelties), and colors per style (usually 2 to 5). Price points are established so that fabric and labor cost limits can be determined. The plan also shows the *total units* that need to be manufactured and the *total net dollars* (value of those garments).

■ *DESIGN DEVELOPMENT*

The designer creates the styles for the collection, giving form to fashion ideas.

The current consumer demand for fashion and uniqueness has made creativity in design more important than ever. Couture and top ready-to-wear designers are able to enhance their creativity with expensive fabrications and beautiful workmanship because they are able to sell at higher prices. This freedom enables them to create trends. Mainstream designers must know how to interpret these trends to suit their own customers and select fabrics that fit into their company's price range. They are responsible for concepts, styling, and color selection. Designers must also supervise pattern-making, fit, and sample-making as well as see their lines through to a successful completion.

An Esprit Kids sportswear group. *(Courtesy of Esprit)*

Line and Group Concepts To begin work on a collection, many designers use concept boards to show their ideas to the management team. They make a collage of color and fabric swatches, sketches of ideas, and *swipes* (idea photos) from magazines that capture a mood or theme. These can also be developed on computer systems. When the concepts are approved, designers develop those ideas into specific themes for groups and individual garment designs.

Groups

Collections, or lines, are divided into groups of garments. Liz Claiborne and Jones New York, for example, do six to eight groups in each line release in each division. Each group has a specific *theme* based on a fabric, color, or a particular fashion direction. Ideas for the theme come from research and environmental influences (see Chapter 4). The styling of each garment within each group creates variety, yet carries out the central theme. To present a visually pleasing group of dresses, gowns, sportswear, suits, or coats, a few common elements are needed.

Dresses

Groups of dresses may begin with an *anchor,* a bestseller from the previous line with a change of color and/or fabric. Often, dress designers emphasize only a few silhouettes, called *bodies,* interpreting each of them in several prints, or they will feature one print in a variety of styles. Within the group, the garments must offer a variety of silhouettes, sleeve treatments, necklines, and/or other details. Women's suits and coats are also merchandised in this manner.

Suits and Outerwear

Men's suits are treated as individual units sharing only a basic silhouette. The manufacturer's objective is to include a variety of muted colors and suitings in the line, providing a wide choice for both the retail buyer and the consumer. The prime factors in styling men's suits are fabric and silhouette. Generally few details change from season to season. The ideal suit is a timeless classic.

Women's suits, on the other hand, may be fashion-oriented or classic. They are merchandised rather like dresses with a variety of silhouettes, collar treatments, details, and fabrications.

Sportswear

Sportswear pieces are designed to be worn together. A balanced mix of skirts, pants, jackets, shirts or blouses, and other tops are included in each group to give the consumer a choice of styles. There are usually two to three tops for every bottom (skirt or pant). There may be a basic jacket and a fashion-forward jacket, various skirt lengths, a basic pant and an updated version, and shirts and other kinds of tops with a variety of necklines. One garment ties all the group colors together, perhaps a striped or plaid shirt.

- **Coordinated sportswear** is designed to mix and match interchangeably and is sold as a package to the retailer.
- **Integrated sportswear or jeanswear** is also merchandised in groups. Parts are meant to be worn together but do not constitute as obvious a relationship as coordinated sportswear.
- **Separates** do not show an obvious relationship and are sold individually.
- **Men's sportswear** is also merchandised in integrated groups or as separates. A group may include pants, jackets, vests, shirts, and sweaters. Fabrication mixes are very important inasmuch as basic styles do not change so much.

The number of pieces or styles in a group is determined by the statement the company wishes to make and the variety of pieces needed to complement one another as stated in the merchandising plan. The designer must think through what the customer can wear with what and how the group will look in the store. A top has to go with more than one jacket and/or bottom. Multipurpose clothing is very important in today's market.

In large sportswear companies, such as Levi Strauss and Eddie Bauer, designers may be specialists in one category of the group, such as bottoms, knit tops, or woven tops. In this case, the design director is responsible for the cohesiveness of the group.

Fashion versus Basics

Every group must have a balance of fashion and basics. Even if the manufacturer is not a designer business, fashion pieces give the company credibility by showing retail buyers that the company is aware of fashion trends. However, basics are often what brings in the money to allow them to do the fashion. Even designer lines such as Ralph Lauren make most of their sales and profits on one or two hot basics such as khaki pants or polo shirts. Tommy Hilfiger says that he begins with basics for the core of his men's wear collection and then adds newness and fashion to that.[5]

Some large manufacturers further divide groups into product segments for fashion and basic apparel. Basics, such as a turtleneck sweater or twill pants, are kept in stock for long periods of time and available on a *replenishment* basis, automatic delivery when stock is low. New fashion styles are delivered to the stores every two to eight weeks to make the merchandise assortment fresh.

Items

Some manufacturers produce single *items*, garments that do not relate to each other. Items are popular styles that a consumer can use to update an existing wardrobe. Each garment must be strong enough to sell on its own, not depending on the strength of other garments in a group. Such garments are usually produced at moderate or budget price ranges at the request of retailers for private labels (see Chapters 12 and 13) and/or by a knockoff house.

Knockoffs

A *knockoff* is a copy of someone else's design, usually a garment that is already a best-seller for another manufacturer. Knockoff companies simply buy a particular garment, make a pattern from it, order large quantities of the same or similar fabric, and have the garment manufactured. Production and fabric costs are lower because of the huge quantities made. The knockoff producer must

have (1) an acute awareness of what garments are selling well at the retail level, (2) rapid production capabilities to capitalize on the success of the style while it lasts, and (3) lower prices. Now, in an age of instant global communications, copies often reach stores before the originals and at a fraction of the cost.

Many designers are understandably very annoyed with this practice. However, Oscar de la Renta called copying the "highest form of flattery. What would really upset me is if no one copied me." Allen Schwartz of ABS, the self-anointed King of Copycats, said, "The word 'original' does not exist in fashion. Everything starts from some sort of inspiration."[6]

Because this practice is very unfair to the original creator, some designers try to copyright their designs. Copyright is nearly impossible, however, because of the fast pace of the industry. By the time a design is granted a copyright, the garment is no longer in fashion. To protect their profits, some designers copy their own designs in a lower-priced line a season later.

Fakes

Copying becomes an even more serious problem when it involves *counterfeit merchandise,* imitations with fake labels intended to deceive the consumer. Fake Gucci and Ferragamo accessories and Levi jeans are seen all over the world and even sold on the Internet. U.S. government officials confiscate this merchandise when they discover it. It is difficult to control internationally, however, because a designer or brand name must be registered separately in every marketplace. The cost of registration plus legal fees is very high when it must be paid in every country. An agreement was reached between China and the United States to protect trademarks, and the World Trade Organization is also working to stop counterfeiting.

An interesting combination of fabrics in Ferré's wrap shirt, satin pants, and tapestry coat. *(Courtesy of Gianfranco Ferré, photo by A. Albertone)*

Design Elements

Keeping the theme of the group in mind, a designer must incorporate a pleasing combination of all the elements of good design—color, fabric, line, and shape—into each garment. The ingredients of design, which are essential to every art form, are not a recipe for success and cannot substitute for experience. The designer does not think of these elements consciously; the use of them becomes inherent. Also, because fashion changes continually, there are no hard and fast rules. Sometimes trends defy good design!

Fabric

Color is interpreted in fabric, the designer's artistic medium. Designers and merchandisers first select fabrics for each group in the line and specific fabrics for each style.

Fabric Selection *Fabrication* is the selection or creation of an appropriate style for a fabric, or the reverse, the selection of the right fabric for a design. Next to understanding the needs of the customer and interpreting trends for them, choosing a fabric suitable for a particular style is one of the most important aspects of designing.

The designer chooses fabrics on the basis of fashion trends, quality, performance, price, and suitability.

Fabrics themselves often inspire garment design. For example, the softness and drapability of a jersey might inspire gathers in a dress. Christian Dior wrote, "Many a dress of mine is born of the fabric alone."[7] Other designers work the other way around, first getting an idea, perhaps developing it in a sketch, and then finding the appropriate fabric for it. However the designer works, he or she must ultimately decide which fabric will work best with a design, or vice versa. Designers must develop the ability to picture a design already made up in a fabric. This ability comes through observation and experience.

Many firms build a line or even an entire reputation on one fabric, such as denim or stone-washed silk. In sportswear, *a base fabric* is selected for jackets, pants, and skirts. In jeanswear, for example, the base fabric is always denim. An assortment of fabrics, solids and patterns, is chosen to go with the base fabric. The designer or merchandiser must be sure to include a variety of weights, textures, and patterns in a line, as well as a balance of fashion and classic fabrics.

Fabric Characteristics Fabric suitability is determined by characteristics such as fiber content, weave, texture, performance, hand, pattern, and color.

Texture is the sensuous element of design. It is the surface interest of a fabric, created by the weave and by light reflection. Our eyes appreciate the play of light on smooth or rough surfaces, we feel the surface with our hands, and sometimes we can even hear the texture, such as the rustle of taffeta. Combinations of textures, such as suede with jersey (rough with smooth), create interest in a garment. Texture is a very important element in today's fashion.

Performance refers to a fabric's wearing and cleaning properties based on fiber content, weave, and finish. Fabric performance is an important consideration regarding the function and durability of a garment, especially in activewear and outerwear. A ski jacket must keep a customer warm in subzero conditions, for example.

Weight and hand dictate the silhouette of a garment. *Weight* is the heaviness or lightness, thinness or thickness of a fabric. *Hand* is the feel, body, and fall of a fabric. A garment must be styled in a fabric that is compatible with the desired silhouette.

■ *Firm fabrics,* such as worsted wools, gabardines, and linen are needed to carry out a tailored look. These fabrics have both the crisp look and hand necessary to achieve the desired effect. Interfacing, a fabric sewn or ironed into the garment's inner construction, is used to give additional stiffness to finished edges such as necklines, collars, cuffs, and buttoning areas.

Veronique Branquino's unusual combination of a hound's tooth-check knit sweater and a layered tweed skirt. *(Courtesy of Veronique Branquino, photo by Houbrechts-Daniels)*

■ *Soft fabrics* such as crepe, jersey, chiffon, and challis are ideal for draped designs that delineate body shape. Additional fluidity can be achieved by cutting fabric on the bias grain, so that the diagonal of the fabric falls vertically in the garment. However, bias is difficult to lay out on a *marker* (pattern layout) and thus expensive to produce. Softness may be increased by the additional use of gathers, shirring, smocking, and unpressed pleats.

Fabric weight must be suitable for the type of garment. For example, blouse weights are lighter than bottom (skirt or pant) weights. Manufacturers often buy fabrics in specific weights, such as a 5-ounce shirting or an 11-ounce denim. The weight is determined by the square yard for wovens and by the linear yard for knits.

Fiber Content　Fibers must also be appropriate for the season and styling suitability. Warm fabrics are needed for winter, and light, cool ones are needed for summer. Specific natural fibers have traditionally been considered appropriate for certain seasons. Wool is used for fall and winter because it is warm. Linen and cotton are used as warm-weather fabrics because they are light, cool, and washable. However, many fabrics are seasonless. A fabric such as jersey can be worn year round. Cotton, traditionally a summer fiber, can be woven into warm, bulky fabrics such as corduroy for fall and winter garments. Wools can be woven into lightweight fabrics for spring. Blends of natural and manmade fibers have become very important to create interesting new fabrics. Fabrics with spandex, to add stretch, are a major consideration for today's body-conscious styles.

Josh Patner and Bryan Bradley's unexpected mix of patterns in this asymmetric top and skirt for Tuleh. *(Courtesy of Tuleh)*

Patterns　The *scale,* or size, of a pattern must complement the design. To show a large print to its best advantage, it should not be cut up with seams and details, but rather allowed to be the most important element of the garment; so construction should be kept simple. On the other hand, if a design idea begins with dominating lines and details, then the fabric must be of secondary importance. Scale is particularly important in children's wear because the garment pieces are small.

The *repeat* of a print is the amount of fabric necessary for a floral or geometric pattern to duplicate itself totally. Large repeats are not usually suitable for trims or for children's wear. In addition, garments to be made in border prints must be carefully thought out so that fabric is not wasted in production cutting.

The designer must recognize patterns that require special matching because they increase the amount of fabric used and, therefore, the cost. Bold plaids and irregular stripes must match when sewn together. One-way prints and pile fabrics also use more yardage, because all the pattern pieces must be cut in the same direction. Many fabrics today are directional and the manufacturer cuts them all one way to prevent variations in color.

Environmental Concerns　Many manufacturers are concerned with the condition of our environment and want to do their part to try to improve the situation. Management at these companies think that it is the fashion industry's responsibility to make environmentalism fashionable because fashion is an important communicator of values to people. To do this, manufacturers may choose organic cotton, linen, wool, tencel, or recycled materials that are treated with low-impact or bifunctional dyes, enzyme washes, and other safe finishes. Patagonia uses fabrics made out of recycled plastic bottles. A few designers are using recycled fabrics in their designs. Some companies are returning to natural materials for buttons and using nonelectroplated metal trimmings.

Reviewing Fabrics　The designer's involvement in fabric selection for a manufacturer varies. Sometimes designers have the entire responsibility for fabric selection. In a large company, designers may share the responsibility with a fabric merchandiser, especially when an entire group is built around one particular fabric. The fabric merchandiser may also research the textile market for trends and sources and follow through with fabric purchases.

Before a new season, designers and/or merchandisers review the fabric market to research fabric trends. Designers may visit one of the international fabric trade fairs, such as Premier Vision. This is the best way to keep abreast of the newest fiber or fabric developments that might be the source of ideas for both fabrics and garments.

Designers and merchandisers also frequently travel to a major fashion capital such as New York, where most textile mills and converters have headquarters and fabric libraries (see Chapter 6), for an overall picture of the season's textile offerings. Moreover, at these centers, the designers can discuss their ideas directly with textile designers and technicians. Designers often work directly with mills or converters to develop a new pattern or fabric. Fabric mills or converter sales representatives also call on the designer at work. Each season, designers try to see as many fabric representatives as possible to learn about the variety of fabrics available.

Price Considerations　Fabric quality, and therefore cost, must be appropriate for the price of the line. An expensive designer collection is made of the finest fabrics; a moderately priced line requires less expensive materials. A general rule is that fabric and trimming costs must balance labor costs.

Sample Cuts　Color or swatch cards from textile companies help designers and merchandisers make fabrication decisions. To test the fabric, the designer orders a three- to five-yard cut of a fabric to make a sample garment. If the designer and merchandiser are very enthusiastic about a fabric, they may initially order enough for many samples—perhaps 100 yards or more. They also have to consider the availability of the fabric for orders and production. They may have to commit to a fabric order before even having a collection to show. Once fabrics have been selected, the designer can begin to create styles.

Color

Color is the first element to which consumers respond, often selecting or rejecting a garment because of its color appeal. Color is particularly important in today's fashion. Therefore, designers must consider their customers and provide colors that are both appealing and flattering. People connect certain col-

Miuccia Prada successfully combines hot pink with black and gold banding. *(Courtesy of Prada)*

ors with holidays and seasons. Although much less predictable than formerly, they expect to see some earth tones in fall clothing, jewel colors for the holidays, pastels in the early spring, and white for the summer. Many manufacturers include a few of these colors in their lines.

Color Dimensions Color has three different dimensions: hue, value, and intensity.

Hue enables us to tell one color from another, such as red from blue or green.

Value refers to the use of darks and lights or the variation of light strength in a color. The value scale runs from white to black. White is pure light; black is the total absence of light. Adding white lightens a color and adding black darkens it. The lighter values are called *tints* and the darker ones *shades.* Every garment has value contrasts, even if only those created by normal gathers and folds. Strong value contrasts (pure black against pure white is the strongest) achieve a dramatic effect.

Intensity or chroma is the relative saturation, brightness (strength) or paleness (weakness), of a color. Bright colors are considered high intensity, pale ones are low intensity. For instance, when paint is paled by adding water, the intensity of its color is lowered. For example, marine blue is high intensity, and soft pastel blue is low intensity.

Warm Colors We classify red, yellow, and orange as warm colors because of their association with fire and the sun. Warm colors are stimulating, aggressive, and lively. Red is associated with matters of the heart: valentines, love, and romance; it is also exciting, fiery, and dangerous. A popular color for women's wear, it is one of the few colors used in high intensities for clothing in every season. Yellow is bright, sunny, cheerful, friendly, and optimistic. Orange has become popular in the youth market.

Cool Colors The cool colors—blue, green, and purple—remind us of the sky and the sea. Blue is quiet, restful, and reserved. Denim blue and navy have become wardrobe classics. For that reason, most manufacturers include blue especially in their spring or summer lines. Green is a soothing color, suggesting peace and calm. It is used primarily in a dark value in fall sportswear lines or mixed with neutrals to create earthy olive or loden. Purple, historically associated with royalty, has come to represent wealth, dignity, and drama.

Neutrals In apparel, neutrals such as beige, tan, taupe, brown, white, gray, and black are even more popular than the colors just mentioned. The reason is probably that they present a pleasing background for the wearer without competing for attention. Neutrals are part of every season's fashion picture, as either a strong fashion statement or a way to round out a color story.

White is associated with purity and cleanliness. Because it reflects light, it is cool in the summer. In Western culture, black has been connected with villains and death, but it has overcome these associations to become the most popular fashion basic.

Color Relationships There are no hard and fast rules for the use of colors. Rather, colors are considered harmonious if they are used so that one color enhances the beauty of the other. Colors are now combined in many more unusual ways than ever before. Ethnic influences on fashion have changed our view of color combinations, making us more receptive to new ideas. In addition, colors run in fashion cycles just as styles do.

Color Naming An exciting color name can be important in promoting a fashion look. Fashion colors sometimes reappear with new names that make them seem fresh. "Plum" of one year might return as "aubergine" in another. Oil-paint color lists, as well as books featuring the names of flowers, trees, wood, fruit, vegetables, spices, wines, gems, and animals, can provide color-name ideas. To create moods, colorists and fashion journalists use exotic names such as "China Blue" or "Poison Green."

Color Selection Within a line, each group is usually formulated around a *color story*, a color plan consisting of two or more colors. The color story might be all brights, or all muted, or a balance of darks and lights. The group may be anchored with neutrals, darks, white, or black. As trendsetters, couture and top ready-to-wear designers have the privilege of basing their color story on whatever inspires them.

Mainstream fashion designers usually rely on color forecasts provided by color and design services, trade associations, or fiber companies. By basing part of a color story on these trend forecasts, the designer is assured that the group will be in the mainstream of fashion. Usually, designers combine trend colors with their own choices to make their color stories unique.

Color choices must also reflect season, climate, and garment category. Active sportswear, for example, employs many more vivid colors than business attire. Every line should include a range of colors that appeals to a variety of customers.

Line

After selecting the fabric, the designer must consider the other elements of good design. In this section, the term *line* refers to the direction of visual interest in a garment created by construction details such as seams, openings, pleats, gathers, tucks, topstitching, and trims. (It is confusing that the apparel industry also uses the term *line* to refer to a collection of garments.) Line direction should flow from one part of the garment to another and should not be meaninglessly cut up.

Straight lines suggest crispness, such as that of tailored garments; curved lines imply fluidity. However, a

Vertical line direction is created by the black bands down the sides of Ralph Lauren's striking white leather dress. *(Courtesy of Ralph Lauren)*

Mark Badgley and James Mischka created this intriguing silhouette with its asymmetric hemline.
(Courtesy of Badgley-Mischka, photo by Dan Lecca)

garment designed with only straight lines is too severe; a garment with all curves is too unstable. For optimal beauty, the two should work together. Straight lines are softened by the curves of the body, and full curves must be restrained to be compatible with the human form.

Lines have the power to create moods and feelings. Vertical lines remind us of upright, majestic figures and suggest stability. Horizontal lines are like lines at rest; they suggest repose, quiet, and calm. Soft, curving lines express grace, and diagonal lines imply powerful movement and vitality.

Shape

Another function of line is to create shape. We use the term *silhouette* to describe the outline of the whole garment. Because the silhouette is what we see from a distance, it is responsible for one of our first impressions of a garment. Silhouettes tend to repeat themselves in cycles throughout history. At times a more body-conscious, natural (hourglass) silhouette is popular. At other times rectangular, inverted triangle, or tubular shapes that de-emphasize body contours may be prevalent.

A silhouette should be related to body structure, but some variation is needed to add interest. Sometimes one part of the silhouette, such as sleeves, hips, or shoulders, predominates. Bodies that do well in one season are usually updated in a new fabric or color for the next season.

Lines also divide the silhouette into smaller shapes and spaces by means of seams, openings, pleats, and tucks. The minute a waistline is added, a garment is divided into two new shapes: a bodice and a skirt. The sleeve becomes another shape. These parts create new spaces for smaller details, such as collars and pockets. The pattern of the fabric can create even smaller shapes.

Design Principles

Whether design elements are used successfully depends on their relationship to one another within the garment. Design principles serve as guidelines for combining elements. Designers may not consciously think of these principles as they work, but when something is wrong with a design, they are able to analyze the problem in terms of proportion, balance, repetition, and emphasis to create a harmonious design. These principles are flexible, always interpreted within the context of current fashion trends.

Proportion

Proportion is simply the pleasing interrelationship of the size of all parts of the garment. When conceiving a style, the designer must consider how the silhouette is to be divided with lines of construction or detail. These lines create new spaces, which must relate in a pleasing way. Generally, unequal proportion is more interesting than equal proportion. Many mathematical for-

mulas have been proposed as guidelines, but the best results come from practice in observing and analyzing good design. Standards of proportion change with fashion cycles along with the evolution in silhouette and line.

The height and width of all parts of a design must be compared. Individual sections of a garment, such as sleeves, pockets, and collar, must all relate in size to each other as well as to the total silhouette. A jacket length and shape must complement the length and shape of the skirt or pants.

The spacing of trimmings, pleats, and tucks must relate to the total design. Trimmings must not be too heavy or too light, too large or too small to harmonize with the space around them. Every line, detail, or trim changes the proportion because it breaks up the space even more. A designer continually experiments with subtle variations in proportion: line placement, hem length, and size and placement of trims. The designer gives the pattern-maker specific measurements for these details.

Balance

Balance refers to "visual weight" in design. A garment must be balanced to be visually pleasing.

Symmetrical Balance If a design composition is the same on both sides of the garment, then the design is considered symmetrical or formally balanced, following the natural bisymmetry of the body. Just as we have two eyes, two arms, and two legs, a symmetrical garment must have exactly the same details in just the same place on both sides. Formal balance is the easiest most logical way to achieve stability and, therefore, is the most commonly used in design. Even slight deviations, when minor details are not exactly alike on both sides, are considered approximate symmetry. A sensitive use of fabric, rhythm, and space relationships is needed to keep a symmetrical design from being boring.

Asymmetrical Balance To achieve a more exciting, dramatic effect, asymmetrical or informal balance can be used. Asymmetrical design composition is different from one side of the garment to the other and is achieved by a balance of visual impact. A small, unusual, eye-catching shape or concentrated detail on one side can balance a larger, less imposing area on the other side. Striking line, color, or texture can appear to balance larger masses of less significance. Asymmetrical balance is usually reserved for evening wear because it is dramatic, and technically, makes pattern layout more difficult and, therefore, more expensive.

Repetition

Repetition, or a sense of movement, is necessary to create interest in a design and to carry out the central theme. This can be achieved by the repetition of lines, shapes, and colors. We can see a rhythm of lines and

This symmetric, bias-cut gown with embroidery was created by Randolph Duke. *(Courtesy of Randolph Duke, photo by Dan Lecca)*

Marc Jacobs combines the rhythm of repeating burgundy ruffles with a matching wrap. *(Courtesy of Marc Jacobs)*

shapes in the repetition of pleats, gathers, and tiers or in rows of trim, banding, or buttons. The dominant color, line, shape, or detail of the garment may be repeated elsewhere with variation. The sense of movement should be felt, even if subtly.

The use of repetition is one of the most helpful guidelines in designing. A design line, shape, or detail repeated in another area of the garment helps carry the theme throughout the whole design. In dress design, for example, a V neck might be repeated upside down in bodice seaming or in an inverted pleat in the skirt. Soft gathers at the neck could be repeated at the hip to unify the design.

Emphasis

Emphasis, a center of interest, draws attention to the focal point of a garment. A center of interest must create more visual attraction than any other design element in the garment, and all other elements must support it by echoing its design message. A center of interest should be related to the total structure of the garment.

Emphasis can be achieved by color accents, significant shapes or details, lines coming together, groups of detail, or contrast. A combination of these methods gives the focal point added strength, as does placing the decorative emphasis at a structural point. Karl Lagerfeld does it simply with rows of gold buttons for Chanel.

In the designing of sportswear, each piece is considered a part of the whole. Although some pieces are simple basics, they create a background for or complement another piece such as a jacket, which creates the center of interest.

Successful Design

A successful design is achieved when all the elements and principles of design work together harmoniously. The theme of the garment is carried out with nothing overdone or forgotten. Overdesigned fashion does not sell well.

An effective design results from a well-developed idea or theme. For example, if the theme of a design or group is dramatic, the design should have a bold statement of line, an exaggerated silhouette, large space divisions, bright or dark colors, strong contrast, large prints, or extreme textures. There are many ways to develop ideas and themes. Well thought-out use of the elements and principles of design is most apparent in an evening gown when the drama of the occasion makes it appropriate to create something sensational. For daily wear, however, garments are simple and practical, and elements less noticeable.

The best way to gain experience in design is by experimentation. A designer on the job is always learning. The designer often tries many variations of a design before creating one that has the perfect combination of fabric, color, line, and silhouette and the correct use of balance, proportion, emphasis, and repetition.

Designers usually work up their ideas in sketch form to test them. The designer must determine objectively whether all the elements work together to create a harmonious, consistent visual effect.

Sketching Ideas

Ideas sometimes originate on the drawing board. French couture designer Christian Lacroix admitted, "I pile up hundreds of drawings."[8] Starting with an idea for a silhouette or a neckline, a designer may experiment, sketching alternative ways to complete the design. On paper, a designer can see two-dimensionally which design elements might enhance one another. A designer must also be able to imagine how the garment will look three-dimensionally, when made up in a fabric.

The designer makes a *working sketch,* a proportioned drawing, showing exact details of seam line and trimmings. Sketches must be clear so that the pattern-maker can use the drawing as a guide. The working sketch usually includes notes on construction and measurements. Fax machines have been a big help in letting designers communicate their design ideas quickly to overseas offices and production facilities.

Computer-Aided Design (CAD)

Designers can also sketch on a computer but it is difficult. Some programs allow designers actually to piece together apparel designs from Paris, Milan, and New York! Computer graphics can also show the repeat of a fabric pattern, simulate fabric drape on the figure, and help designers experiment with color and fabric changes quickly (see Chapter 6 for textile design).

Betsey Johnson sketching ideas in her New York office. *(Photo by the author)*

An entire line of garments can be organized and edited on a product data management (PDM) computer system. Computer companies are also experimenting with the idea of converting sketches automatically into first patterns.

Style Board

To chart the development of the line as a whole, the designer arranges working sketches of all the garments in fabric and color groups on a large board, which is essentially a master plan. The board is posted on the wall of the design room. Styles are added and subtracted until the line is finalized. Again, in large companies, this is usually managed on a CAD or PDM system.

■ DEVELOPING A SAMPLE GARMENT

The first sample garment or prototype is the test to see if a design is successful.

The First Pattern

The next step in the product development procedure is making the first pattern, which is used to cut and sew the *prototype,* or first sample garment. The pattern is made in a sample size, the one used for testing and selling purposes. Sample sizes are 7 or 9 for juniors, 8 or 10 for missy, 34 for men's trousers, and 38 for men's suits. The pattern-maker can use either of three methods for making patterns: draping, flat pattern, or computer-generated.

Draping

The pattern-maker or assistant designer uses the *draping* method to cut and shape muslin or garment fabric on a dress form to create a pattern. Like fabric sculpture, draping is ideal for soft, flowing designs. This method is used mainly for couture dresses and evening wear. It enables the pattern-maker and designer to see the proportions and lines of the design exactly as they will look three-dimensionally on the wearer. The design is often altered as it develops on the form.

Everything must be carefully marked: center front, shoulder line, seams, armholes, buttonholes, and so on. When the designer is satisfied with the look and fit, the muslin is taken off the form and trued up. *Truing* is correcting the sketched lines with drafting curves, angles, and rulers. Finally, the pattern is redrawn on heavy paper.

Flat Pattern

First, basic shapes, such as bodices, sleeves, pants, or skirts, are draped or drafted. *Drafting* is blocking a set of prescribed measurements on paper. These patterns, once tested for accuracy, become *blocks* or *slopers* that can be changed or

Draping a pattern in the sample room. *(Photo by the author)*

New York designer Han Feng (in white) works with her pattern-maker.
(Photo by the author)

adapted to each new style by moving darts and seams. The *flat-pattern method* uses angles, rulers, and curves to change existing board patterns.

Computer Patterns

Computer-generated patterns are discussed fully in the production pattern section of Chapter 10.

The pattern is laid out on the fabric, traced, and cut out by the assistant designer or the sample cutter to be sewn into the first sample or prototype.

Prototype

The prototype is made by a sample-maker, the best of the factory sewers. Sample-makers must have factory sewing skills and know how to put an entire garment together. The design staff works closely with the sample-maker to solve construction problems. Factory construction methods must be tested as the garment is sewn. Many manufacturers have their samples made abroad at the same factory where production will be to test quality.

Fit

The next step is to test the sample for fit and total effect. The ability to create a good fit is the most important skill needed in the development of the garment. The garment must be fitted on a model to test comfort and ease of movement. Donna Karan likes to try on her samples herself.

The Designer Work Sheet

Records are kept on all styles as they develop. Each designer fills out a work sheet containing information that guides the production department in figuring costs and in ordering *piece goods* (the factory term for fabrics) and trim-

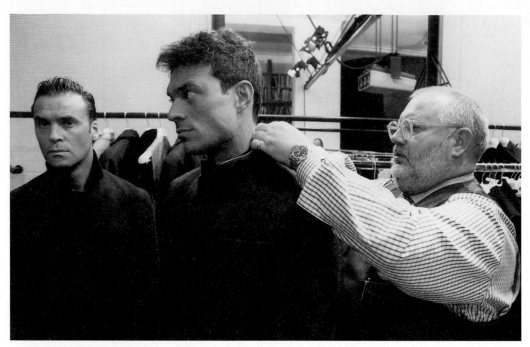

Gianfranco Ferré checks the fit of a jacket at his studio in Milan, Italy.
(Courtesy of Gianfranco Ferré, photo by Arnaldo Castoldi)

mings. Many companies now use product data management systems (PDM) to collate this information. In this case, each department responsible (such as fabrics, trims, design) enters its own data into the computer.

The work sheet or PDM form usually includes all of part of the following information:

1. The date the garment was designed
2. The selling season
3. The sizes in which the design will be made
4. The style number assigned to the design (each manufacturer has a code of numbers representing season, fabric, and pattern)
5. A short description of the garment
6. A working sketch of the design to make it easy to identify the garment
7. The colors or color combinations in which the design is offered
8. Fabric swatches of what is used in the garment
9. Material descriptions, including each fabric type and source, width, and price per yard
10. Marker width, usually one inch narrower than the fabric
11. Trimmings information: the kinds, sources, sizes, and prices of buttons, zippers, braids, lace, belts, elastic, and so on; special fabric treatments done by outside contractors, such as pleating, spaghetti straps, and ties, are also included
12. Labor costs for grading, marking, cutting, sewing, finishing, garment dyeing, and washing; these may be listed either on the designer work sheet or on a separate cost sheet figured by the costing department (see Chapter 10).

The work sheet becomes an adoption form when the final line is selected.

■ *LINE SELECTION*

Designers develop many designs for each line, which are then edited.

A designer must be objective in judging each design and develop an un-biased, critical eye—a difficult task when judging a personal creation.

Editing

Regular weekly or monthly progress meetings are held to analyze the development of the line. From all the samples, management, the designer, and the merchandiser choose the best for the line. Production and sales specialists are also consulted. Designers are visual and prefer creating new styles, sales managers base their decisions on sales histories, and production managers favor garments they have produced before. They try to achieve a balance. Retail buyers are often asked for their opinions because of their familiarity with customer preferences.

Some styles are weeded out, leaving only the most successful combinations of fabric, style, and price. Some designers think that they need a closely edited line so that combination possibilities are not confusing to the customer. Some large companies like to give their customers more options. Jones New

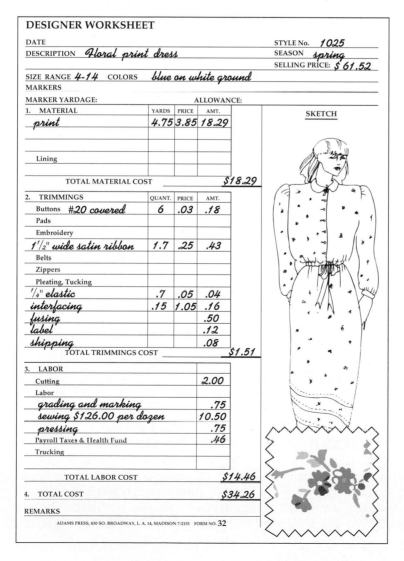

DESIGNER WORKSHEET

DATE _____ STYLE No. *1025*
DESCRIPTION *Floral print dress* SEASON *spring*
SELLING PRICE: *$ 61.52*

SIZE RANGE *4-14* COLORS *blue on white ground*
MARKERS
MARKER YARDAGE: ALLOWANCE:

1. MATERIAL	YARDS	PRICE	AMT.
print	4.75	3.85	18.29
Lining			
TOTAL MATERIAL COST			*$18.29*

SKETCH

2. TRIMMINGS	QUANT.	PRICE	AMT.
Buttons *#20 covered*	6	.03	.18
Pads			
Embroidery			
1½" wide satin ribbon	1.7	.25	.43
Belts			
Zippers			
Pleating, Tucking			
¼" elastic	.7	.05	.04
interfacing	.15	1.05	.16
fusing			.50
label			.12
shipping			.08
TOTAL TRIMMINGS COST			*$1.51*

3. LABOR			
Cutting			2.00
Labor			
grading and marking			.75
sewing $126.00 per dozen			10.50
pressing			.75
Payroll Taxes & Health Fund			.46
Trucking			
TOTAL LABOR COST			*$14.46*

4. TOTAL COST			*$34.26*

REMARKS

York, for instance, typically shows 5 groups of 32 pieces per season (or 800 pieces per year). On the other hand, Betsey Johnson shows an average of 100 pieces per season, 40 pieces per monthly delivery (or 500 per year). Recently, manufacturers have carefully edited their collections to reduce their size, to encourage larger sales per style, and to try to avoid cutting styles from the line that do not sell well enough to produce.

Reassessment of the Merchandise Plan

At this point, merchandise plans might be reassorted. If a group looks particularly strong, styles or colors could be added. The merchandise plan discussed at the beginning of this chapter might be revised so that it states the exact number of styles adopted, the actual price of fabrics chosen, and the yardage estimates for each style.

Line Presentation

Just before the scheduled line-release or collection-opening dates, the line is presented to the sales force. The designer or merchandiser must explain the line concepts, current fashion trends, and new developments in fabrications to the sales representatives and, sometimes, to retail buyers.

A consistent visual image created by a well-developed theme is a good selling tool on both the wholesale and the retail levels. Visual impact is what makes the line competitive once it is displayed in a retail store. The designer cannot be there to explain each style idea to the customer, so the product must speak for itself.

Product and design development is a challenge. Not only must designers be creative, but they must also understand production and know what sells. Claude Brouet, fashion director of Hermès, said, "There are plenty of designers with great talent, but one also needs to understand production, distribution, and on-time delivery. If you don't have those, even the most beautiful collection will be useless."[9]

Duplicates

After the line is complete but before the line release date, duplicates are copies of the sample garments chosen for the line that are made to keep in the showroom to show to buyers or to give to sales representatives to take on the road. These are made in the factory to test production. Basic styles are put into production according before the line is sold.

■ SUMMARY

In this chapter we discussed product development, merchandising, and design. The company establishes an image and a product to appeal to a target market. The merchandiser prepares plans to achieve sales goals and meet consumer needs. The design department creates a seasonal line of items or groups. The designer is especially concerned with color and fabric and other design elements to develop attractive garments. After a sketch and first pattern are complete, the sample garment or prototype is made as a test of the design and fabric. Finally, the line is selected and prepared to show at wholesale markets.

■ CHAPTER REVIEW

Terms and Concepts

Briefly identify and discuss the following terms and concepts:

1. Collection or line	10. Elements of design	19. Working sketch
2. Seasons	11. Color story	20. First pattern
3. Merchandising	12. Fabrication	21. Draping
4. Dollar merchandising plan	13. Texture	22. Flat pattern
5. Designer	14. Performance	23. Sample garment
6. Items	15. Sample cuts	24. Designer work sheet
7. Knockoffs	16. Proportion	25. Style board
8. Planning groups	17. Asymmetrical balance	26. CAD
9. Theme	18. Repetition	

Questions for Review

1. Name the three major divisions of a clothing company and discuss their relationship.
2. Discuss the merchandising function in relation to the design function.
3. Discuss the basic conceptual differences between merchandising sportswear and dresses.
4. Name the elements of design. Discuss briefly why it is important for these elements to be represented in a design.
5. What are the principles of design? How do they help a designer analyze the effectiveness of a design?
6. Explain briefly the development of a sample garment.

Projects for Additional Learning

1. Write a short description of an imaginary or real person. Include the person's age, build, job, place of residence, interests, and life-style. This person will be the typical customer for your new sportswear line for the season eight months from now. Determine a price range and style range according to your customer's life-style. Design a group of 20 coordinating pieces or related separates. Develop a color story and suggest fabrications. (Merchandising students may cut pictures of sportswear items from magazines and display them on a board.)
2. Find examples of 10 successful designs in European and American fashion magazines. Describe the beauty of each in terms of line, silhouette, shapes and spaces, color, and texture (fabric, pattern, and trims), as well as balance, proportion, rhythm, and emphasis. Do all elements and principles work together harmoniously? What elements dominate? Find two garments that you believe are unsuccessful. Analyze them in the same way to discover what element or principle has not been properly used.
3. In a local specialty or department store, compare two dresses or two suits of similar price from different manufacturers. Try them on. Which has the better fit? Compare fabric choices in terms of quality and suitability to the design. Compare styling. Which is more innovative? Taking all factors into consideration, which dress or suit is the better buy? Discuss your findings in a written report. Describe or sketch the dresses or suits.

■ NOTES

[1] "Slimane Talks About Dior, YSL," *Women's Wear Daily*, July 5, 2000, p. 9.

[2] As quoted in "Lauren at 25," *Women's Wear Daily*, January 15, 1992, p. 7.

[3] Bau, Deborah. "Armani Stands at Crossroads Amid Consolidation," *Wall Street Journal*, October 24, 2000, p. B17.

[4] Robin Howe, Design Director, Jones New York, interview, May 4, 2000.

[5] Tommy Hilfiger, interview, September 23, 1994.

[6] As quoted in "The Culture of Copycats," *Women's Wear Daily*, November 2, 1999, p. 8.

[7] Christian Dior, *Talking about Fashion* (New York: Putnam's, 1954), p. 35.

[8] "Lacroix Tells Us about Christian," *Marie Claire*, October, 1998, p. 1.

[9] As quoted by Katherine Weisman, "Hermès, Loosening the Reins," *Women's Wear Daily*, March 2, 1994, p. 15.

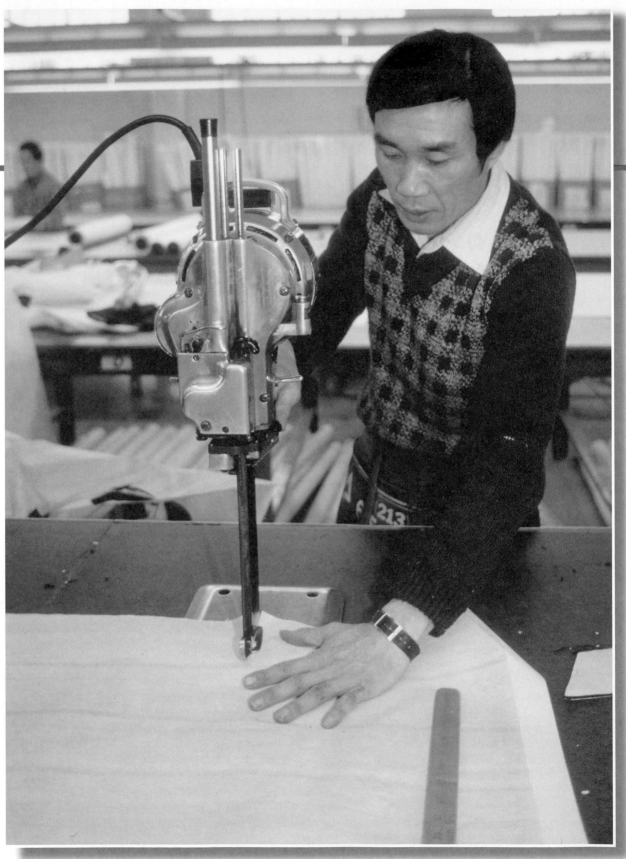

A cutter using a straight-knife machine at Jessica McClintock's factory.

(Photo by the author)

10

Apparel Production

■ CAREER FOCUS

An interesting variety of technical job possibilities exist in apparel production. Technical training in both patterning and computers is needed for positions as patternmakers. Those interested in materials may consider positions as fabric and trimmings buyers. Numbers-oriented people might like to work in cost analysis and production planning. Many of these jobs, however, are now being done at factories overseas. Supervisory positions require extensive travel.

■ CHAPTER OBJECTIVES

After reading this chapter, you should be able to:

1. Explain the costing of a garment;
2. Describe, in order, the steps in garment production;
3. Explain the various types of contracting;
4. List all the uses of computers in manufacturing;
5. Explain the differences between men's tailoring and men's sportswear production;
6. Describe the two commercial methods of knitwear production;
7. Discuss the importance of quality control.

*P*roduction is another of the three integral phases of fashion manufacturing: design, production, and sales. Without design, there would be nothing to sell; without sales, there would be no reason to produce. Conversely, sales would not continue if orders were not produced properly and delivered on time. To keep its retail customers, each manufacturer tries to maintain a consistent price structure, quality of styling and construction, and timely deliveries. This chapter focuses on apparel production, from costing to quality control.

Even before a collection is shown at market, production may begin based on sales forecasts. Production of basic garments is almost constant to replenish stock. After a collection or line is shown at a market, it may be possible to adjust cutting orders somewhat.

■ COSTING A GARMENT

The production cost of a garment must be determined to set the wholesale price, the price that retailers pay for goods that they purchase from manufacturers.

Costing is an exact calculation by the costing or import department, using actual figures for materials and labor. The costing department uses the designer's work sheet, a prototype garment, and the production pattern to analyze materials and construction step by step. The designer may be consulted for information or to recommend more practical or cheaper ways to make the garment.

Labor costs may be calculated by time studies. In this case, engineers time each operation, such as closing a seam, or how long it takes to make an entire garment. For contracted work, a prototype is sent to the contractor for costing. A detailed cost analysis is made for each garment, including expenses for fabric, trims, cutting, labor, overhead, sales commission, and manufacturer's profit. The final cost is plotted on a cost sheet.

The Cost Sheet

1. **Materials**—The total amount of fabric needed for the garment is estimated and then multiplied by its cost per yard to find the total material cost per garment. Because higher volume allows more flexibility in making the marker and, thus, a more efficient use of fabric, material cost is somewhat reduced for high-volume styles.
2. **Trimmings**—The cost of trimmings needed for each garment are multiplied by the number of units to be produced. Dividing the total by the number of units gives the cost per garment.
3. **Production pattern-making, grading, and marking**—Most companies allow for these costs in the general overhead that also covers the design department. However, if these functions are performed outside by a pattern service or by a contractor, there is a fee. To find the cost per unit, the total cost is divided by the number of units to be cut. If the garment is later recut (because of reorders), there will be no new cost for patterns and grading.

Table 10.1
Manufacturer's Cost: Wholesale Unit Pricing for a Typical Dress
(each company uses a unique pricing structure)*

Direct Cost	Amount	Average Percentages
Fabric (cost depends on quantity purchased)		
4.75 yards at $2.48	$18.29	30
Trimmings	1.51	2
Labor (cost depends on number of garments sewn)	14.46	24
Total Direct Cost	34.26	56
Indirect Cost		
Design and Manufacturing: Design Staff Salaries, Sample Fabrics, Cost of Samples	5.00	8 (8–10)
General Administrative Overhead: Office Salaries, Rent, Insurance, Utilities	5.28	9 (8–15)
Sales Commission	4.50	7 (7–10)
Trade Discount	5.00	8
Markdown Allowance, Promotion, or Other Retail Services	2.40	4
Shortages	0.96	2
Total Indirect Cost	23.14	38
Total Cost	57.40	93
Profit Before Taxes	4.12	7
Wholesale Price of Dress	$61.52	100

*Refer back to design chapter for work sheet on same dress; see retailing chapter for retail price of the same dress.

4. **Spreading and cutting**—The cost for cutting done "in house" (in the company's own factory) is based on the cutter's hourly wage multiplied by the number of hours it takes to cut the style and divided by the number of units cut. If the cutting is done by a contractor, the total negotiated cutting cost is figured on the number of garments to be cut. The contractor adds his or her fee to this amount.

5. **Assembly**—Some companies break down labor costs by each operation. Information for this kind of costing structure is gathered through time-and-motion efficiency studies. The cost for each operation, such as the closing of a shoulder seam, is determined. To figure the total costs for a whole garment, the individual operation costs are combined. Other manufacturers calculate the average time it takes to sew the whole garment and multiply that by the worker's hourly rate. If the garment is made by a contractor, the contractor and manufacturer negotiate a price based on these calculations.

6. **Finishing**—Costs must be included to cover final preparations for shipping. In designer apparel, this may include some handwork. For most apparel, pressing and/or folding are sufficient. The cost for packing in preparation for shipping is also figured.

7. **Freight**—The cost of shipping completed garments from the contractor to the manufacturer's warehouse must be calculated. For domestic shipments, the garments are usually trucked. If the garments are imported, then a percentage of the air or sea freight cost must be added to the cost of each garment. Obviously, sea transportation is cheaper

and, therefore, adds less cost to the garment, but valuable lead-time is forfeited. The cost of shipping garments to the retailer is generally paid by the retail store (the receiver). Manufacturers must pay air-freight, however, if they are late with their delivery.

8. **Duty and quota**—In the case of imports, there are additional costs for duty and quota. These are included if a "package" price is negotiated (see overseas production methods).

Wholesale Pricing

The wholesale price is determined by adding the cost of labor, the cost of materials, and a markup. The markup covers sales commission (usually 7 to 10 percent), overhead, and a profit, which is necessary for staying in business. *Overhead* includes all the daily costs of running the business. *Fixed overhead* expenses, those that do not change from month to month, include rent, heat, lights, trash collection, insurance, salaries, taxes, and legal and auditing services. *Variable overhead* expenses include advertising, promotion, equipment repair, markdowns of leftover fabrics and garments, and losses due to fire and theft. Companies also have to use a large portion of their profits for capital investment in new equipment and technology.

Most companies add a markup of between 28 and 44 percent of the wholesale price. In other words, they increase the direct cost by 56 to 88 percent. Budget companies usually take the lowest markup and hope to make a profit by volume sales. For example, a blouse costing the manufacturer $21 to produce would cost $35 wholesale with a 40 percent markup. Today, with partnerships building between retailer and manufacturer, pricing often begins with the price wanted by the retailer. The manufacturer works backward, trying to provide a garment that would sell at the requested price.

Production meeting of managers, costing analysts, and fabric buyers to plan production and sourcing at Esprit. *(Photo by the author)*

Cost Merchandising

Another important aspect of costing is whether the garment's perceived value is worth the price charged. Each garment has to compete on the market with other similar garments. If two garments are very much alike, the less expensive one is more likely to sell on the retail level. Therefore, both the styling and the quality of a garment must be better than those of competing garments. Therefore, the price of a style may be adjusted slightly higher or lower to try to affect its sales potential. Occasionally, a manufacturer uses a *loss leader* (a garment with a low markup) to attract buyers.

Some companies figure an *average markup* so that their garments fit into a price line. For example, in sportswear manufacturing, shirts often cost out higher than pants and skirts because of expensive fabrications and labor. Therefore, the shirt price may be lowered so that it is more acceptable (a practice called *low-balling*), whereas the skirt and pant prices are raised (*high-balling*). In this way, the average markup is within an acceptable range.

Many volume manufacturers *reengineer* some of their first samples to meet their target price points if the garment in question is important to the line. This is accomplished by altering features such as the sweep of a hem or facings or pockets to reduce labor or fabric consumption.

■ *PURCHASING OF PIECE GOODS*

Ordering the materials necessary to produce garments is usually done by the manufacturer's fabric or piece goods buyer.

The piece goods buyer acts as a liaison between the mill or converter and the manufacturer. The buyer must know all the properties of fabrics and have information on prices, availability, and delivery.

Electronic data interchange (EDI) allows the exchange of piece goods ordering information by computer. As discussed in Chapter 2, this linkage has fostered partnerships between manufacturers and suppliers to ease purchasing procedures. Computer software is available that uses sales figures to automatically adjust planned production and the amount of fabric and trim needed.

The following issues must be considered in the purchasing of piece goods:

Environmental Concerns

Consumer preference for environmentally safe products has led some manufacturers to look for fabrics made with organically grown cotton, linen, wool, and tencel; vegetable-based and water-based inks in prints; fiber-reactive, low-impact dyes; and safe finishes. Some manufacturers now have special lines of environmentally friendly clothing.

Volume Purchases

Generally, volume manufacturers purchase goods from large textile companies that can handle big orders. Ordering in quantity may give the manufacturer a cost advantage. The goal of a volume manufacturer is to obtain the lowest-priced goods at the widest width to use an efficient marker layout.

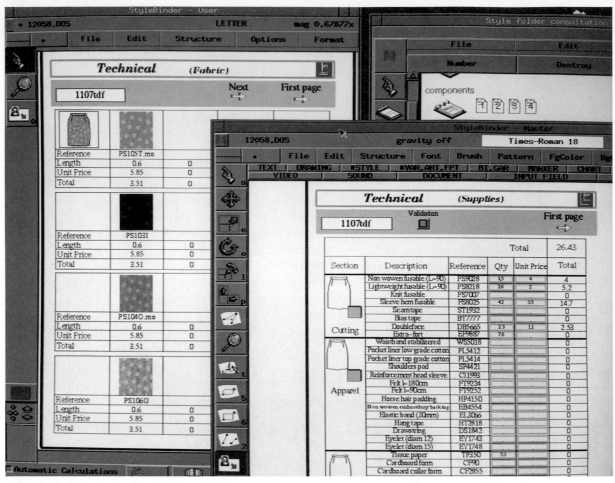

Product data management (PDM) printouts show computer organization of fabric and supply purchases.
(Courtesy of Lectra Systems)

Small Orders

Conversely, small manufacturers usually deal with small textile firms, which can do shorter runs, or buy from fabric brokers. This often forces U.S. manufacturers to use foreign-made fabrics because their minimums are lower. For example, a manufacturer may be able to buy a minimum of 300 yards of a fabric from Asia versus a 2,000-yard minimum in the United States. Domestic textile producers have made an effort to lower minimums.

Ordering

Fabric buyers must be aware of fabric prices at various mills to negotiate the best price. The buyer must also calculate the amount of yardage needed to supply the cutting order. Orders for stock yardage are based on sales histories and on forecasts of future sales. Textile sales representatives encourage manufacturers to make a commitment early in the season to buy a specific amount of yardage. Ordering in advance ensures the availability and on-time delivery of a popular fabric, which may subsequently be in short supply. Volume orders may require a six- to eight-week *lead-time* for delivery. Popular fashion fabrics and yarn dyes can require as much as a six-month lead-time,

but manufacturers are pressuring the textile industry to cut these lead-times down to 14 weeks.

Fabric for Reorders

The manufacturer must also consider the amount of fabric that may be required for possible reorders, although reorders are rarely possible. A manufacturer takes a great risk by stocking up for anticipated orders. To eliminate some risk, manufacturers often commit for greige goods only, to be dyed later. Then, as sales information becomes more precise, colors can be *assorted*. In other words, the greige goods can be dyed for the colors needed, according to the sales percentage established for each. Manufacturers may be unable to reorder materials if the fabrics are imported or if they have developed their own fabrics.

Trimmings

The fabric or trim buyer buys trimmings and notions (functional trimmings). These are the materials used to finish garments or fashion accessories. Other sundries purchased by the trimmings buyer include labels, hangtags, hangers, and plastic bags. The trim buyer at Koret, for example, must purchase an average of five different trimmings and notions per single fabric order. Trim buyers may attend the Bobbin Show in Atlanta each September or the Trimmings Expo in New York each November to see new products.

Trim buyers must find the best trimmings available for each kind of application in each garment. Trimmings must have the same care properties as the fabrics used in the garment. For example, if the fabric can be safely washed, the trimmings must also be washable. Buyers must also ensure that the colors of all trimmings used match the fabrics and each other. They must also coordinate deliveries from each trim producer so that all trims are in house in time for manufacturing.

Fabric Quality and Dye Lots

In some factories, fabrics are still inspected for flaws, which are marked with colored threads or flags at the side of the fabric so that they can be avoided in cutting. In an automated factory, a computer-programmed inspection system locates flaws, color differences, and variations automatically. If there are too many defects, the fabric is returned to the mill. Many manufacturers count on the mills to inspect fabrics before shipping. For imported fabrics, a manufacturer can hire an outside inspection agency to check the goods before they leave the mill.

In small factories, all measuring and inspecting is done on the cutting table. In this case, the spreader has the responsibility of measuring, inspecting, and spreading the fabric in preparation for the cut.

Some apparel manufacturers build strong reputations on the reliability of their products. They perform washing, dry cleaning, steaming, and pressing tests to check tensile strength, durability, color cracking, color fastness, and shrinkage. They also test how the fabric holds up during sewing—whether it pulls or frays excessively.

Coordinating tops and bottoms must be cut from the same dye lot (or be garment dyed), and at the very least, shipments to the same store must be within acceptable variations of color if from different dye lots (see Chapter 6 regarding garment dyeing).

A pattern-maker uses a stylus that automatically records lines in the Accumark pattern development system and shows them on the computer screen.
(Courtesy of Gerber Technology, Inc.)

■ *PATTERN-MAKING*

Accurate pattern-making is crucial for successful apparel production.

The Production Pattern

In a traditional apparel factory, the production pattern-maker relies on the same methods used in the sample room to make patterns: draping, drafting, or flat-patterning from standardized basic blocks. In fact, in many small companies the same person does both the sample and production pattern-making. In production, strict attention must be paid to company size specifications, which are standardized measurements including ease (extra room for movement) for each size. When using fabrics that shrink, such as cotton, patterns have to allow for that shrinkage. Also, the seam lines of each pattern piece must exactly fit the piece to which it will be sewn, with notches marked perfectly for operators to follow. Grain lines, plaid lines, and other annotations are also marked on the patterns.

Computer Pattern-Making

At most large manufacturers, patterns are made on a computer. With *computer-aided design* (CAD) systems, the pattern-maker manipulates small graphic patterns on the computer screen with a handheld control device. *Geometry drivers* can make an infinite number of changes to the shapes and sizes

of the patterns, including creating new design lines or adding pleats, fullness, and seam allowances.

To allow pattern-makers to make patterns manually on a computer, another system has been developed allowing the pattern-maker to work life-size on a sensitized table with traditional tools and a *stylis* that is attached to the table and the computer. The stylis picks up the lines drawn on the table and shows them on the screen. Changes can also be made directly on the screen.

In both cases, patterns are immediately available for other operations, such as grading and marker making.

Grading Sizes

Patterns, like garments, must provide for different sizes. *Grading* is the method used to increase or decrease the sample-size production pattern to make up a complete size range. For example, the sample size 10 pattern must be made larger to accommodate sizes 12, 14, and 16 and smaller for sizes 8 and 6. Each company sets predetermined grade *specifications,* or rules. For example, a "missy" manufacturer's grade-rules might call for increments of one and a half inches in width and a quarter inch in length for each size.

Today, most manufacturers grade patterns on CAD systems. The pattern-maker guides a *cursor* around the edges of the sample pattern on a digitized table. At each of the key points, he or she pushes a button to record a grade point. Each point is cross-referenced by a grade-rule table stored in the computer, which enlarges or reduces the pattern automatically according to predetermined increments and in a predetermined direction.

If the pattern was originally made on a computer, data are already in the computer and can be enlarged or reduced automatically. Preprogrammed grade

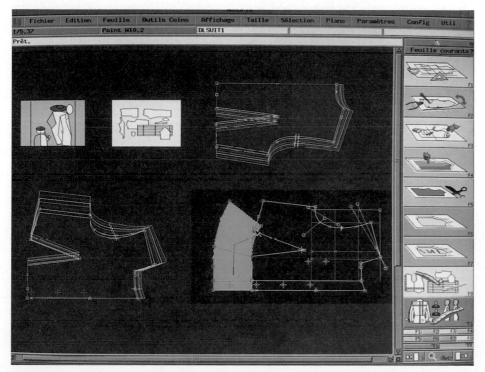

Examples of computer grading and pattern-making. *(Courtesy of Lectra Systems)*

rules for increase or decrease are automatically applied to the pieces at each grading location. Then the computer can print out the pattern in each new size. Manufacturers often use an outside service to make patterns, grade patterns, and make the marker. Overseas contractors usually make the patterns there.

Making the Marker

From all the pattern pieces of varying sizes, a master marker is made. The marker is the cutting guide or pattern layout made on a sheet of lightweight paper the same width as the fabric. The purpose of the marker is threefold: to make a layout for the cutter to follow, to place pattern pieces close together to avoid fabric waste, and to accommodate the *cutting order* (ensuring that the correct quantities of each size are cut). The desired economical use of space is called a *tight marker,* which utilizes the highest percentage of fabric possible to avoid waste. Patterns are laid out so that each size and color is cut as needed (popular sizes are repeated on the marker). Grain direction, one-way prints, plaids, stripes, and naps are considered in making the marker.

Most manufacturers now make their markers on a CAD system or have it made by an outside service or contractor. Miniatures of the graded pattern pieces are displayed graphically on the computer screen. The operator can electronically position the pattern pieces into the most efficient arrangement. Once the marker is completed, a full-scale marker is printed by the plotter on a long sheet of paper. The pattern-maker checks the arrangement on the screen or prints out a mini-marker to check. Copies of the marker are made to use in each cut. Miniatures of an entire marker can be faxed to locations around the world, or the entire marker can be printed out on a plotter wherever cutting is to be done.

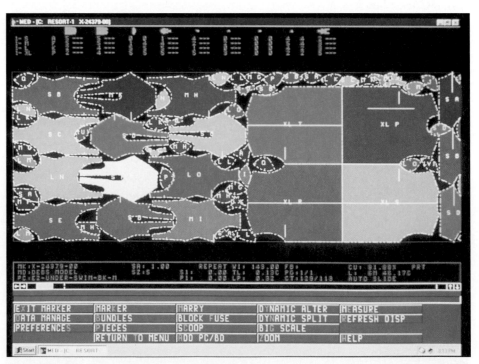

A computer-made marker. (*Courtesy of Gerber Technology, Inc.*)

■ *PRODUCTION SCHEDULING*

The production manager or merchandiser schedules cutting and garment assembly in time to meet shipping dates.

Issue Plan

A computer-generated production schedule or *issue plan* is created to ensure that delivery dates are met. This schedule is a reverse timetable, usually covering six months. The first date on the schedule is a shipping date that will meet the retail store's order requirements. The schedule progresses backward to include completion dates, cutting dates, and fabric delivery dates. Production scheduling is very difficult because it has to be organized to take maximum advantage of plant capacity as well as to meet shipping dates.

Orders for each style must be compiled to determine how many garments of each size to produce. There are two philosophies of production planning: cut-to-order and cut-to-stock.

Cut-to-Order

The safest method of production is to *cut-to-order,* that is, to cut and produce only orders. This means waiting until all orders are in and then working quickly to cut, sew, and deliver. This method is reserved for high-priced couture and designer garments and the newest fashion items in a line, when sales forecasting is difficult.

Cut-to-Stock

The method with the greater risk involves cutting estimates of projected sales or *cutting-to-stock.* Projections or forecasts (expected sales) are determined by the economy, sales histories of similar garments, the season, and the strength of the particular line.

The cut-to-stock method is necessary, at least for basics, to enable production to be spread out over time. It is also necessary when orders for fabrics require long lead times, as is the case with yarn-dyed fabrics, sweaters, and imports from Asia. The method enables the company to start work in slack months on those items with the highest projected sales.

Inventory Control

The introduction of *computerized inventory control* has made planning more accurate. Computer systems are used to create

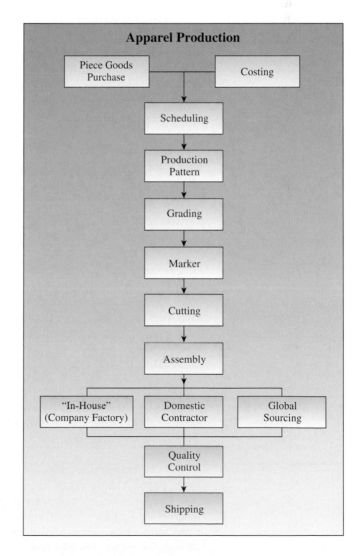

issue plans and cutting orders. All fabrics and works-in-progress are given *universal product codes (UPC)*, which identify style, color, size, price, and fabrication. *Product data management (PDM)* systems collate product data on a single program, forming an "electronic filing cabinet" of designer drawings, supply sources, pattern information, grading sheets, cost sheets, and cutting tickets. They also provide current information on the number of units that are cut, in work, or in stock. With these data, manufacturers can update fabric commitments and production plans to correspond with demand.

Plant Capacity

Plant capacity, the quantity of garments that can be made in a factory at a certain time, and construction difficulties must be considered in planning the production schedule. For example, some styles are more difficult to produce than others and, therefore, take more time. Operators are slower at their work when it is new to them; plant capacity builds as operators become accustomed to the sewing operation and are able to work faster.

Standard Allowed Hours

Plant capacity is figured according to the time it takes to complete each operation or garment, as it is in costing. Plant engineers time each operation to find the "standard allowed minutes" it takes to complete a specific operation and the "standard allowed hours" to make a total garment. Standards are used to figure how many garments can be sewn in one hour or one day. For example, if 50 people can make 100 pants in one hour, then they should be able to make 800 pants a day.

■ SPREADING AND CUTTING PROCEDURES

Using the markers made from graded patterns, in accordance with the issue plan, fabrics are cut to prepare for garment assembly.

Following the issue plan, the cutting order tells what to cut, what fabrics to use, and how to cut. A computerized cutting order uses programmed data to determine what markers should be made; how fabrics should be spread and cut; and the most cost-effective number of plies, colors, and size mixes.

Spreading the Fabric

A crane moves a roll of fabric into the *hopper* (fabric-feeding device) of a spreading machine. Conventionally, a spreader machine is guided along a table, laying fabric on the cutting table, the length determined by the marker. The fabric is cut at the end, the machine returns to the other end, and the next layer is laid face up on top of the first, in the same direction. Fabric is spread on the cutting table with one ply on top of another so that many layers can be cut at the same time. The number of layers is prescribed by the cutting order. Spreaders must be aware of how fabric finish, pile, stripes, floral designs, and other factors affect their work. More than 200 layers may be cut at one time, depending on the fabric thickness. Thinner fabrics may be more difficult to handle and are cut in lower stacks for more control.

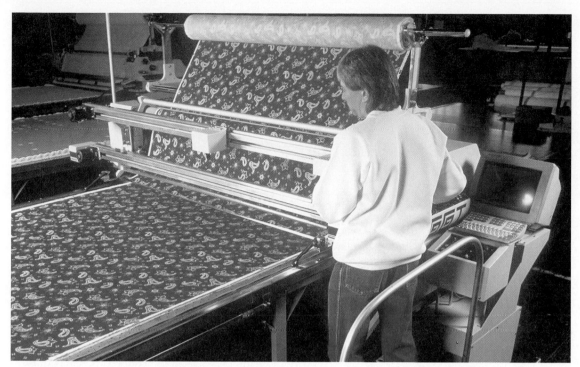

A computer-controlled spreader that provides distortion-free fabric spreading at high speeds. *(Courtesy of Gerber Technology, Inc.)*

In most factories today, spreading is done automatically with a computer-programmed spreading machine. In this case, a motorized spreader moves automatically up and down the table, unwinding up to 80 yards of fabric per minute.

Cutting Techniques

The marker is put on top of the layers of fabric. With the conventional method, a skilled cutter follows the pattern outlined on the marker, using a straight-knife machine with a long, thin blade that vibrates vertically as it is pushed through many layers of fabric (see the photo at the beginning of the chapter). A vertical knife can cut to a depth of 9 inches. For only a few layers, a cutting machine with a rotating circular knife may be used. The cutter must select the correct speed and blade for each type of fabric. For example, a coarse blade edge is used for tightly woven fabrics and a smooth edge for softer fabrics.

Computer Cutting

A numerically controlled cutter reduces labor and improves the accuracy of the cut. A beam structure across the table holds the cutting head. The beam can move up and down the table whereas the cutting head moves across. Movement is directed by marker data in the CAD system. The knife in the cutting head vibrates vertically to cut the fabric.

Laser-beam cutting is sometimes used for men's suits, which are cut a single layer at a time. The laser, a concentrated light beam, is also directed by a computer. *Water-jet cutting* is being used for some fabrics and leathers, especially in the shoe industry. A thin stream of water, also computer directed, is fired under high pressure through a tiny nozzle to cut the leather.

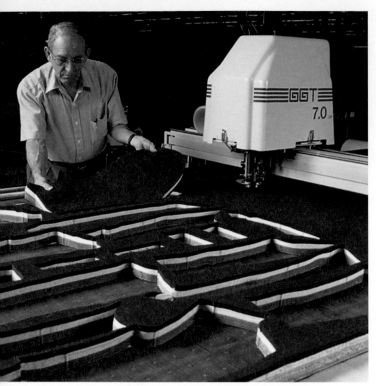

Automated computer cutting showing the cutting head, beam structure, and multiple-layer cut pieces. *(Courtesy of Gerber Technology, Inc.)*

Environmental Concerns

Manufacturers of apparel are giving increased attention to environmental concerns. They are trying to identify ways to reduce and recycle their supplies. Their primary concern is the disposal of fabric scrap, which makes up a large percentage of production waste. One possibility for the disposal of this waste is to use an on-site incinerator to generate electricity. Some fabric scraps are shredded and spun into new yarn. Levi Strauss recycles its scrap denim to make blue letter paper. However, most environmental improvements and recycling are still too expensive for most manufacturers to implement.

Bundling

The process of sorting cut pieces and organizing them for assembly is referred to as bundling. Parts of garments and necessary findings must be grouped for the sewing machine operators. Barcoded identification tickets attached to each bundle constantly keep track of work-in-progress and each garment by size and color. Bundled work is distributed to machine operators in the factory or sent out to contractors to be sewn.

■ CONTRACTING

Manufacturers are able to purchase pattern-making, cutting, and sewing from outside services or factories.

Most manufacturers do not handle garment production in their own factories. They are responsible for all phases of manufacturing, from design and fabric purchase to selling and shipping, but they may contract out some or all of the production. A *contractor* is an independent producer who does sewing (and/or cutting and pattern-making) for manufacturers.

Many manufacturers contract out all sewing because they do not own any production facilities. These manufacturers do not have to pay wages during slack seasons or be concerned with hiring, training, or wage demands of personnel. They also do not have to invest in plant facilities and machinery, which require large capital investment.

Contracting provides greater production flexibility, but it can involve problems. The manufacturer has less control over quality. There is extra movement of goods, which results in more costs and some losses. There may also be communication problems or a possibility of late deliveries.

The production manager selects the contractor who is most reliable and best suited for a particular job. Most contractors specialize either in a particular quality of sewing or in sewing one type of fabric, such as knits or wovens. Others are specialists in shirring, smocking, ruffling, pleating, or belt-making. Some manufacturers may arrange to work exclusively with one or more contractors. They try to make long-lasting partnerships with reliable contractors for their mutual success.

A contractor agrees to maintain a certain standard of workmanship and to finish work by a specific date. It is very important that the production head work closely with the contractor to make sure that standards and time schedules are met. For assembly, fabric is sent to the contractor, where it is cut and sewn. The contractor is given a sample duplicate and specifications to follow. Many contractors also make the patterns, markers, and samples. Finished garments are returned to the manufacturer for shipping to retail stores. Manufacturers may use domestic or foreign contractors.

Global Sourcing

Contractors can be located anywhere in the world where labor is abundant; wages are reasonable; and facilities, machinery, and transportation are available. In spite of technological advances, apparel manufacturing remains labor intensive. Therefore, manufacturers continually seek the cheapest sources of labor in Asia, Eastern Europe, Mexico, and the Caribbean. Apparel is manufactured in whatever country can produce the best garment for the lowest price. Now U.S. manufacturers are even sourcing in Swaziland, Burma, Cambodia, Moldova, and Turkmenistan. U.S. imports of apparel rise every year. Liz Claiborne, for example, sources, or contracts out, approximately 90 percent of its requirements offshore with some 250 independent contractors in 32 countries.[1] Sourcing situations change every month, so many manufacturers find that they must spread out their production so that one country is never the predominant source of production.

Apparel production for the American and European markets is vital to the growth of Third World countries. Since World War II, Asian countries have used textile and apparel production to build their economies, which in turn raises their standard of living.

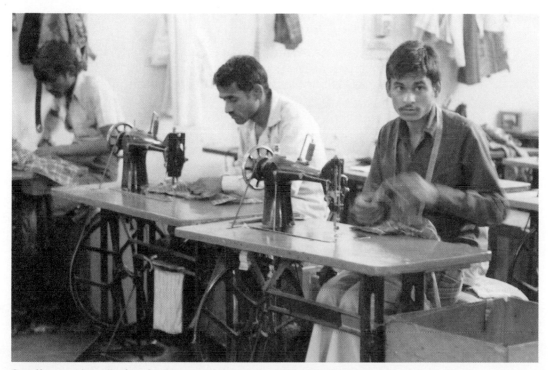

Small operations in developing countries such as this are disappearing as contractors build modern factories. *(Courtesy of Katrena Bothwell Meyer)*

Some American manufacturers have purchased or opened their own production facilities in Asia, the Caribbean, or Mexico. Asian firms are counteracting by investing in the United States, Mexico, Central America, and the Caribbean Basin.

Asia

Overseas production started in Hong Kong, which became the capital of Asian apparel manufacturing. Now these workers have become so skilled and well paid that only the highest quality clothing is made there. Manufacturers then sought cheaper labor sources in Taiwan, China, and South Korea. As these countries increased their skills and wages, other developing Asian economies, including India and Bangladesh, and Southeast Asian nations, such as Indonesia and Malaysia, were found as new sources. Also, areas developed specialties, India and Sri Lanka which are known for embroidery and beading. Compared with an average hourly wage of $12.97 in the United States, typical hourly wages (in U.S. dollars) are as little as 60 cents per hour in India or 62 cents per hour in China (but $5.65 in Hong Kong).[2] In the 1980s, 70 to 80 percent of apparel imports came from Asia.

Eastern Europe

Countries such as Poland, Hungary, Moldova, and Slovakia in Eastern Europe, which used to supply the former Soviet Union, are providing cheaper skilled labor for European manufacturers. Some American fashion companies, such as Liz Claiborne and Levi Strauss, are producing there as well. These countries have had to adjust from working in a command-oriented economy, where delivery schedules were not a problem, to working in a market-driven economy.

Sub-Saharan Africa

The United States has recently extended trade perks to apparel made in sub-Saharan African countries such as Mauritius, South Africa, Botswana, and Namibia, as long as U.S. textiles are used. This requires shipping the textiles there to be cut and sewn.

Mexico and the Caribbean Basin

As retailers increasingly order closer to season, manufacturers are sourcing closer to home. Production in these areas are also encouraged by the U.S. textile industry as domestic textiles can be sent there to be cut and sewn. Also, since NAFTA (see Chapter 2) was enacted, there are no tariffs on imports from Mexico. Several large U.S. and Mexican textile companies have created "Textile City," an industrial park south of Mexico City, to serve as a base for U.S. apparel manufacturers. Mexico is already the world's sixth largest apparel manufacturing country and the largest source of apparel imports to the United States.

Recent legislation has ended quotas and duties for Caribbean and Central American countries that use U.S. yarn and fabric. CBI sourcing is mainly in the Dominican Republic, Costa Rica, Guatamala, Honduras, Jamaica, Colombia, and El Salvador.

U.S. manufacturers like the quick turn around time provided by the close proximity of these countries and so tend to produce fashion apparel there.

Asian imports are now down to 37 percent of the total, whereas imported apparel from Mexico and the Caribbean Basin (CBI) is up to 40 percent.[3]

Overseas Production Methods

Importing, bringing merchandise in from other countries, involves numerous negotiators. Manufacturers need an agent to represent them in the country where production is done, a customs broker to assist in processing the import application papers with the U.S. government to bring the goods into the United States, and a freight-forwarding agent to handle shipping. Manufacturers must rely on a good agent or company representative to keep control of quality, prevent late deliveries, and handle difficulties in communication caused by language differences. Price negotiations are usually made in U.S. dollars because of the fluctuations in international currency exchange rates. Now that many overseas factories have become sophisticated, they are capable of producing an entire *package.* The factory managers are given a sketch (and perhaps a sample) and the sizing standards; they buy the fabrics and trims and are responsible for pattern-making, cutting, assembly, quality, and shipping.

Manufacturers must allow approximately 30 days for sea transportation or three days for express air delivery from Asia or Europe, plus trucking within the United States. An extra four days to two weeks must be allowed for customs clearance.

To produce overseas, manufacturers must send patterns, specifications, and/or samples as guidelines. In many cases, sketches and specs are sent by Intranet, and the factory makes the patterns and samples. All details must be exact and clear. Precise records and open lines of communication are a necessity. Fabric (which is also sourced abroad) is shipped directly to the contractor who does the cutting and sewing. There are three basic methods of producing clothing overseas: a production package; cut, make, and trim; and offshore assembly.

Production Package A manufacturer purchases a production package through an agent or company representative. In this case, everything originates in the production area, including raw materials, production, finishing, labeling, packaging, and shipping. Using an agent is the most expensive method, but it is advantageous because the agent takes full responsibility for production, quality control, and the delivery schedule. A manufacturer may also have its own representative abroad to find raw materials; work with agents and contractors; and oversee production, quality control, quotas, duties, and shipping.

Cut, Make, and Trim (CMT) A manufacturer may buy fabric from one country—silk from Korea, for example—and then send it elsewhere, to China perhaps, to be cut, sewn, finished, and labeled.

Offshore Assembly Fabric is purchased and cut in the United States and sent to Mexico or the Caribbean countries for sewing. This classification, item 9802 in the Harmonized Tariff Schedule (still referred to as the "807 program") is being encouraged to promote the use of U.S. textiles. For this reason, there is a guaranteed access level (large quotas) for this classification. Duty is charged only on the portion of labor done offshore.

Quotas The United States allocates *quota,* a limit on the quantity each country can produce for export to the U.S. A contractor must purchase this quota from those governments. The process is obviously very political and costly. As a result, quota is often the determining factor for the choice of country and contractor. Manufacturers seek out contractors that "own" enough quota to cover the amount of production to be done. However, after 2005, world trade will be almost quota-free, so sourcing will change dramatically.

Pricing To further complicate matters, manufacturers have to choose from various combinations of production and transportation packages that must be negotiated. Manufacturers make these arrangements according to how much they want to work directly with contractors and agents.

- Free on board (FOB) includes payment for the contractor to get the finished merchandise to the ship in the country where it is made. The manufacturer has to arrange and pay separately for transportation and deal with duties (taxes on imported goods). FOB is often used when dealing with Asia to make sure that the manufacturer is getting the cheapest transportation.

- Landed, duty paid (LDP) is a complete package, paying the contractor to ship the merchandise, including paying duty, to the distribution center in the United States by a specified date. This costs more but is less bother. It is often used for merchandise coming from Europe.

- Cost, insurance, freight (CIF) pays for insurance and freight to the final destination (only used when manufacturers do not want to or are unable to work with customs themselves).

Apparel Imports

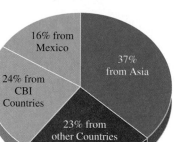

16% from Mexico

24% from CBI Countries

37% from Asia

23% from other Countries

Caribbean Basin Initiative Countries: Honduras 6.51%, Dominican Republic 5.43%, El Salvador 4.43%, Guatemala 2.23%, Costa Rica 2.21%, Jamaica .85%, Haiti .78%, Columbia .59%, and Nicaragua .49%, for a total of 24%.
Asia: China 10.20%, Hong Kong (separate customs and quota system) 5.90%, Korea 3.73%, Philippines 3.35%, Indonesia 3.07%, Thailand 2.97%, Cambodia 1.50%, Malaysia 1.22%, and small amounts from other countries, for a total of 37%.
Other Countries: Bangladesh 5.79%, Sri Lanka 2.50%, India 2.48%, Pakistan 2.03%, Canada 1.91%, Turkey 1.83%, Macau 1.60% and small amounts from the European Community, Eastern Europe, the Middle East, Africa, and South America, for a total of 23%.

Data source: "Major Shippers Report," U. S. Department of Commerce, Washington, D.C., September, 2000, pp. 1-4.

Reasons for Sourcing Abroad

The advantage of contracting overseas has been to keep production costs down, especially for garments with complicated construction. However, even though labor is inexpensive, there are other obstacles such as customs duties (tariffs), quotas, politics, freight costs, lengthy lead-times, and maintaining production controls at a distance, or having production supervisors move overseas. Also, additional costs are involved, such as travel to and communications with foreign countries. The trend toward increased overseas production continues, however. Manufacturers are continually seeking new sources of cheap labor.

The garment workers' union has been against overseas production because it takes jobs away from U.S. laborers. Since NAFTA was passed, 149,000 apparel workers (15 percent of the industry) have lost their jobs.[4] The United States has shifted from manufacturing to service industries. Most young people in America are just not interested in this work.

Sweatshops

Americans are deeply concerned about apparel contractor employees, both here and in Third World countries, who work in deplorable conditions. It was found that many workers in Asia were physically or verbally abused, punished for petty mistakes, forced to work overtime, and interrogated by police if they complained.

Officials from industry, human rights groups, and organized labor have set up a task force to set standards for garment factories worldwide. The participants issued a "Statement of Workplace Rights," setting guidelines for such issues as child labor, harassment, discrimination, health and safety, union organization, working hour limits, and wages. The task force wants to limit work to 10 hours a day and a 48-hour workweek, with a top limit of 60 hours including overtime. Wages would be tied to the cost of living for basic necessities, such as food and shelter, based on the cost of living in each individual country. Companies complying with these rights would have to consent to a monitoring program of their factories, but in turn would be able to advertise that they manufacture sweatshop-free products. Some American apparel companies have initiated their own strict contracts and audit procedures regarding employee conditions at contracting facilities. They are trying to set a good example for human rights.

■ GARMENT ASSEMBLY

The next step in production is the actual assembly or sewing of quantities of garments.

Assembly Operations

The steps involved in garment assembly are called operations. A man's suit may have as many as 200 different sewing operations. No two manufacturers use all the same methods, but all follow the same basic order. A supervisor analyzes a garment's construction to determine the best and fastest way to sew the garment. An operation sheet is drawn up, listing all necessary operations in sequence. This is usually part of a product data management computer system that collates all the information regarding the production of a garment style.

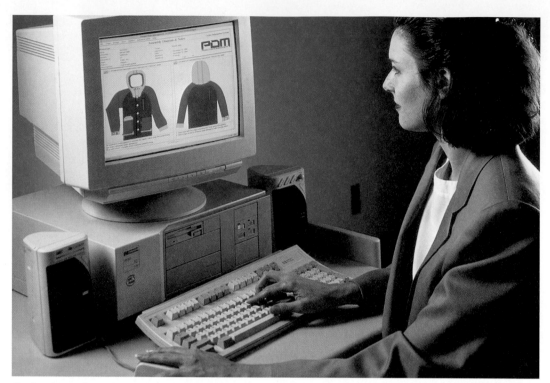

Gerber's product data management (PDM) system shows specifications and notes for jacket construction. *(Courtesy of Gerber Technology, Inc.)*

The introduction of specialized operations or new machinery requires additional training of operators, which results in higher production costs during the training period. As apparel manufacturing remains labor intensive, manufacturers and contractors find it necessary to rely on their operators as individual skill centers or as part of a small production team.

Individual Incentive Systems (Piecework)

Some sewing machine operators, finishers, and pressers are paid on a piecework rate. That is, they are paid a set amount for each operation that they complete, rather than by the hour. Rates vary with the difficulty of the operation. As proof of work completed, the operator signs the identification ticket or removes one segment of it. Actually, most companies pay a guaranteed wage, with piecework acting as an incentive for operators to work faster and, therefore, earn more.

Assembly Systems

Sewing operations must be performed in sequence. The three methods of construction are the progressive-bundle system, the tailor or whole-garment system, and the modular manufacturing system.

Progressive-bundle systems, which were used most often for sportswear but are fading out of use, require each operator to repeat one assembly task, such as closing a shoulder seam or stitching on a pocket. Referred to as *section work,* machine operators are grouped to follow the order of production; they pass the garments in units of 20 to 30 (typically in dozens) from one section to the next as each operation is completed. The advantage of progressive-

bundle systems is that the work area can be designed to complete a specific operation using the best machinery and trained operators for that job.

Whole-garment systems use a single operator to sew a whole garment together. This system is similar to the one used for sewing sample garments. In this case, finishing tasks may be performed by another operator who specializes in these operations. This system is used most often for dresses and couture.

Modular manufacturing is a team concept that involves the cross-training of operators and the development of small quality-circle production groups as initiated by the Japanese. Modular manufacturing involves a group of four to seventeen people who set their own standards and work together to produce a finished garment. Each team member works on more than one operation, and group incentives may replace or supplement individual piecework. Modular manufacturing has many advantages, including shorter cycle times, enhanced quality, fewer incidents of cumulative trauma (resulting from movement from machine to machine) and injuries, and higher morale because the work is less boring.

Ergonomics is the development of workplace equipment designed to improve the safety, health, and efficiency of workers. Government regulations, the high cost of workers' compensation, and rising health care costs have activated ergonomic strategies. As a result, new technology has produced quieter, easier-to-operate machines that reduce stress and injury and thereby build morale.

Computer Technology Used in Garment Assembly

Most factories have installed automated systems for the movement of goods and sewing to speed up production and cut lead-time. Manufacturers attend trade shows, such as the Bobbin Show in Orlando each September or the Sewn Products Expo in Los Angeles each April, to purchase machinery and learn the newest technology.

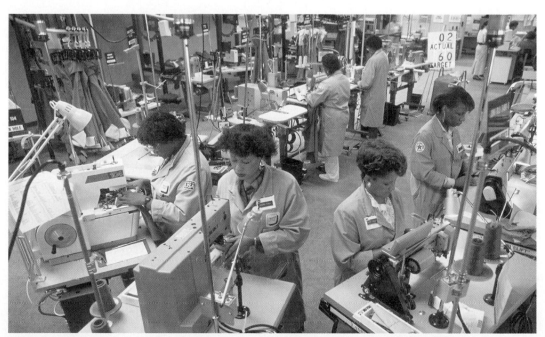

Modular manufacturing involves a group of people who work together to produce finished garments. *(Courtesy of [TC]², Textile/Clothing Technology Corporation)*

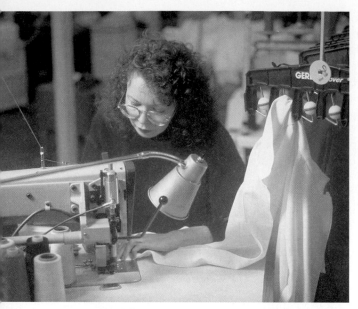

With this unit-production system, operations can be performed without removing parts from the hanger, thereby reducing production time.
(Courtesy of Gerber Technology, Inc.)

Computer-aided manufacturing (CAM) applications include computerized cutting and programmable sewing machines.

Unit production systems (UPS) use conveyors to move garments automatically from one work station to the next where each operator is responsible for one stage of the assembly process (see progressive-bundle systems).

Computer-integrated manufacturing (CIM) can connect these systems and share data for total automation. For example, a manufacturer can network data from a CAD pattern-making, grading, and marking system directly to a CAM cutting system.

Computer simulation allows for the viewing of a manufacturing floor plan on a computer screen before actual implementation. Through simulation studies, the type and number of machines and the number of operators needed may be determined before the assembly process begins.

Flexible manufacturing is simply a variety of strategies used by one manufacturer. Not all garments lend themselves to traditional or automated technologies; a flexible system uses a combination of methods.

The American Textile Partnership (AMTEX) is working together with the National Aeronautics and Space Administration (NASA) and the Department of Energy (DOE) to transfer their technology to the apparel industry. The areas of targeted research are analysis, simulation, and integration; automation; improved materials and processes; environmental quality and waste minimization; and energy efficiency.

Power Sewing Machines

Three main types of power sewing machines are used in traditional factories: the lock-stitch, the chain-stitch, and the overlock machine.

The lock-stitch machine sews a straight seam on the same principle as a home sewing machine. This machine makes it possible for the top thread to go under the bottom thread around a bobbin, creating a lock. This is the most secure stitch possible, but it leaves an unfinished seam, undesirable in fabrics that ravel easily. Also, of course, operations must be stopped frequently to rewind the bobbin.

The chain-stitch machine works on a principle similar to crocheting: it makes a series of loops pulled through one another. The top needle goes in and out of the fabric, making loops underneath that catch into one another. The chain-stitch is not as secure as the lock-stitch, but because the chain-stitch machine does not have a bobbin, the operator does not need to stop in mid-operation to rewind it.

The overlock or serging machine is based on the same principle as the chain-stitch machine and is also not as secure as the lock-stitch. It was created to make an edge finish as well as to sew seams. In one operation it sews the fabric together, cuts off the fabric to make a smooth edge, and wraps thread around the edge. A simple overlock machine has one needle and two loopers (which look like thick, bent needles) and works with three spools or cones of thread. The needle and loopers work together in a reciprocating pattern, the loopers moving back and forth from the needle to the fabric edge. This stitch

is ideal for knits because it gives with the stretch of the fabric.

The safety overlock machine is a combination of the chain-stitch and the overlock. The safety factor is that if one row of stitching comes out, the other still holds the garment together. With a total of two needles, three loopers, and five cones of thread, it functions as two machines in one. It provides the straight chain-stitch needed for factory assembling plus an edge finish.

The blind-stitch hemming machine is also based on the chain-stitch. The hem is folded back and caught by the needle at even intervals.

Button machines sew buttons onto a garment. Button placement is marked on the fabric. A sew-through button is placed in a holder, which moves the button back and forth while the needle sews it onto the fabric underneath. A shank button is held in position sideways so that the needle can go through the shank on its back. Some machines have a hopper, a feeding device that automatically positions the button.

The buttonhole machine is essentially a zigzag lock-stitch machine with automatic devices to control the width and length of the buttonhole and to cut it open.

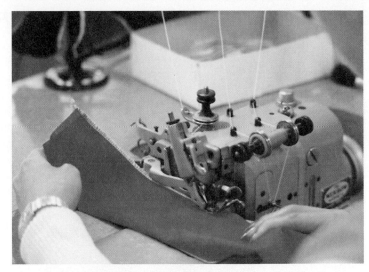

The overlock machine creates a finished edge as it makes a seam. *(Photo by the author)*

Programmable Sewing Machines

Generally, operators must first load fabric pieces into the sewing machine and press a button to start the sewing. Fully automated machines are microprocessor controlled and sensor activated, with an arm to grasp the cloth, align the fabric, and move it through the machine. Programmable machines have been very successful at surging or seaming basic pieces in garment assembly.

However, automated sewing is a difficult task because of the handling of different types of fabrics as they are sewn. Moving silk through a sewing machine is very different from moving wool, for example. The clothing industry remains labor intensive for two reasons. First, textiles are floppy and soft, which makes it difficult for robots to handle them and for computers to simulate their shapes. Second, since the industry is fashion sensitive, automated machinery must be able to change as fashion does, and it is very expensive to reprogram the machinery.

Finishing

Tailoring, the unseen quality handwork formerly done inside collars and lapels to form and hold their shape, has virtually disappeared because of the high cost of skilled labor. Most "tailoring" today is done simply by fusing or machine basting interfacings into the garment to give it shape.

Hand-finishing is usually seen only in couture garments. In better garments, some hand finishing is necessary, such as sewing in linings or sewing on buttons, but this too is becoming rare. In moderate- and lower-priced garments, all finishing is done by machine.

■ *PRODUCTION OF MEN'S SUITS*

The production of men's suits is one area in which tailoring is still used.

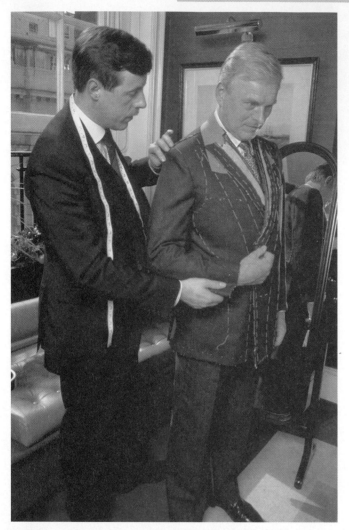

A fitting at Savile Row tailor Gieves & Hawkes.
(Courtesy of Gieves & Hawkes, London)

Traditionally, the men's clothing industry has been divided into firms that produce tailored suits, coats, and trousers and furnishing producers that make shirts, ties, underwear, and sleepwear. Tailored garment production used to dominate the industry, but with the trend toward casual dress for men, there has been a growing demand for sportswear. The production of men's sportswear is similar to that of women's.

Production of a man's suit, however, can require more than 200 steps. Inner construction to give a suit shape and body makes production lengthy, complicated, and costly. Formerly, the industry used a numbered system to rate the quality of men's suits, on a scale from 1 for machine-made suits to 6 for hand-tailored suits. This rating is no longer used because hand-tailoring has virtually disappeared.

Modern technology has introduced automation into an industry that was traditionally handwork oriented. Fusible interfacing has replaced hand-applied canvas in chest pieces, shoulders, lapels, collar, and buttoning areas to supply the required body and shape. Hand tailoring can be found in only the most expensive suits, such as Hickey-Freeman and Oxxford in America, or custom-made and other high-quality suits made in Europe and Hong Kong. At Oxxford, for example, tailors still put more than 2,000 hand stitches into the lapels of each suit jacket to give them a lasting roll.

Production Steps

The following basic steps are used in the mass-production of men's suits:

- Fuse or hand-stitch interfacings and jump-baste chest pieces and bridal tape on lapel crease for support
- Press, line, and stitch on pockets
- Join main pieces together
- Set in sleeves
- Set in linings by machine or, in the case of an unlined jacket, bind seam edges
- Sew buttons and buttonholes

■ *MASS CUSTOMIZATION*

Mass customization provides the individual fit consumers are increasingly demanding.

Retailers such as Levi Strauss & Co. and Brooks Brothers have adopted body-scanning technology developed by the Textile/Clothing Technology Corp. [TC]². This system uses white light to capture three-dimensional body images, a series of dense map points across the body, which are then converted to measurements via a software program. The resulting information can be sent to a laser, which would cut the cloth that would be sewn into a custom-fitting garment.

■ *PRODUCTION OF KNITWEAR*

The production of knitwear requires special skills and machinery.

The two commercial methods of knitwear production are cut-and-sew and full-fashioned.

Cut-and-sew is a method by which garments are made from knitted fabrics. This type of knitted garment requires the same patterning as that used for woven fabrics, except that pattern-makers must take the amount of stretch into consideration when making the patterns. Stretchability is the key to knitted garments; therefore, an overlock stitch is used, because it is flexible and gives with the fabric. Knitted braids and bands must be used as trims and finishes because all components must have the same stretchability.

Full-fashioned knits, mostly sweaters, are actually shaped on the knitting machine. The specifications for each piece are programmed into the knitting machine, which forms the shape as it is knit by adding or dropping stitches at the edge of each piece to widen or narrow it. Then the pieces are joined together. Most full-fashioned production is done in Asia because manufacturers saw the potential of cheaper labor there and invested in specialized machinery. Factories in Asia provide both affordable prices and variety of production.

Computers have also changed the production time and cost of knitting. Computer-aided design (CAD) systems permit designers to see a pattern or garment design on the computer screen or printed out on paper without having to knit a sample. Knitting machines tied into the computerized design screens will accept pattern and stitch changes in minutes rather than hours, allowing greater freedom for experimentation. Each type of sweater, whether it is intarsia, Jacquard, shaker, cable, or pointelle, has a different lead-time, quantity and weight of yarn required, gauge (stitch size), finishing treatments, and special skill and machinery needed to produce it.

Pattern is introduced by Jacquard and intarsia knitting systems. Jacquard patterns are created by various needle arrangements on electronic knitting machines. *Float Jacquard* shows the pattern on the face of the sweater while the yarns are carried on the back until needed again for the pattern. To create *a full Jacquard,* both the front and back beds of the knitting machine are

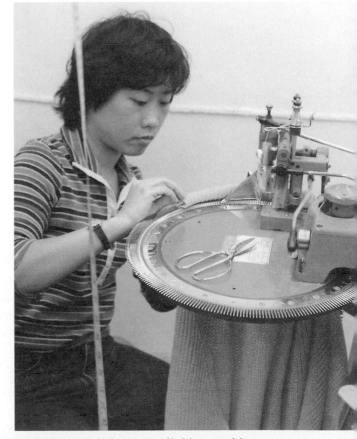

Joining sweater pieces on a linking machine at a knitting contractor in Hong Kong.

(Courtesy of Katrena Bothwell Meyer)

used, creating a heavier, double knit. The main design appears on the front with another simple pattern on the back to avoid floats. For *intarsia* patterns, the yarn is knotted and cut off in back when no longer needed for the pattern on the front.

Some sweaters are also hand-knitted or crocheted. Hand-knits have the greatest variety of stitches and detailing. However, because of the time needed to make them, they are very expensive. Hand-knit garments for commercial marketing are usually made abroad, where labor is cheaper and more readily available.

■ *PREPARATIONS FOR SHIPPING*

Pressing enhances a garment, quality control eliminates imperfections, and filling orders promptly facilitates on-time deliveries.

Dyeing and Washing

To ensure a perfect color match between garments to be worn together, manufacturers can dye the finished garments, which are in this case made with greige (gray) goods. This also allows manufacturers to assort colors later, according to actual orders. Benetton was a pioneer in this method. However, it is as expensive as it is difficult to control dye baths to prevent shading.

In jeanswear, washing is sometimes a way of finishing the garment. For a bleached look, environmentally friendly enzyme and stone washes have replaced acids. A popular trend in sportswear today, especially for denim, is simply to wash and fold the items.

Pressing

Pressing vastly improves the look of a garment. It can hide a multitude of imperfections, such as puckered seams and collars that do not lie flat. Garments are pressed during the course of construction as well as at completion. Steam irons are used for areas not easily accessible. Various buck pressing machines, like those seen at a dry cleaner, are used on tailored garments to flatten jacket edges, crease trousers, and so on. Automated pressing is done by computer-controlled pressing equipment.

Quality Control

Quality control is the standardization of production using specifications as guides. The last garment sewn should be the same as the first garment. A sample-maker can make one garment neatly and accurately, but it is more difficult to control quality in the mass production of 500 or 1,000 dozen garments. To ensure that production has been done correctly and to prevent returns, both work-in-progress and finished garments are inspected either totally or by random sampling. Quality controllers not only check for poor sewing, but also spot-check measurements against original specifications. Quality control teams may travel to spot-check quality at contractors' facilities. If there are mistakes in *first stock,* the production manager tries to correct them at the sewing or cutting source.

Production standards are very important and must equal the manufacturer's reputation and warrant the garment's price. It means nothing to have a beautifully designed garment if it is not produced well. Inferior garments

may be rejected by the store and returned to the manufacturer, or they may look so unappealing on the hanger that customers will not buy them. Either event would mean loss of reputation and future sales.

Computer bar coding or numbers on each garment's label identify the factory where the garment was made, enabling construction mistakes to be traced to their source. Besides construction mistakes, reasons for returns include poor fabric and fabric shading. The manufacturer tries to prevent these mistakes in future shipments. Manufacturers have realized the need to improve the quality of their products as consumers become more demanding.

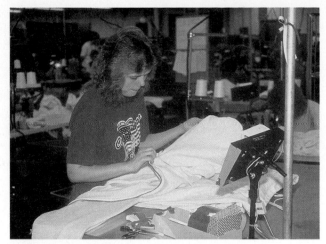

Quality control is an important part of apparel production. *(Courtesy of the National Cotton Council)*

Labeling

Labels are the sources of identification for garments. Along the production line, various labels must be attached to the garment. These include manufacturer and/or designer identification, fiber content, care instructions, country of origin, size, and a union label if made in an American union shop. Federal law requires listing fibers in order of percentage used, along with cleaning or washing instructions.

Labels can help establish the company's image. They tell the consumer the name of the brand and/or designer. Some people are attracted to a particular label or brand because of its reputation for quality or fit. The brand label is usually made on satin or twill ribbon and sewn inside the center-back neck, inside the waistband, or somewhere on the inside of the garment. It has even become fashionable to put labels on the outside of sportswear garments. Jeans often have a leather-like printed patch sewn on the outside.

A label showing fiber content, care instructions, and country of origin must also be included in the garment. This information is usually on a separate small label under the brand label or on an inside seam.

There are pages of government regulations concerning fiber-content and country-of-origin labeling. Essentially, the predominant fiber in the garment is listed first along with its content percentage, followed by the other fibers in decreasing order of content. Care instructions are recommended and can be very specific. These instructions not only protect the consumer but also protect the manufacturer against returns made by consumers who do not care for their garments as instructed.

A country-of-origin label is required by customs if the garment is made outside the United States. The label must say "Made in (name of country)" or "Made in USA of imported fabric." A "Made in USA" label is reserved for garments made entirely in the United States of American fabric. Items made partially in a foreign country and partially in the United States must disclose these facts; for example, a tag might read "Assembled and sewn in the USA of components made in (name of country)."

In addition, sportswear often has pressure-sensitive labels showing sizes on the outside of garments, particularly when they are folded. *Flashers,* printed cards that give product information, may be stapled to the outside of sportswear.

Hangtags, printed paper tags, may be hung from the garment by plastic staple, barb, or string. Hangtags are designed to draw attention to the garment and are hung on the side of the garment so that the customer can see them

easily. They usually show the brand name, perhaps style number, color, size, and other product information. Sometimes hangtags are provided by the fiber or fabric producer to promote their fibers or finishes.

Floor-Ready Standards

Striving for "seamless distribution," to trim distribution costs, and put new merchandise on the sales floor more quickly, many retailers are requiring manufacturers to comply with "floor-ready" standards. Manufacturers are requested to preticket garments with bar-coded price tags provided by the retailer and to have the merchandise already on Voluntary Inter-industry Communications Standards (VICS) hangers. This eliminates the need for distribution centers to unpack shipments, tag and price goods, and put garments on hangers before repacking and shipping them to individual stores. VICS is also recommending improvements such as universal security tags, hanger recycling, and reinstituting direct shipments to stores. Radio-frequency technology (RF) allows tags to be embedded into garments that contain information on source of fabric, factory location, shipping, and importing.

Filling Orders

At distribution warehouses, garments are checked for quality and then divided into groups according to style, size, and color and put into stock, a storage area where they may be hung on racks or stacked on shelves.

Retail orders for a certain quantity of units, on a form that includes entries for style number, color number, and price per unit, have been preanalyzed for a credit rating. Purchase order forms are becoming standardized, which makes ordering and shipping more efficient. The next step is to see what is available in stock to fill the order. Large orders and orders from important regular customers are filled first. Merchandise is pulled from stock to fill orders in the correct style, size, and color. Orders can be transmitted by EDI and then automatically translated into *advance shipping notices (ASNs)* and invoices. ASNs are sent to the store before the shipment arrives so that they know what it contains.

Garments are folded into shipping boxes and marked with the means of transportation specified by the retailer. Large manufacturers are using robotic automated warehouse equipment to speed packing. A packing slip (an invoice without prices) is enclosed in the box, while the actual invoice is mailed separately for payment. Manufacturers often use bar-coded "128" or "2D" cartons, which can be scanned at the retail distribution center to reveal the contents without opening the box. The boxes are labeled with addresses and then moved by trolley or conveyor belt to be loaded on the delivery truck and sent to the retailer.

On-time deliveries are extremely important to prevent cancellation of orders. On the basis of reliable production and delivery standards, a manufacturer builds and keeps a reputation for dependability that accompanies its reputation for innovative styling.

■ SUMMARY

In this chapter, we discussed garment costing, pricing, and production scheduling. We have seen how garments are manufactured, from piece goods purchase and inspection, through patterning, grading, marking, cutting, assem-

bly, and finishing, to quality control. Many manufacturers use foreign contractors for production to reduce labor costs. Factories try to use the newest computer technology, including inventory control and electronic data interchange, as well as computer pattern-making, grading, marking, spreading, cutting, and assembly systems to reduce costs and speed production. Men's suits and knits present unique methods of garment production. Quality control and on-time deliveries help the manufacturer maintain a good reputation for dependability.

■ CHAPTER REVIEW

Terms and Concepts

Briefly identify and discuss the following terms and concepts:

1. Wholesale pricing
2. Cost sheet
3. Cost merchandising
4. Loss leader
5. Grading
6. Tight marker
7. Issue plan
8. Cut-to-order versus cut-to-stock
9. Piece goods
10. Contracting
11. Global sourcing
12. Laser-beam cutting
13. Offshore assembly
14. Piecework
15. Progressive-bundle assembly system
16. Computer-integrated manufacturing
17. Modular manufacturing
18. Unit production systems
19. Tailoring
20. Cut-and-sew knits
21. Full-fashioned knits
22. Quality control
23. Preticketing

Questions for Review

1. What factors are considered when costing and pricing a garment?
2. What are some of the things to consider when purchasing piece goods?
3. Discuss the differences between the cut-to-order and the cut-to-stock methods of production.
4. Briefly explain making and grading patterns on a computer.
5. Describe the differences among the major cutting methods.
6. Describe three ways in which computers aid apparel manufacturing.
7. Explain various systems of garment assembly.
8. Why do manufacturers use contractors?
9. Discuss what is involved in overseas production.
10. How has the construction of men's suits changed over the years?
11. Explain the two methods of producing knit garments.
12. Why is quality control so important?

Projects for Additional Learning

1. If there is an apparel manufacturer or contractor in your area, try to make an appointment for a factory tour. Observe production methods. Do operators do section work, or does one person sew one whole garment together? What computer technology is used in the factory? What production methods are unique to the product? Compare the wholesale price range of the garments being produced with the quality of production.
2. Visit a local store and compare imported ready-to-wear with domestically produced items that retail at the same price. Consider fit, styling, and quality. Which is better? Why? What conclusions can you draw from this comparison?
3. Investigate a major apparel manufacturer by interviewing managers, reading the company's annual report, reading trade newspaper articles about the company, or writing to the company for information. Write a profile of the company, including ownership, type of garments produced by each division, type of customer to which they appeal, type of production, price line, and where products are sold.

■ NOTES

[1] Bob Zane, Senior Vice President, Manufacturing and Sourcing, Liz Clairborne, interview, May 2, 2000.

[2] *The U.S. Textile Industry: Scope and Importance,* American Textile Manufacturers Institute, Washington, D.C., 1999, p. 42.

[3] David Link, ATMI, interview, February, 2000.

[4] *The U.S. Textile Industry: Scope and Importance,* p. 47.

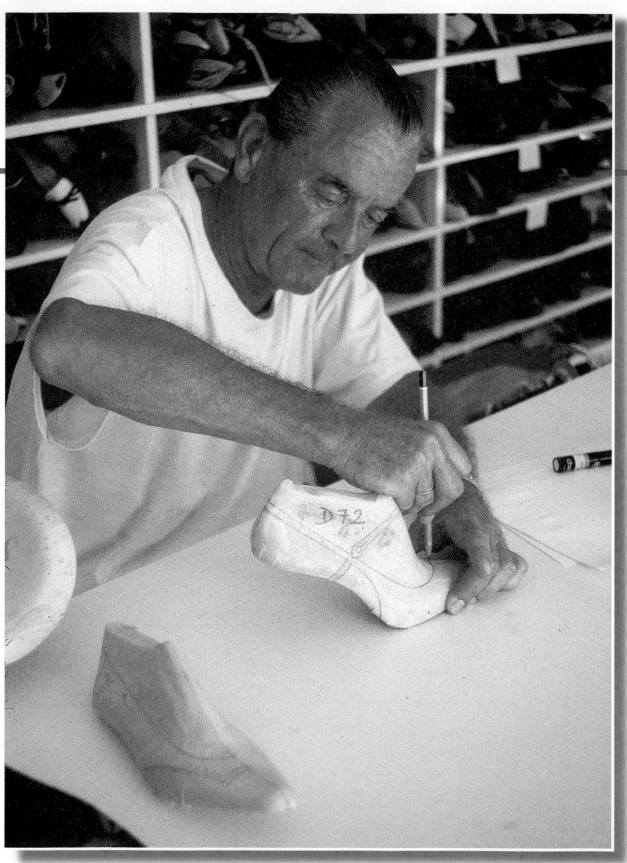

Trend-setting shoe designer Andrea Pfister at work at his studio in Italy.
(Courtesy of Andrea Pfister, photo by Mary Trasko)

11

Accessory and Fur Manufacturing

■ CAREER FOCUS

Almost every category of accessories is a separate industry. Each area needs its own product developers, merchandisers, designers, pattern-makers, production managers, marketers, and sales representatives. In the fur industry, production jobs are limited, but marketing careers are possible in major fur centers.

■ CHAPTER OBJECTIVES

After reading this chapter, you should be able to:

1. Discuss the unique design considerations of various accessories;
2. Describe production methods for the major accessories;
3. Explain accessory design and production centers;
4. Discuss aspects of marketing for accessories;
5. Explain fur garment production.

*T*his chapter discusses design, manufacturing, and marketing as they particularly apply to accessories and furs. Handbags, shoes, belts, gloves, and furs have in common the age-old use of animal skins as a raw material. Separate sections cover the styling and production of shoes, handbags, belts, gloves, hats, scarves, hosiery, jewelry, and furs because each type of accessory has its individual methods for design and production. Although fur coats and jackets are wearing apparel, they are discussed separately because of the specialized methods used in their manufacture.

■ *FASHION ACCESSORIES*

Accessories are an important, integral part of the fashion business.

Award-winning accessory designer Kenneth Cole now also designs ready-to-wear. (*Courtesy of the Council of Fashion Designers of America, photo by Mary Hilliard*)

Accessories such as shoes, handbags, belts, hats, and jewelry are designed to coordinate with apparel to create a total fashion look. The fashion for particular accessories is usually at the mercy of apparel designers and how they accessorize their designs on the runways. However, one of the most notable developments in the fashion industry over the past several years is the emergence of new apparel collections by accessory companies, such as Gucci, Ferragamo, Louis Vuitton, Kenneth Cole, and even a Nine West apparel line by Jones New York!

Over the last several years, the accessory industry has become one of the most exciting segments of manufacturing and retailing. Accessories are sometimes more important than ready-to-wear. Abe Chehebar, CEO of Accessory Network explained, "Because accessories are so visible on the first floor of most retail stores, they communicate new fashion ideas, color, and designer or brand names to the consumer. Designers are communicating their image through their accessories."[1]

Each category of accessories is an industry unto itself. The shoe and hosiery businesses are dominated by large companies. The handbag, glove, scarf, millinery, and jewelry industries are comprised of many small firms in New

York City and all over the country. However, like the apparel business, there have been many consolidations.

Fashion Trends

The popularity of various accessories is cyclical. As fashion changes, so does the need for certain accessories. The fashion for belts is related to waist interest in apparel. Accessories such as jewelry and scarves become more important when clothing is classic and simply styled. Fashion in hats is related to hairstyles. There are currently simultaneous trends for extravagant elegance and casual looks. Accessory manufacturers are catering to both.

Product Development and Design

Designers, merchandisers, and product managers of accessories must be aware of fashion trends to make accessories that successfully complement apparel. These individuals may attend the Premiere Classe accessories show, held twice a year in Paris. They are also influenced by the same factors as apparel designers (see Chapter 4) and develop their seasonal collections in much the same ways. Accessory manufacturers have anywhere from one to five seasonal lines per year, depending on the type of accessory and its price range. Within each line, groups usually have a theme based on function, fabrications, quality, and/or price range.

Diversifying Products

Brands and designer names drive today's accessory business. To balance product lines in the face of fashion cycles and to increase business by capitalizing on strong brand images, many accessory companies have diversified into other areas. Ferragamo, the famous shoe manufacturer, also makes handbags, jewelry, and even ready-to-wear. Hermès has added ready-to-wear to their venerable line of scarves and leather goods. Handbag designer Kate Spade has added stationery, shoes, pajamas, luggage, scarves, and glove lines. Shoe designer Kenneth Cole has more than 30 licenses including a sportswear line by Liz Claiborne. Even Samsonite now has a ready-to-wear collection.

Apparel designers want accessories that are specifically created to go with their apparel collections. For this reason, leading apparel companies such as Donna Karan have added accessories to their product lines by opening their own accessory divisions, through licensing arrangements, or through joint ventures with accessory manufacturers. Even though the designer name is on the product in the store, it is produced and sometimes marketed by an accessory manufacturer with expertise in that area. Accessory marketing benefits from the designer's apparel advertising and the resulting consumer name recognition.

Production

The differences in function and fabrication are why production is so vastly different in each accessory area. Production methods are discussed separately under each category.

Except for hosiery, the accessory market is very involved with importing. High-end accessories from foreign manufacturers, such as Ferragamo and Gucci, are imported by retail stores. Other importers bring in merchandise to sell under retail store private-label names. Also, because accessory production

is labor intensive, many U.S. manufacturers have their merchandise produced in other countries where labor is cheaper: in Asia (especially China), the Philippines, Eastern Europe, and South America. On the other hand, some American accessory manufacturers have had success exporting. Nike, Reebok, and Betmar are just a few examples.

Marketing

Marketing methods vary from company to company depending on the type of accessory and price range. Most manufacturers show their new collections in their New York showrooms during market weeks. They also may have showrooms in major market centers around the country, such as Los Angeles, Dallas, Atlanta, or Chicago, as well as sales representatives who call on retail store buyers across the country. Manufacturers may show their products at the Fashion Accessories Expo or Accessories Circuit three times a year in New York City, showing spring and summer merchandise in January, fall merchandise in May, and holiday and resort merchandise in August.

Accessory manufacturers are experimenting with E-commerce and setting up websites. Initially, they are using the Internet to make their brands known and to educate consumers. Some companies, such as Dooney & Bourke and Fossil, have online catalogs. Customers can see the products up close and three-dimensionally. Sites are updated frequently to show seasonal and holiday merchandise.

In another effort to control merchandising and image and have direct access to consumers, many accessory companies have opened their own retail stores. In Europe, it is common for accessory companies such as Ferragamo, Gucci, and Aigner to have their own retail stores. Also, American shoe companies have traditionally had their own retail stores in order to stock sufficient inventory and maintain trained sales staffs. However, retailing is a fairly new idea for most accessory manufacturers in the United States. Now accessory companies, such as Nike, Carlos Falchi, Robert Lee Morris, and Carolee, are opening their own specialty stores. These stores provide accessory manufacturers with increased brand awareness and the opportunity to present their entire collection unedited by a buyer, as well as to make customer contact.

Accessory manufacturers also have merchandise representatives who work at multi-brand retail stores to educate sales associates, arrange merchandise displays, and help customers. Accessory designers may make personal appearances in stores to promote sales and test consumer reactions to new styles. Many stores also have in-store boutiques featuring brand-name and designer accessories. Bloomingdale's, for example, has accessory boutiques for Salvatore Ferragamo, Louis Vuitton, Chanel, and Judith Leiber.

Large retail stores may also have accessories produced for them to sell exclusively. Store accessory departments have traditionally been on the main floor. Now many retailers have opened accessory shops on their ready-to-wear floors next to apparel to help sell accessories and to help the consumer find a complete outfit in one area.

Footwear

Footwear, including shoes, sandals, and boots, is the largest category of accessories. More than seven billion pairs of shoes are produced worldwide each year. Both functional and fashionable, shoes come in assorted materials, including calf, kid, suede, and reptile skins; imitation leathers; and fabrics such as canvas or nylon.

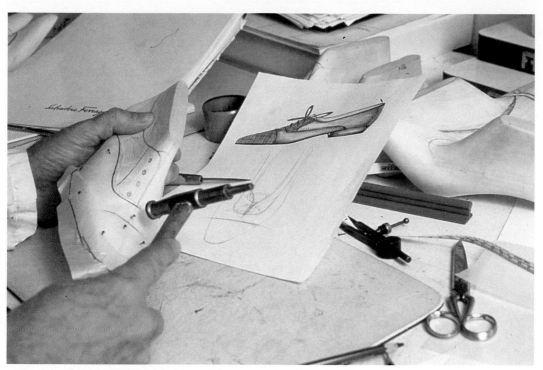

Test of a paper shoe pattern on a wooden last. (*Courtesy of Ferragamo, Florence, Italy*)

Today the shoe industry caters to both dress and casual trends. As a result of the enormous popularity of sport shoes, comfort has become an important element of shoe design. A number of popular shoe brands, from Florsheim to Ferragamo, have tried to combine style with the comfort of athletic shoes.

Design of Leather Fashion Shoes

Most dress shoe design direction comes from Europe. Creative international shoe designers such as Manolo Blahnik and Robert Clegerie set international trends for women's fashion shoes. Shoe designers study fashion trends so that their shoes will coordinate with apparel.

Many shoe company designers or *line builders* (product managers) attend the shoe fairs in Düsseldorf, Germany, and Bologna and Milan, Italy, to get ideas for a new shoe collection. Like an apparel merchandiser, the line builder begins with concepts for groups and works with designers who develop individual shoe styles. Designers are primarily concerned with materials, color, shape, and proportion. They must consider the view of the shoe from all angles. Many shoe companies are using computer-aided design (CAD) systems that are capable of both two-dimensional design (design of uppers and size grading) and three-dimensional design (design of the last, a foot-shaped form, and projection of the drawing on the last).

Sometimes the line builder will buy *prototypes* (sample shoes) from a *modelista* (model maker) at a studio or shoe fair. Or, the line builder might forward a designer's sketches to a modelista, who makes the first model. If the line builder and modelista live in different countries, ideas and samples must be sent back and forth by the Internet or via fax. The sample shoes are edited to form a balanced collection. Duplicates are then made for the sales staff, showroom, and trade shows.

Leather Sourcing

Leather sourcing is usually close to production: Italian leather for shoes produced in Italy, South American leather for Brazilian-made shoes, and Chinese leather for Asian-made shoes. However, leather is sometimes sourced in one country, sent to another for production, to be marketed in a third country.

Production of Traditional Leather Shoes

Traditional shoe production is complex, involving various measurements for length and width combinations. The full range of women's shoe sizes includes 103 width and length combinations between sizes 5 and 10. Shoes for the American market are made on American lasts. European shoes have only one width, whereas European shoes exported to the United States are usually made available in four widths.

Another factor contributing to the complexity of shoe production is the skilled labor needed to complete the number of operations performed. Two to three hundred operations can go into the production of a finely made fashion shoe. If a shoe is made in a factory, 80 different machines could be involved in its production. Shoe parts must be joined together for a smooth, perfect fit. Whether a shoe is handmade or mass-produced, there are usually 10 basic steps:

- **Making the last**—A foot-shaped form called a *last* is created. The original last is made of wood and requires as many as 35 different measurements. A shoe factory needs thousands of lasts, one for each size, width, heel height, and basic style. Duplicate polyethylene lasts are made from the master.

- **Pattern-making**—A pattern is created based on measurements taken from the last and from the original *pullover model*, which is sewn and tacked onto a last. A trial shoe is made from this pattern. The line builder

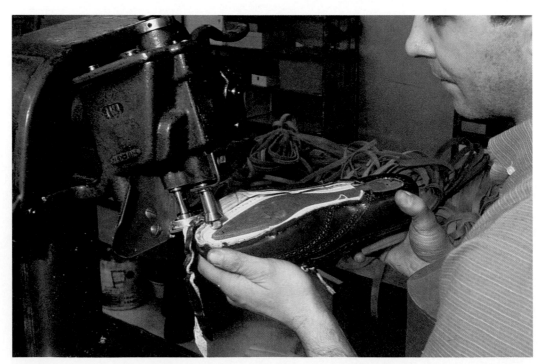

Attaching a leather shoe upper to a last. (*Courtesy of Bally of Switzerland*)

further assesses and refines style selections at this time, and the final line is closed or "frozen." Trials are duplicated as samples for sales representatives.

■ **Cutting**—Paper patterns are converted into steel dies that cut the leather. Modern factories use programmed continuous cutting machines or water-jet cutters to cut the leather.

■ **Stitching and fitting**—The upper portion of the shoe is made, including buttonholes, topstitching, and all other upper design details. Then linings are added.

■ **Lasting**—The shoe upper is pulled over the last and attached to the innersole.

■ **Bottoming**—The sole is attached to the upper by sewing, cementing, vulcanizing, nailing, stapling, or molding. Most shoe soles are cemented to the uppers.

■ **Heeling**—Heels, premolded in plastic and covered with leather or wood, are attached.

■ **Finishing**—The finished shoes are polished, and the last is removed.

■ **Treeing**—Shoes are dried and receive a final inspection. Tissue and sticks are put into the shoes to help them retain their shape.

Large companies have a competitive edge because they have the capital necessary to invest in the most advanced machinery and computer technology. Widespread use of *computer-aided shoemaking systems* enables manufacturers to speed production, improve quality, and keep labor costs down. Programmable machines are now available for nearly every aspect of production, including sewing and lasting.

Domestic shoe production has declined so that there are only about 375 manufacturers operating 460 plants in the United States with employment at approximately 48,200. The small amount of domestic shoe production left, primarily of men's shoes, is done in New England and the Midwest. These firms include better classic men's shoes, such as Johnston & Murphy, Allen-Edmonds, Cole-Haan, and Alden, and moderate shoe lines, such as Florsheim, Bass, Dexter, and Bostonians. In the future, it seems that weaker firms will continue to close while stronger ones will consolidate plants and invest in new technology to narrow the gap between foreign and U.S. labor costs.

Imports

The increasing number of imports has had an enormous impact on the U.S. shoe industry. As there are no quotas on shoe imports, they have reached a new high of 88 percent of the 1.1 billion (nonrubber) pairs purchased in the United States (80 percent of those imports come from China).

The highest quality women's fashion shoes, such as Robert Clegerie, Manalo Blahnik, Andrea Pfister, Patrick Cox, Prada, Bruno Magli, and Ferragamo, are made by hand in Italy with the finest leathers. Apparel designers such as Calvin Klein have shoe collections made by Italian shoe manufacturers, in this case Diego Della Valle, in joint ventures or via licensing arrangements. Some women's manufacturers, such as Magli and Ferragamo, also make men's shoes, as do men's shoe companies, including Borri and Lorenzo Banfi.

Bridge lines such as Adrienne Vittadini, Anne Klein II, Via Spiga, Amalfi, or DKNY may be made in Italy or Spain. Better shoes, including Liz Claiborne, Nickels, Caressa, or Pappagallo, are typically made in Spain, Brazil, or China. China now makes 80% of all shoes sold in the United States!

Moderate, budget, and sport shoes are usually made in China, Korea, or Mexico. Manufacturers are always seeking new, cheaper production sources. Some companies buy production time in overseas factories; others own facilities in Italy, Spain, or South America.

Marketing

Most shoe importers, such as Schwartz & Benjamin, are essentially marketers. They buy or license the designs and contract production. They operate this way because they believe they know what their customers in their own countries want and, therefore, can market the shoes more effectively.

Shoe companies may have shoe lines in all price ranges and categories. For example, Nine West has acquired the Bandolino and Easy Spirit brands from the former U.S. Shoe Company.

Because of the large inventories needed to stock shoes in all styles, colors, sizes, and widths, many shoe manufacturers own their own stores. Nine West and Florsheim, for example, have their own shoe stores. Some also lease departments from department and specialty stores, but this practice is on the decline.

MICAM, the prestigious international shoe fair, is held in Bologna in March to show fall styles and in Milan in September to show spring styles. Other important international markets include the GDS footwear show in Düsseldorf; MIDEC in Paris; and FICC in Elda, Spain. The Fashion Footwear Association of New York (FFANY) holds six markets a year at the Hilton in New York: The New York Shoe Expo in June and November, Collections in January and August, and Market Days in April and October. The largest shoe show is organized by Western Shoe Associates (WSA) in Las Vegas each February and August. Buyers shop for early spring styles in June, for spring and summer in August, for early fall in December, and for fall and holiday in February. Shoe manufacturers use methods such as the Internet and seminars to educate consumers and sales personnel about quality and styling. Some shoe companies, such as Ferragamo or Nine West, also manufacture handbags.

Handbags

A handbag must be both decorative and functional; it must hold necessities conveniently as well as fit into the fashion picture. Large bags such as totes, satchels, portfolios, or backpacks tend to be functional; smaller bags such as clutches or envelopes are usually decorative. Handbag styles range from classic, constructed types to soft shapes. Leather, including suede and reptile, still represents approximately half of handbag material; vinyl, fabric (tapestry, rug prints, needlepoint, silk, wool, nylon, and canvas), and straw make up the other half. Prada and Gucci are among the trendsetters in handbag design. Major trends include a wide variety of shapes in an array of colors, some with beading or embroidery.

Product Development and Design

The elements of fabrication (leather or fabric), silhouette, and color, as well as current trends in ready-to-wear and footwear, are the most important components of handbag design. From an initial sketch, a sample is made from muslin or imitation leather. A final sample is made up in leather or fabric with appropriate supportive stays (made of treated paper). Felt, foam, and fabric interlinings are layered around the stays to give the bag a nice hand and

Handbag designer Joanne Loiacono designing on a computer at Accessory Network.
(Photo by the author)

cushion. Ornaments, closures, and/or handles must be chosen to complement the shape and fabrication. Linings differ with each type of bag and each fabrication.

The product development team, designer, pattern-maker, sample-maker, production manager, and sales managers, critique the samples. The most successful are chosen for the collection. Within the collection, groups may be based on fabrications, silhouettes, or themes. Usually, a variety of silhouettes are included, perhaps in various fabrications (types of leather). Several groups create a well-rounded collection.

Production

When the final line is chosen, cutting dies are made from the pattern and used to stamp out leather, or the leather may be cut by water jet. Luxury handbags are cut by hand. Rising prices and reduced availability of leather in recent years have had a great impact on the styling and production of handbags. Fabric bags are cut by methods similar to those used in the apparel industry.

Luxury Handbags The type and quality of workmanship varies greatly. At the top of the luxury market are Hermès handbags, which are entirely handcrafted. Production is limited and is allocated by the number of hours it takes to make a bag. For example, it takes 16 hours to make a "Kelly handbag," which costs more than $3,000. Each bag is dated and stamped with the craftsperson's initials. Distribution is limited to maintain exclusivity.

Judith Leiber is the only American luxury handbag company to actually produce in the United States; her *minaudier* (hand-molded metal) evening bags are made in New York. Most other luxury handbags are made in France or

Italy, including those for Chanel, Bottega Veneta, Prada, Fendi, and Ferragamo. The Italians are trying to encourage young people to learn craftsmanship to carry on the Italian tradition of quality production of luxury leather goods.

Designer and Better Handbags In the production of better handbags, both fabrics and leathers may be stitched by machine, but much of the assembly of linings, ornaments, handles, and closures must still be done by hand. Although this handwork is expensive, some handbags are still made in the United States, primarily in New York, Maine, Connecticut, Massachusetts, and Florida. However, to keep costs down, many manufacturers worldwide for the cheapest labor. Of the imports, better handbags are made in Hong Kong. Other handbag production sources include South America, Indonesia, Korea, Taiwan, China, and India.

American handbag designer lines include Carlos Falchi, Kenneth Cole, and Kate Spade; apparel designer handbag collection examples are Anne Klein or Donna Karan New York (DKNY); and bridge brands include Bally of Switzerland, Coach, Etienne Aigner, or Donney & Bourke. Coach bags are also made in the United States.

Moderate and Inexpensive Handbags Moderate bags are sometimes made of leather but usually of vinyl or fabric. Examples of moderate brands are Nine West, Liz Claiborne, and Esprit.

Moderately priced bags are primarily imported. Handbag imports have risen to approximately 75 percent of U.S. consumption, mostly from China. To keep prices down, many stores create *private-label* handbags in all categories.

Marketing Director Karen Weiss showing a handbag line in the Accessory Network Showroom.
(Photo by the author)

The retailer works directly with a manufacturer, labels the handbags with the store's private brand, and eliminates the cost of wholesale marketing.

Marketing

Luxury collections can be found at Mipel, the Italian trade fair in Milan twice a year. U.S. collections are shown in New York and other market center showrooms as well as at the Fashion Accessories Expo. The two major handbag markets occur in May for the fall and in November for the spring. Smaller markets are in August, March, and January.

Belts

The fashion for belts in women's wear is *apparel driven* (corresponding to waist interest in apparel styling). In women's wear, a return to classic apparel means a rise in belt sales. Fashion belts are made of lightweight leathers and suedes, metallics, woven cord, metal chain, fabrics, and elasticized fabrics. Men's belts are strictly functional and must withstand everyday wear, so they are traditionally made of heavy (5- or 6-ounce) leather.

Many apparel companies, such as Chanel, Donna Karan, Calvin Klein, and Liz Claiborne, have belts manufactured to accessorize with their clothes. Accessory companies such as Hermès, Ferragamo, and Gucci also make belts to coordinate with their handbags. These firms try to carry a design element throughout their accessory lines. A chain belt might repeat the design of a chain strap on a handbag, or a handbag clasp might be copied as a belt buckle.

Production

Leather and imitation leather materials are cut on *strap-cutting* machines or on computer-aided cutting machines. These machines cut the material into long, straight lengths of any desired width. Shaped belts are made either by die cutting or from Plexiglas patterns. With die cutting, the pattern is made into a die resembling a cookie cutter. A *clicker* machine presses the sharp edges of the die through the leather. Plexiglas patterns are used like paper patterns for single-layer cutting. The cutter must carefully cut around the patterns, using only flawless pieces of leather. Computer-automated cutting has helped speed up production and ensure accuracy.

The cut leather is then sewn or laminated to a backing with a *walking-foot machine* or on computer-automated machines. Belt buckles, made from metal, wood, or plastic, come mostly from Italy (for high-priced lines) or Taiwan. Sterling silver buckles also come from the Southwest for western-inspired styles. Holes are made at one end of the belt by a foot-press or kick-press machine. The holes, the slit for the buckle, and the shape of the tip may also be cut by a die. In addition, a die can emboss a pattern onto the leather. Belts are finished with trims, such as stitching, cording, nail heads, or rhinestones, and may have an edge finish.

Belt manufacturers tend to be small firms. The industry is centered in the New York metropolitan area because of that city's proximity to suppliers, but production is also growing in California. A large investment in equipment is needed to finish leather well, but some of the operations can be contracted out. As in the manufacture of other accessories, belt production has moved extensively to Asia. Many belts are now made in China, Taiwan, Korea, and Hong Kong.

Markets

As with handbags, belt markets are held five times a year in New York and market center showrooms. Belt manufacturers also show at the Fashion Accessories Expo.

Gloves

Gloves are both functional and fashionable. They are needed to protect hands for work, sports, or from the cold. The fashion aspect is cyclical; gloves are more in demand when fashion apparel is elegant.

Product Development and Design

Glove manufacturers have only one line per year, which is shown in November for the following fall and winter. This means that designers must work up to 2 years in advance of the selling season. The timing is very difficult because designers want their gloves to accessorize with apparel, particularly outerwear. Therefore, they have to be aware of apparel trends well in advance. Designers may travel to Europe to study apparel as well as the Italian glove market for ideas.

Like other accessories and apparel, glove collections are usually divided into groups. The basis for the groups might be function, such as: dressy or sophisticated, tailored or classic, outdoor or country. Groups are also often based on materials: deerskin, pigskin, suede, shearling, cashmere knits, wool knits, fleece, or nylon. Linings are the second most important component and may be made of silk, cashmere, microfibers, olefin and polyester-insulating fabrics, fleece, or wool.

There is usually a variety of colors within each group. Black remains the most popular color for dress gloves, but brights are also included in glove collections. Natural colors predominate in casual leather gloves, and a variety of colors are found in fleece or ski gloves.

Production

American glove production was originally centered in Fulton County, New York. However, domestic industry employment is now only about 2,000. Glove firms have remained small because of their specialized, handcrafted operations. Most gloves are still produced by a painstaking process that requires many hand operations.

Fine gloves are still table cut from patterns one at a time because it is most precise. There are pieces for the front and back of the hand, the thumb, the *fourchettes* (pieces that shape the fingers between front and back), and sometimes *quirks* (small triangular pieces sewn between the fingers in expensive gloves). The leather is kept damp during cutting and sewing. Because of the curved seams, a glove-maker can only sew up to 12 pairs a day on a sewing machine, a French Pique machine, or by hand. Gloves are hemmed and may be lined with knit, pile, or thermal fabrics. Dress gloves may be trimmed with real and fake fur, buttons, bows, braid, embroidery, lace, tassels, and zippers. Finished gloves are rolled or layered in damp cloths and then fitted on heated brass hands, called *laying-off boards*, which press them to take out wrinkles and straighten seams. Finished gloves are buffed to a glossy finish.

Less expensive gloves are made with less expensive materials and may have fewer pieces. They can be cut faster with patterns made into iron dies.

In this case, a clicker machine presses the sharp edges of the die through the leather. Some gloves are knit, but even those are labor intensive because the fingers are closed by hand.

Some glove companies also produce scarves, hats, socks, or mittens. Aris Isotoner has added slippers, socks, and umbrellas to its product lines. Major U.S. manufacturers include Aris Isotoner, Fownes, Gates, and Grandoe. LaCrasia and Carolina Amato make high-fashion gloves. Glove companies continually work on production innovation, waterproofing techniques, and washability.

Imports

Almost all fine gloves are now imported. Italy has been a traditional leader in the glove industry; some Italian glove companies produce their own lines as well as gloves for major designers. Portolano, for example, also produces for Moschino, Fendi, and Barry Kieselstein Cord. Many European and American glove manufacturers have either purchased plants or use contractors in China, Hong Kong, or the Philippines. Grandoe, for example, has its own plants in the Philippines, China, and India. Some wholesalers (as compared to manufacturers), such as Shalimar, simply buy gloves directly from factories in Italy, Portugal, or Romania.

Marketing

Glove manufacturers show their dress lines in November and sport styles in January each year in their own New York showrooms and/or take part in one of the accessories exhibitions. Many glove lines are not marketed under the manufacturer's name but carry the retailer's label. Grandoe, for example, makes gloves for the L. L. Bean, Nordstrom, and Saks Fifth Avenue labels. Gates makes gloves for Eddie Bauer. For branded gloves, manufacturers often provide hangtags with product care information and in-store training to educate salespeople and to promote sales. Like other accessory manufacturers, some glove companies are opening their own stores. LaCrasia, for example, has its own store called Glove Street.

Hats

In the past, the most important accessory was a hat. A woman bought a new hat to add a bright spot to her wardrobe; a businessman was never seen on the street without one. The trend toward more casual life-styles changed that, and the millinery industry suffered a severe setback. Of course, functional hats to protect against the cold weather remained a necessity. Today, hats are enjoying somewhat of a comeback. Part of this rise in sales is caused by fashion, and the other is because of an increased demand for sun protection.

Product Development and Design

Hat manufacturers produce two seasonal collections per year. The spring collection is centered around a wide variety of straws and fabrics, such as cotton and linen. Fall collections are dominated by felt and fabrications of velvet, velveteen, fake fur, and corduroy.

Hat collections are usually divided into groups organized around fabrications, color schemes, themes, or price ranges. Hat designers are aware of fashion trends, especially color projections, and use many of the same design sources as apparel designers.

Hat designer Patricia Underwood at work in her sunny New York studio. *(Photo by the author)*

Designers and Manufacturers

Successful hat designers include Chena (Gale) Chapeau, David Cohen, Gretchen Fenston, Louise Green, Deborah Harper, Heartfelt by Jan Stanton, Eric Javits, Kokin, Deborah Rhodes, Lisa Shaub, Maude Stewart, Patricia Underwood, Susan van der Linde, and Marjorie Lee Woo. Leading apparel designers such as Donna Karan, Ralph Lauren, and Calvin Klein also have hat lines to complement their clothing. These are usually made for them by hat manufacturers as joint ventures.

There are a few large manufacturers such as Betmar, Commodore, and Liz Claiborne, but most are small. More than 100 companies manufacture hats in the United States, primarily in New York City and the Los Angeles area, but also in Chicago, Texas, and Florida. World centers include Paris, Milan, Germany, England, and Australia.

Production

Traditionally, fine hats were referred to as *millinery*. Designer millinery is made of the finest materials. Natural straw, imported from China, Indonesia, Japan, Ecuador, or the Philippines, or felt is first steamed and then hand blocked over wooden forms. *Blocking* makes the straw or felt into the shape of a hat. The edges can be hand trimmed and then wired or bound with ribbon. The best quality ribbons, flowers, and other trims are applied by hand.

Hats in the inexpensive to moderate price range are machine-blocked by a stamper (metal on metal) or a hydraulic press (a rubber inset mold presses on metal). New machinery from Italy automatically regulates the heat and timing for steaming and blocking. Decorative-trims are applied by hand.

Soft hats and caps are made from fabrics. Patterns are made for the crown and brim of the hat and used to cut the fabrics. The pieces are sewn together, some over stiffening material, and then hand trimmed.

Marketing

Market weeks for early spring lines are in November, spring/summer in January, fall lines in May, and holiday/resort in August. The manufacturers show their lines in their New York showrooms, followed by regional markets. They may also show their collections at the Fashion Accessories Expo or Accessories Circuit in January, May, and August. Some designers show at the same time as the apparel shows. Manufacturers also have sales representatives at major market centers such as Los Angeles, Atlanta, Chicago, and Dallas. The Headwear Information Bureau gives annual "Milli" awards for outstanding hat design.

At retail stores, hat designers are using sales training and personal appearances in the stores to promote their designs. Many upscale stores create comfortable areas with chairs, mirrors, and special lighting for their customers to try on hats. Some stores are opening hat shops on apparel floors to help customers accessorize their clothing purchases.

Blocking a hat form by machine. *(Photo by the author)*

Scarves

The popularity of scarves, shawls, and stoles, like other accessories, is cyclical. Design is usually based on historic textiles, fine art, and ornate architecture, as well as apparel trends. A collection includes groupings based on motifs, fabrications, colorways, and scarf shapes. Scarf manufacturers may either buy a print design from a design studio or have their own in-house artist.

Scarves can be made of silk, wool, cashmere, cotton, and manmade fibers. Pashmina, a luxurious cashmere from the Capra Hircus mountain goat is particularly popular for shawls, usually blended with silk. Fabrications include challis, sheers, metallics, and knits that can be printed, embroidered, or beaded.

Production

The production of scarf fabrics, particularly silk, rayon or polyester, is the same as other woven textiles (see Chapter 6). The difference is in the printing and finishing. A small percentage of scarves, those made of the finest fabrics, are made in Italy or France. Most of the printing is done by silk screen, which lends itself to the square or rectangular shape of the print. Hermès, which makes the finest scarves, uses an average of 24 color screens and up to 50 screens for their highest quality! Less expensive scarves use only 4 to 10 color screens. The printed fabric is cut and then hand rolled, machine rolled, flat hemmed, or fringed.

Most scarf production is located in Asia, where expertise as well as inexpensive labor can be found. Many American manufacturers buy their fabrics in Japan, Korea, or China and have the scarves printed there as well. Solid

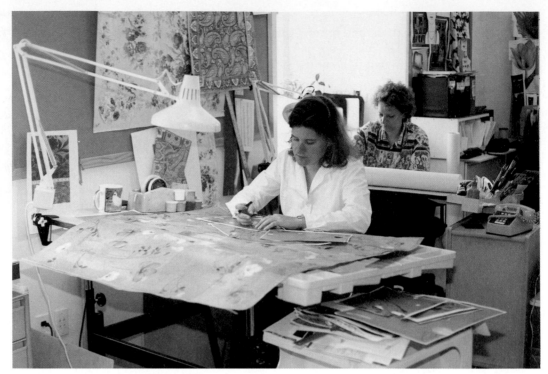

Scarf designers and colorists at work at Accessory Street, New York City. *(Photo by the author)*

or textured scarves are cut and sewn from available fabrics from textile companies.

Designers such as Ralph Lauren and Donna Karan also have scarves made for them in licensing arrangements or joint ventures. Collection XIIX, for example, manufactures Anne Klein and Ellen Tracy scarves as well as their own brand. Accessory Street makes scarves for Oscar de la Renta and Adrienne Vittadini to coordinate with their apparel collections. Echo produces scarves for Ralph Lauren, Laura Ashley, and Coach.

The three market seasons are spring/summer, shown to buyers in November and January; fall, shown in March; and holiday, shown in May and August. The high price of silk and the cost of labor has made the scarf business very competitive. Retailers have to order early to get on-time deliveries because of the long lead-time involved in overseas production. Some retailers act as manufacturers by importing scarves and selling them under the store's private label. Scarf manufacturers have developed videos and brochures on how to wear scarves to help the customer and promote sales.

Hosiery

Hosiery serves as both a fashion accessory and a practical covering to keep the feet and legs warm. Major changes in the recent history of the women's hosiery business include the development of nylon stockings in 1940, which were stronger and more uniform than silk, and the development of pantyhose in 1965, which liberated women from gartered stockings, were more comfortable, and dominated the industry almost overnight. Today, hosiery is manufactured in a wide range of knits, colors, and categories such as sheers, support, opaques, tights, and socks. The men's business, of course, is all socks.

Trends

Manufacturers of women's hosiery are now offering consumers more variety in large and petite sizes for better fit, figure-enhancing products such as control-top pantyhose, better fit with spandex, and multicolor patterns using polypropylene with nylon. Recently, driven by the trend to casual dressing, the sheer hosiery business has decreased, whereas tights and casual socks have grown to a major part of the business. The fashion for pattern or color on the legs is cyclical and does not necessarily coincide with variations in skirt length.

Product Development

The number of seasonal hosiery lines varies from two to four depending on the manufacturer and the price range. Some companies specialize in sheers and tights or socks; others make both. Collections are usually grouped by construction categories, such as pantyhose, control-top hose, support hose, stockings, thigh-highs, and socks. Constant research is done to develop better constructions and a variety of nylon and spandex combinations. Within each group there is an assortment of colors and, in the case of socks, a variety of patterns.

Production

Hosiery is produced in knitting mills where machines run 24 hours a day. Pantyhose and socks are both knit on automated circular knitting machines with special techniques to shape the heel. Sock machines use thicker yarn and fewer needles. Knitting machines have become more productive, capable, and flexible with electronic patterning to enable individual control of every stitch. The steps involved in hosiery production are knitting, dyeing, drying, *boarding*

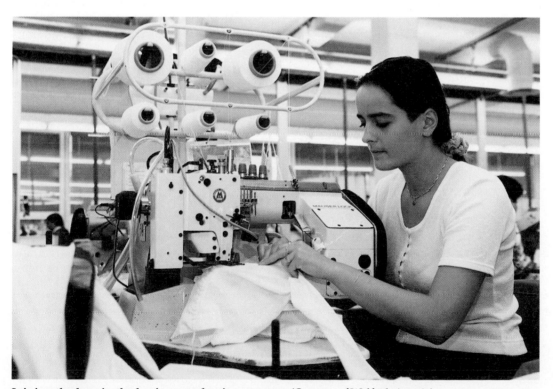

Joining the legs in the hosiery production process. *(Courtesy of Wolford, Austria)*

(a heat-setting process), pairing (for stockings and socks), labeling, and packaging.

There are approximately 800 hosiery mills in the United States, located primarily in North Carolina. It is the second largest accessory industry, and it is dominated by large companies, such as Berkshire, Ithaca, Kayser-Roth, Pennaco, and Sara Lee. Sara Lee owns both Hanes and L'eggs and has the Donna Karan, DKNY tights, and Liz Claiborne licenses. Kayser-Roth owns No-Nonsense, Burlington, and Hue Hosiery and has the Calvin Klein license. Pennaco's brand is Round the Clock. Ithaca produces the Evan-Picone and Vanity Fair (VF Corporation) lines. Sock manufacturers include Bonnie Doon, Burlington, Gold Toe (Great American Knitting Mills), Hot Sox, and Trimfit. Designers and designer brands such as Giorgio Armani, Kenneth Cole, Christian Dior, Givenchy, Donna Karan, Calvin Klein, and Ralph Lauren have hosiery and socks produced for them by licensing arrangements.

Hosiery manufacturers attend the biennial International Hosiery Exposition in Charlotte, North Carolina, every other April. There they look for information on the newest equipment and services such as automated sewing machinery, linking and labeling systems, packaging, and display forms.

Marketing

Hosiery manufacturers also maintain sales headquarters and showrooms in New York City and sales representatives to work directly with their retail clients around the country. The two main markets are in March for the fall lines and in September for the spring lines. More fashion-oriented lines, such as Calvin Klein from Kayser-Roth, may be shown four times a year with apparel collections. Basic hosiery lines change little and are constantly replenished in the stores.

The hosiery business is extremely competitive. Hosiery manufacturers have huge national advertising budgets. They also invest in other promotional material, such as informative packaging, point-of-sale visuals, in-store events, and merchandisers. Merchandisers help stock shelves, train salespeople, and generally do whatever is necessary to assure that their products are well placed in the sales area.

Stock replenishment is especially important in the hosiery business. Manufacturers take responsibility to see that stores consistently maintain complete inventories of all sizes in each style category. Manufacturers are using replenishment systems such as electronic data interchange (EDI) and bar coding to keep track of and continually replace inventory.

Jewelry

Because jewelry is made from metals and stones, it is a completely different industry from the other accessory businesses that use leather or fabrics. It would take an entire book to describe the many facets of the design, production, and marketing of jewelry. Here is an overview of fine, bridge, and costume jewelry.

Fine Jewelry

Fine jewelry is made of precious metals and gemstones; it is made by hand or with settings reproduced by casting. The quality of craftsmanship, the beauty of the design, and the value of the metals and gemstones determine the cost. Because fine jewelry is usually a life-long investment, its design is often classic. However, there is increased demand for fashion and innovation in fine jewelry.

Metals Only precious metals such as 10-, 14-, or 18-karat gold, platinum, and sterling silver are used to make fine jewelry. Since precious metals in their pure state are generally too soft to retain shape or to hold stones securely, they are combined with other metals. Gold alloys are made with copper, silver, palladium, or nickel. Gold content is expressed in *karats:* 24 karats is pure gold; 14 karats is 58.3 percent gold. Platinum is mixed with silvery metals such as palladium. Silver must be 925 parts per thousand of silver to be considered sterling. Erwin Pearl has recently developed a pure silver, called 999 Super Fine, which is brighter and shinier than sterling. *Goldsmiths* use these precious metals to create jewelry and to make settings for precious gems.

Gemstones Precious gems are hard, natural stones selected for their beauty and cut or polished for use in jewelry. Gemstones include diamonds, rubies, emeralds, sapphires, alexandrites, aquamarines, topazes, tourmalines, garnets, jade, opals, lapis lazuli, turquoise, and real pearls. Exotic stones, such as tanzanite, are currently popular. Price depends on clarity, color, rarity, and size. The weight of gemstones is measured in *carats,* a standard unit of 200 milligrams. The term carat comes from the seeds of the carob tree, which were once used to balance the scales used for weighing gems. Gemstones are found mostly in Asia, especially Thailand.

Diamonds Diamonds have traditionally been the most valuable and coveted of gems. Diamonds are the strongest natural element known: a diamond can be cut only with another diamond. Eighty-five percent of the world's diamond production is controlled by DeBeers, a huge South African conglomerate.

Stonecutting Transparent stones such as diamonds and aquamarines are cut by a *lapidary* (stonecutter) into symmetrical facets to show off their beauty. At least 50 percent of a rough gem is wasted in cutting. Stonecutters have developed new shapes such as the "trillion," a triangular shape. Cabachon stones—the unclear stones such as jade, opal, and coral—are domed, carved, or left in their natural state. Cabachon rubies and sapphires are also treated this way, a process that results in star rubies and sapphires. Although computers have recently been programmed to direct the cutting of gemstones, it is by and large still a craftsperson's field. Major stonecutting centers are in Antwerp, Belgium; Tel Aviv, Israel; London; New York City; and Idar-Oberstein, Germany.

Bridge Jewelry

Bridge jewelry is a category between fine jewelry and costume jewelry defined by lower price points than fine jewelry. However, it is still made of precious metals, such as vermeil (a process of electroplating gold over silver) or sterling silver, 14-karat gold trim, and semiprecious and cubic zirconia (faux diamond) stones.

Costume Jewelry

Costume jewelry is mass-produced to provide consumers with a variety of styles to coordinate with each look in their wardrobes.

Classic costume jewelry simulates the look of fine jewelry, using base metals such as brass, palladium, aluminum, copper, tin, lead, or chromium *electroplated* (coated or bonded) with gold or silver. When shapes are cut or stamped out of the sheet, the edges must be covered with gold. Freshwater or

faux (glass or plastic) pearls and enameling are also used to make classic costume jewelry.

Fashion jewelry is more trendy and utilizes metals that imitate gold and silver, as well as materials such as wood, plastics, leather, beads, glass, or clay. Fashion jewelry is often colorful, and styles change seasonally in keeping with apparel design. This jewelry is not created to look like fine jewelry but rather to make a fashion statement.

Product Development and Design

Like any successful fashion company, jewelry manufacturers try to identify their target customers and find a market niche. They develop a special look, perhaps concentrating on certain materials.

Jewelry design is often inspired by fine art and nature, such as flowers and leaves. Designers often go to the International Jewelry Show in Basel, Switzerland, each April to study jewelry trends and/or attend the Tucson Gem and Jewelry Show in Arizona each February to see what stones are available. Manufacturers also pay particular attention to the jewelry that designers show on the runways with their apparel collections.

Major jewelry categories are rings, necklaces, earrings, and bracelets. A manufacturer might further subdivide categories into diamond, gold, precious, and semiprecious jewelry, or copies thereof, and then into price ranges. Each collection features a balanced variety of designs and materials based on the seasons and how the jewelry will be worn. As in apparel design, the designer may first develop storyboards around themes for various groups within the collection.

Jewelry Production

There are as many techniques of making jewelry as there are jewelry types. Artisans use various methods of carving, grinding, drilling, filing, hammering,

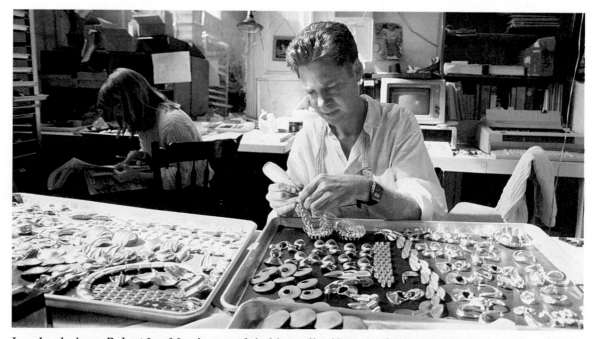

Jewelry designer Robert Lee Morris at work in his studio. *(Courtesy of Robert Lee Morris)*

and welding metal into desired shapes. There are also many ways to mass-produce jewelry by using sheet metal, metal cast in molds, and wire.

Flat shapes are usually stamped out of sheet metal and may be decorated with embossing or engraving.

Casting is a process used to produce three-dimensional shapes. Rubber molds are used to cast low-temperature metals, such as tin alloys. *Lost-wax casting* is used for high-temperature metals, such as gold, silver, and brass (for both fine and costume jewelry); wax is first formed in the rubber mold, and a new plaster mold is made over the wax forms. The wax is then burned out, and molten metal is forced into the plaster mold. Finally, the plaster mold is broken open to expose the shaped pieces of metal, which are then snipped off of a supporting tree structure and polished.

Electroform is a process that applies gold electrostatically around a base metal core. The metal is then chemically dissolved, creating a hollow shell of gold with a seamless surface.

Wire is used to make chains and various necklaces and bracelets. Band rings may be made by slicing tubes of metal. Fake jewels and pearls are made from glass.

Ornamentation may be applied with enamel. Enamel work is distinguished by the way it is applied; methods include cloisonné, champlevé, basse taille, and painting.

Resources

Fine Jewelry Italy, New York, and Israel are international centers for the creation of fine gold jewelry. There are approximately 2,000 jewelry firms in the United States, found mostly in New York, Rhode Island, and California. The two largest fine jewelry firms in the United States are Town & Country Corporation and Andin International. Contemporary fine jewelry designers include Elsa Peretti, Henry Dunay, and Michael Good.

Bridge and Costume Of the approximately 750 costume jewelry firms in the United States, the majority are concentrated in Providence, Rhode Island, and New York, although small firms exist all over the country. Growing competition comes from imports from South Korea, Taiwan, Singapore, and Hong Kong. Dominique Aurientis, Angela Cummings, Ted Meuhling, Robert Lee Morris, and Jay Strongwater are among the well-known bridge jewelry designers. Designer costume jewelry manufacturers include Carolee, Carol Dauplaise, Chanel, Ciner, Judith Jack, Kenneth Jay Lane, Miriam Haskell, and St. John.

Among branded jewelry lines are Anne Klein II by Swank, Christian Dior, Liz Claiborne, Marvella, the Monet Group (also Trifari and Marvella), Napier, Swarovski, Victoria Creations, and the 1928 Jewelry Company. Designers license their names to companies that have the expertise to manufacture jewelry. For example, Victoria Creations produces licensed Karl Lagerfeld and Bijoux Givenchy lines as well as Richelieu, its own pearl brand, and Worthington for J. C. Penney.

Marketing

Fine jewelry manufacturers usually have two collections a year. Fine jewelry collections may be shown at the Jewelers of America (JA) Show in New York each February and July and the JCK Show in Scottsdale in June. Costume jewelry is presented at the United Jewelry Show in Providence, Rhode Island,

each March, June, and September. Some costume jewelry firms bring out new collections five times a year in January, March, May, August, and November. Manufacturers have showrooms in New York City and major market centers, as well as sales representatives.

Large jewelry vendors are emphasizing consumer and sales staff education to promote multiple sales. Trifari, for example, has full-time fashion accessory consultants on the selling floor who are paid in part by Trifari and in part by the store. Jewelry designers, such as Henry Dunay and Carolee Friedlander, also make personal appearances at stores to promote their jewelry and get customer feedback. Some manufacturers also use booklets to show the consumer how to accessorize with jewelry and what styles look best on what facial structures and necklines.

Certain jewelry companies, such as Carolee, have in-store boutiques in various specialty and department stores. Another trend in the business is specialty retail stores devoted solely to costume jewelry, such as Erwin Pearl.

Watches

Watches have become a fashion accessory. Watches have intricately detailed mechanical works, are usually hand- or self-wound or quartz powered. Many include alternative functions such as the phase of the moon; the corresponding time halfway around the world; chronograph capacity, which indicates time intervals; perpetual calendars; and/or an accumulator that indicates elapsed time. Watches may be shock-resistant and/or water-resistant.

Luxury watches have become status symbols. Many watches are 18-karat gold, and some are covered with diamonds. The most expensive brands include Breguet, Blancpain, and Patek Philippe and can cost up to a million dollars. Other top-end luxury watches include Audemars Piguet, Gerald Genta, Ulysse Nardin, and Vacheron & Constantin. Less expensive luxury watches are Rolex, Ebel, Cartier, Baume & Mercier, Corum, Piaget, and Omega. Switzerland produces 95 percent of the world's luxury watches. Two important world markets are the Salon International de la Haute Horlogerie in Geneva and the World Watch, Clock and Jewelry Show in Basel, both in March/April. The United States is the largest importer of Swiss watches.

In 1967, a Swiss firm produced the first quartz watch, which was copied by Japanese and American fashion watch companies. Most fashion watches now use a battery-activated quartz crystal, computer chip, or electronic motor.

By the late 1970s, the Swiss share of the world market had dropped from 43 percent to 15 percent due to competition from less expensive watches made in Japan and Southeast Asia. Unable to compete, many Swiss watchmakers were going bankrupt until the Société Suisse de Microelectronique et d'Horlogerie (SMH) developed the colorful, pop-art Swatch in 1982. By limiting the number of components needed to make a good watch and by using synthetic materials, SMH was able to keep costs to a level low enough for mass production. The Swatch set a fashion direction for a whole new market of fashion watches at popular prices.

New brands are continually appearing as consumers buy watch wardrobes to accessorize every style of dressing. Watch companies manufacture for various brand names. E. Gluck, for example, produces Anne Klein and Looney Tunes; Timex produces Nautica, Guess, and Timberland.

■ *FUR GARMENT MANUFACTURING*

Furs were the earliest form of clothing and, like leather accessories, are made from animal skins.

The processing of fur pelts was discussed in Chapter 7. Some manufacturers buy furs directly at auctions and contract out the processing operations or have their own vertical operations. Other manufacturers buy processed furs from merchants. Once the pelts have been processed, the actual production of fur garments can begin.

Product Development

As in the styling of cloth coats, fur designers plan a collection of coats and jackets for their one season a year, fall/winter. They may specialize in one type of fur or plan a variety of furs within their collection. Groups may be planned around themes. Designers also plan a variety of silhouettes, neckline treatments, and closures to please a variety of tastes, and some manufacturers also make accessories such as hats to go with their coats and jackets. Creating a good fit and maintaining a light weight are important considerations for the designer. Collections are still dominated by classic, timeless styles because of the expense to the consumer. However, many designers add interest to a collection or build an entire reputation around trendy looks and innovation.

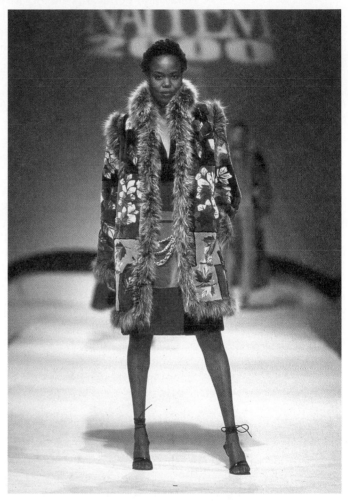

A mosaic of sheared, dyed beaver with raccoon trim was used in this coat designed by Zuki of Canada. *(Courtesy of the Fur Council of Montréal, Canada, photo by S. Najman)*

Styling Trends

Fashion trends influence the design of fur garments and the popularity of specific furs. Trends include shearling, sheared fur, dyed fur, recycled fur, knitted fur, and reversible leather-fur or cloth-fur coats. Saga has even developed washable mink, which has great merchandising appeal. There is an increased use of fur as trim on cloth coats, suits, or jackets. Fur is also seen in accessories such as hats, scarves, and even handbags. Another direction is the increasing sportswear orientation of fur designers; using less expensive furs and less complicated production procedures to keep prices down. These trends cause a blurring of the boundaries between textile and fur garments and attract new, younger customers.

Industry Organization

Fur garment styling centers include Milan, Paris, Frankfurt, Hong Kong, Montreal, and New York. Famous fashion names in fur manufacturing include Alixandre, Ben Kahn, Birger Christiansen, Corniche, Danzl, Grosvenor, Fendi, Maximilian, Revillon, Solecitti, Theo, and Zuki. Some well-known apparel designers, such as Oscar de la Renta for Alixandre, Ferre for Mondialpelli, or Michael Kors for Pologeorgis, create styles for fur manufacturers on licensing arrangements.

Manufacturing Centers

The area of New York City between Sixth and Eighth Avenues and Twenty-sixth and Thirtieth Streets is the center for the creation of luxury fur coats in the United States. Furs designed by many designers, including Valentino and Karl Lagerfeld, are manufactured in New York.

On the world market, China is the largest producer of fur garments, followed by Greece, Canada, and Korea. Over half of fur apparel imported into the United States, however, comes from Canada.

Production

No two fur pelts are totally alike; the furrier must match pelts according to quality and color to achieve uniform texture and color in the finished garment. The sewing of furs requires much skill and does not lend itself to mass-production techniques.

The two basic methods of fur manufacturing are the skin-on-skin technique and the letting-out technique.

Skin-on-Skin Method

In the less costly skin-on-skin method, one full skin is sewn next to another in a uniform alignment. This method is also often used to sew together the leftovers of expensive furs, such as paws and flanks, into less expensive garments.

Letting-Out Method

Luxurious furs such as mink are often manufactured by the letting-out method, which accentuates length, reduces width, and enhances draping. This technique involves splitting each skin in half lengthwise and then slicing every half pelt into diagonal strips 1/8 to 1/4 inch wide. The strips are then rematched and sewn together to form a narrower, longer skin that can run the full length of the garment. The result is a slimmer, longer pelt that is often more beautiful than the original. A let-out coat might have anywhere from 1,000 to 20,000 seams, which is one reason that fur coats are expensive.

Sewing

The strips are sewn into sections according to the coat or jacket pattern. They are first dampened, stretched, and stapled onto the pattern on a wooden board. After the sections are dried into shape, they are sewn together.

The next operation is called glazing. The fur is again dampened, and the hairs are combed in the desired direction. Gums and other materials, which

Stapling damp sections of coat into shape. *(Courtesy of the Deutsches Pelz Institute)*

often increase the luster of the fur, are applied to hold the hair in the desired position. Then, the fur is slowly dried and the lining is sewn in.

Some fur designers and manufacturers have innovative methods for creating fur garments and accessories. Paula Lishman of Canada, for example, cuts fur pelts into strips and then weaves, crochets, or knits these strips into garments. The company Roots makes accessories, such as backpacks out of recycled fur.

Fur Labeling

The United States Fur Labeling Act requires that the label (as well as related advertising) contain the following information: fur species, country of origin, type of processing and dyeing, whether the furs have been reused, and whether the garment contains paws or tails. If the garment resembles another fur, it must be labeled with the name of the actual pelt used.

Marketing

Annual fur fairs are held to show retail buyers fur collections from manufacturers around the world. International fairs include the Tokyo Fur and Fashion Fair in February, Fur Industries International Salon (SIIF) held in Paris in March, Milan's MiFur in March, Fur & Fashion Frankfurt in March, The North American Fur and Fashion Expo (NAFFEM) in Montreal in May, and Fur Fashion Week in New York, in June. The Fur Council of Canada holds seminars to educate retailers on how to merchandise fur, how to recognize good quality, and on lighting, temperature, and security requirements.

The demand for furs depends on a number of variables: climate, the world supply of mink, economic conditions, nonexclusivity of fur because of cheaper coats, and sympathies with animal rights activists. There is a renewed interest in furs and luxury, including new markets in Russia, China, and Europe, resulting from cold winters and recovering economies.

■ *SUMMARY*

Fashion in accessories is cyclical and related to apparel styling. Many apparel designers create accessories to complement their clothing. In the shoe business, a modelista makes the first models of shoe designs, and then the line builder organizes them into a balanced collection. The production of shoes is a complex process from last-making to finishing. Manufacturers are using computer-aided machinery to speed up production and save labor. In handbag production, dummies are first made to test a design. Expensive bags are made by hand of quality leather, whereas less expensive bags are made of imitations or fabrics. The manufacture of belts is done at many small companies. Glove production involves many hand operations. Designer hats are hand blocked and made of the finest materials, while less expensive fabric hats may be cut and sewn. High-end scarves are made in Italy, with many color screens on the finest fabrics, while less expensive scarves are made in Asia. Hosiery manufacturing is dominated by large knitting mills. Fine jewelry is made of precious metals and gemstones and tends to be classic in design. Better costume jewelry is vermeil or gold filled and is made out of sheet metal, cast metal, or wire.

Most of the accessory manufacturers are small firms because highly skilled crafts are involved in production; however, the shoe and hosiery industries are dominated by large companies. Virtually all shoes, handbags, gloves, and scarves are now imported from countries where labor costs much less.

The fur industry produces coats, jackets, and hats, as well as trimmings for textile and leather apparel. The largest centers of fur production are China, Canada, Korea, and Greece. The two methods of fur production are skin-on-skin and letting-out. Because the latter is especially tedious and time-consuming, the coats and other fur garments so produced are very expensive.

■ *CHAPTER REVIEW*

Terms and Concepts

Briefly identify and discuss the following terms and concepts:

1. Accessories
2. Last
3. Line builder
4. Modelista
5. CAD
6. MICAM
7. Hermès
8. Clicker machines
9. Millinery
10. Blocking
11. Gemstones
12. Cabachon stones
13. Carat versus karat
14. Lapidary
15. Vermeil
16. Casting
17. Electroform
18. Letting-out method

Questions for Review

1. How do fashion cycles influence accessory production?
2. Discuss the pros and cons of an apparel firm expanding to include accessory collections.
3. Why are certain countries specializing in dress shoe production while others lead in casual shoe production?
4. Explain the major steps involved in traditional shoe production.
5. How are computers used in mass shoe production?
6. Name five important shoe designers or manufacturers.
7. What is the role of imports in the U.S. shoe market?
8. Briefly describe handbag production.
9. Explain how belt styles are driven by apparel.
10. Name three well-known hat designers.
11. What is the difference between fine millinery and inexpensive hats?
12. What is used to make the finest scarves?
13. What are the basic steps in hosiery production?
14. Why is most of the hosiery business still in the United States while many other accessories are produced overseas?
15. What materials are used to make fine jewelry?

16. What is bridge jewelry?
17. Briefly explain two types of jewelry production.
18. How has the Swiss watch industry responded to competition from low-priced watches?
19. What is the effect of imports on accessory manufacturing?

20. Why has fur manufacturing remained basically free of mass-production techniques?
21. Discuss the differences between the two main fur manufacturing methods.
22. How do animal rights activists influence the fur industry?

Projects for Additional Learning

1. Arrange to visit the fur salon in a department or specialty store. Ask to see and feel a variety of furs. Note the fashion styling of today's furs. How do you feel about fur as wearing apparel?
2. Visit the hat department of a local specialty store. Note the differences between hats and fine millinery and the variations between functional and fashion styling.

How do the millinery looks tie in with the apparel trends in the store?
3. Look for shoe advertisements in a fashion magazine. Collect pictures of five popular dressy styles and five popular casual or sport styles. How has function affected styling?

■ *NOTES*

[1] Abe Chehebar, CEO, Accessory Network, New York City, interview, May 4, 2000.

The entrance to the Prêt-à-Porter, Paris. *(Courtesy of the Prêt-à-Porter, Paris, photo by Jean-Marc Hanna)*

12

Wholesale Marketing and Distribution

■ CAREER FOCUS

To create a marketing-chain link to retailers, manufacturers try to establish contacts and a good rapport with the stores they supply and, often, with consumers directly. This requires a coordinated effort of manufacturing management, designers, merchandisers, sales managers and representatives, customer service representatives, merchandising representatives, and all the various people involved in marketing. This includes catalog directors, publicists, writers, photographers, video producers, models, fashion show coordinators, television fashion specialists, and trade association personnel.

■ CHAPTER OBJECTIVES

After reading this chapter, you should be able to:

1. List the major international markets of apparel;
2. Discuss collection openings, line releases, and market weeks;
3. Describe distribution policies;
4. Discuss various aids to selling;
5. Identify the various forms of marketing;
6. Explain the use of EDI in distribution.

*I*nternational wholesale apparel and accessory markets are the means of distributing the manufacturer's finished products to retailers. A *market* is the potential demand for a product or the place, area, or time at which buyers and sellers meet to transact business. In this chapter, we refer specifically to the *wholesale* fashion market, in which the sellers represent fashion manufacturers and the buyers are fashion retailers. This material is presented from the manufacturer's standpoint, whereas Chapter 14 discusses buying from the retailers' point of view, as part of their merchandising process.

Traditionally, fashion markets have been located close to suppliers and manufacturers; therefore, most market centers are also production centers. Newer market centers have been created in various locales for the convenience of buyers or where there is abundant convention and hotel space, such as Las Vegas.

We refer to the domestic market (the United States), to the regional markets within it, and to the international or global market (see Chapter 2). This chapter discusses major international fashion centers and regional fashion centers and their role in buying and selling on the wholesale level. Although it is usually possible to buy year round, specific weeks are scheduled for collection openings or for the purpose of bringing buyers and sellers together.

■ *INTERNATIONAL MARKETS*

Markets are the time and place where buying and selling occur.

After each manufacturer's collection or line is designed, it must be presented to retail buyers so that they can buy for their stores. This presentation can be accomplished by various means, including fashion shows, market weeks, showroom presentations, and contacts with sales representatives. Fashion shows serve as advertising as well as showing new collections.

The terms "collection opening" and "line release" are synonymous; both signal the first opportunity for retail buyers to see fashion merchandise for a new season. Line release is the designation used by most fashion manufacturers to indicate that their new seasonal merchandise is ready to be seen. Collection openings are held by designer houses and involve extravagant catwalk shows.

Runway versus Showroom Designer Narciso Rodriguez said, "It's easy to embellish something to make it a showpiece. It's much harder to make a very clean, exquisitely cut garment look new . . . and to get that across on a runway . . ."[1] Many designers, such as Galliano, McQueen, or Gaultier, present outrageous creations on the runway to attract attention. However, their showrooms (where buyers come to order) are also filled with saleable merchandise! "Shock versus stock" is typical of the discrepancy between runways and showrooms.[2]

European Collection Openings

Couture

Paris continues as the world center for couture. Some Italian designers, such as Valentino and Versace, even show their couture collections in Paris. The spring collections are shown in January and the fall collections in July. These shows are by invitation only to private clients and the press. There are only about 2,000 private clients in the world! Some couturiers try to attract attention with extreme fashion and theatrical productions. "Pre-collection" essential merchandise, which can represent a large percentage of sales, is often shown to buyers before the shows. Collections are largely shown at a new fashion center beneath the Place du Carrousel near the Louvre and other nearby venues.

The couture is highly regulated by the French Ministry of Industry and the Fédération Française de la Couture. Designers have to show a minimum of 50 pieces in a collection; new couturiers have to show only 25 pieces for a two-year transition period. It costs approximately $1 to $2 million a year for a large house to produce and show their two couture collections, including expensive fabrics, labor-intensive handwork, specially made accessories, highly paid models, a catwalk, and high-tech sound systems for the show. In addition, *houses* (couture companies) may show or send videotapes or a CD-ROM of the collections to private clients (instead of producing the 45 informal fashion shows that used to be required).

To compensate for the expense, the French government gives support to the couture to promote exports. DEFI, the commission for promotion of textiles and apparel, has developed a campaign called "La Mode de France." Government-owned French television gives the couture free exposure. This

Gianfranco Ferré with his models for the show of his collection in Milan.
(Courtesy of Gianfranco Ferré)

kind of publicity is more prestigious than costly advertising and helps generate sales for ready-to-wear, perfume, and licensing businesses. In the past several years, the couture has generated more worldwide press coverage than ever before. Each show attracts more than 1,000 French and foreign journalists.

Prêt-à-Porter Collections

European designer ready-to-wear shows are held twice a year: fall collections are shown in early March and spring collections in early October. They are shown earlier than couture to allow time for mass production. Currently, the New York shows are first, followed by London, Milan, and then Paris. A buyer needs more than two weeks to see the shows in all three cities. Paris is such a draw that designers from other countries, such as Romeo Gigli from Italy and Kansai Yamamoto from Japan, show their collections in Paris. Buyers complain that the Paris shows are spread over too many days, that many shows do not start on time and are too long, and that many of the clothes are for editorial purposes only.

Retail-store buyers of better merchandise and approximately 2,000 journalists from all over the world flock to see the individual showings of many designers. Most buyers see 10 shows a day, from early morning until late at night, taking notes to remember styles. After analyzing the collections from the point of view of their stores' needs, buyers place orders, usually through *commissionaires* (representatives) or their own buying offices in each city. Ready-to-wear collections may also be shown to buyers in company showrooms, and many manufacturers now present four or more collections per year in that manner, as in the United States. Deliveries are staggered so that new merchandise arrives periodically in the stores to capture customer interest.

Market Weeks and Fairs

Manufacturers also show and sell fashions at market weeks or trade fairs. Markets often coincide with collection openings or line releases. Markets in major centers are held first, followed by regional markets. Markets are held in specially built buildings (fairgrounds), convention centers, or hotels. A market can last from three days to two weeks. European trade fairs are markets and not just expositions. In Germany, for example, businesses often sell 75 percent of their merchandise at these markets. Markets are an excellent opportunity for the manufacturer to reach new stores, establish new accounts, and, in turn, help retailers looking for new resources.

Paris The French prêt-à-porter shows are not limited to the designer collections. Other shows and groups of exhibitors are spread out all over Paris, organized by various fashion associations. Prêt-à-Porter Paris (often referred to as "The Pret") is held at the Porte de Versailles. There are also other exhibit groups called Who's Next, Paris sur Mode, Atmosphere, Workshop, and Tranoi. Some manufacturers show in hotels or restaurants. The city has launched a public relations campaign called "Paris Capitale de la Mode" to offer transportation, hotel reservations, maps, information booklets, and other services to visiting buyers.

Milan Both the Milano Collezioni Donna (Milan women's collections) and Modamilano are together at the fairgrounds with some overflow in hotels. The National Chamber of Fashion also promotes Italian fashion internationally.

Düsseldorf Collections Premieren Düsseldorf (CPD) is Germany's largest women's wear and accessories trade fair with over 2,000 exhibitors, held in conjunction with Igedo Body & Beach. Manufacturers from 38 countries show their fashion lines to more than 50,000 buyers each February and August.

Men's Wear

The Salon International de l'Habillement Masculin (SIHM, men's and boys' wear) takes place in Paris each January and September. The Milano Collezioni Uomo (Milan men's designer collections) and the Pitti Immagine Uomo (men's wear) take place in Florence each January and June. Other markets of men's clothing are held in London, Cologne, and Copenhagen in January or February and again in August or September.

Collection openings, fashion fairs, or market weeks are going on somewhere the year round. Table 12.1 presents a calendar of the world's most important fabric, apparel, and accessory fairs and market weeks.

Table 12.1
Important International Fashion Markets and Collection Showings
(Some of the hundreds of fashion related markets happening year round throughout the world)

January	
Pitti Uomo and Uomo Italia (men's)	Florence
Milano Collezioni Uomo (men's)	Milan
Designer Men's Wear Collections	Paris
Fashion Accessories Expo, Accessorie Circuit and Market Week	New York
Hong Kong Fashion Week	Hong Kong
NAMSB—National Assn. of Men's Sportswear Buyers Show	New York
Couture collections (women's, spring)	Paris
Market Week (women's r-t-w)	New York
Los Angeles market	Los Angeles
Pitti Bimbo (children's wear)	Florence
Salon de la Mode Enfantine (children's wear)	Paris
Prêt-à-Porter Paris (women's ready-to-wear)	Paris
Premiere Classe (accessories)	Paris
SIHM—Salon International de l'Habillement Masculin (men's)	Paris
February	
Fashion on Top, Herren Mode Woche (men) and Interjeans	Cologne
CPD—Collections Premieren Düsseldorf	Düsseldorf
FFANY-Fashion Footwear Association of New York and National Shoe Fair	New York
WSA—Shoe Show	Las Vegas
Market Week (women's r-t-w)	New York
MAGIC (men's and women's)	Las Vegas
March	
7th on Sixth and Market Week (women's r-t-w for fall)	New York
Prêt-à-Porter Designer Collection Shows	Paris
Milano Collezioni Donna and Modamilano (women's r-t-w)	Milan
London Fashion Week	London
MIDEC—Mode Internationale de la Chaussure (shoes)	Paris
MIPEL (leather accessories)	Milan
MICAM (shoes)	Bologna
SIIF—Fur Industries Salon	Paris
NAMSB Show (menswear)	New York

April	
Fur and Fashion Frankfurt	Frankfurt
American Designer Collection Shows (women's r-t-w)	New York
Los Angeles women's market	Los Angeles

May	
Fashion Accessories Expo and Accessorie Circuit	New York

June	
Moda Prima (knitwear)	Milan
Milano Collezioni Uomo (men's designer collections)	Milan
Pitti Uomo and Uomo Italia (men's wear)	Florence
Pitti Bimbo and Moda Bimbo (children's wear)	Florence
NAMSB Show (men's wear)	New York
Market Week (women's r-t-w)	New York
Los Angeles women's market	Los Angeles

July	
Mode Enfantine (children's wear)	Paris
Designer Men's Wear Collections	Paris
SIHM—Salon International de l'Habillement Masculin (men's)	Paris
Haute Couture Collections (fall-winter)	Paris
Hong Kong Fashion Week	Hong Kong
Market Week (women's r-t-w)	New York

August	
CPD—Collections Premieren Düsseldorf (women's r-t-w)	Düsseldorf
Fashion Accessories Expo, Accessorie Circuit, Market Week	New York
Los Angeles R-T-W market	Los Angeles
Herren Mode Woche (men's wear) and Interjeans	Cologne
MAGIC	Las Vegas
FFANY—Fashion Footwear Association of New York and National Shoe Fair	New York
WSA Shoe Show	Las Vegas
Salon de la Mode Enfantine (children's wear)	Paris

September	
MIDEC—Mode Internationale de la Chaussure (shoes)	Paris
MICAM (shoes)	Bologna
MIPEL (leather accessories)	Milan
7th on Sixth and Market Week (women's r-t-w for fall)	New York

October	
Prêt-à-Porter Paris (women's r-t-w)	Paris
Première Classe (accessories)	Paris
Milano Collezioni Donna and Modamilano (women's r-t-w)	Milan
London Fashion Week (women's r-t-w)	London
NAMSB Show (menswear)	New York
Market Week (women's r-t-w)	New York
Fashion Accessories Expo, Accessories Circuit and Market Week	New York

November	
Los Angeles market (women's r-t-w)	Los Angeles

December	
Moda Prima (knitwear)	Milan
FFANY—Fashion Footwear Association of New York and National Shoe Fair	New York

■ *DOMESTIC MARKETS*

Domestic market weeks and trade shows in New York City, California, and other regional centers are important wholesale markets for U.S. retail buyers.

New York

New York remains the major fashion market center of the United States. More than 23,000 apparel buyers visit the city each year for collection showings, market weeks, and trade shows.

Women's Wear

7th on Sixth—Seasonal designer collections are usually presented to buyers and the press as fashion shows. The Council of Fashion Designers of America (CFDA) organizes the "7th on Sixth" (Seventh Avenue on Sixth Avenue) shows of women's wear, which are held in two large tents in Bryant Park. Women's fall collections are shown in late March or early April and spring collections in late September.

Controversy over these dates is continuous. Some designers like the shows early, before Europe, to leave more time for production and deliveries; others prefer to show after Europe to have more time to order fabrics and prepare. More than 100 shows in ten days, sometimes with three shows running concurrently, present a huge organizational project as well as a hectic week for buyers. Many European designers are also showing in New York, which makes the schedule even more crowded.

New York Trade Shows—In addition, trade shows are organized by public relations or communications companies in hotels, convention centers, or other venues in New York City during market weeks. These companies rent showrooms or booths to manufacturers from across the country and around the world. These shows give the manufacturers an opportunity to show to visiting retail buyers. The larger groups include Fashion Coterie, Style Industrie, and Intermezzo. Smaller venues for young designers include Gen Art, South of Seventh, and Designer Debut. Other small hotel shows include American International Designers, Designers at the Essex House, Atelier, and Pacific Designer Collections.

Trade Shows coincide with manufacturers' line releases (when the new lines are shown to buyers), which usually occur five times a year:

- Summer merchandise is shown in January.
- Early fall merchandise is shown in late February or early March.
- Fall II merchandise is shown in late March or early April.
- Holiday and/or resort merchandise is shown in August.
- Spring merchandise is shown in November.

Children's Wear

Formerly shown only twice a year, children's wear has now become so fashion oriented that it is shown three or four times a year depending on the type of apparel. Dress manufacturers, for example, have major lines for holiday and spring. Sportswear manufacturers have three or four seasonal lines. Some trendier 7 to 14 manufacturers have new lines almost monthly.

The International Kids Fashion Show is held in New York featuring fall fashions in March and spring fashions in August. The Florida Children's Guild

Show is held in Miami in September. However, most children's wear companies show their lines only in their showrooms.

Men's Wear

The Designers Collective Show features upscale tailored suits and coats in late January for fall and in late August or early September for spring.

7th on Sixth also has shows of designer men's wear collections in February and July.

The National Association of Men's Sportswear Buyers (NAMSB) has increased shows to four times a year since the sportswear market has grown so much. Summer lines are shown in January, fall lines in March or early April, holiday and resort lines in June, and spring lines in October. These shows are followed by regional markets.

The Clothing Manufacturers Association (CMA), a men's wear trade organization, arranges tailored clothing market weeks in January for fall lines and August or September for spring.

Showrooms

A *showroom* is a place where manufacturers' sales representatives show samples to prospective retail buyers. Many manufacturers show their sample merchandise only in their own showroom, usually next to design studios. Even after the collection shows, buyers often come to the showrooms to see the garments up close. Fashion shows build brand image. Designers create many showstoppers just to get attention; the saleable merchandise is seen in the showrooms. The showroom is the primary setting for selling merchandise to retail buyers, where the orders are placed.

A typical Liz Claiborne showroom in New York City. *(Photo by the author)*

In designer showrooms, fashions are modeled; in medium- to lower-priced apparel showrooms, clothes are displayed on hangers. The showroom is outfitted with display racks, sometimes mounted on the walls for greater visibility, with tables and chairs for the clients' comfort. Showrooms provide continual exposure for the line.

In New York City, apparel showrooms are located in the "garment district," in the vicinity of Seventh Avenue and Broadway between Thirty-Third and Forty-Second Streets, close to the theater district. The district is also often referred to as "Seventh Avenue." They are usually grouped in buildings according to merchandise classification and price range. Grouping by apparel type was organized for the convenience of the buyer who does not have the time to travel all over town yet must see everything offered in a particular category and price range.

For example, the prestigious addresses of 530 and 550 Seventh Avenue have traditionally been designer addresses. Showrooms for moderately priced women's wear are usually located on Broadway. Lingerie and intimate apparel are centered on Madison Avenue. Children's wear showrooms are grouped around Thirty-Fourth Street and Sixth Avenue and at Thirty-Third Street and Sixth. One large building at 1290 Avenue of the Americas has showrooms representing approximately 75 percent of domestically produced men's clothing. The Empire State Building houses showrooms of men's furnishings.

The buildings are becoming less specialized, however, as showrooms relocate because of high rents, lease losses, or the need for more space. Advertising and Internet firms are coming into the area, which is beginning to change the identity of the district and drive up rents. Many fashion companies have been forced to move to other areas.

Garment District Improvements The fashion industry and the city have been working together to improve conditions for the fashion industry in New York. They have formed the Fashion Center Business Improvement District (BID) to enhance the garment district. They hope to establish a permanent fashion center for shows, exhibitions, and a museum and to offer tax breaks for expanding or upgrading manufacturing. The city is also endorsing marketing programs to promote the fashion industry.

Virtual Showrooms The Internet is providing the opportunity for manufacturers to sell online. Styleexpo.com, for example, allows designers and manufacturers to display their merchandise to retailers via the Internet. Their web site provides all the information a buyer would find in a real showroom, including close-up and three-dimensional views of the merchandise. The advantage of the Internet is its access to the global retail community.

National Trade Shows

MAGIC, the Men's Apparel Guild in California, has grown from a regional market to a national one. MAGIC produces the largest men's apparel trade show in the world with more than 3,500 exhibitors and 90,000 buyers attending! The interesting thing is that it is no longer held in California, and it is not held in a permanent mart. It takes place in Las Vegas, Nevada, each February and August. MAGIC now encompasses four simultaneous markets: men's, children's wear, The Edge (young fashion), and women's (in cooperation with *Women's Wear Daily*).

The Super Show, the world's largest sports product trade show, is held in Atlanta each February.

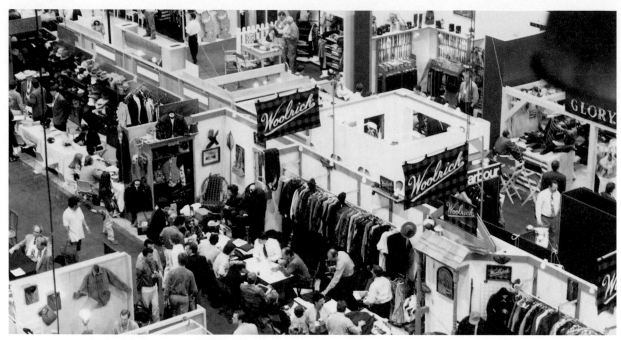

An aerial view of showrooms at MAGIC. *(Courtesy of the Men's Apparel Guild in California)*

Regional Market Centers

New York trade shows and market weeks are followed by regional markets, used primarily by small store owners who have neither the time nor the money to travel to New York. Some of these regional markets have developed because the area was first a manufacturing center. Large buildings called marts have been built in these centers to house showrooms. These showrooms represent local manufacturers as well as representatives of manufacturers from all over the United States and foreign countries.

Within the marts, showrooms are grouped according to category for the buyers' convenience. For example, men's furnishings showrooms may be grouped on one floor, women's lingerie on another, and so forth. Regional markets are primarily known for moderate and budget apparel because of the needs of the stores that buy there. The major regional centers are as follows:

Los Angeles—Los Angeles has become the nation's second largest fashion market center and is a showcase for California designers. First opened in 1964, the recently renovated 13-story, 5-building California has 1,500 permanent showrooms housing 10,000 lines.

Dallas—The International Apparel Mart is part of the Dallas Market Center Complex. Opened in 1964, the mart now has 2,200 permanent showrooms and 300 men's wear showrooms. The Apparel Mart hosts the annual Dallas Fashion Awards each October and continues its outreach to foreign retailers.

Chicago—The Chicago Merchandise Mart, serving the Midwest, opened in 1977 and has approximately 800 permanent showrooms exhibiting 4,000 lines. The mart has also recently developed temporary exhibit areas called Pavilion Suites.

Atlanta—The AmericasMart, which serves the Southeast, opened in 1979 and now houses 1,200 permanent showrooms. AmericasMart offers buy-

ers the convenience of cross-marketing with an adjacent gift and merchandise mart.

Miami—The Miami International Merchandise Mart, opened in 1968, has over 300 showrooms. Due to its strategic location, it has emerged as a wholesale center for the Americas, with many Latin American and Caribbean buyers attending its 16 trade markets each year.

Other regional marts are the Denver Merchandise Mart, Colorado; the Carolina Trade Mart, Charlotte, North Carolina; the Miami Merchandise Mart, Florida; the Northeast Trade Center, Woburn, Massachusetts; the Radisson Center, Minneapolis, Minnesota; and the Trade Center, Kansas City, Missouri.

All the regional fashion marts offer year-round market weeks, fashion shows, and educational seminars on subjects such as visual merchandising, management, and fashion show production. Other facilities include restaurants, auditoriums, hotels, hair salons, health clubs, printing services, and parking. To attract retailers and stimulate business, regional marts have developed aggressive new strategies. *Megamarts* (combined women's, men's, children's, and accessory markets) have been created for *crossover buying* so that buyers can make fewer or shorter trips to market and save travel costs. Other incentives include free or discounted hotel accommodations and airfares, and more events throughout the year aimed at specific market niches.

■ *DISTRIBUTION*

Manufacturers decide on a distribution policy to ensure proper merchandising of their apparel and accessories.

Distribution Policy

Bernard Arnault, chairman and CEO of LVMH-Moët Hennessy Louis Vuitton (owner of Chanel and Dior, etc.) has said, "If you control your distribution, you control your image."[3] Manufacturers' image, quality, and prices must be at the proper level to attract their target customers and, therefore, appropriate retail stores. For example, manufacturers of designer fashion sell to better department stores and fine specialty shops. Manufacturers of moderately priced apparel and accessories sell to a wider variety of department and specialty stores. Popular and budget-line manufacturers sell to discount and other price-oriented retailers.

The manufacturer must plan distribution so that (1) the appropriate stores buy the merchandise, (2) the merchandise is represented in desired geographical areas, (3) one store does not create unfair competition for another, and (4) the estimated business volume is obtained. The manufacturer may have an *open distribution policy*, selling to anyone who can pay for the goods (which is most common), or a *selected distribution policy*, limiting the number of stores in an area. When Giorgio Armani opened Armani Boutiques in West Germany, he took the Emporio Armani line away from 150 clients who had carried it before, to keep his clothes more exclusive. Manufacturers such as Hermès and Chanel limit the actual number of garments or accessories they produce and distribute to maintain exclusivity. Retailers often compete to be allowed to buy designer lines.

Positioning　Some manufacturers "position," or target, specific lines for specific stores. Liz Claiborne, for example, creates their Russ line exclusively for Wal-Mart; First Issue for Sears; Villager for Kohl's and Mervyn's, and Crazy Horse for J.C. Penney; and Emma James for department stores.

A seminar for buyers at the Dallas Apparel Mart. *(Courtesy of the Dallas Apparel Mart)*

Brand Names

Brand names have become very important in the fashion business. *Brand names* identify products made by a particular manufacturer. Some names are fictitious, such as Ellen Tracy, others may be the names of designers such as Dana Buchman or Liz Claiborne (the founding designer). Brand names must fit the image that the manufacturer wants to project, reflect the style and mood of the clothes, and appeal to the intended customer. The ultimate goal of the manufacturer is to establish the identity of a particular brand to such an extent that consumers prefer that brand over all others—a phenomenon sometimes referred to as *consumer franchising*.

Retailers who wish to buy popular brands often must fulfill minimum order requirements that are aimed at ensuring proper merchandising of the collection. Consumer franchising makes it difficult for other manufacturers in the same product area to compete because retail budgets are already allocated to the popular producers. However, although the label is an element in the consumer's decision-making, it has to be backed up by quality and value.

Manufacturers support *brand integrity* with unique fashion, quality control, licenses kept to a minimum for purposes of control, appropriate advertising campaigns, in-store fixtures to create a consistent image, service to retailers and consumers, and sometimes by owning their own stores. Successful manufacturers clearly identify and maintain a tight focus on their target customer and do not expand their scope beyond that image and what they can effectively manage and deliver.

Building a Brand

Manufacturers strive to strengthen their brands to build their businesses. Successful manufacturers, such as Calvin Klein, Ellen Tracy, Jones New York, Liz Claiborne, Nautica, and Tommy Hilfiger, for example, are able to develop

national or global brands. To do this, they can become multi-product manufacturers, export their merchandise, or open their own retail stores.

Multi-Products

Manufacturers often add new categories to build their businesses:

Secondary Lines Manufacturers may add secondary lines at lower prices, such as designer-label manufacturers who have added bridge lines. Almost all successful women's wear designers have added them.

Size Ranges Manufacturers often add large sizes and/or petites to an existing missy size range. This is lucrative because added sales can be achieved by simply grading patterns to the additional sizes.

New Product Divisions A sportswear manufacturer may start a dress line, or vice versa; a women's wear company might start a men's division, or the opposite. Calvin Klein and Donna Karan, originally women's wear designers, have

Building Esprit's brand image. *(Courtesy of Esprit, San Francisco)*

gone into men's wear; Ralph Lauren, first a men's wear designer, added women's wear. Liz Claiborne has built a clothing empire with line extensions such as Liz Sport and Lizwear and spinoffs such as Dana Buchman (bridge) to reach a wide variety of customers at many price levels.

Acquisitions To gain new product divisions, manufacturers can also buy existing companies. This is usually done to obtain new products at other price ranges. Liz Claiborne, again as an example, purchased Villager, Crazy Horse, and Russ to broaden their distribution.

Accessory Collections Manufacturers may include accessories in their product lines, usually via licensing arrangements or joint ventures. Donna Karan, Liz Claiborne, and many other designer names and brands have added accessories to complete their fashion statement.

As manufacturers grow into multi-product companies, they have to be sure to stay focused on a particular target customer, age range, or life-style to retain brand identity and integrity. They may oversee the manufacture of these new products themselves to maintain tight control over product and marketing or form joint ventures or licensing agreements.

Licensing

Licenses provide a means of diversification for the designer or brand without the risk of capital investment or the responsibility of production. Under *licensing agreements*, popular designers and brand-name manufacturers give other manufacturers permission to use their names. For this, the designer or brand name is paid a *royalty*, a percentage of wholesale sales.

Licenses make it possible for designers to reach a broader audience, to produce a line of coats or accessories, for example, to complement and complete their fashion statement, things they could not make in their own company for lack of expertise or capital. The licensee has expertise in production and marketing of a particular product but in exchange gets the designer image to trade on. The licenses are supported by brand name and designer advertising, and vice versa.

To protect the quality associated with their image, designers are being selective in allowing licenses, exerting more control, and participating more in the design and marketing process than they used to. Ralph Lauren licenses his women's wear collection, fragrances, eyewear, hosiery, leatherwear, Chaps men's wear, luggage, and handbags.

However, manufacturers are wary of indiscriminate licensing for a broad range of products because they must be careful to maintain control of design, quality, marketing, and image.

Joint Ventures

Joint ventures accomplish the same goals as licenses, but in a different business arrangement. They are a partnership between designer or brand-manufacturers and specialty producers. For example, a coat manufacturer and a designer could arrange a joint venture to produce that designer's coats. It is a give-and-take relationship in terms of merchandising and marketing the line. The designer has more control over the product and the licensee has less risk, because payment is usually on the basis of profits.

Exports

American manufacturers are slowly learning to be exporters. Domestic markets are not growing; manufacturers are just competing for market share. Therefore, exporting (selling to overseas retailers or opening stores abroad) is one of the few ways for businesses to grow and find new markets. The Europeans are long accustomed to exporting. French fashion houses, for example, export four-fifths of their merchandise. Many U.S. designers and brands have opened stores in Canada, Mexico, South America, Europe, and Asia. Manufacturers are also investigating the expanding markets in Asia, Russia, and the Middle East.

However, while trade agreements are beginning to eliminate many barriers, manufacturers need research to understand the foreign consumer, make connections with foreign sales agents or retailing experts, understand customs regulations, and deal with problems of currency fluctuations and credit. Many manufacturers would like more support from the U.S. Department of Commerce. Some designers and manufacturers use licensing (with local manufacturers) as a way to reach certain countries where trade barriers exist.

Manufacturers as Retailers

Many manufacturers open their own retail stores to enhance and control their image, to merchandise complete collections, to test new ideas, to build brand loyalty, and to expand their businesses. They use *vertical integration* to combine two levels of the marketing chain. This practice is common in Europe, where designers such as Giorgio Armani, Ferragamo, or Chanel have traditionally had their own retail stores. In the United States, vertical opera-

Donna Karan has opened colorful DKNY retail stores. *(Courtesy of the Donna Karan Company, photo by David Turner)*

tions such as Brooks Brothers are fairly common in the men's wear field, and many vertical shoe companies, such as Bally or Johnston & Murphy, operate chain stores. However, this is a fairly new idea for women's wear manufacturers. Now, more and more designers and popular brand manufacturers are opening retail stores that carry only their lines. Firms such as Ralph Lauren, Nicole Miller, Liz Claiborne, BCBG, Nike, and Esprit have opened their own stores.

By having their own stores, apparel companies are able to sell directly to the consumer and, therefore, eliminate some distribution costs, saving money for both the company and the consumer. This arrangement also affords them the opportunity to both market their image and display their total concept, including accessories, without having it edited by a buyer. However, many retailers are not pleased that they are in direct competition with their own suppliers.

Factory Outlet Stores

Formerly the only retailing done by manufacturers, outlet stores were located at production facilities where they sold *overruns* (garments not purchased by a store) or *seconds* (garments with flaws). But now most of the merchandise is flawless and *deep* (industry jargon for exceptionally full stock) in size and selection. Outlet stores have opened around the country in specially created outlet malls. Retailers are naturally unhappy about "two-tiered marketing," that their own suppliers are underselling them (see Chapter 13 for a complete discussion of retailing).

In-Store Boutiques

Some designers or brands are so popular that they are able to demand that their apparel and/or accessories be displayed in a strategic location, and with

a specific decor, within a department or specialty store. This "store within a store" concept gives designers or brands prime retail space, merchandising, and image control without having to administer a store themselves. Sometimes the decor and fittings for the shop are provided on a cooperative basis.

Catalog, Television, and Internet Sales

Certain manufacturers avoid retailers altogether by mailing their own catalogs directly to the public, understandably called *direct marketing*. Some sell their merchandise on QVC or the Home Shopping Network. Many others have web sites that they hope will grow into successful sales vehicles. Those who have been successful selling on the web find that a surging demand for shipments can strain their resources.

These manufacturers have divisions with specific staffs to merchandise and market these strategies. Industry experts believe that catalog, television, and Internet sales are the wave of the future due to today's busy life-styles and because they enable the manufacturer to reach people across the country and around the globe. Traditional retailers are understandably threatened by them (see Chapter 13 for more information) but are developing their own similar strategies.

Other Forms of Distribution

Franchising

In a *franchising agreement*, a manufacturer sells the rights to retail its merchandise or product line. Manufacturers benefit from this arrangement because the product must be sold under the brand name and merchandised according to specifications that protect the manufacturer's image. Retailers benefit because they are guaranteed availability of stock and the right to use the brand name in advertising, supported by the manufacturer's national or global advertising campaigns. The store has no rights to selection from the line but must carry the entire range of merchandise. Escada of Germany, Hermès of France, Benetton of Italy, and Nicole Miller of the United States franchise at least some of their stores.

Leased Departments

Manufacturers sometimes lease space in stores to sell their merchandise, although this practice is becoming rare. This arrangement requires no selling to a retail buyer. Leasing space is especially useful in retailing types of apparel and accessories that require salespeople with particular expertise. Fur, jewelry, and shoe manufacturers, for example, may lease departments because their sales associates must have special knowledge of their products.

Consignment Stores

Small manufacturers may sell their merchandise on consignment. In this case, the retailer provides only floor space and personnel but accepts no risks for the merchandise. The merchandise is lent to the store, and the store pays only when the merchandise is sold. The manufacturer must take back any unsold merchandise and try to sell it elsewhere which, of course, is very difficult.

Jobbers

In the fashion industry, merchandise is usually sold directly from manufacturers to retailers. The exception is the *jobber,* a middleman who buys goods from many manufacturers and resells them. These goods are usually overruns or markdowns bought at the end of a season at a large discount to clear the manufacturer's warehouse (especially if the manufacturer does not have an outlet store). They may sell in volume to small retailers or sell to the public in their own outlet stores.

■ *MARKETING*

Manufacturers use specific marketing strategies, such as advertising and publicity, to make their merchandise known to prospective retail buyers and to the public.

Effective marketing can often mean the difference between success and failure for an apparel company. Although the term "marketing" can mean the entire process of making and selling merchandise, in this case the apparel industry is using it specifically for publicity, advertising, and other activities. Marketing strategies are adjusted globally to suit local habits, styles, and tastes. A global company may have one type of campaign in Europe, another in Asia, and yet another in the United States.

Collection Shows and Market Weeks

Designers and manufacturers have a press attaché, or hire a public relations (PR) firm, and a trade association to handle the extensive arrangements for collection- and market-openings. For major collections, invitations are sent to journalists the world over, as well as to the designer's/manufacturer's best customers. A "run of show" (numbered list of models to be shown) is given out at the show. After the shows and market week, a dossier or press kit is prepared and sent to each journalist. The kit includes photographs and sketches of a few pieces from the collection, a press release or analysis of the collection, and perhaps a biography of the designer.

With so many lines for buyers to remember, manufacturers often use gimmicks such as distinctive invitations or souvenirs to draw attention to their products. They even hire celebrities to sit in the front row seats to attract the press! Promotional items such as shopping bags or T-shirts with the manufacturer's name on them can serve as walking advertisements.

Major designer fashion shows are very costly ventures. It costs at least $150,000 to present a seasonal designer collection to buyers and the press. Typical expenses include approximately 20 models for a full day, lighting, set design, videotaping, accessories, rental of a facility, hairstylists, music, makeup artists, invitations, postage, and programs. As a result, some designers are making their shows less extravagant or showing only in their own showrooms.

Publicity

Publicity is information given to the public regarding products, policies, personnel, activities, or services. Fashion manufacturers use in-house public relations or publicity staffs, consultants, or agencies to create publicity material and obtain *editorial coverage* of their collections in newspapers, magazines,

and on television. Fashion editors of publications and television choose the material for their articles from information and photographs sent to them by the manufacturers. Although manufacturers do pay to create the publicity materials, they do not have to pay for the media coverage.

Advertisers are putting more pressure on publications for editorial coverage. However, Suze Yalof, Executive Fashion Director at *Glamour Magazine* explained, "Although we pay attention to our advertisers and make sure we cover them, if their merchandise isn't newsworthy, we won't use it."[4] Designer Michael Kors explained why editorial coverage is so important: "Advertising establishes your image, but editorial is it for prestige—and sales."[5]

Television and Films

Fashion programs on television are also an opportunity for designers to get publicity. E! Entertainment's Style Channel, "Style with Elsa Klensch" on CNN, and MTV's "House of Style" offer various approaches of giving free publicity to designers and brands. TV events also give exposure to the designers of the stars. The Academy Awards has become the "world's largest fashion show." Beginning with Giorgio Armani, designers have been donating gowns to celebrities to wear in public. Now, the competition to dress the stars is fierce. The publicity of having a celebrity photographed in a designer's creation is worth a fortune.

Many companies are aggressively campaigning to get their products placed in feature films and on the most popular TV shows. Donna Karan's clothes were featured in Twentieth Century Fox's modern version of Great Expectations. In their quest to link their clothing and accessories with the biggest names in entertainment, they have to choose the appropriate film and celebrity to endorse their product and reach their target market. In addition, designers themselves are making personal appearances on talk shows or guest spots on shows. They think that this gives them direct communication with their customers.

Advertising

Advertising is the planning, writing, producing and scheduling of paid announcements designed to attract potential customers' attention to the manufacturer's merchandise. Manufacturers have in-house staffs or hire outside agencies or consultants to develop and produce advertising campaigns. Large manufacturers of apparel, hosiery, and shoes advertise their brand names nationally or globally. Advertising budgets are usually 2 to 4 percent of projected business volume.

Media

Manufacturers use both trade and consumer media, thereby reaching both markets. Media buyers are faced with an overwhelming choice: publications, outdoor (billboards, painted walls, buses, bus-shelters, taxis, and phone kiosks), radio, TV, Internet, and event sponsorships.

Usually, an advertising campaign is supported in a variety of media. Peter Connolly, executive vice president of marketing at Tommy Hilfiger Corp. commented, "You have to have a good mix. Not everyone just reads magazines, or just watches TV, or just looks at outdoor advertising. If you're trying to raise quick awareness for a new brand, then you might want to go with outdoor. To sustain an existing business . . . you want to go into the core fashion books.

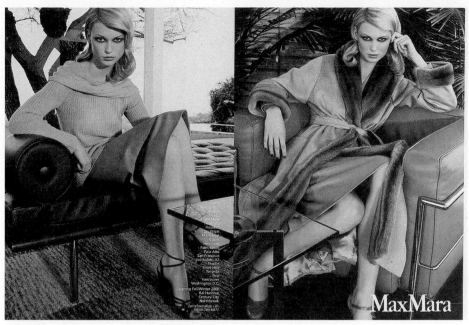

A Max Mara advertisement. *(Courtesy of Dente & Cristina Associates, Inc.)*

Where your brand is, is as important as the ad itself."[6] Many advertisers bombard consumers with impact units of 4- to 26-page ads in both trade and consumer magazines to achieve brand name recognition. Advertisers also look for premium positions and a publication's event tie-ins.

Television has become increasingly important as an advertising medium for the manufacturer. Also, many catalogs and World Wide Web sites are produced only for advertising purposes. Tommy Hilfiger's ad agency created a teen "soap" called *The Houseparty* on its web site, just as an advertising vehicle. Advertising CDs are inserted in magazines that provide entertainment, such as designer interviews, as well as the opportunity to see merchandise close up from all angles.

Image Advertising

Designers and manufacturers may use *image advertising* to make the consumer aware of their names or brands. Image advertising tries to capture the spirit of the product and build brand identity. Product takes on a secondary role to build a distinctive brand image that transcends seasons. Image advertising tries to get the consumer to buy into a life-style, first on a psychological, emotional, or aspirational level, and then on a product level. There are so many brands in the marketplace, marketers search for something that touches the consumer, that makes her choose to buy one brand over another. The most successful ad campaigns are those that manipulate feelings. This is done most often through visual imagery.

Marketers have to differentiate themselves in some way to catch attention. Advertisements may use controversy, humor, celebrities, sex, or shock to get attention. "There is a brand for every life-style imaginable: Calvin is hip, Ralph is rich, Tommy is American apple pie, DKNY is city slicker, Diesel is outrageous, and Benetton is controversial."[7] Large fashion companies spend millions of dollars each year on image advertising.

Celebrities as Models

Celebrities, such as Gwyneth Paltrow and Kristin Scott Thomas, and popular models command huge sums of money to help shape company images. Each person has to be selected on the basis of his or her appeal to the target customer. Designers also give clothes to celebrities, hoping they will wear them in public, especially to the Academy Awards. Advertising agencies arrange to have these celebrities photographed.

Item Advertising

When item advertising is desired, manufacturers choose one outstanding style from their collection to picture in an ad. With item advertisements, they are able to see direct sales response. Dana Buchman, for example, advertises one item twice a year.

However, fashion changes so quickly that it is often impossible to produce an ad of a specific style for national media. In addition, since each store carries different styles from any one line, it may be impossible to advertise one specific style for all stores.

Cooperative Advertising

Many manufacturers cooperate financially with textile producers and retailers on advertisements to make the public more aware of brand names. Manufacturers may offer to share costs with retailers who advertise their styles. Or textile producers may help fund manufacturers' ads, if their fibers or fabrics are used. Textile and apparel manufacturers' co-op allocations may provide a retailer with up to 50 percent of its media costs. The cooperative ads carry the names and logos (brand or store symbols) of each contributing company.

Other Marketing Aids to Retailers

Manufacturers often provide retailers with aids that they can use in their advertising, publicity, and public relations. Each manufacturer constantly tries to develop more selling and promotional tools. A manufacturer may offer one or more of the following to stores that purchase its merchandise.

Personal Appearances Many designers make personal appearances at retail stores to draw crowds. These visits may be accompanied by a fashion show, talk, and/or luncheon.

Designer Trunk Shows This is a similar idea to the personal appearance, but in this case the designer brings the entire collection. Trunk shows are hard work but very successful because the line is not edited by a buyer. There is direct payback because customers can order garments in their own size immediately after a fashion show. Small manufacturers who cannot afford national advertising have found this method to be very profitable for them. Some couturiers are even trying this idea and arranging for fittings to be done in the stores.

In-Store Clinics Many manufacturers have discovered that their merchandise sells better if it is thoroughly explained to both salespeople and store customers. Therefore, the designer or a manufacturer's representative may visit stores to train and educate the sales associates and/or customers with demonstrations, slides, and a talk.

Videos Another trend in fashion promotion and training is to show the collection on video. Specific videos for training purposes demonstrate selling techniques and how pieces work together. Couturiers send videos to their best customers. Videos of fashion shows are often shown in stores. Accessory firms use videos to show customers in a retail store how to drape a scarf or wear a hat.

Image Books These booklets are mini-catalogs that show a sampling of a collection. They may be distributed to retailers, the press, and customers. Dana Buchman, for example, offers look books for customers and/or sales associates to learn about the product and how pieces work together. Depending on the size and number of books sent out, which can be anywhere from 5,000 to 250,000 per season, image books cost between $40,000 and $100,000 to produce.

Display Fixtures Manufacturers sometimes provide stores with fixtures to enhance visual merchandising. Ellen Tracy, for example, offers stores an *enhancement package* including mannequins and signing.

Radio Scripts and TV Commercials Stores can "tag" media spots provided by the manufacturer with their own names and run them in their local areas.

Glossy Photographs Photographs of merchandise may be provided to stores to be used for publicity or advertisements. Couturiers also send photographs, sketches, and swatches to their best customers.

Statement Enclosures Small mailing pieces, similar to pages in a catalog with photos of merchandise, can be provided for stores to send to customers in their monthly mailings.

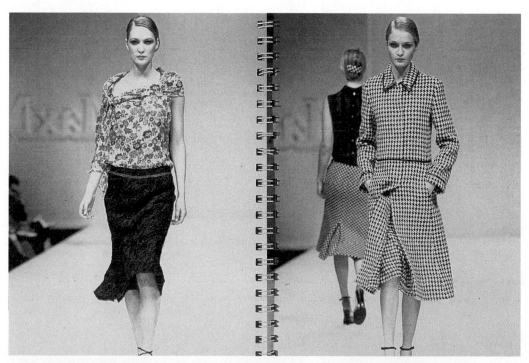

A Max Mara Look Book for customers and sales associates to learn how collection pieces work together. *(Courtesy of Dente & Cristina Associates, Inc.)*

Hangtags To help carry out a designer or brand image, a manufacturer's advertising department or agency may create consistent packaging, including hangtags for their garments or accessories.

Associations that Promote Fashion

Trade associations support manufacturers in promoting particular segments of the industry and organizing trade shows. The American Apparel Manufacturers Association (AAMA), the Council of Fashion Designers of America (CFDA), the Fashion Footwear Association of New York (FFANY), and The Fashion Association (TFA) are examples of the specialized organizations that exist.

The Fashion Group International, Inc., founded in 1931, fosters careers in the industry. Primarily promotional and educational in purpose, it now has over 6,000 members with regional chapters in 33 American cities and nine foreign countries. The Fashion Group programs include slide shows of collections and industry executives as speakers, activities to raise funds to fight breast cancer, and "Rising Star Awards."

Fashion Awards

Fashion awards presented by various organizations generate interest in fashion because of the publicity they create.

Oscar de la Renta, Womenswear Designer of the Year, and Jean-Paul Gaultier, International Designer of the Year, at the CFDA Awards gala. *(Courtesy of the Council of Fashion Designers of America, photos by Dan Lecca)*

The Council of Fashion Designers of America presents annual awards in a mimimum of four categories: men's, women's, accessories, and the Perry Ellis Award for new fashion talent. The winners are chosen by a committee of fashion editors and retailers. The CFDA has also organized "7th on Sale" to raise money to fight AIDS.

The Dallas Fashion Awards, which began in 1976 as a local awareness program, evolved into a recognition ceremony to honor American designers. Three designers are nominated in many categories and then national retailers can vote for the winners by mail.

■ *SELLING TO RETAILERS*

Management and sales representatives carry out the activity of selling fashion merchandise to retail buyers.

In a manufacturer-retailer relationship, the manufacturer is often referred to as the vendor. The vendor sales team of management and sales representatives must communicate design and merchandising concepts to retailers. Sales teams also do more and more *assortment customizing* for each separate account so that the line or collection looks different at each store. Vendors recommend what part of the line should be purchased on the basis of the store's image, customers, and needs. Susan Clatworthy, president of Laundry, said, "Selection has to be a partnership between the wholesaler and the retailer."[8]

The two basic ways of selling fashion merchandise to retail stores are corporate selling and by way of sales representatives.

Corporate Selling

Most major vendors, including designer companies and large manufacturers, no longer have sales representatives. Fashion distribution to large store chains and groups has become so complex and so important to volume sales that the selling is now done *management to management*. Marketing executives work at maintaining consistency of product and a good relationship with the store. Manufacturers and retailers are trying to build partnerships or alliances to help each other do better business.

Sales Representatives

Some companies still employ sales representatives ("reps") to call on specialty stores that do not have the time or money to travel to New York. Sales reps are salaried or paid on a commission basis ranging from 5 to 10 percent, on orders actually shipped to and accepted by the stores. Most commissioned representatives pay all their own expenses, including part of showroom or market costs, which can run as high as one-third of their income. Independent sales reps carry several small, non-competing lines. Sales representatives belong to associations that sponsor market weeks.

After a line release, sales reps receive duplicate samples and take the line "on the road" to market weeks around the country and to towns and cities within their assigned geographical territories. The rep usually sets up a presentation in a mart showroom or centrally located hotel room where buyers from the area can come to see the line. To win new accounts or to introduce a new line, reps have to go to the buyers because the buyers rarely have time to look for new resources themselves.

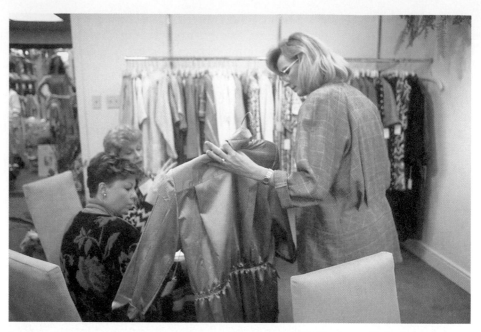

A sales rep presents her line to a buyer. *(Courtesy of the Dallas Apparel Mart)*

Selling Incentives

Retailers look for manufacturers whose styling, quality, and dependability they can trust and from whom they can expect the same level of styling season after season. Retailers expect the following:

■ Consistent quality

■ Continuity of styles (a guarantee that all styles ordered will be produced)

■ On-time deliveries (buyers are shopping later and yet expecting prompt deliveries)

■ Value

■ Reorder performance (manufacturer is able to fill reorders when needed)

However, styling, value, quality, and on-time deliveries are often not enough. As there are fewer and fewer retailers controlling retail distribution, they have the power to be more demanding with non-key vendors, insisting on contributions for markdowns, advertising, and promotions. Small manufacturers have a difficult time competing with so many demands that eat into their profits. The manufacturer may offer or the retailer may demand one or more of the following so that the retailer can maintain a minimum profit margin:

■ Incentive pricing (to allow for greater profit margins)

■ Off-price or promotional goods (special buys at low prices, usually offered as a pre-selected package)

■ Credit

■ Markdown allowances (credit on goods that had to be marked down)

■ Exchange or return privileges (allowing a retailer to return any unsold garments for credit or a refund)

- A discount of 8 percent if bills are paid on time (taken even if they pay late)
- Fines for violations of ticketing, packing, and shipping rules
- Cooperative advertising allowances
- Promotional aids such as in-store clinics, designer trunk shows, and brochures
- Assistance in reordering (for those firms that reorder, reorder forms or direct reordering contact via electronic data processing terminals may be supplied)
- Merchandise representatives
- Customer service

Orders

Electronic data interchange can automatically put through a purchase-order transaction from retailer to vendor. Through computer networks, orders can be entered via telephone from anywhere in the world. *Inventory management systems (IMS)* can instantly report on what is in stock and what delivery dates a customer can expect based on the information that it has sorted and filed.

Customer Service

Computer technology also helps the customer service department follow up on a sale by automatically printing invoices, handling reorders, and even pre-ticketing and pre-marking boxes for retailers. Fed the correct information, IMS systems keep track of shipments and adjust inventory records automatically. Some manufacturers use round-the-clock inventory management systems that provide up-to-the-minute reports of what is selling and what is not throughout the country. These systems enable companies to continuously monitor selling patterns and alter production accordingly. Customer service representatives follow up on orders, field questions from retailers, and solve problems to ensure customer satisfaction.

Merchandise Representatives Many manufacturers believe that stores have failed in their responsibility to train sales associates properly, so they have hired consultants to work *in* the retail store. Some work exclusively for a large store, whereas others are regional merchandisers servicing a cluster of stores in a particular area. Examples include Ellen Tracy's "retail merchandisers" and Laundry's "selling specialists." They check to see that merchandise is in stock and displayed properly. They educate both sales associates and customers on how the line should be merchandised, worn, and accessorized. They are in the position to give feedback to the manufacturer on competitive lines and customer reactions. It is very costly to maintain these consultants, but they drive multiple sales and full price sell-through.

Sales Analysis

At the end of a season, merchandisers and sales managers use IMS records to compare actual sales figures with the original sales- and profit-plan to see if goals were met. These records also give merchandisers and designers specific information on what colors, styles, fabrications, and price ranges sold best, which helps them plan future lines.

Manufacturer-Retailer Relationships

A breakdown has occurred in the traditional buy–sell relationship between retailers and manufacturers. Due to intense competition for market share, manufacturers and retailers are learning to work together to share risk and information on forecasting, product development, production scheduling, and distribution. They are developing partnerships or alliances, a sort of informal vertical integration, to exchange information and create seamless and cost-efficient marketing, production, and distribution. Ideally, large manufacturers team up with large retailers, and small with small.

Automatic Replenishment

Agreements between suppliers and retailers may allow manufacturers to automatically refill stock when inventory levels are low. Coded information on that style (including needed colors, fabrics, and sizes) immediately informs the fabric producer to send more fabric to the apparel manufacturer and the apparel manufacturer to issue new cuts. This arrangement needs the complete cooperation of each level of the industry, a willingness to supply on a reorder basis, and the flexibility to sell smaller quantities of fabric and issue smaller, more frequent cuts. This allows production to be done closer to the selling season to get reactions to sales data.

■ SUMMARY

The retailer and the manufacturer, who traditionally represent two separate businesses, communicate through wholesale markets. Fashion showings and markets are held in market centers all year long around the world.

Brands and designers expand their businesses by adding product lines, exporting, and opening retail stores. Manufacturers have various distribution policies to ensure that their goods are merchandised properly. Many offer incentives to retailers to buy their merchandise. They also use publicity, advertising, and other promotional aids to foster sales.

Computer technology has helped suppliers, manufacturers, and retailers form partnerships to try to speed turnaround time for production and distribution and keep records of inventory and sales.

The final test for fashion merchandise is whether the consumer buys it at the retail level. Each season brings a new chance for success or failure. No wonder the apparel industry is a competitive and often nerve-racking business.

■ CHAPTER REVIEW

Terms and Concepts

Briefly identify and discuss the following terms and concepts:

1. Markets
2. Line release
3. 7th on Sixth
4. MAGIC
5. Showrooms
6. Marts
7. Selected distribution policy
8. Corporate selling
9. Brand integrity
10. Licensing
11. Franchising
12. Factory outlet stores
13. Overruns
14. Jobbers
15. Trunk shows
16. Cooperative advertising
17. Image advertising
18. Brand-name saturation
19. Look books
20. Merchandise representatives
21. Enhancement packages
22. IMS

Questions for Review

1. What role do wholesale fashion markets play?
2. Name five important international apparel or accessory markets or fairs and their location.
3. Name five important international designer collections and the cities where they are shown.
4. What are two regulations regarding couture showings?
5. Why did regional, national, and international fashion markets develop?
6. How does the presentation of a high-priced collection differ from that of a moderate- or low-priced line?
7. Explain the difference between open and selected distribution policies.
8. How and why do manufacturers diversify?
9. Why should the American apparel industry concentrate more on exports?
10. How do manufacturers act as retailers?
11. List five promotional aids that manufacturers offer to retailers.
12. Explain how computer technology aids marketing.

Projects for Additional Learning

1. Analyze the imported fashion merchandise and accessories at a large retail store. Make a list of the countries represented and the merchandise specialty of each.
2. Ask a local buyer if you can sit in when a sales representative shows a line. Is the line presented in groups? Did the sales rep pre-merchandise the line in terms of the store's needs? Do you believe that the line is successful? Why? Summarize your findings in a written report.
3. Sell the line you designed in Chapter 9 to your class, explaining its concepts and features.

■ *NOTES*

[1] As quoted in "Narciso's Homecoming," *Women's Wear Daily,* December 6, 2000, p. 8.

[2] Marylou Luther, "Trend Report," *FGI,* Spring/Summer 2001, International Fashion Group, New York City, p. 2.

[3] As quoted in "Liberté, Fraternité—But to Hell with Égalité," *Forbes,* June 2, 1997, p. 88.

[4] Suze Yalof, Executive Fashion Director, *Glamour Magazine,* interview, April 1, 2000.

[5] As quoted by Teri Agins, "Editorial Plugs for Apparel Are in Style," *Wall Street Journal,* October 6, 1992, p. B-1.

[6] Quoted in "The Media Maze," *Women's Wear Daily,* May 28, 1999, p. 6.

[7] Lisa Lockwood, "Image, Is It Everything?" *Women's Wear Daily,* March 28, 1997, p. 16.

[8] Susan Clatworthy, president, Laundry, interview, April 21, 2000.

PART IV

Fashion Retailing

Part Four covers all aspects of fashion retailing from retail centers to marketing. It is important to have read Chapters 2, 3, 4, 8, and 12 to understand basic concepts before reading these chapters.

- Chapter 13 discusses retailing centers, types of retailing, and retail organization.

- Chapter 14 deals with retail merchandising and all the aspects of buying and selling fashion.

- Chapter 15 examines fashion marketing including advertising, publicity, special events, and visual merchandising.

Bergdorf Goodman on Fifth Avenue, New York City.
(Courtesy of Bergdorf Goodman)

13

Retailing

■ CAREER FOCUS

Retail store line management begins with a chief executive officer (CEO), director of stores, individual store managers, floor and area managers, department managers, and their assistants. Retailing careers are also possible in mail order, E-commerce, and television. Merchandising positions will be discussed in Chapter 14.

■ CHAPTER OBJECTIVES

After reading this chapter, you should be able to:

1. Explain today's retail situation and trends;
2. Discuss the various types of retail stores;
3. Explain the organizational differences between single-unit and multiple-unit stores;
4. Identify the major international stores and famous shopping areas;
5. Compare the organizational structure of a small store with that of a retail chain;
6. Discuss the growing importance of non-store retailing.

*R*etailing is the link between the manufacturer and the consumer. Retailers buy fashion merchandise from *vendors,* their suppliers, all over the world and bring it to their stores for convenient selling to consumers. Nearly 1.4 million retail establishments do business throughout the United States. About 117,000 of these retailers specialize in fashion apparel and accessories.[1] True success in the fashion business is finally achieved at the retail level by consumer acceptance measured in purchases.

Many factors go into the making of a successful retail store: skillful management, well-executed logistics, a convenient location, a pleasant atmosphere, efficient sourcing, exciting and appropriate stock, buyers with an understanding of customer needs, helpful salespeople, and customer service. Too often, success also lies more in sheer scale than in superior merchandising vision or innovation.

The first half of this chapter examines the current retail situation, global retailing, types of fashion retail stores, non-store retailing, and the organization of single- and multiple-unit stores and corporations. Chapter 14 covers the merchandising function, the buying and selling of fashion merchandise.

■ THE RETAILING PICTURE

Enormous changes have occurred in retailing methods, management, and ownership, which will have long-range implications for retailing.

Retailing's Roots in the Cities

Most of the world's top retail stores began in manufacturing and marketing centers, such as Paris, London, Tokyo, Rome, Milan, or New York. Certain city streets or areas have become famous for retailing: Fifth Avenue and Madison Avenue in New York City; Oak Street in Chicago; Union Square in San Francisco; Rodeo Drive in Beverly Hills; the Faubourg St. Honoré, Avenue Montaigne, Boulevard Haussmann, Rue de Passy, les Halles, and the St. Germain district in Paris; Via Condotti in Rome; Via della Spiga and Via Monte Napoleone in Milan; the Roppomgi and Harajuku districts in Tokyo; and Regent Street, Bond Street, and the Knightsbridge area in London. Most *flagship stores,* the first or main store of a chain, have remained in the cities, and new ones have been added.

Shopping Centers

The shopping centers that now line many of the world's highways developed as a result of the shift to suburban living that followed World War II, and their growth has been fostered by real estate developers. A *shopping center* is defined as a group of retail establishments that is planned, developed, owned, and managed as a single property. A *mall* is enclosed with a climate-controlled walkway between two facing strips of stores, whereas a *strip center* is an at-

tached row of stores without enclosed walkways linking the stores. Our discussion is limited to those centers with apparel and accessory stores.

The rest of the world has followed America's lead in creating shopping centers. The United States now has 44,000 centers, followed by Canada, Australia, England, France, Germany, Sweden, and Switzerland. So far, the West Edmonton Mall in Alberta is the largest shopping mall in the world, with 5.2 million square feet and more than 800 stores, including 10 major department stores.[2] Including the entertainment section, The Mall of America, in Bloomington, Minnesota, is the second largest.

Regional Centers

The traditional center or mall is "anchored" by at least two stores with many other small specialty stores in between. The anchors might be a moderate department store, such as Macy's, a discount store, such as Target, or a mass merchant, such as Sears, with a variety of specialty stores catering to various market niches. The typical regional center is 400,000 to 800,000 square feet.[3]

Unfortunately, many malls have become predictable and indistinguishable. Most of the recently built malls just take market share away from existing malls. Yet, the older malls are compelled to expand just to compete. Many malls are competing by developing one of the following alternatives.

Fashion Specialty Centers

These centers are composed mainly of upscale apparel shops of high quality and price in a rich decor. They may be anchored by a specialty department store, such as Neiman Marcus or Nordstrom, along with many smaller specialty stores in between.

Europa Boulevard, West Edmonton Mall, Alberta, Canada. *(Courtesy of West Edmonton Mall)*

Power or Value Centers

Value retail centers, malls, or strip shopping centers, made up entirely of discount stores, are growing in number, size, and popularity. When older malls are faced with overwhelming competition from new ones, one option is to convert into value centers. "Power" centers are those dominated by large discount, off-price, or warehouse clubs with only a minimum of small specialty stores.

Outlet Centers

Manufacturer and retailer outlet or clearance stores are usually found in specially designated malls around the country. These malls are located away from traditional department and specialty stores to avoid competition with them. Examples of large malls that blend outlet, value, and off-price retailing are Franklin, Potomac, Gurnee, and Sawgrass Mills.

Recreational or Theme Centers

Competition has caused some malls to use entertainment to draw customers and to capitalize on the recreational aspects of shopping. Malls are becoming the new amusement parks. The West Edmonton Mall in Alberta incorporates an ice arena, a deep-sea theme park, a golf course, movie theaters, and 110 restaurants and snack bars! The Mall of America in Bloomington, Minnesota, includes movie theaters, an indoor theme park, a roller coaster, and a miniature golf course. At Forum Shops Mall in Las Vegas, Caesars Palace Casino is the anchor. Henry Gluck, chairman of Caesars World, Inc., said, "Our thinking is that in the future, our best competition will be people with more bells and whistles."[4]

The Mall of America, Bloomington, Minnesota, includes 14 movie theaters, an indoor theme park, a roller coaster, and a miniature golf course. *(Courtesy of Mall of America)*

Town Center Malls

In the face of mall over-saturation and dwindling traffic, some malls are struggling to establish an edge by repositioning themselves as "town centers." In addition to shops, they provide restaurants, libraries, meeting rooms, and a range of other services to create one-stop shopping and a destination where families want to go.

Vertical Malls

To give city-dwellers the convenience of a shopping mall, some developers have created vertical malls of specialty stores in downtown areas. This allows many shops to be built on a small area, often one square block, of high-cost real estate. Customers take escalators from one level of shops to the next. The San Francisco Centre, for example, is built on only 43,000 square feet of ground space, but its nine floors provide a total of 500,000 square feet of shops. This includes 312,000 square feet devoted to Nordstrom as the anchor store on the top five floors.

Transportation Centers

Some airports and train stations are being transformed into shopping centers. They make ideal malls because they have a steady flow of high-income passengers, resulting in much higher sales per-square-foot than traditional malls. Successful airport malls developed at Heathrow, near London, and Frankfurt, Germany. Pittsburgh Airport and Union Station, Washington, D.C., made a success of the idea in the United States. Many retailers, such as the Gap, are finding transportation centers to be an innovative alternative location.

Retail Bankruptcies and Consolidations

Across the country, once solid companies have closed their doors, been purchased by other companies, or been forced to consolidate. Since 1980, long-established retailers such as Abraham & Straus, B. Altman, Bonwit Teller, Frederick & Nelson, Garfinkel's, Gimbel's, I. Magnin, Wards, and many others have either been acquired and absorbed by other retailers or have closed due to heavy debt, fierce competition, sourcing and inventory control problems, real estate costs, and/or poor management. Many retailers are still consolidating, restructuring, or closing. As a result, there is a great loss of independent and privately held apparel retailers. Surviving stores are trying to deal with a highly competitive marketplace with more supply than demand.

Too Many Stores

In spite of bankruptcies and consolidations, too many stores still exist for the number of consumers! Although there are fewer retail names, there is an increasing number of stores. In the 1970s, an estimated 7 square feet of retail selling space existed for every person in the United States; now there are 19 square feet per person.[5] Yet the big retailers are still getting bigger. Large chains such as Wal-Mart and the Gap continue to open new stores. The reality of retailing is that it is a mature business with no room for growth because of a stagnant market. Retailing today is competition for existing market share.

Rising Rents

The healthy economy is pushing up rents and real estate values. The number of tenants able to pay prohibitive rents is dwindling. Rising real estate rents are forcing many small, long-term tenants to relocate or close, while units of big chains are moving in to replace them. Some rents, especially in major fashion centers, have doubled in a very short time. Landlords are also making even more demands, such as a percentage of gross sales.

■ RETAIL STRATEGIES FOR THE 21ST CENTURY

With increased competition and a stagnant market, retailers try to reflect trends in consumer shopping habits and life-styles to survive and be profitable.

Retailers are taking various approaches to compete. To be successful and improve *productivity* (sales per square foot), a retailer must create a competitive advantage and set itself apart by offering something special. Six areas of focus seem to be the most promising: value, service, uniqueness, entertainment, a return to city and town retailing, and global expansion.

Value-Directed Retailing

Consumers look for value, convenience, and fair prices. Value-oriented retailers include discounters, outlet stores, warehouse clubs, catalogs, or any retailer where customers think they are getting their money's worth, whatever the price points. Successful retailers in the new century have the proper price/value and assortment relationship. They give customers what they want, where they want it, when they want it, at a fair price. Retailers are attempting to reduce expenses and become efficient to keep prices down.

Service-Oriented Retailing

Retailers are attempting to become *consumer driven* (to anticipate and focus on the needs of their customers), in fact, to exceed their customers' expectations. They are trying to make shopping more convenient and friendly so that their customers will enjoy it. Many retailers are using capital investments to renovate existing units to create a warm, hospitable atmosphere. E-commerce and catalogs capitalize on convenience. Customer service also includes maintaining in-depth stock. Service-oriented retailers include Nordstrom, Wal-Mart, and many mail-order retailers, such as L. L. Bean and Lands' End (see Customer Service, Chapter 14).

Unique Merchandising

With so much consolidation, uniqueness is often lost because many national retailers carry merchandise from the same large apparel manufacturers. In fact, some large stores, such as the May Company, limit buying to core vendors only. As retailers narrow their vendor structures, many stores have become too mainstream and boring. Retailers are trying to find new ways to provide unique styling with private label merchandise (see Private Label, Chapter 14). With the renewed interest in fashion, this is especially important.

Harrod's of London is a major tourist attraction, providing shopping as entertainment.
(Courtesy of Harrod's)

Entertainment

In an effort to keep stores alive, many retailers are trying to add excitement to the retail experience. Stores are providing live music, DJs, personal appearances, special events, video walls, CD listening posts, computer games, and other sights and sounds to draw customers. Levi's, for example, has created a club-inspired environment with DJ dance music, flashing neon, and multi-color spotlights. Entertainment may make it worthwhile for people to come into the stores, but then the merchandise has to be enticing enough to buy.

Revitalization of Downtown and Main Street Retailing

In Europe, where cities have continued to be the centers of fashion retailing, many streets have been closed to automobile traffic, creating pleasant walkways between shops. In the United States, retailers and community groups are also reacting to the consumer's need to be connected to community and the renewed interest in neighborhood shopping. Many cities and towns are conducting revitalization projects, including the refurbishing of

older department and specialty stores and the construction of malls such as Water Tower Place in Chicago, Pacific Place in Seattle, and the San Francisco Centre. Madison Avenue in New York City has attracted upscale retailers from around the world. Cities and towns try to maintain their individuality with their own unique mixture of national and international stores, local shops, restaurants, and services.

Global Expansion

Just as globalization has affected manufacturing, many retailers believe that one way to increase market share is through global expansion. Many European firms, such as Prada of Italy, Zara of Spain, or H&M (Hennes & Mauritz) of Sweden, have found the size of the American market attractive and, therefore, have opened shops here.

Americans are following suit. Levi Strauss has opened a store in London. The Gap has 325 stores in five foreign countries. Several American designers, such as Donna Karan, have stores in Europe. Saks Fifth Avenue plans expansion in Europe and Japan. Japan has already attracted several American retailers such as Barneys, Brooks Brothers, Talbots, and Ralph Lauren. Brooks Brothers has 31 freestanding or in-store shops in Japan. Closer to home, J. C. Penney, Dillard's, Sears, Price Club, and Wal-Mart are expanding in Mexico. Wal-Mart is opening warehouse clubs in a joint venture with Cifra, Mexico's largest retailer.

In addition to opening stores in other countries, companies are investing in foreign retailing businesses. Marks & Spencer of the United Kingdom owns Brooks Brothers, Aquascutum in the United Kingdom is owned by Renown of Japan, and so on. Most retailers think that globalization is the only way to survive in the future. On the other hand, with global retailers opening stores in every major city, the same merchandise is available everywhere, and regional markets lose their identity.

■ STORE-BASED RETAILERS

Many types of retail operations have been created to try to serve customers' needs.

Over the past hundred years, various kinds of retail operations have evolved, including specialty stores, department stores, mass merchants, catalogs, and now, electronic retailing, often referred to as "E-commerce." The distinction between these different forms has blurred. There are many overlaps among categories, and even retail experts do not agree on how to categorize stores. Retailing is continually evolving; new categories are emerging and old ones are combining.

Specialty Stores

Specialty stores cater to a particular target customer by providing a narrow focus of merchandise. Most specialty retailers stock merchandise within a certain price range as well as in a specific category. In Europe, specialty stores have continually predominated in fashion retailing. Examples of international specialty stores are Harvey Nichols, Brown's, and Joseph in London; Le Bon Marché and Franck et Fils in Paris; and the traditional small designer shops of Paris, Milan, Florence, and Rome, such as Hermès, Chanel, and Prada.

Neiman Marcus is a fashion-forward, multibrand specialty store.
(Courtesy of Neiman Marcus)

Specialty stores present a clear merchandising message to consumers. The customer can easily identify with a particular retailer by virtue of the merchandise, presentation, and advertising image. With smaller formats, specialty retailers are able to locate in downtown and neighborhood shopping districts. Specialty retailing has grown in the past two decades, overtaking department stores in market share.

There are four general types of specialty retailers: *single-line,* which carry just one category of merchandise; *single-brand,* which carry only private-label merchandise; *limited-line,* which stock related categories of merchandise; and *multiple-line* (sometimes categorized as specialty department stores), which offer many categories.

Single-Line Stores

Single-line stores carry deep inventories of one specific classification. They have a very narrow focus catering to a specific consumer need, giving their customers a wide selection in one category of merchandise. They might sell only accessories, or athletic shoes, or ties, or just socks. These stores can be small independents or grow into regional or national stores (see Multiple-unit Stores).

Single-Brand or Private-Label Retailers

Not to be confused with single-line stores, *single-brand* stores carry only merchandise sold under the store's name or *private label.* Private-label retailers maintain their own design departments or use the services of design

H & M (Hennes & Mauritz), a very popular Swedish private-label retailer, has expanded globally.
(Photo by the author)

studios, such as Mast Industries in Boston or Dominique Peclers in Paris, to design their lines. These retailers usually contract production of their product or may establish joint ventures with factories (see Chapter 14 for information on private-label merchandising). If the retailers do the manufacturing themselves, they are also considered to be *vertical* retailers because they perform functions on two levels of the fashion industry. Because they are vertical operations, they can be flexible and maximize a trend quickly. The Gap, Brooks Brothers, and Ann Taylor are examples of single-brand or private-label merchants. They have established their stores' names as important brands.

Limited-Line Stores

Limited-line retailers cater to narrow groups of consumers. They may carry just apparel and accessories for women, for example, or just children's wear, or just men's wear. Within that limited category, they may carry different price ranges and brands.

Multiple-Line Stores

Multiple-line retailers carry a wider variety of categories, such as women's and men's apparel and accessories. In addition, they may have children's wear, cosmetics, and even gifts. Because they have many departments, they are designated by some observers as "specialty department stores." Leading multiline, multibrand fashion specialty stores across North America include Bergdorf Goodman; Saks Fifth Avenue; Neiman Marcus, based in Dallas; Nordstrom, based in Seattle; and Holt Renfrew in Canada.

Department Stores

Originally, department stores dominated the American center-city retail scene and later served as the anchors and magnets that made regional malls successful. The term *department store* comes from the practice of presenting many different kinds of merchandise, each in a separate department. Apparel and accessories for men, women, and children are sold along with household goods such as furniture, lamps, linens, and tableware. Each department has a specific selling space allocated to it. Department stores used to also have appliances, toys, and other products that are now handled by individual specialty stores. Department stores usually concentrate 70 to 80 percent of their merchandise in the moderate to upper-moderate price ranges. Women's wear usually accounts for more than half of the sales volume.

Internationally, Seibu in Japan claims to be the biggest department store in the world. GUM in Moscow is the largest in Eastern Europe; Harrod's of London is the biggest in Europe, and Macy's (now part of Federated Department Stores) is the largest in the United States. Other leading international department stores include Liberty and Selfridges in London; Galeries Lafayette and Printemps in Paris; Rinascente in Italy; KaDeWe, Karstadt, and Kaufhof in Germany; and Matsuzokaya, Mitsukoshi, and Isetan in Japan.

Many established regional department stores, such as John Wanamaker, Jordan Marsh, Abraham & Straus, Bullocks, and the Broadway, went out of business or were taken over by national retailers during the 1980s and 1990s. The field is now dominated by just six retailing giants. Well-known American department stores include Federated Department Stores (owners of Macy's, Bloomingdale's, Rich's, Burdines, Lazarus, and Bon Marché), the May Company (which also owns Lord & Taylor, Hecht's, Foley's, Famous Barr, and Strawbridges), Dillard's, Target Corporation (owner of Marshall Field, Dayton-Hudson Department Stores, Mervyn's, and the Target discount stores), Sears, and J.C. Penney. Sears and Penney's are often categorized separately as "middle-market" department stores or "national chains."

The Galeries Lafayette department store in Paris. *(Courtesy of Galeries Lafayette)*

Mass Merchants

Mass merchandise retailers have built their businesses providing *commodity merchandise* (standard basics) at low prices, with limited service, in a no-frills environment. Because of their ability to buy in volume, mass merchants are able to buy at lower prices and pass the savings on to their customers. Most retail consultants include discounters, off-price retailers, and factory outlets as mass merchants. Today, over 50 percent of all apparel units are purchased at mass retailers. Most of these stores are general merchandise retailers, but this discussion is limited to those that also carry fashion apparel and accessories. Many of these stores have been doing an excellent job of presenting fashion merchandise, in addition to the basics, at low prices.

Discounters Discounters offer low prices by buying large quantities of lower priced merchandise and keeping expenses down with low rent, a simple decor, fewer salespeople, and fewer customer services. Consumers' quest for value and the increased popularity of casual dressing has spurred the growth of discounters. Discount stores have more than doubled since 1980 and have taken business away from the traditional department and specialty stores. Led by Wal-Mart and Target, discounters have become the largest retailers in the United States. Some discounters now have "super centers," large megastores that include apparel, general merchandise, groceries, and services, which appeal to their price-conscious customers.

Off-Price Retailers Some retailers specialize in selling merchandise at low prices by offering special buys, closeouts, overruns (manufacturers' overproduced merchandise), last season's goods, off-colors, and manufacturers' returns. The need for low rents excludes them from high-rent malls and prime downtown areas. Examples of off-price retailers are Burlington Coat Factory, Ross, Loehmann's, TJ Maxx, and Marshalls.

Outlet Stores Like manufacturers that sell overruns and out-of-season merchandise in their own outlet stores (see Chapter 12), retailers have found it profitable to run their own clearance stores for out-of-season or slow-moving merchandise. Macy's, Neiman Marcus, and Nordstrom are examples of stores that have their own outlets, such as Nordstrom Rack.

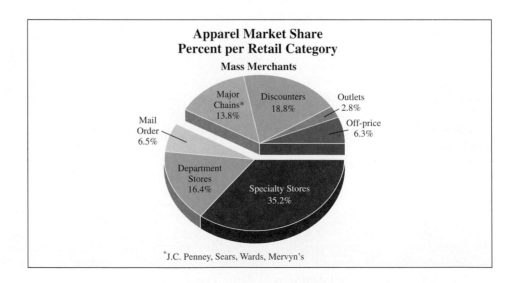

**Apparel Market Share
Percent per Retail Category**

Mass Merchants

Major Chains* 13.8%
Discounters 18.8%
Outlets 2.8%
Off-price 6.3%
Mail Order 6.5%
Department Stores 16.4%
Specialty Stores 35.2%

*J.C. Penney, Sears, Wards, Mervyn's

Warehouse Clubs These retailers, which charge a small membership fee, offer consumers deep discounts on general merchandise in a warehouse setting. Although they do offer some clothing on racks, it is primarily casual or active sportswear. With stores ranging from 40,000 square feet to 160,000 square feet, these retailers offer approximately 3,000 to 5,000 deeply stocked products. Sam's Club, owned by Wal-Mart, is the largest with approximately 300 stores in 42 states.

Promotional Stores

Any store, be it a specialty store, department store, or mass merchant, that is price-directed is a promotional store. They are stores that offer special buys from manufacturers and frequent sales in an effort to get customers into the store. Many consumers like to buy on sale because they believe they are getting a bargain. Examples of promotional stores are Macy's, the May Company, Mervyn's, and Target. Whereas some stores have become more promotional, others are trying to get away from this strategy with consistent value pricing.

■ RETAIL ORGANIZATION

Retail organizations offer many opportunities for a variety of experiences and responsibilities.

Retailing functions are generally divided into six areas of responsibility: merchandising, store operations, marketing, finance and control, real estate, and human resources. Merchandising, operations, and marketing are all responsible for sales. However, each store or corporation has its own unique structure.

Merchandising has the responsibility for planning, buying, and selling merchandise; the goal is to provide the store's target customer with the right merchandise at the right time as discussed in Chapter 14.

Store operations has the responsibility for planning, managing, and maintaining the retail building, protecting the store and merchandise, providing customer services, and coordinating the movement of goods and people within the building.

Marketing directs the focus and image of the store and is responsible for informing customers about goods and services through advertisements, displays, publicity, special events, and public relations (see Chapter 15).

Finance controls expenditures and keeps records of money spent and received: accounts payable (goods received but not yet paid for), payroll, taxes, credit (customers' charge accounts), and inventory.

Real estate or store planning oversees store location, property investment, building and construction, and fixtures.

Human resources staffs the store with people who are qualified and trained to handle the work that needs to be done and assures compliance with state and federal labor laws.

Small Stores

The typical small store is often managed by one person, usually the owner, who assumes many roles in the store's operation, such as manager, buyer, salesperson, stockperson, and bookkeeper. In some cases, several peo-

ple jointly run a store, each assuming responsibility for the jobs he or she is most capable of doing. As sales grow, the owner hires employees who perform a wide range of activities. Successful stores may grow in size or open additional locations.

Small stores can offer their customers highly personalized service that larger stores cannot provide, such as wardrobe planning. They can also get to know the needs of their customers through personal contact. Although small stores are often unable to buy from large manufacturers because they usually have high minimums, they can buy from small manufacturers, offering their customers unique merchandise in a unique setting, or buy through a buying office together with other small stores.

Small independent specialty stores have a difficult time competing. Some observers say that the needs of today's customers are not satisfied by the small specialty store that does not have the assortment that a Neiman Marcus or a Saks Fifth Avenue has. On the other hand, the small specialty store may be the only avenue left for the unique fashion made by small manufacturers. For this reason, there is a resurgence of small fashion boutiques, such as Jeffrey, Janet Brown, Linda Dresner, and Louis.

Large Stores

As sales increase, the owner hires more employees and increases space. As additional managers are hired, specialization occurs; the retailing functions are divided among people who are specialists in the performance of their respective jobs. Individual managers have the responsibility for separate functions, such as merchandising, operations, human resources, or finances. The store may hire an outside financial service and an agency to do the advertising and publicity. The larger the store—by sales, square footage, or number of stores—the more complex the organizational structure.

Stores Within a Store

In-Store Designer Boutiques

Popular designers or brands often require that a retail store furnish a permanent location and "real estate" (a certain amount of square footage) within the store devoted solely to their merchandise. The retailer provides space and purchases the product. The designer or brand vendor prescribes how the merchandise is to be visually merchandised and accessorized. They negotiate with the store regarding creation of boutique environments and may supply the fixtures. An example is the Ralph Lauren Polo boutique with its mahogany shelves, polo sticks, umbrella stands, shaving mirrors, and other "British gentleman" accessories.

In-store boutiques allow designers and brands to present their entire collection and strengthen their image. They also can present their own accessories together with the clothes. In so doing, they present the consumer with "the world of" Giorgio Armani, Calvin Klein, or Ralph Lauren (many of these same designers and manufacturers also have their own freestanding shops). Wal-Mart has even opened a "vendor store" where manufacturers are permitted to take charge of selecting and displaying their own merchandise.

In order to present a cohesive store image and to promote in-house brands, some department stores, such as Marshall Field's, are phasing out in-store shops. They are returning to grouping apparel by category to make shopping easier for their customers.

The Giorgio Armani "Elements" in-store shop at Bloomingdale's, New York City.
(Photo by the author)

Leased Departments

To provide additional services for their customers, many stores lease certain departments to an outside organization better able to handle a particular specialty. Leased departments in retail stores are merchandised, owned, and operated by an outside firm rather than by the store itself. Departments such as furs, shoes, and fine jewelry are sometimes leased because special training for sales associates is necessary. Today, leasing is used less frequently because it is more cost-effective for a store to run its own departments.

Multiple-Unit Stores

A successful *single-unit* store may open additional locations, to grow into a *multiple-unit* operation. These range from small retail organizations with just a few locations to national retail "chains" with hundreds of stores and thousands of employees. The success of the multiple-unit retailer is based on its ability to buy in large quantities and distribute the merchandise and operating costs throughout the organization.

National and global single-brand stores, such as the Gap or Ann Taylor, and department stores, such as Sears and J. C. Penney, are chain organizations. National multibrand specialty stores, such as Saks Fifth Avenue, are actually chain organizations, too, although they prefer to be known as "national specialty stores." Some chains have become megaretailers. J. C. Penney has 1,360 stores, and Wal-Mart has more than 2,000. The Gap operates 1,700 stores worldwide (325 are in five foreign countries), including Gap Kids, Old Navy, and Banana Republic. Retailing is increasingly dominated by large chains.

The Gap stores are organized as a national specialty chain. *(Courtesy of the Gap)*

Chain Organization

Naturally, the management of a chain is more complex than that of small retailers, especially because individual stores, referred to as "doors," are often geographically far apart. Most chains have similar organizational structures. The chief executive officer (CEO), the Chairman or President, is the head of the management team. Vice presidents are responsible for separate functions, such as merchandising, marketing, store operations, regional stores, planning, visual merchandising, finance, human resources, and customer service. In the stores operations division, a general manager or store manager is responsible for each store. Group sales managers, sales managers, and sales associates work with customers in a specific area of each store.

Senior executives work at company headquarters. Merchandise managers and buyers may also have offices in New York City, to be close to national markets (organization of the merchandising division is discussed in the next chapter). Centrally purchased merchandise is distributed to all stores from a central or regional distribution center. Individual store managers and their employees work at stores throughout the chain.

■ *TYPES OF OWNERSHIP*

Another way to classify retailers is by their type of ownership.

Sole Proprietorships

Most independent fashion stores are owned by a single person or sole proprietorship. There are many more of these businesses than corporations, but they do only a small fraction of the total retail business. Most of these stores are owner-managed. They have direct contact with their customers, are not bound by corporate rules, and, therefore, can be flexible and respond quickly to customer needs. However, these owner-managers have to have a broad

range of capabilities to effectively operate their businesses. They usually hire outside financial services and advertising agencies.

Partnerships

A partnership is a business owned by two or more persons under a contractual agreement. In this case, each partner assumes responsibility for separate functions. One owner may manage merchandising and the other might be in charge of finance and running the store, for instance. As the store hires more employees, the jobs become more specialized. As a business grows, it is usually converted to a corporation.

Corporations

Virtually all fashion retail chains are corporations or divisions of larger corporations or holding companies. Stockholders finance the corporation and elect a board of directors. They, in turn, select a chairman and other corporate officers to run the company. The main functions of the management team are to set policies and make sure that strategies are carried out properly. Officers manage specific areas of responsibility, depending on their expertise.

As we discussed at the beginning of the chapter, there has been considerable consolidation and restructuring of corporate retail chains. Regional department stores, such as Hecht's, have been acquired by national retail corporations. Federated Department Stores acquired Macy's and have separate divisions for Macy's East, Macy's West, Bloomingdale's, Rich's, Burdines, etc. Proffitt's acquired Saks Fifth Avenue and changed its corporate name to Saks. This corporate group also includes such regional retail chains as Younkers, Parisian, Carson Pirie Scott, etc.

Each acquired retailer becomes a separate division within the corporation. Usually, each division is a semi-independent unit with its own central merchandising and management. However, corporate management handles overall organization, strategic planning, and finance. All the divisions share communication, information, and distribution systems, private label development, catalog production, and E-commerce development, which helps to reduce costs. Retailing executives think that consolidation is also necessary because large companies have more buying power. Fewer corporate chains now dominate fashion retailing, but they keep growing by adding new stores. There was considerable concern that these corporations would drive independent retailers out of business, but boutiques are currently enjoying a resurgence.

■ *NON-STORE RETAILING*

Non-store retailing has developed for the convenience of the consumer.

Many consumers dislike the inconvenience of traffic, parking, crowds, and going from store to store in search of a coordinating wardrobe. Also, many busy people do not have the time to go shopping. They want to buy clothing and accessories quickly and efficiently. To answer their needs, mail-order, cable television, and Internet shopping are offering consumers the convenience of shopping from home. Large retail corporations have separate divisions to handle catalogs and E-commerce.

Although home shopping is still just a small segment of retailing, it is growing rapidly. Many major store-based retailers are also selling via catalogs and the Internet. The wave of the future is multi-channel retailing—traditional stores, catalogs, and the Web working together because consumers will expect merchandise to be available anywhere at any time. However, although non-store retailing is convenient, customers can't touch the merchandise, see the details up close, or try it on.

Mail-Order Merchants

Mail-order retailing offers merchandise to consumers in a catalog or direct-mail format. Mail-order catalogs provide consumers with the opportunity to compare merchandise and prices while sitting at home. Direct mail offers merchandise in brochures, often sent with retail store billing statements (see Advertising, Chapter 15). Consumers like the convenience of ordering by telephone and having merchandise delivered.

Many mail-order businesses, including Talbots and J. C. Penney, also have retail stores. Some opened stores after their catalog businesses became successful; others were already established retailers. In fact, all retailers are finding that mail-order complements their store merchandising and brings them increased business. Apparel catalog retailers include Abercrombie & Fitch, Delia's, Eddie Bauer, J. Crew, Lands' End, L. L. Bean, Spiegel, and Talbots. Catalog size runs the gamut from J. C. Penney's semi-annual 1,000-page book to Talbots 48-page catalog. Some of these companies are coming out with micro-catalogs that focus on specific niche markets.

Catalogs are a difficult business, however, and success often depends on how carefully a company organizes production and distribution. The length of

The first proof, showing corrections, of a page from an Eddie Bauer catalog.
(Courtesy of Eddie Bauer)

time needed to design, develop, and distribute catalogs makes it difficult to respond quickly to new trends in fashion. High production and paper costs and postal rates make catalogs expensive to produce and send. J. Crew, for example, mails out approximately 80 million catalogs annually to a mailing list of millions. When customers call the toll-free number to place orders, operators can access information about past purchases, making it easier for customers to order. However, many consumers are concerned about companies collecting and using this private information, such as selling mailing lists.

To increase business, some mail-order merchants have extended distribution to foreign countries. However, foreign languages, higher postal rates, and the absence of 800 numbers are some of the barriers they face. In addition, some catalog merchants are offering versions of their print catalogs on CD-ROM disc. Using a mouse, consumers can browse through the catalog, locate specific items, and order interactively. To meet the challenge of online shopping, many catalog retailers are selling via the Internet themselves.

E-Commerce

E-commerce is the term often used by the industry to describe online retailing via the Internet, where the customer and the retailer communicate through an interactive electronic computer system. The retailer transmits information and graphics to the customer's computer via the Internet, and the customer can order merchandise directly through the interactive system. Price-Waterhouse-Coopers analysts equated the Internet with "a gigantic electronic vending machine for everything on sale on earth."

There is a huge increase in the number of people accessing the Internet, and a similar rise in the number of commercial sites. Online apparel sales are now fourth after media (books and music), travel services, and computer software.[6] More and more retailers, from Saks Fifth Avenue to Lucky Brand Dungarees, are selling online. Forecasters predict strong growth as more consumers purchase computers capable of reaching electronic retailers and more retailers develop "shops" in cyberspace; estimates are that the Internet will handle half of all apparel sales in the future.

The Internet opens up global markets. It reaches many people without the cost of running a store. It is also possible to present an actual "virtual store" online. Specialty-store owner Ron Herman explained, "technology allows people on the Web...to get a 360-degree view. People can [see a close-up of] a shelf or a wall or a display, just like they would at the real store."[7]

Consumers like the convenience of shopping anytime, day or night. They want to have easy access to a site, to find what they want quickly, to get personal service, and to have the merchandise delivered promptly. Sites need to be easy to navigate, updated frequently, and have clear graphics that convey a retailer's image. Successful E-commerce is also dependent on how well a company can monitor inventory, fill orders, and handle customer service. E-commerce is easiest for catalog companies that already have warehouse and distribution systems in place. E-commerce retailers also need to develop industry standards for both credit card and customer information privacy. Research indicates that consumers are gravitating to retail web sites that are tied to stores they already know, and they find it easier to make returns to "E-tailers" that have stores. Stores with web sites are often referred to in the press as "brick and click" retailers.

Ideally, electronic catalogs will eventually enable shoppers to custom search among many E-tailers for a product by size, brand, and price range and zoom in for a closer look at the item. Online shopping services, such as

cybershop.com, fashionmall.com, shop@aol.com, and styleclick.com, are trying to give consumers this service; new services appear often and others go out of business.

Television Shopping

TV home shopping includes shopping networks and infomercials that allow consumers across the country to see merchandise in their own living rooms, order it by phone, and have it delivered. The major cable networks are QVC and Home Shopping Network (HSN); however, only 20% of their business is fashion, and most of that is jewelry. Most of their business is selling jewelry. *Infomercials* are TV programs that mix entertainment with product demonstrations and solicit orders, but are rarely used for fashion.

Industry analysts do not see much growth potential for television shopping: if people are too busy to shop in stores, they won't have time to watch much television and viewers have to wait for specific times when certain merchandise is shown. As a precaution, both networks see the Internet as a natural extension of their businesses; HSN has acquired the Internet Shopping Network, and QVC launched its own iQVC shopping service on the Web.

■ SUMMARY

This chapter examined the current retailing situation of closures and consolidations due to fierce competition. Retailers are trying to cope by meeting consumer needs with value, service, entertainment, unique merchandising, and global expansion. There is a renewed interest in inner-city retailing, and malls are diversifying to stay in business.

Retail operations include specialty stores, department stores, mass merchants, and mail-order and electronic retailers. There are both single- and multiple-unit stores, some growing into large chains. Store functions include marketing, merchandising, store operations, finance, real estate, and personnel. In small stores, all of these jobs are handled by only a few people; in large stores, each function is directed by a different executive.

To maintain a competitive position, a retailer must be focused on the needs of its target customer. To appeal to that customer, the store must have a unique yet appropriate image carried out in its merchandise, marketing, and services.

■ CHAPTER REVIEW

Terms and Concepts

Briefly identify and discuss the following terms and concepts:

1. Retailing
2. Expansion versus renovation
3. Fifth Avenue and Madison Avenue
4. Department stores
5. Specialty stores
6. Deep-niche retailing
7. Flagship stores
8. Private-label retailers
9. Off-price retailers
10. Promotional stores
11. E-commerce
12. In-store boutiques
13. Chain stores

Questions for Review

1. What is the purpose of retailing?
2. What is the reason for restructuring and consolidation in retailing?
3. What strategies are retailers using to compete in the 1990s? Which do you think are the most effective and why?
4. How does globalization affect retailing?
5. Explain the different types of shopping malls that have emerged in the United States.
6. How does a department store differ from a specialty store?
7. Explain the differences in organization between a small store and a large store.
8. Why has off-price, discount, and warehouse retailing increased?
9. Briefly explain the growth of mail-order retailing.
10. What impact will Internet retailing have in the future?
11. Describe the basic functions of a retail organization.
12. How can small stores compete with large ones?

Projects For Additional Learning

1. Find out whether one of the department or specialty stores in your community is owned by a retail corporation. Find out what other stores are part of the same corporation.
2. Research the history and growth of a large store in your area. Contact the store's public relations department for information, and check your college or local library for further information.
3. Watch a fashion presentation on the QVC cable network. Write an analysis of the program, including the effectiveness of the moderator, the presenter, and the merchandise. Was the show successful in terms of sales? What do you think of the future of television shopping?

■ NOTES

[1] Bruce Van Kleeck, National Retail Federation, Washington, D.C., interview, September 1997.

[2] International Council of Shopping Centers, New York City, April, 2000.

[3] Ibid.

[4] Henry Gluck, chairman, Caesars World, Inc., interview, March 1993.

[5] "Theories of Evolution," *Women's Wear Daily*, May 24, 1999, p. 9.

[6] "Cyberworld," *Women's Wear Daily*, March 6, 2000, p. 26.

[7] Ibid.

Retail selling floor of Gieves & Hawkes, Savile Row, London.
(Courtesy of Gieves & Hawkes)

14

Retail Fashion Merchandising

■ CAREER FOCUS

Fashion merchandising is most often directed by retail management, merchandise managers, and sometimes a fashion director. However, the actual buying and sell-through of merchandise are the responsibility of buyers, planners, and their assistants. Buyers are also involved in sales promotion, as discussed in Chapter 15.

■ CHAPTER OBJECTIVES

After reading this chapter, you should be able to:

1. Discuss the buying and selling aspects of merchandising;
2. Explain buying procedures at the market;
3. Describe all aspects of inventory control and evaluation;
4. Discuss the importance of customer service and sales associates.

*M*erchandise is the term used to signify articles for sale; it derives from the word *merchant*, the actual seller or retailer. *Fashion merchandising* includes all the planning and activities necessary to supply the fashion wants and needs of retail customers. In the past, fashion merchandising was usually associated only with women's apparel and accessories. Today, stores use aggressive merchandising techniques for men's and children's clothing too. Fashion influence has also spread to all other areas of retailing, from cosmetics and home furnishings to cookware.

This chapter covers the planning and carrying out of buying and selling activites including the responsibilities of buyers. It follows the flow of merchandise from arrival in the store to purchase by the consumer.

■ MERCHANDISING ORGANIZATION

Every area of merchandising responsibility needs planning and organization to make it function properly and to ensure successful buying and selling.

Merchandising responsibilities are usually divided between two chains of command. The *buying line* has responsibility for merchandise content and assortment; the *store line* is the liaison between the merchandise organization and customers. The buying line works behind the scenes; the store line interfaces with customers on a daily basis. The goal of both is to sell merchandise.

Responsibilities of the Store Line

The main responsibilities of the store line are operations: to coordinate receiving and the movement of goods and people within the store, to train sales associates, to provide customer services, to control expenses, to maintain the building, and to maintain security. Above all, store line executives must work together with merchandise managers, buyers, and sales associates to produce positive sales results. Everything and everyone involved in the operation of the store must be organized to achieve this goal.

The director of stores, who heads the store line, supervises individual store managers in multiple-unit organizations. Store managers are responsible for merchandising, sales, employees, and the general success of the store. They, in turn, usually delegate responsibilities to group sales managers, floor managers, or area managers, who supervise department managers. Department managers and their assistants run the department, communicate and distribute information about merchandise to and from management and buyers, put out stock, mark sale merchandise, and supervise sales associates. Although buying careers interest most retailing students, there are more opportunities as managers. It is also very important for buyers to have the experience of working with customers in the store line.

Responsibilities of the Buying Line

The merchandise managers and buyers of the buying line must do all the planning and other activities necessary to bring the right merchandise into the store at the right time to satisfy the store's customers.

General Merchandise Managers

The retail chief executive officer (CEO) delegates merchandising responsibilities to several general merchandise managers (GMMs) or corporate merchandise managers (CMMs). They set merchandising policies for the entire store and are responsible for sales volume. The general or corporate merchandise managers are in charge of several divisions. The divisions may be related, such as a general merchandise manager for women's wear and accessories, or the divisions may be totally unrelated.

Divisional Merchandise Managers

Merchandising responsibility is further segmented into single divisions such as women's sportswear or men's furnishings, directed by divisional merchandise managers (DMMs). In the women's area, divisionals might be in charge of missy dresses, missy sportswear, junior dresses, or junior sportswear. A national retailer with decentralized buying would have regional merchandise managers (RMMs) instead.

Buyers

Each division is composed of *departments*. These departments may be based on life-style, styling categories, price ranges, or vendors. According to life-style, women's dresses might be divided into social occasion and career. If categorized by price ranges, the departments might be divided into designer, bridge,

Marian Goodman, divisional merchandise manager for ready-to-wear at Bloomingdale's, with her staff. *(Photo by the author)*

better, contemporary, moderate, and budget. In a large chain, buying responsibilities may be further subdivided. Accessories are subdivided into handbags, hosiery, hats, jewelry, and so on.

Each department is further segmented into *classifications,* a related group of merchandise. A buyer is responsible for the success of one or more classifications, one department, or several departments. One buyer may buy just a few bridge or designer collections. Each retailer has its own unique breakdown of classifications and buyer responsibilities.

Fashion Merchandising Direction

Fashion direction is established to maintain cohesive fashion merchandising in line with a distinctive store image (see the end of Chapter 13). In single-unit stores, the owner usually acts as fashion director and buyer. In large stores or chains, management may employ a fashion director. The fashion director is the bridge between corporate marketing policy and actual merchandise-buying decisions. He or she works with merchandise managers, buyers, and promotion executives to suggest what merchandise to choose and how to present it.

Along with management and designer collection buyers, the fashion director may attend European and American collection openings to study fashion trends. These trends are analyzed (see Chapter 4) in relation to the store's image, and this information is passed on to buyers as a guide to merchandise planning and advertising. The fashion director may also work with buyers to select appropriate merchandise, to develop the store's private label, and to coordinate their buys with merchandise in other departments. A fashion director also prepares seasonal fashion presentations for sales associates so that they can understand the new fashion concepts and the store's merchandising approach and, therefore, better help their customers.

■ BUYING PREPARATIONS

Careful planning is done to help merchants buy merchandise efficiently and successfully.

The Merchandise Plan

Management determines a fashion merchandising policy, a long-range standard for fashion buying, selling, and related activities. Retailers make up a merchandise plan within the framework of the policy, goals, and fashion direction set by management. Actual sales figures and evaluations (see end of chapter) from the corresponding season of the previous year, recorded in computer-based forecasting and planning systems, are used as a basis for the new plan.

The merchandise plan is a financial plan allocating specific amounts of money to each department or division for the purchase of an appropriate assortment of fashion merchandise that will meet consumer demand and sales goals. Usually, management determines financial plans for the company as a whole, divides the totals, and assigns sales goals to general merchandise managers. These plans are then further subdivided to divisional managers and buyers who also work on developing their part of the plan.

Merchandise plans are based on a fiscal calendar, are determined four months to a year before the selling season, and cover a six-month or one-year period: the spring season (February through July) and/or the fall season (August through January). The plans are developed on computer spreadsheets, which show what needs to be purchased and sold per month to reach sales and profit goals.

Merchandise Plan Components

- Receipt plans—cost of goods (at retail value) that need to be received to sell in the store
- Sales plans
- Mark-up plans—adding on to prices to cover costs; see Retail Pricing
- Mark-down plans—reducing prices to move goods
- Inventory shortages
- End-of-month stock levels—goods that are in the store
- Weeks of supply—how long it will take to sell out merchandise
- Gross margin—profits
- Promotional plans
- Stock turn—figured by sales ÷ average stock

Planning Sales Goals

The retailer's goal is to exceed its own merchandise plan. To make a realistic estimate of prospective sales, a buyer must consider the following points:

- Economic conditions—anticipating a recession, buyers tend to buy conservatively, whereas in a good year, they may buy more in hopes of an increase in business
- Market and trend analyses (see Chapter 4)
- Shifts in population
- Local retail competition
- Variations in consumer demand
- Seasonal consumer demand—swimsuits for resort and summer, and back-to-school, for example
- Weather—mild winters result in poor coat sales, for example
- Holidays—how holidays will affect buying patterns including the number of shopping days, especially weekends, between Thanksgiving and Christmas, whether Easter is early or late, or the length of time between Easter and Mother's Day, Father's Day, Labor Day sales, and so on
- Physical expansion or alterations needed in the store
- An individual department's ability to house and display the merchandise effectively
- Which marketing activities are needed to support the merchandise
- Basic stock, merchandise in consistent demand throughout the year or during the same season each year
- The effects of casual dress in the workplace—casual clothes are less expensive than dress clothes, which means average sales are lower

■ The retail price of the average purchase—are customers buying multiple items of high-priced garments and accessories per purchase or only single items at low cost?

Units

In many cases, the plan also exactly specifies the *units,* or number of garments and accessories, to be purchased to meet these sales goals. Accessory units, for example, are divided according to the number of handbags, belts, scarves, and so on, that should meet demand. The scarf classification would be further broken down into the number of shapes (for example, oblong or square), prints and solids, and desired fabrications. The merchandise plan is further broken down by vendor, class, and item. Merchandise plans may be directed by management or buyers. Unit plans are recorded into merchandising information systems (MIS) that are used for ordering, allocation, and unit control.

Planning Stock

The next step in planning is to determine the amount of stock, in terms of dollar investment, necessary to meet consumer demand and, thereby, to support planned sales. Stock must be brought to a peak just before the expected time of peak selling and enough units must be available to fill the floors. Stock plans are part of the retailer's computer-organized financial systems.

Buyer Julia Immel at work on a buying plan.
(Photo by the author)

The Buying Plan

The *buying plan* is a description of the types, quantities, prices, and sizes of merchandise that a buyer expects to purchase from vendors within a specific period of time. The totals state exactly how much may be spent on merchandise in each category in line with sales goals and the financial merchandise plan.

The more detailed the buying plan, the less confusing buying decisions will be, allowing the buyer to concentrate on the fashion aspects of the merchandise during the seasonal market. The plan must be flexible enough, however, to allow for revision if conditions change; for example, should buyers not find what they want in the market.

Assortment Planning

A merchandise *assortment* is a collection of various styles, quantities, and prices of related merchandise, usually grouped under one classification within a department. The buyer plans to buy a balanced assortment of merchandise to meet consumer demand and appeal to a particular group of target customers.

Open-to-Buy

Considering stock on hand at the beginning of any given month (BOM) and the end of each month (EOM), the buyer has to calculate the amount of purchases that can be made if stock and sales are to be kept in balance. The difference between actual stock and planned stock equals *open-to-buy* (OTB), the value of planned purchases.

$$\text{actual stock} - \text{planned stock} = \text{open-to-buy}$$

Stacey Kaye, former fashion director of Henri Bendel, likened open-to-buy to a checkbook, "When you have money in your account, you can spend it."[1] The open-to-buy budget is adjusted according to business. When business is good, stock is low and needs to be replenished. When business is slow, buying has to be reduced. In addition, open-to-buy often has to be based on the amount of space or "real estate" that a buyer has available for specific categories and merchandise or for particular vendors. However, open-to-buy has to remain flexible enough to leave money for that special item.

■ BUYING

The buyer purchases merchandise in accordance with the merchandising plan and sales and profit goals.

The Buyer's Role

Experience

A buyer's knowledge of merchandise stems from both education and experience. The ability to evaluate merchandise and judge whether it is suitable for a customer develops over years of examining all types of merchandise for quality, styling, and price. It is also very important for buyers to have store line experience; they need to be on the sales floor to learn about customers' wants and needs. Leslie Wexner, founder of the Limited, said that his "experience of being in stores, watching customers' reactions to merchandise and its presentation, and overhearing their comments" helped him develop a retail sense.[2]

Research

Market and trend research becomes second nature to the buyer. As discussed in Chapters 2 and 4, buyers must constantly research the following influences:

- Demographics and psychographics
- The effect of economic conditions on demand for certain types and prices of merchandise
- Global influences on styling and sourcing
- Market and fashion trends
- Influence of the media and celebrities on fashion
- The competitors' merchandise offerings

Bottom-Line Versus Creative Aspects of Buying

The buying process is part analytical and part creative. The mechanics involve knowledge of sales histories and the development of a merchandising plan. Their increased responsibilities to the bottom-line leave many buyers no choice but to be just administrators. In industry jargon, they must find a balance between being "number driven" and "merchandise driven." The creative side of buying is the ability to spot trends and buy merchandise with sizzle that will appeal to customers. Buyers tend to play it safe, but they need to take more risk, especially now that the market is more fashion-oriented again.

Buyer-Planner System

Some retailers separate buying functions into a *buyer-planner system.* Under this system, buyers are able to focus on shopping the market and merchandise selection as well as financial control, while planners concentrate on distribution.

Planners shape the size of the buy, monitor adherence to the plan, plan distribution to individual stores, and team up with buyers to maximize their business. Planners analyze regional differences, designating appropriate merchandise for particular stores based on sales histories of color preferences, life-style needs, climate variations, ethnic tastes, and so on. They also reallocate merchandise to stores where it is selling best and make sure basic merchandise is kept in stock. Most stores now have computer-based forecasting and planning systems that include allocation.

The Buyer as Editor

Buyers can influence consumer buying to a large degree by their selection of merchandise, which narrows the choice for the consumer. By determining what parts of a collection will be sold in the store and in what quantity, the buyer affects the public perception of a manufacturer's line. However, they have to show enough of a line or collection to represent them properly.

The Buyer's Role in Marketing

Ideas on how to market and sell merchandise are thought out ahead. The buyer makes plans for advertising, including direct mail and E-commerce, visual merchandising, and special events (see Chapter 15 for more information).

Advertising　Buyers request ads on the basis of their merchandise plans and negotiate with vendors for co-op money (see Chapter 15). They must provide complete information about the merchandise—concerning fabric, colors, styling details, price, and sizes—to the advertising copywriter. The garment or accessory itself must be given to the illustrator, layout artist, or photographer. The buyer helps determine the proportion and position of the ad and must carefully check ad copy for accuracy. He or she must then make sure that the merchandise has been delivered and is on the selling floor, with appropriate sign copy, when the ad runs.

Visual Merchandising　Buyers may also request window and in-store displays for particular merchandise. They must also make sure that a good selection of that merchandise is on the selling floor for possible customer purchase.

Special Events Buyers may initiate special events and fashion shows. For example, the buyer of a designer collection might arrange with the fashion office for a designer to make a personal appearance to introduce a new collection.

To evaluate marketing strategies, buyers compare sales statistics two weeks before the ad, presentation, or event, the day of, and two weeks after. They try to determine if these strategies were successful in promoting sales.

Target Customers

The buyer tries to select the right styles, color assortment, and fabrics, at acceptable prices for their target customer. Buyers need to keep in touch with their customers' life-styles to buy merchandise to fit their needs. One San Francisco-based buyer of long formals and evening dresses spent a late spring evening sitting in the lobby of a downtown hotel to see what young people's preferences were in prom dresses (see Chapter 2 for background information on determining target customers).

Micro- Versus Macro-merchandising

Because of the large number of market segments, based on age, ethnicity, and life-styles, there is increasing need for customizing merchandise. *Micro-merchandising,* identifying and serving one market-niche, is in response to the recognition of a diverse society with diverse tastes and needs. This means that national retailers must differentiate their merchandise from region to region, and store to store. Retailers such as J. C. Penney have decentralized buying systems that allow local buyers to vary assortments according to the needs of individual stores. At retailers with centralized systems, planners use computer-based allocation systems to distribute merchandise appropriately. Micro-merchandising is an opportunity for small retailers and manufacturers because a narrow focus is easier for them.

Some national retailers, such as the Gap, are *macro-merchandisers* that prefer to convey a unified image throughout the chain. They make some concessions to climate, but they want consumers to find the same Gap merchandise in every store.

The Buying-Selling Cycle

The buying and selling cycle is related to the fashion cycle of consumer acceptance (as discussed in Chapter 3). Therefore, a buyer's responsibilities involve a complete cycle: planning what to buy; searching the markets and selecting the right merchandise; working with advertising, display, and special events to promote merchandise; training sales personnel; and marking down leftover merchandise.

The buying-selling cycle is constantly overlapping: new goods come into the store while other goods reach their peak or decline in sales. Thus, the buyer's job of identifying and interpreting consumer demand and evaluating current sales is a continuing process.

Broad Assortment Buying Ideally, buyers would like to buy a *broad* (many styles) but *shallow* (only a few of each) assortment of merchandise at the beginning of a season to test consumer reaction, and then, as certain styles emerge as best-sellers, increase stock in depth. By comparing current sales of

a particular style with the previous week's or month's figures, a buyer can determine whether sales are rising or declining. If sales of certain styles are on the rise, then more of these looks may be ordered. However, reorders are often difficult, as best-selling merchandise may no longer be available from the manufacturers.

Narrow and Deep Buying If a category of merchandise is very popular, or if the buyer feels strongly about a style, he or she may buy *narrow* (just a few styles) and *deep* (many garments in each size and color).

Short-Cycle Buying Buyers use *short-cycle buying* (buying closer to the selling season) to judge market conditions and trends and to respond quickly to the market, particularly for junior and contemporary fashions. Also referred to as *just-in-time merchandising,* short-cycle buying helps reduce inventory. This is completely dependent on the manufacturer's production cycle and availability of merchandise.

Planning Promotions Buyers have to plan ahead for *promotions,* special buys at low prices. When a particular item is popular, such as cashmere sweaters, for instance, a buyer might arrange for a volume purchase at a special price and then pass the savings on to customers. Many retailers would like to cut down on the practice of constant sales and promotions, but it is difficult because consumers now expect them.

Planning Markdowns Although buyers hope to select merchandise with full *sell-through* (selling at full price), they also have to plan ahead for inevitable markdowns. Many stores mark down prices after the merchandise has been on the selling floor for approximately eight weeks. Retailers are speeding inventory turns by marking down clothes to clear out stale merchandise. Merchandise may be left over because it has passed its peak of popularity or because of *broken sizes and colors* (incomplete assortments resulting from customer purchases).

Retailers usually charge manufacturers for *markdown allowances* to help offset their losses. Some manufacturers may even suggest to the retailer when it is permissible to mark down merchandise to make room for new deliveries. Many consumers have a "markdown mentality," they shop only for sale merchandise. "To combat this mentality," Julie Dugoff, bridge collections buyer for Saks Fifth Avenue, explained, "retailers cut back on inventory, carefully editing their buys, to encourage full sell-through."[3]

Shopping the Market

After the buying plan has been established, fashion buyers shop the market to view the merchandise available for the coming season. For the retailer, the manufacturer is the *supplier, vendor,* or *resource* of fashion goods. Buying trips are timed to cover markets that are important for the buyer's particular category of merchandise.

Buyers visit different market centers for different needs. Many people imagine a buyer's job to be a glamorous one involving many trips to Europe. However, only designer department buyers and fashion directors of large stores attend the European collections. Even then, with packed appointment schedules leaving little time to eat or relax, business travel does not remain glamorous for long. Many French and Italian designers now have New York showrooms so that buyers do not necessarily have to go to Europe.

Buyers from all over the world at the Prêt-à-Porter market, Paris. *(Courtesy of Prêt-à-Porter Paris, photo by Jean-Marc Hanna)*

Designer and bridge buyers go to New York to see the American collections. Contemporary, better, junior, and special size buyers go to specific market weeks for their specialty in New York. Men's and children's wear buyers, too, may go to New York for their markets. Moderate- and budget-priced apparel buyers may go to manufacturers' showrooms at regional markets. Regional stores may also do all their buying at regional markets. Buyers from Dillard's, for example, buy approximately half of their merchandise at the Dallas markets. Merchandise may also be bought from manufacturers' sales representatives who call on small stores for the convenience of owners who may not be able to get away to markets. Some retailers, such as J. C. Penney, show selected merchandise to their buyers in Texas via teleconferencing.

Line Buying Versus Trend Buying

The buyer shops for new fashion from both key resources and new ones. *Key resources* or *core vendors* are those who have maintained a reputation for dependability and whose merchandise sells through because of appropriate styling, quality, price, and/or a nationally advertised brand name. The practice of buying from these major resources is called *line buying*.

Matrix System Some retailers are requiring that 80 to 90 percent of all merchandise be purchased from core vendors! The most restrictive is the *matrix system,* strict centralized merchandising developed by the May Company and Dillard's. They think that large retailers can only be serviced by equally large vendors that can supply all of their stores. Buyers are limited to a list of core vendors and are not permitted to buy from other manufacturers. Of course, this system cuts out small apparel manufacturers who cannot supply all the stores in a large chain or corporate group and contributes to a lack of choice for consumers.

Trend Buying Buying merchandise for its innovative styling is referred to as *trend buying*. Trend buying is especially important for leading fashion stores. Because buyers do not always have time to seek out new resources, some retailers are providing *vendor days* when manufacturers can come to the store to show their merchandise. Finding an exciting, unique resource can mean an important merchandising statement for a fashion store. There is an increased focus on fashion, newness, and uniqueness so that all stores should do some trend buying.

Market Procedures

Buyers visit the showrooms of manufacturers who produce the specific types and price lines of merchandise that they need. As the entire line is shown to them by management, a merchandiser, or a sales representative, buyers take notes, usually on their laptop computers, recording information about style numbers, descriptions, size and color ranges, fabrication, and wholesale price, using separate discs for each vendor.

Buyers look for styling, quality of fabric and production, good fit, sound company management and financial backing that support the product, and on-time deliveries. Julie Dugoff at Saks said, "A buyer has to believe in the resource and see its long-term potential."[4] Buyers must evaluate whether styling and quality compare favorably with other merchandise they have seen in the same price range. Retail store square-footage is limited; when a buyer tries a new resource, it takes space away from others. Buyers also consider the possible sales potential of each style for their stores and how the clothes will look "on the floor." At the end of the market trip, a buyer reviews his or her notes on merchandise seen, eliminates the less desirable styles and any duplications, and decides which styles to purchase.

Corporate Buying In the case of a major store making a large purchase, buying is often done management to management by a group of executives including the buyer. Wal-Mart, for example, tries to do all of its buying in this manner. In this case, the buyer is part of a buying team.

Retailer-Vendor Alliances

Manufacturers and retailers try to work together toward mutual success. Vendor executives, designers, merchandisers, and/or sales representatives suggest appropriate merchandise for each retailer's particular customers. Buyers and sales representatives continue to work together throughout the selling season regarding advertising, reorders, markdowns, and sell-through. Buyers also provide vendors with weekly selling reports.

Purchase Orders

Placing an order for merchandise is considered a contract between the store and the vendor. Therefore, writing an order commits the store to taking the merchandise if it meets quality expectations and delivery requirements. Standard purchase orders specify the date of the order, the name and address of the resource, the terms of sale, shipping instructions, the store's shipping address, the name of the department, the quantity ordered, descriptions and prices of styles ordered, and obligations between buyer and seller. Purchase orders are most efficiently done by Internet vendor-linked computer systems, which can instantly supply information on what goods

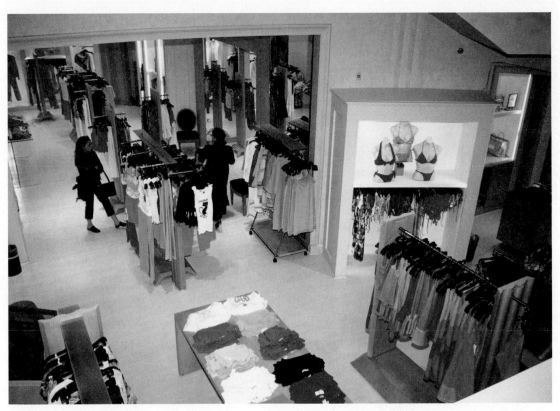

Colorful merchandise at Henri Bendel, a store that specializes in trend buying.
(Courtesy of Henri Bendel, photo by the author)

are available or are in work and what shipping dates are expected. The purchase order information becomes part of the retailer's total merchandise information systems (MIS), which keeps track of merchandise as it is ordered, received, and finally sold.

Deliveries are timed so that sufficient quantities of merchandise are in the store to meet various peaks in the consumer demand cycle. The vendor is committed to meeting these delivery dates or the order may be cancelled or a discount required.

Automatic Replenishment

In an effort to maintain stock of basic merchandise, retailers use automatic replenishment, made possible by electronic data interchange systems that link them to vendors. This system sends sales and inventory information directly to vendors so they can plan production. As discussed in Chapter 2, this strategy attempts to speed ordering and distribution, thereby reducing inventories for textile and apparel producers and retailers.

To implement automatic replenishment, retailers must be willing to adopt a *continuous open-to-buy position* for basic merchandise to let suppliers replenish without any retail management approval or review. Sears, for example, has implemented a computer system called CFAR (Collaborative Forecasting and Replenishment) to allow suppliers to keep each store stocked at all times. The use of automatic replenishment is especially important for underwear, hosiery, and shoes, to make sure that all sizes, colors, and so forth, are in stock. The use of automatic replenishment is also growing for other merchandise.

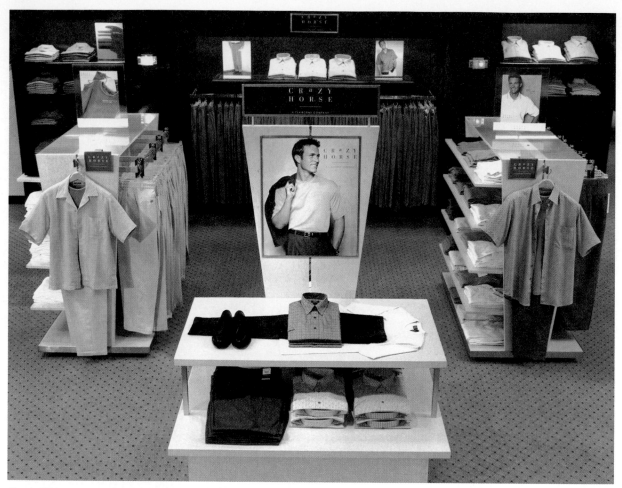

Crazy Horse, manufactured by Liz Claiborne, is a brand exclusive to J. C. Penney.
(Courtesy of J. C. Penney)

■ *NATIONAL BRANDS VERSUS PRIVATE LABEL*

Retailers provide their customers with house brands to differentiate themselves from the competition.

Multi-brand retailers across the country try to provide their customers with a wide selection of popular national brands. *National brands,* manufacturers' brands that are available nationwide, help the customer identify with a consistent standard of styling, fit, and quality from season to season. However, as stores stock more and more of the same national brands, exclusivity tends to decrease and stores look too much alike.

Exclusivity has long been an important aspect of a fashion retailer's uniqueness. Buyers seek distinctive fashion looks from out-of-the-way sources in foreign markets or from little-known, aspiring young designers to give their customers something that no other store has. Some retailers work with national-brand manufacturers to produce *exclusive brands* for them. Nordstrom, for example, has an exclusive line of BCBG. Many retailers also turn to private label.

Private Label

In an effort to save costs and provide quality, value, and uniqueness, most multi-unit retailers are selling private-label merchandise. *Private-label* merchandise carries the store's label, such as "Saks Fifth Avenue Real Clothes," or a fictitious name, such as Macy's/Federated's "I.N.C." or Nordstrom's "Classiques Entier." Private labels can be named after a celebrity, such as the Kathie Lee (Gifford) Collection at Wal-Mart. The general public is usually not aware of the difference between a private label and a national brand; to the consumer, they are all "brands."

Cost Savings

Private-label merchandise can be produced less expensively than premium national brands. Lower costs allow the retailer higher markups, thereby improving gross margin. Savings are also passed on to the consumer.

Exclusivity

Private-label merchandise also provides retailers with merchandise that is exclusive to them. Previously limited to basics such as polo shirts, retailers are now providing quality fashion merchandise under private label. These fashion collections or pieces help retailers to differentiate themselves from their competition.

Retailers as Manufacturers

Retailers have private-label merchandise made directly for them to their specifications by guaranteeing a quantity order. Manufacturing may be arranged in several different ways.

- Retailers may simply have a "hot" item copied by a contractor.
- They may have a line created for them by a design service, such as Peclers, and then have it produced.
- They may set up their own design and merchandising department, which works with contractors.
- They may work with a manufacturer that specializes in private label, such as Cygne Designs, or one that produces both branded merchandise and private label, such as Kasper or Tahari.

Retailers started private label for basic merchandise, such as hosiery, underwear, and basic furnishings. Major retailers today have hundreds of lines of private-label clothing, which account for at least 20 percent of all men's and women's apparel sold. Private label accounts for half of J. C. Penney's merchandise. Retailers are trying to find the right balance between national brands and private label.

Many retailers have developed private labels that can compete with national brands, such as J. C. Penney's Original Arizona Jeans Company. Successful private labels become recognized as national brands and have even spawned a new chain of specialty stores, such as Macy/Federated's Aeropostale. As discussed in Chapter 13, some retailers, such as the Gap or Ann Taylor, sell only private-label merchandise.

■ *BUYING OFFICES*

To facilitate buying, many stores are affiliated with resident buying offices located in international and domestic market centers or have their own corporate buying offices.

Although the term *buying office* is still used in the industry, its role has greatly expanded to fill a wide variety of functions. The two primary types of buying offices are independent and store owned.

Independent Resident Buying Offices

Independently owned and operated, these buying offices charge fees to noncompeting stores for market services. The current largest is the Doneger Group, which represents more than 800 stores.

Store-Owned Resident Buying Offices

There are basically two types of store-owned buying offices: associated and corporate.

■ **An associated buying office** is jointly owned and operated by a group of stores. Member stores usually have similar sales volume, store policies, and target customers but are in noncompeting locations. Operating expenses are allocated to each member store on the basis of the store's sales volume and the amount of services rendered. Associated Merchandising Corporation (AMC) is a well-known example.

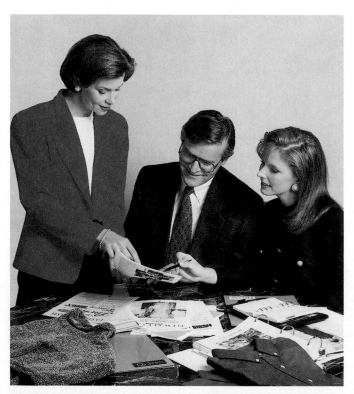

The Doneger Group offers consultations, market coverage, workshops, design direction, direct mail programs, special merchandise, and other buying information to customers.
(Courtesy of the Doneger Group)

■ **A corporate buying office** is owned and operated by the parent organization of a group or chain of stores. At Federated Department Stores, 70 percent of the buying for member stores is done centrally by the parent company, while the other 30 percent is done by individual member stores.

International Buying Offices

Many large retail stores have their own buying offices abroad or use foreign commissionaires, agents representing stores in foreign market centers. These offices are equipped to handle import-export transactions in the language of the country, check quality control, figure currency exchange rates, provide a consolidated center for shipping, and wade through customs red tape.

Buying Office Services

Buying offices act as market representatives for member stores. Their merchandisers see the lines of vendors, prepare market analyses, and send out bulletins to their member stores reporting on new fashion directions, bestsellers, trends, and special price offerings. However, unlike buyers, they do not make final decisions as to purchases and do not place orders unless specifically asked by the buyer of the retail store. Buying offices also organize group purchases for small stores so that the total order is large enough to meet the minimum-order requirements of large or important manufacturers.

Buying offices also offer many other services to their clients, such as color and trend forecasting, product development for private label, sourcing, facilitating imports, advertising and promotional support, and advice and information on all aspects of retailing. They provide members with information by means of reports, newsletters, workshops, and consultations.

■ RETAIL PRICING

Retail selling prices are based on predetermined store pricing policies and wholesale costs.

Markup

Markup is the difference between the wholesale cost and the retail price of merchandise. It can be figured as a percentage of retail value or calculated on the basis of cost. Most retailers calculate markup as a percentage of retail price. This method is used because expenses and profits are commonly expressed as a percentage of net sales based on retail prices. The markup must cover markdowns, shortages, and operating expenses and still create a profit. Operating expenses include salaries, travel expenses, sales promotion, and overhead, including rent, utilities, and store maintenance.

$$\frac{\text{Retail price} - \text{cost}}{\text{Retail price}} = \text{Markup}$$

Price Points

Several price points are offered in each department or merchandise category. The term *price range* refers to the span between the lowest and highest price points. Merchandise of comparable quality usually falls into the same

Table 14.1 Retail Pricing		
Pricing of a Typical Moderately Priced Dress		
Retailer's Costs		
Wholesale cost ($61.52 less 8 percent discount for prompt payment)	$56.60	
Allowance for markdowns (averaged over all dresses in stock)	5.00	
Allowances for shortages and pilferage	3.00	
Salaries and benefits (averaged per garment)		
Sales staff	7.00	
Merchandising and buying staff (including expenses)	8.00	
Clerical and stock room staff (receiving, marketing, deliveries, and other expenses)	5.00	
Advertising, display, and sales-promotional staff	8.00	
Administrative staff (executives, credit and accounting officers, including expenses)	11.00	
Employee fringe benefits	2.00	
Overhead (rent, insurance, utilities, cleaning, and security)	10.00	
TOTAL	$115.60	
Profits before taxes	8.40	
SELLING PRICE	**$124.00**	Retail price
	−56.60	Cost
54% Markup	$67.40	Markup

*These are approximate figures; percentages vary depending on the kind of store. Markup percentages vary according to volume and store.

price range. Within a price range there must be enough difference between price points that variations in quality at each level are obvious to customers.

■ RECEIVING

Merchandise purchased by buyers is received into a regional distribution center, then into the store, entered into stock, and put on the selling floor.

When buyers place orders at the market or with sales representatives, they indicate delivery dates which are usually staggered so that new merchandise is constantly on the selling floor.

Merchandise is accepted into a *central* or *regional receiving and distribution* warehouse where it is counted and checked for quality. Merchandise is ticketed according to information stated on the buyer's purchase order. The ticket includes bar code numbers for vendor, season, classification, department, and retail selling price. When this information is recorded into the retailer's mer-

Central receiving at Marks & Spencer in England. *(Courtesy of Marks & Spencer)*

chandise information system, the data are used for automatic ticket printing, record keeping, and accounts payable. Efficient receiving is achieved when manufacturers send *advance shipment notices* and *preticket* merchandise with information they obtain through electronic data interchange (EDI).

Retailers try to reconcile *fall out*, differences between actual shipments and purchase orders, and decide whether to accept or reject partially filled orders, substitutions, or late shipments. If the order is unacceptable to the buyer for any of these reasons, it may be returned to the manufacturer, or an unfilled order may be cancelled. Retailers use *chargebacks* to withhold payments to vendors to cover manufacturers' mistakes such as late shipping, missing paperwork, or incorrect assortments.

Planners decide on the proper distribution of merchandise to multi-unit stores, which may be already designated on the purchase order. Then merchandise is sent to individual stores and on to departments. The department manager also checks and verifies both the count and the information on the price tag. If approved, the merchandise moves into a stock room or onto the selling floor.

■ *RECORD KEEPING*

Retailers need to keep control of inventory, what merchandise is in stock and what has been sold, so that they are able to evaluate what to buy in the future.

Unit Control

To track and maintain records of *units,* or items, retailers use a *unit control system,* part of their overall computer-based merchandise information system (MIS). Unit control is a system for recording the number of units of mer-

chandise purchased, on order, received, in stock, or sold. Records are kept of additions to or subtractions from stock, from the time an order is placed with a manufacturer until that merchandise is sold. Information for unit control comes from receipts, sales records, and *merchandise transfers* (movement of merchandise from one store to another or elsewhere).

The major advantage of unit control systems is that the records enable a buyer to keep track of consumer demand. If certain styles are selling quickly, the buyer may reorder them; if styles are selling too slowly, the buyer may make markdown plans. Unit control systems also give a realistic growth picture in inflationary periods, when dollar volume increases may be misleading.

Inventory Control

Inventory control keeps records of the *dollar value* of merchandise on hand. Most stores use the retail method of inventory control, which involves figuring inventory at retail prices rather than on the basis of the wholesale cost.

Computer *inventory management systems* (IMS, part of the retailer's financial systems) record receipts, sales, additions to and subtractions from stock, stock transfers from one store to another, and returns by customers in dollars. When merchandise is sold, the point-of-sale terminal automatically feeds this information into sales records and deletes it in inventory records. Retailers integrate their unit and financial systems when it is possible.

Physical Inventory

A *physical inventory* is the actual item-by-item count of all merchandise on hand, taken one to three times annually to confirm computer records and to comply with accounting regulations. In case of discrepancies between the computer records and physical inventories, the physical count prevails and the inventory records must be adjusted accordingly.

Stock Shortages and Overages

Discrepancies between computer and physical inventory are described as stock shortages or overages.

Shortages mean a lower physical inventory than computer inventory and are the result of theft, damage, or clerical error. Shortages are common, and allowances must be made in initial pricing to cover these losses.

Overages indicate a higher physical inventory than computer inventory, and may be caused by clerical error, misticketing, or shipment to an incorrect location.

■ CUSTOMER SERVICE

To many consumers, and in many stores, service has become more important than fashion.

American retailers were pioneers in offering customer service. Years ago, Montgomery Ward and John Wanamaker, retailers that were established in the 1800s, instituted guaranteed-refund policies. The success of Nordstrom and Wal-Mart, where customer service is a priority, has paved the way for a re-

The shoe department at Nordstrom, the pace-setting retailer for customer service.
(Courtesy of Nordstrom)

newed interest in improved service in every store. The service in these stores has become the yardstick by which other stores now measure their own levels of customer service.

Many retailers are attempting to become "customer driven" (to anticipate and focus on the needs of their customers), in fact, to exceed customers' expectations. They train sales associates to be knowledgeable and helpful and may offer an increasing number of services:

■ To be "in stock"—having merchandise the customer needs available in all sizes, styles, and colors

■ Special incentive programs for core customers (such as Saks First Club)—which identify and reward high-spending customers, using proprietary credit cards

■ Customer appreciation days or courtesy days usually offering customer discounts

■ Specialized newsletters

■ In-store events such as wardrobe-planning clinics

■ Interactive videos that supply information on product location

■ Alterations

■ Gift registries and gift wrapping

■ In-store services such as photo finishing, restaurants and snack bars, packaging and mailing, and banking

■ Free use of fax machines and telephones for customers waiting to be fitted

■ Appropriate music

■ Free personal shopping services

- Knowledgeable and helpful sales personnel will check stock at other units
- Newsletters or "look" books
- No-question return privileges
- National credit card acceptance
- 800 telephone numbers
- Extended store hours
- Convenient restrooms and comfortable places to sit
- Free local delivery and valet or free parking
- Ordering kiosks in the store for catalog and online ordering

■ RETAIL SALES

Selling techniques have become very important in trying to establish repeat business and customer loyalty.

In many stores, customers have to hunt for assistance. At mass merchants and discount stores, sales help is often limited to cash register clerks. Training sales associates to be more knowledgeable and attentive helps maximize sales.

Sales Training

Fashion selling requires special training that gives sales personnel merchandise information, confidence, and motivation. In small stores, training is informal, usually based on getting experience on the selling floor. In larger stores and chains, training is likely to be more structured. H & M, for example, pairs new recruits with seasoned mentors. Chanel gives intense training aimed at teaching the selling staff how to establish ongoing relationships with customers to build loyalty and repeat business. Large chains have formal training programs.

At the beginning of a season, new merchandise is presented, often on video, to show sales associates how garments should be worn and accessorized. The fashion director or buyers explain the selling features of merchandise so that the selling staff in turn can point out quality, fashion, and performance features to their customers. Buyers try to infuse enthusiasm into the sales force, hoping that it will be transmitted to the customer.

The Department Manager

In multiple-unit stores with one buyer in a central location, day-to-day operations, including responsibility for sales and the maintenance of visual merchandising, is generally left to a department manager. Department managers may request more stock of a hot item and give the buyer a projected estimate of quantities that they expect to sell within a certain period.

Selling

Sales, after all, are the key to success in retailing. Of course, much depends on the buyer's selection of fashion assortments and whether the merchandise

is in stock to meet consumer demand. However, success also depends on the ability of sales personnel.

Personal Selling

Personal selling, the method involving the most customer contact, is used most often in specialty stores and for luxury merchandise. In this method, sales associates actively help customers choose merchandise suited to their tastes and needs. Sales associates are encouraged to greet customers at the door and to treat them as guests; tell them about the store's merchandising concepts; and ask questions about their life-styles, needs, and preferences. To build a multiple sale, associates are ready with alternative selections, wardrobe extenders, and accessory suggestions.

Sales associates at luxury retailers keep files on customers, noting style and color preferences, sizes, and other pertinent information. New computer-based systems create and maintain electronic profiles of customers including size and style preferences, physical measurements, career and social clothing needs, and sometimes even digital photographs. When new merchandise comes in that seems appropriate for their customers, these sales associates call or write a note to those customers.

Sales Incentives

To improve customer service, many stores are now offering their sales staffs incentives to increase productivity. These incentives, which may take the form of higher salaries or commissions, help attract better sales personnel. At some

Personal selling at Hermès. *(Photo by the author)*

stores, salaries are now based on the productivity of each sales associate. Nordstrom, for example, offers their sales associates a 6.75 percent commission, good benefits, and stock options as incentives.

Merchandise Representatives

Vendors are getting much more involved in retail sales. Some manufactures are supplying *merchandise representatives* or *sales specialists* to help train salespeople and help customers. For example, Ellen Tracy's representatives conduct seminars on merchandising, presentation, and selling. Vendors often supply other aids to selling, such as videotapes, slide shows, look books, or brochures (see Chapter 12).

Cooperative Salesperson Programs

Vendors become directly involved in retail selling by contributing to the salaries of sales associates through various types of programs. Some vendors share the cost of salaries and/or provide clothing allowances; others pay entire salaries of exclusive salespeople recruited either by the vendor or the retailer. It is difficult, however, to work for two masters.

■ *MERCHANDISING EVALUATION*

Evaluation of the success or failure of a season helps buyers plan for better merchandising for the future.

Retailers use an intranet (internal) communications system and access their merchandise information systems to make merchandising evaluations during and at the end of each selling season. These systems organize information about suppliers, merchandise, and customer preferences based on point-of-sales (POS) data. Retailers might use MIS to find out what colors, sizes, or vendors are selling best. They may be able to analyze sales information by store or by item, on a daily, weekly, or monthly basis. They can combine statistics in various ways to analyze their business. Each retailer's system is different and yields different information. Managing information technology will be the key to retail success in the future.

How Merchants Use Data

By evaluating exactly what merchandise has been sold, retail executives are better able to plan for the future, thus beginning a new cycle of buying and selling. With this information, they are also able to measure the merchandising impact on the store's profitability. Buyers' performance appraisals and bonus awards are also directly related to the achievement of financial goals. These evaluations can be ongoing or periodic processes.

Vendor Analyses The buyer may compile a *vendor analysis* showing the initial markup, markdowns, and profit percentages gained on products from an individual resource. A vendor must maintain a high percentage of regular price "sell-throughs." Although a vendor may have one or two bad seasons, the store will most likely drop a resource whose merchandise consistently offers no profit.

Comparisons Sales data can also be very revealing in relation to other important information. When compared with the previous year's data for the same period, the numbers show whether the store's volume grew over the year. When compared with the merchandise plan, the results show how well the store met its objectives established at the beginning of the period and, therefore, how well planning was done. The ultimate goal is to have exceeded objectives. When compared with inventory on hand and on order, as well as with customer returns, the figures can indicate whether merchandising, planning, and promotional activities were successful.

Sales-Related Ratios Sales data are also used to determine important ratios such as average gross sales, sales per square foot, and stock or inventory turnover. These sales-related ratios are used not only to evaluate a department or store but also to compare different stores within a retail chain. Due to fierce competition in a non-growing market, retailers experience pressure for higher gross margins, growth of average sale, more sales per square foot, and growth of market share.

- **Average gross sales**—Total dollar sales for a given period divided by the number of transactions for the same period provide *average gross sales.* This ratio indicates the dollar volume per transaction. An increase in the ratio can indicate higher prices, which result from better merchandise, inflation, or multiple sales per customer.

- **Sales per square foot**—Total sales for a period divided by the number of square feet of selling space of a floor or store provide *sales per square foot,* an internationally used indicator of productivity. Sales per square foot are monitored seasonally or sometimes monthly. In their desire for internal growth, many stores are focusing on raising dollars per square foot in existing units, often through renovation. As a result, new departments may be created, or existing ones may be increased or decreased.

- **Stock or inventory turn**—Stock turn is basically the number of times stock (inventory) is sold out and replaced in a given period. A high turnover is usually very desirable because it speeds the buying and selling cycle and frees funds for renewed use, thus increasing the profitability of the retail operation. *Stock turn* is calculated by dividing total sales by average stock or inventory. For example, if seasonal sales total $1 million and average stock is $500,000, then the stock turn is 2.

- **Gross margin**—Because the only source of income for most retail stores is the sale of merchandise, the projected sales must cover more than expenditures to produce gross margin objectives. The *gross margin* is the fundamental income from which expenses (including cost of goods, shortages, salaries, sales promotion, and store operations) are deducted to obtain the necessary profit to stay in business.

$$\text{net sales} - \text{all expenses} = \text{gross margin}$$

Planning Ahead All these indicators are used by buyers and management not only to measure the success of the retail merchandising operation but also to refine and improve the long-range planning of future merchandising activities. Evaluation and the establishment of new and more accurate goals result in a more profitable retail operation.

The major drawback of merchandising evaluations is that they cannot determine what styles, colors, or sizes customers wanted but could *not find* at the

store. So far, this information can be learned only informally through conversations with customers. Retailers hope to gain this information in the future via direct consumer responses fed into databases.

■ SUMMARY

As merchandisers, retailers must buy the right goods and have them in the store when their customers want them. Merchandising is guided by the fashion director and merchandising managers; responsibilities are divided between the buying line and the store line. Store policies and long-range planning help retailers do their jobs effectively. The merchandise plan allocates specific amounts of money for the purchase of fashion assortments. Assortment planning is expressed as a buying plan that includes descriptions of the types, quantities, prices, and sizes of merchandise needed. Retailers provide their customers with both national brand and private-label merchandise.

Buyers' responsibilities cover both the buying and the selling aspects of retailing. Buyers plan what to buy, search the markets for goods that will meet their customers' needs, promote sales, and supervise merchandising and selling, only to begin the cycle again for a new season.

Merchandise information systems aid in the planning, monitoring, and evaluation of retail sales. Internet data exchange allows for automatic replenishment of basic merchandise, computer records of business transactions keep records of sales and inventory, and merchandise information systems also help retailers evaluate sales to make future merchandising plans.

Customer service has become very important, as have sales training and incentives. Customer acceptance in terms of sales is the basis for success and profitability in retailing. Retailers face a constant challenge to serve the public more efficiently and effectively to ensure continued growth and development.

■ CHAPTER REVIEW

Terms and Concepts

Briefly identify and discuss the following terms and concepts:

1. Fashion director
2. Buying line
3. Classifications
4. Merchandise plan
5. Assortment planning
6. Stock turn
7. Open-to-buy
8. Vendor
9. Key resources
10. Corporate buying
11. Line buying
12. Matrix system
13. Resident buying office
14. Private label
15. Central receiving
16. Markup
17. Unit control
18. Personal selling
19. Sales incentives
20. Customer service
21. Markdowns
22. Sell-through
23. Sales per square foot
24. Merchandise information systems
25. Vendor analysis
26. Merchandise representatives
27. Gross margin

Questions for Review

1. How are merchandising responsibilities organized?
2. Explain the differences between the store line and the buying line.
3. How can the merchandise plan be either management or buyer directed?
4. Describe the buying-selling cycle.
5. What are a buyer's responsibilities?
6. Why must a buyer research fashion trends?
7. What is the difference between line buying and trend buying?
8. Describe the difference between broad assortment and short-cycle buying.
9. What is the difference between a national brand and a private label?
10. What services does a buying office provide?
11. Describe inventory control systems.
12. Name five customer services. Are they effective?
13. Discuss the techniques and advantages of personal selling.
14. Explain the difference between promotions and markdowns.
15. Why is merchandising evaluation important?

Projects for Additional Learning

1. Interview a local store's fashion buyer. Ask how and where he or she buys fashion merchandise: At a market? From a sales representative? Through a buying office? From a catalog? What type of merchandise is purchased in what way? What is the buyer's favorite method and why? How often does the buyer go to a market center? Which one does he or she attend? Summarize the answers in a written report.
2. Visit the contemporary sportswear department in a retail store and examine the merchandise. Is it all from one manufacturer, or has the buyer mixed garments from several vendors to carry out a fabric or color theme? Who are the major vendors in the department? What are the price ranges for jackets, sweaters, skirts, pants, and shirts? Which manufacturers have the most innovative looks? Ask salespeople which groups are selling the best and why they think so. Does the department have a good selection of sizes, colors, and styles? Write a critique of the department.
3. Shop a large department store. Study the three different ways to merchandise the suit look. Compare suits in (a) the missy coat and suit department (the suit is priced as a single unit); (b) the sportswear department (components are priced separately); (c) the dress department (components are priced as a unit, usually a dress with a jacket). What suit styles do you find in each department? Compare the selection (assortment), price ranges, quality, and fit in one department with those in the others. Which department has the best value and selection?
4. In a local store, evaluate a sale rack. Is the merchandise marked down or is it a special purchase (garments purchased at a lower price and offered as a promotional event)? Why was the marked-down merchandise marked down? In your opinion, was it because of styling, poor timing, poor construction, poor fit, unattractive colors, or too high a price? Summarize your findings in a short report.

■ *NOTES*

[1] Stacey Kaye, New York City, interview, May 2, 2000.
[2] As quoted by Pete Born, "Wexner Shares Trade Secrets at FIT," *Women's Wear Daily*, February 23, 1989.
[3] Julie Dugoff, Buyer, Saks Fifth Avenue, New York, interview, May 4, 2000.
[4] Ibid.

Rachael Arnold, visual merchandising director at Bloomingdale's, discusses an installation with stylists Wayne Anderson and Gary Warren.

(Courtesy of Bloomingdale's, photo by the author)

15

Retail Fashion Marketing

■ CAREER FOCUS

Marketing provides a wide variety of interesting and creative career opportunities. Retail marketing executives have the responsibility for, or work together with, those in charge of advertising, public relations, market research, and new business development. The advertising director works with in-house and agency creative directors, ad managers, and copy chiefs, layout artists, writers, media buyers, merchandise coordinators, and photographers. Corporate directors of fashion, special events, and/or public relations have regional managers or store coordinators to carry out responsibilities in individual stores. The visual merchandising director of a chain of stores oversees regional or individual store visual merchandising managers and a staff of designers.

■ CHAPTER OBJECTIVES

After reading this chapter, you should be able to:

1. Explain the purpose of marketing;
2. Explain how a store's fashion image is conveyed to consumers;
3. Explain the purpose, goals, and procedures of advertising, publicity, special events, and visual merchandising;
4. Describe various types of media and their relation to target customers.

■ *MARKETING*

Marketing is the responsibility of everyone in retailing from management to sales associates.

In its broadest sense, marketing encompasses all of the activities needed to sell merchandise to the consumer. *Marketing* involves communicating a store image and/or the existence of a product to consumers. It is an attempt to attract the type of customer for whom the merchandise is intended. The primary challenges of marketing are to attract new customers, get customers into the store, and generate sales and increase market share by inspiring new and current customers to buy more.

In retail stores, fashion marketing more specifically refers to the efforts to further those sales by means of advertising, publicity, special events, and visual merchandising. The store shopping experience has to be interesting and fun to compete with the allure of shopping at home. Ideally, retailers should have several channels of distribution; store retailing should be balanced with online and catalog merchandising so that the customer has alternate ways to find merchandise.

This chapter deals with all aspects of retail fashion marketing, including market research, fashion leadership and store image, visual merchandising, advertising, public relations, and special events. The methods used by retailers to market fashion vary considerably. Merchants must choose the approach best suited to their customers, the merchandise, and the size of their business and budget.

Market Research

Whether setting up a new store or reevaluating an existing one, retailers study the types of people who live in the community, their life-styles, and ultimately, their shopping wants and needs. As discussed in Chapters 2 and 4, retailers use telephone and online surveys, focus groups, feedback from sales associates, and point-of-sale (POS) data to study their customers.

Retailers analyze sales data on a store-by-store basis to uncover differences in customer buying habits. They issue their own credit cards to get even more precise information about their customers. All of this information is entered into databases for use in store planning and merchandising. They also use these databases to establish loyalty programs to reward good customers.

Retail Target Customers

Retail management decides which group of consumers it wants to reach and how it wants to reach them. The term *target market* is used for the group of consumers the store wishes to attract. As discussed in Chapter 2, customers comprising a specific target group are within a general age range, have similar life-styles, and, therefore, have similar needs and tastes. No retail store can be all things to all people; it must select one or a few groups of people to serve. Massimo Ferragamo explained, "You can't take the customer for granted and just hope they come floating into the store. We want to know who they are, their likes and their dislikes."[1]

While specialty stores may aim at one market segment, a department store tries to appeal to several categories of target customers. Separate departments, areas, or floors are created for each category. Once retail executives determine the target market, they tailor the store's image, merchandise focus, and marketing efforts toward those consumers.

Saks Fifth Avenue is a fashion-forward, national multibrand specialty store.
(Photo by the author)

Fashion Leadership

Each store plays a role in fashion leadership according to the customer it wants to reach. Fashion leadership can be separated into three loosely defined categories:

Fashion-forward stores, such as Bergdorf Goodman, Saks Fifth Avenue, Neiman Marcus, or Henri Bendel, seek leadership by carrying high-priced fashionable merchandise from around the world. There are fewer of these stores because the percentage of customers who can afford their high prices is relatively small.

Mainstream retailers identify with consumers who want fashion adaptations available to them at moderate and upper-moderate prices. Most of the department stores, such as Nordstrom, Macy's, or Dillard's, fall into this category, as do some specialty stores, such as Banana Republic.

Mass merchants such as Wal-Mart appeal to people who simply cannot or will not spend more money on their clothing. However, even at this price level, mass merchants find that they need a balance of fashionable and basic merchandise.

The Retailer's Image

Consumers are overwhelmed with so many choices, and it is often difficult for them to understand a store's message. It is important for a retailer to define its *image* clearly, the personality or character that it presents to the public. This image or uniqueness reflects its degree of fashion leadership and its market niche and, therefore, appeals to its target customers. Ralph Lauren said,

The rich, warm, traditional environment of Bergdorf Goodman's men's department. *(Courtesy of Bergdorf Goodman)*

"Retailers have to have a point of view. It's the most important thing for retailers to have an identity, a sense of who they are."[2]

In keeping with that image, retailers strive for a store atmosphere that is both a complementary background for merchandise and an inviting environment for the customer. The store's merchandising, advertising, interior decoration, and customer services develop, maintain, and reflect that image and try to generate excitement about the merchandise to create a desire to buy.

■ *PLANNING AND DIRECTION*

The sales marketing director, fashion director, advertising and creative directors, visual merchandising director, merchandise managers, and buyers work together to plan and coordinate marketing strategies.

In small stores, a single person may direct all marketing activities with the help of outside consultants or agencies. In a large store, a marketing director may coordinate the joint efforts of advertising, special events, visual merchandising, public relations, and the fashion office (sometimes the fashion office is part of merchandising, and visual merchandising is part of store planning). In large chains there may be a vice president to head each area.

Buyers recommend plans for marketing activities in conjunction with their projected merchandise plans. The marketing director, fashion director, advertising and/or creative directors, visual merchandising director, merchandise managers, and buyers must agree on marketing strategies and how to reach their target market. At planning meetings, they discuss how to communicate fashion trends and important designer or brand promotions within the context of the store's image.

Stores schedule marketing activities for seasons and holidays throughout the retail calendar year as an integral part of the year's merchandising plan. Advertising and promotional events, such as holiday sales or customer appreciation weeks, are often scheduled up to a year ahead of time. In spite of all the scheduling, however, new promotions and other events can supersede all the best laid plans. For example, plans for scheduled activities could be cancelled in order to launch a new product. Marketing has to be flexible.

■ *VISUAL MERCHANDISING*

The corporate visual merchandising director, store planning director, architects, regional creative directors, and individual store visual managers and designers create a store's visual image.

Visual merchandising, or visual presentation, is one of the means to communicate a store's fashion, value, and quality message to prospective customers. The purpose of visual merchandising is to entice the customer into the store, to enhance the store's image, effectively present the merchandise the store has to offer, and show the customer how to wear that merchandise and accessorize it. With increased competition, retailers are trying to create more exciting and aggressive presentations. They use a variety of methods, such as humor, shock, elegance, and minimalism, to get attention or enhance store image. As visual presentation is an opportunity to create uniqueness, each retailer has its own approach.

Visual merchandising is a team effort involving management, including the fashion director and the marketing director; store planners; merchandise managers and buyers; the visual merchandising director, designers, and staff; the sign shop; and the individual department managers and sales associates. The actual presentation work is done by visual merchandising designers, and the daily arrangement of merchandise is carried out by department managers and sales associates.

Store Planning

The building design plays an important part of establishing a store's image. Although building and renovations are managed by a separate *store planning division*, it is helpful to discuss it as a background to visual merchandising. A store's effectiveness and uniqueness lies in the retailer's ability to plan, create, and control both the store's image and its physical building. Store planning management must consider store location, architecture, and interior layout.

Store Location

The location of a store is very important in relation to its potential customers. *Demographic research* is done to determine what location would best attract target customers. Computerized site-selection programs provide data

on area population forecasts, descriptions of households by income, median age of market-area residents, and information about the competition.

Store Design

Store architects have to create an environment that is conducive to both retail operations and consumers' shopping needs. They consider the exterior design, major entrances, the relationship of the building to the mall or surrounding stores, interior layout, and space planning. Interior aesthetics must be in keeping with store image and the comfort of customers.

In addition, department relationships, aisle space, and traffic patterns are considered to make the departments and merchandise accessible and to help customers find what they want easily. To comply with the American Disabilities Act, aisles must be wide enough for easy wheelchair access.

Renovations

Many retailers are renovating existing stores, sometimes to reflect the characteristics of local communities, to generate new traffic and to increase market share. Renovation is a way to reposition a store, generate new traffic, and broaden the customer base without the expense of building a new store.

Store Image and Environment

Store management, including the visual merchandising director, store planners, and architects, want the store image to be reflected in the design of the store. The store's image must also appeal to target customers. For example, attracting the mature customer to a store or department with quality merchandise requires the creation of a warm, comfortable atmosphere. This may be achieved with wood paneling, comfortable seating, paintings, and furniture, such as those found in an elegant home. In the case of basic merchandise, the retailer may appeal to traditionalists by presenting a clean, orderly environment with neatly folded merchandise, such as that found at the Gap. To attract teens, retailers employ graphics, humor, and music. Macy's, for example, launched teen shops with concrete floors, exposed steel tubing, rotating laser lights, media walls, music videos, and a deejay, to create a club atmosphere.

Seasonal Visual Merchandising

Visual merchandising managers, along with marketing and merchandising executives, make up a *seasonal calendar* indicating the dates on which specific merchandise is to be featured and the number and location of windows and interior displays that are to show the merchandise. Seasonal merchandising themes are planned up to a year in advance in conjunction with the seasons, other store promotions, and arrivals of new merchandise. Planning a theme gives a focus to visual merchandising and a consistent look throughout the store. In some cases, the theme may involve a tie-in with a vendor to introduce a new line.

The visual merchandising budget includes the cost of new mannequins or refurbishing existing ones, props, special effects, and the number of people and the hours needed to create and maintain the windows and interior displays.

Windows

The visual statements made in downtown store windows or at mall store entrances are the customers' first encounter with the store and must effectively and correctly convey the store's image and fashion focus and entice shoppers into the store. As marketing executive Virginia Meyer commented, "Store windows attract, compel, and persuade . . . A good presentation can and should stop you, get your attention, and maybe even make you smile. In a very broad sense, visual presentation not only helps sell the merchandise itself but the store as well. It becomes a part of the store's personality and is one of the reasons for returning to a store time and again."[3]

A window is a total environment, a complete statement on its own. It is also the most secure form of presentation because merchandise in the windows is protected. Windows are usually the most dramatic of the store's visual statements. They can be humorous or theatrical. To attract attention, windows may feature animation, video art, lights, holograms, or other special effects. Some stores use look-through windows to make the windows part of the total store environment.

Special event windows tie-in to events and store promotions or convey the spirit of a holiday season. They create excitement and interest to visit the store.

Fashion message windows feature a designer collection or the newest fashion trends and suggest ways to coordinate accessories. These windows are created to attract attention and coax customers to buy a new garment and/or accessory.

Stylist Kevin Burke retouches mannequins in the window at Bloomingdale's, New York City. *(Courtesy of Bloomingdale's, photo by the author)*

Direct-sell windows, used mostly by stores that carry popularly priced merchandise, show a representative assortment of the store's merchandise accompanied by prices to tempt the customer with a possible bargain. Direct-sell windows are used more often in Europe.

Interiors

The customer is further exposed to fashion and accessory purchase suggestions by interior presentations that may be located near the entrance to the store; at entrances to each floor or department; or in departments. In urban stores, the focus is on the main floor. For stores in shopping malls, which may have few or no windows, visual merchandising must capitalize on the wide store entrance that gives the passing shopper a sweeping view of the selling area, giving entry area displays great impact.

Presentation areas or "environments," positioned in front of each department or shop, highlight the most interesting merchandise from the surrounding area. The props and the backgrounds are chosen to complement the featured merchandise. Different levels of interest are created on ledges, counters, platforms, or even hanging from the ceiling.

Interior displays may take the form of *image* or *life-style* presentations (mannequins posed in a scene and dressed appropriately) or *single items*, shown on a form or stand. Sportswear is usually shown in groups, whereas

evening wear may be shown individually. By showing total wardrobing concepts, including accessories, displays help both to educate and to entice the customer.

Elements of Visual Merchandising

The elements used to show or enhance the clothes on display include mannequins and other forms, vitrines, fixtures, ladders, poles, columns, platforms, tables or other furniture, boxes, paintings and other wall decoration, fabrics, banners, posters, counter cards, lighting effects, accessories, and other props. Most of all, visual merchandisers try to enhance merchandise with other merchandise. Details are very important; every viewpoint has to be considered.

Mannequins

Mannequins change with fashion trends and are made in the image of the current ideal of beauty. For elegant fashion, perfectly coiffed, traditional life-like mannequins are preferred. However, they are very expensive to buy and to maintain. To save money, many stores have replaced them with less expensive papier-mâché torsos or unpainted "mannequin alternatives."

A men's wear interior presentation at Bloomingdale's, New York City. *(Courtesy of Bloomingdale's, photo by the author)*

Standards Manuals

The corporate office sets standards for consistent visual merchandising. Standards manuals list exact specifications for all display forms, fixtures, and props, for example, the height of a T-shaped stand and how it should be placed on the floor, placement of tables, and so forth. Quarterly addenda update the standards as new ideas are implemented. Visual merchandising artists set up the presentations and then sales associates are trained to maintain these standards in each department.

Presentation Packages

The corporate or central visual merchandising office may also create presentation packages for branch stores so that the entire group or chain will have the same look. Large presentation-packages, including floor *planograms* and photographs, are prepared at the flagship store and sent to other units. Flexibility allows customizing of packages for seasonal differences in various regions. For example, a theme around fall leaves in Washington, D.C., would not be suitable in Phoenix, Arizona.

Telecommunications

Many stores are using teleconferencing to show actual visual presentations to other stores in their chain so that local display artists will be able to make all the presentations look the same. They also use virtual computer mockups to share visual concepts with colleagues across the country via Intranet.

Designer/Brand In-Store Shops

In the case of in-store designer or brand boutiques, the vendor has visual merchandising requirements for presenting its line of merchandise. In some cases, the manufacturer supplies the fixtures so that they are the same in every store. It is often difficult to reconcile the individuality of these shops with the store's own identity. Some are de-emphasizing in-store shops or eliminating them altogether. Still other stores try to merge the look of the designer boutique with the store's image.

Departments

The store is divided into departments and/or designer or brand shops by fashion category or life-style. Traditionally, the main selling area is reserved for cosmetics, jewelry, and accessories. The rest of the store is divided into groups of departments and shops that relate to one another by category or price range. Department location is considered, and some shops are given prime location to attract attention. Destination departments, containing merchandise such as swimsuits, lingerie, or coats that customers seek because they are needed, can be in secondary locations.

Successful visual merchandising invites customers into a department. Visual merchandising must draw the customer to the department most suited to his or her life-style. There is no sign that says, "If you are age 38 to 50, live in the suburbs, and wear an average size 10, go to the 'Miss Macy' department." Yet each department is merchandised with certain life-style statistics

A life-style presentation at the entrance to the swimsuit department at Bloomingdale's.
(Photo by the author)

in mind. Informational signing and large life-style photographs on the walls, such as those found at Wal-Mart, help customers find their way.

Stock is arranged in an orderly, attractive manner, to contribute to the visual effect of the department and to help customers quickly find what they want. As popular apparel or accessories are sold, the department manager and sales staff need to rearrange the merchandise. Visual designers train department staff members how to layer clothes on hangers, how to display folded merchandise, and how to arrange merchandise by color groups.

Fixtures In apparel departments, clothing is hung on fixtures which are arranged, usually in a grid pattern, to give access and a clear view of the department from every angle. Assortments may be displayed on *wall racks*, *rounders* (circular racks), *four-way* or *star fixtures* (with four arms), or *T-shaped stands* (with two arms), I-beams (straight bars), or collection fixtures (with folded merchandise on shelves on one side and hanging clothes on the other). Assortment displays must permit customers to see an entire range of colors or styles in each size. To avoid visual monotony, the fixtures are usually mixed. Although wall fixtures utilize space well and rounders show off a color story, they are not the most desirable means of display because the customer is confronted with nothing but sleeves (or sides of garments). On frontal projection fixtures, such as the four-way or the T-stand, the garments face outward so that the customer can see the fronts. The first hanger on a sportswear T-stand is usually an H-shaped hanger showing a coordinated outfit so that the customer can see how the various pieces work together. Fixtures are becoming more sophisticated and many stores are also creating their own custom fixtures to fit in better with overall store design.

Folding and Stacking Stores such as the Gap have made folding a popular and space-saving way to display merchandise. Store standards dictate placement of shelves or tables and how the merchandise should be folded and grouped. Retailers have found that merchandise on tables sells better because it is more accessible.

Accessories

Much more attention is being paid to visual merchandising of accessories. Traditionally located in the main selling area, some accessories are now available on apparel floors, too, so customers can quickly accessorize their clothing purchases. Accessories can be shown in *vitrines* (glass cases), on shelves or tables, or on-wall display racks. Stores must balance the salability of accessible, "open-sell" merchandise with the security and exclusivity of glass-case display.

■ *FASHION ADVERTISING*

The advertising director, creative director, art director, writers, and layout artists work together to create retail advertising. They are usually assisted by advertising agencies.

The largest portion of the marketing budget in a retail store is normally allocated to advertising. *Advertising* involves the planning, writing, designing, and scheduling of paid announcements designed to attract customers' attention to a fashion product or event. Advertising uses wit, shock, elegance, celebrities, and other creative approaches to get attention.

Advertising is designed to reach specific target customers or potential customers. Therefore, advertising style must be altered to reach various types of consumers. To the contemporary customer, trendy clothes are sold with sex and sizzle; to the upwardly mobile professional, merchandise is presented in enhanced status images; to the family-oriented consumer, fashion is presented in an atmosphere of hearth and home.

Kinds of Advertising

Stores use three basic types of advertising: image, item, and promotional.

Image Advertising

Image advertising focuses on fashion image, fashion leadership, community goodwill, a new or remodeled store, or a special event. While it may show merchandise, the product is of secondary importance. The goal is to communicate the store image as a brand, to build consumer confidence, promote community goodwill, create a mood, or create excitement about a new store or event. A variety of strategies, such as shock, controversy, humor, or celebrity models, are used to create a lasting impression. Even mass merchants try to create an image of great merchandise for less money.

Advertising designer Rob Corder discusses an ad proof with Peggi Davis. *(Photo by the author)*

Item Advertising

Item advertising is created to sell merchandise. The goal of item advertising is sales as a direct result of an ad, but the results are difficult to track. This type of advertising may be done as a cooperative arrangement between manufacturers and retailers.

Promotional Advertising

Promotional advertising is price directed. It might proclaim that a store has special values, or it might announce storewide sales or clearances. Some stores, such as Macy's or Mervyn's, are more promotional than others and, therefore, do more promotional advertising. Most stores advertise promotional events, such as sales, customer appreciation weeks, and special buys.

Cooperative Advertising

Fiber producers, fabric producers, and apparel manufacturers often cooperate with retailers to pay for advertisements that feature their merchandise. Co-op allocations are based on a percentage of net sales to the retailer and may provide a large percentage of media and/or production costs. This

additional money enables retailers to make ads larger or to run them more frequently. The resulting increased advertising volume may also help the retailer qualify for a lower media rate. Many retailers would not be able to advertise merchandise without co-op money from producers.

Scheduling and Planning

An *advertising plan* is a guide for a specific period (such as a week, a quarter of the year, or a season) and for the amount of advertising that a store intends to do in that period. The advertising plan is based on past experience, present conditions, and future expectations. Ads are most often scheduled up to a year ahead of the selling season, whereas the actual content may be planned closer to the selling season.

A *budget* is prepared, indicating the allocation of funds for advertising production and media. Advertising space in newspapers or time on radio or television must be contracted. A *production schedule*, or timetable, is developed detailing how and by whom the ad production is to be carried out to meet media deadlines and other requirements.

Media

In advertising, *media* is a general term used to cover all methods of transmitting a sales message. The media include newspapers, newspaper inserts, magazines, radio, television, outdoor boards, the Internet, CDs, and direct mail. Fashion advertisers are faced with an overwhelming abundance of media choices. Advertising department or agency media buyers must choose the medium or combination of media that is right for both product and type of customer. Each consumer group has unique tastes, ideas, and interests and consequently responds to different media. Media buyers must choose which particular radio or television station, newspaper, magazine, or other vehicle will reach the appropriate customer for specific merchandise. Where the ad is placed and how often the ad appears are as important as the ad itself.

Several ads are usually placed in different media to support each other and strengthen the campaign. Peter Connolly, Executive Vice President of marketing for Tommy Hilfiger said, "Not everyone just reads magazines, or just watches TV or just looks at outdoor advertising. And they do different things at different times of the day. You really need to have a mix of media."[5] To balance the spot radio commercial aimed at the car commuter, the store might also place an ad covering the same material in the newspaper for bus and train commuters to read. Repetition and consistency make the advertising message memorable. The same ad heard at the same time every day on the radio, or a fashion ad in the same illustration style every week on the same page in the newspaper makes people keenly aware of the store or brand name as well as the fashion message.

Newspaper

Newspaper advertisements, or *run-of-press* (ROP), are popular among most fashion retailers for the following reasons:

■ They provide visual as well as verbal means of telling consumers what merchandise the company has to offer.

■ They may be offered daily.

■ Layouts, art, and copy are relatively easy to produce.

- Media costs are comparatively low.
- They provide a quick turnaround time from idea to appearance.

Space and Positioning Media buyers buy space in newspapers that reach the store's potential customers. Day after day, readers in specific geographical areas or trade groups are exposed to the company's fashion message. The producer or retailer can buy a certain desirable position in the paper, such as the back page of the front section, on a contractual basis.

Supplements The use of preprinted advertising, especially in magazine format inserted into newspapers, is a successful form of advertising for retailers. Many stores are using the glossy magazine format because, like a catalog, it has a longer "coffee table life" and can be zoned for any area of the country.

Vendors who contribute money toward the cost of supplements like the huge circulation and relatively low cost per thousand. Inserts are particularly cost-effective when the retailer has many branch stores in an area served by just one newspaper. Circulation may be anywhere from a million copies to many millions for stores spread over many states.

Magazines

Stores advertise in magazines that have similar target markets to their own. National retailers such as Saks Fifth Avenue regularly advertise in fashion magazines such as *Vogue* because they can benefit from national circulation. These ads are often image ads that build the retail name as a brand. To attract attention, some retailers pay for impact units of multiple pages, which may also give them premium positions within the magazine.

Some national magazines also have regional editions that carry pages of local store advertising. Retailers may also advertise in shelter or general interest magazines to reach certain markets. Metro or regional magazines are used by stores to target customers in a specific area. There is a large proliferation of fashion, beauty and life-style titles to choose from, in addition to teen, general interest, and entertainment magazines.

To provide direct consumer response, some retailers insert pages of catalog-like advertisements into magazines. Teaming up with Bloomingdale's and Style Source, *Marie Claire Magazine* distributed a CD-ROM catalog insert, featuring merchandise from a variety of vendors and information on trends. Frequently, inserts provide 800 numbers or information to facilitate online ordering. Other stores may use tear-out response cards inserted next

This cooperative ad from Bloomingdale's and InternetPlus offers a selection of merchandise on an actual CD-ROM distributed in *Marie Claire* magazine. *(Courtesy of Dente & Christina Associates, Inc.)*

to their ad in the magazine to pull traffic into the store and to track the success of the ad. Customers are requested to bring the cards to the store to exchange for a free gift or a gift with purchase.

Television

Television advertising is growing in popularity as the general public is watching more and reading less. The medium also offers the advantage of being able to show how clothing might fit into a real-life situation. However, advertising is hampered by consumers' opportunity to browse channels. Other major drawbacks to TV advertising are the costs of air-time and production.

Time Buys Purchased by media buyers, the cost of *air-time* is determined by the length of the commercial, the time of day and the day of the week it is to be shown, and the size of the audience. Prime time, the most expensive, is between 7:00 and 11:00 p.m. when the greatest number of adult viewers is watching. Air-time in a large city with a large viewing audience is much more expensive than air-time in a smaller city or town. Media selection is based on how successful stations are at reaching viewers as measured by subjective gross rating points.

Production A TV commercial might cost anywhere from $50,000 to $500,000 or more for a 30-second production. Production costs cover fees for the writer; producer; director; talent; voice-over announcer; camera work; location; editing; music; and expenses for wardrobe, props, lighting, film, and developing. Commercials are usually produced by broadcast agencies or by local TV stations.

National Television National television advertising is used by large national firms that sell and distribute apparel across the country and have large enough advertising budgets to pay for production and buy network television time. Sears, for example, used TV advertising in its "Softer Side of Sears" campaign to enhance its image. A network television show reaches millions of potential consumers throughout the country. Cable television shopping networks such as QVC and HSN provide an opportunity for direct sales response.

Retailers also compete to dress the stars of TV shows to appeal to teen life-styles. Retailers also use actresses and actors in their ads to build their brands and get attention.

Radio

Because viewers can see the fashion, television has an advantage over radio for apparel advertising. However, radio can make the listener aware of a store location, brand name, or timing of a particular sale. Peak radio listening hours, which cost more than other periods, are during drive time, the rush hours when commuters listen most to their car radios. Stations are selected for their target market appeal. Buyers might choose a rock station to reach teenagers versus an oldies, classical music, talk or news format station for baby boomers.

E-Commerce

The multimedia capabilities of the Internet allow advertisers to combine graphics, text, sound, and moving images on banner ads. However, retailers have to differentiate their ads because there are millions of web sites compet-

ing for attention. Banner ads are sold on a cost-per-click or click-through basis. Prices range from $1.00 to hundreds of dollars for a small ad.

When a consumer makes a purchase from an E-commerce site, the retailer requests the customer's E-mail address. Then the retailer can use that address for advertising, delivering messages about special promotions and products directly to an existing online customer. E-mail allows the retailer to be much more specific and tailor the ad to the consumer's demographics and buying history.

Direct Response

To promote instant sales, retailers provide the means for direct response in all types of advertising. E-mail addresses and 800 numbers are provided in many advertisements to encourage immediate response.

Direct Mail

Direct mail is an extremely popular and highly effective form of advertising because it is addressed to each individual customer. Direct mail has become especially important as retailers compete for market share. As discussed in Chapter 2, databases, with information gleaned from customer purchases, can isolate specific groups of customers according to their buying habits, such as frequency of purchases, average dollar amount of purchases, and the exact departments where purchases were made. Stores are able to mail specific statement enclosures or catalogs to target audiences, such as mothers of small children, large-sized customers, or petite women.

Statement enclosures are advertisements that are sent with monthly billings to charge customers, usually the retailer's best customers. They combine photographs, often provided by manufacturers, with order forms or 800 numbers.

Pages from an Ann Taylor catalog. *(Courtesy of Ann Taylor)*

Catalogs have become a tremendously popular form of advertising because of the shopping convenience they provide to working women, retirees, and those people living away from major metropolitan areas (see Mail-Order Merchants, Chapter 13). Retailers may produce specialty catalogs, shoes for example, in cooperation with vendors.

Store newsletters or magazines are used by some retailers to give customers fashion trend information. Image brochures, provided by manufacturers, are sometimes mailed or given out to customers in the store. These are not catalogs per se because they do not include order forms but simply communicate a manufacturer's or store's merchandising image to customers.

Outdoor Signing

Building-scapes, train platforms, city or mall kiosks, buses, and bus shelters have been surprisingly successful vehicles for fashion advertising. Companies such as the Gap, Esprit, and Levi Strauss pioneered this method, which has grown into a very important medium. Some malls are trying out double-sided, triple-sided, and cylindrical interactive kiosks that will carry large ads in the common areas of the malls and on the surrounding sidewalks.

The Advertising Department

Because they do so much newspaper advertising, some large retail stores have in-house advertising departments. The advertising director supervises three areas: art, copy, and production.

Art

The art department is responsible for *layouts*, the composition of all parts of the ad. Layouts can be made on computer using software programs such as

Production specialist Rick Thoman creates a computer ad layout at Macy's.
(Photo by the author)

Quark Xpress and Adobe Photoshop. Photographs are digitally scanned and incorporated into the layout with the copy, store name logo, and any other graphic art to complete the ad.

The use of photography is currently popular because its realistic qualities lend themselves to promotional or item advertising. Stylists assist the photographers by booking models and locations, accessorizing, and arranging for hair and makeup artists.

Copy

Copywriters produce the written description for advertisements. The good writer pictures the customer who is reading the ad and writes to him or her. Buyers give merchandise information, highlighting unique selling points, to the advertising department. Copy for fashion merchandise, which emphasizes an editorial fashion message is quite different from sales copy, which stresses value.

Traffic

The traffic department is responsible for the flow of projects (graphics, illustrations, photographs, and copy) among the store, service bureaus (which put electronic files into proofs), printers, engravers, newspapers, and radio and television stations. The finished ad can be transmitted electronically via telephone line or satellite to newspapers or printers around the world, or posted to an FTP (file transfer protocol—a third party Internet site) on the Internet for downloading.

Advertising Agencies

Many retailers, even those with their own in-house staffs, use outside advertising agencies to handle special projects, media buys, or for concept development. Agencies also help when there is a heavy workload or for a special project, such as a magazine format insert. Stores also use agencies as a cost-effective way of producing timely advertising without having to retain an expensive in-house staff. Payment may be handled on a project fee basis or an annual contract.

In large agencies, groups of people are assigned to particular accounts under the direction of an account executive, who acts as a liaison between the agency and the client. Agencies also use freelance copywriters, illustrators, and production artists to help them with heavy workloads and special projects. The drawback to using agencies is that it takes time for them to become acquainted with the store's point of view. On the other hand, an agency can offer objective ideas about how to project the store's image.

■ PUBLICITY

Publicity is usually handled by the directors of fashion, special events, and/or public relations.

Publicity is the spreading of information about people, special events, or newsworthy topics through various communications media. There are no media costs for publicity, but for that very reason, it is difficult to obtain. It is also considered more prestigious than advertising because it is the result of an

editor's choice rather than the payment of money. Media editors choose the material they will use based on what they think may be of interest to the community and decide how, when, and where the message will be used. Publicity helps promote the sale of fashion merchandise by making a style, manufacturer, retailer, trend, or other aspect of fashion better known to the public.

Publicity Campaigns

Retailers hope to bring their names to the public eye by calling attention to newsworthy developments in their stores. They may create events such as fashion shows or celebrity personal appearances to obtain publicity. Stores provide the media with information about such events or topics in the hope that the media will publicize them. A publicity campaign may be handled by the public relations office or the fashion office, whichever is more concerned with the topic or event. Alternatively, it may be prepared by an agency or consultant. Every retailer has a different approach.

Newspaper fashion editors often use publicity releases and photos to write their articles. Fashion magazines give publicity to retail stores in editorial credits, the mention of the store name as a source of merchandise that is editorially featured. Paying advertisers are becoming more demanding of the media in their requests for publicity.

Press Package As part of a publicity campaign, a *press package* consisting of a *news release* and photographs might be prepared to send to media editors. A news release is a written statement of the important facts about a person, place, or coming event and is often accompanied by glossy photographs, which may be provided by vendors.

Individual Approaches To achieve maximum benefits from publicity, public relations or fashion office staff direct publicity to the media whose audience would be most interested in their message. News may be approached from various angles to ensure that each medium gets a unique story.

■ *SPECIAL EVENTS*

Corporate directors of special events and/or public relations, regional managers, store coordinators and their staffs need superb organizational skills to carry out a wide variety of special events.

Special events are designed to give customers a specific time and reason to come into a store or to create goodwill. They represent an attempt to replace or renew the personal customer contact that has been lost in many large stores. When well planned and executed, special events can enhance the store's identity, build customer loyalty, and create a sense of community spirit. The retail store as "theater" also caters to the many consumers who enjoy shopping as entertainment. Michael Gould, CEO of Bloomingdale's, commented, "We are in the entertainment business, and if it's pleasant to be in our stores, people will stay there longer."[6]

Most special events are planned and carried out by a special events director and, in the case of a fashion show, in cooperation with the fashion director. In a large flagship store, separate offices may handle each function: fashion, public relations, and special events. In a branch or smaller store, all three functions may be managed out of one office. The special events office must schedule

events in conjunction with the advertising department to support store strategies. The special events office schedules designer guest appearances in the store and sends press releases and invitations for both in-store and community events. These may include fashion seminars, convention tie-ins, community services, charity events, sponsorships, tie-ins with public events, the launch of a new product, wardrobing clinics, and/or fashion shows. Examples of successful events are Macy's Spring Flower Show in San Francisco or their Thanksgiving Parade in New York City.

Fashion Shows

Fashion shows are special events that communicate a fashion story. The selection and organization of the fashions and model bookings may be done by the fashion office, whereas invitations and other arrangements may be handled by the special events department. There are four possible ways to organize these presentations: formal shows, department shows, designer trunk shows, or informal modeling.

Formal fashion shows take a great deal of advance planning involving booking models and fittings and arranging for a runway, scenery, lighting, microphones, music, seating, and assistants. Clothes are generally grouped according to styling, color, or other visual criteria. Models and music are selected to complement the clothes and set a mood. A designer-centered event can cost from $10,000 to $500,000. Because of their cost, these shows are usually reserved for charity events and stores look for cosponsors to share costs. For an Italian designer collection show, for example, costs could be split among the store, the designers, and the Italian Trade Commission.

Designer trunk shows are done in cooperation with a single vendor and are a popular way to sell expensive collections. Invitations are sent to the best customers according to records kept by sales associates. The designer or a representative travels from store to store with the collection, which is usually shown on models in the designer collections department. Customers get to see the entire collection unedited by a buyer and may order from the samples

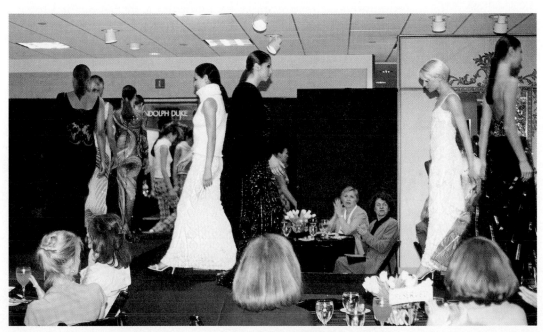

A Randolph Duke fashion show at Neiman Marcus. *(Courtesy of Neiman Marcus)*

in their size. Although some designers and retailers do 50 percent of their to-tal business through trunk shows, others find them time-consuming, ex-hausting work, and have given them up.

Department fashion shows, on a much smaller scale, are produced in-store to generate immediate sales. Usually, a platform is set up directly in the department that carries the clothes.

Informal fashion shows are the easiest to produce. A few models walk through the store showing the fashions that they are wearing to customers who are shopping or having lunch in the store's restaurant. The models can take their time, and customers enjoy asking them questions. This is often done in conjunction with a trunk show or special promotion.

■ *MARKETING EVALUATION*

All the people involved in marketing—directors, managers, coordinators, artists, writers, designers, and buyers—evaluate the effectiveness of their efforts to plan for the future.

At the end of an event or advertising campaign, sales are analyzed and the campaign's effectiveness is evaluated. Advertising can be evaluated by sales volume, but it is very difficult to analyze sales results in relation to visual mer-chandising or special events. For example, unless a fashion show actually takes place in a department and people stay afterward to make purchases, how can the value of the event be measured? Some retailers are experimenting with electronic systems that track people window shopping and entering and exit-ing the store. Management usually evaluates the effectiveness of a campaign as a whole and makes recommendations for the next year.

■ *SUMMARY*

Retail fashion marketing encompasses all of the activities needed to sell merchandise, particularly visual merchandising, advertising, publicity, and spe-cial events. Retailers use market research to define target customers to match their image and role in fashion leadership. Visual merchandising is the in-store presentation of a merchandising message. Advertising is the use of paid time or space in media, such as television, radio, newspapers, magazines, and di-rect mail. There are no media costs for publicity, but any material used is the choice of the media editors. Special events such as fashion shows draw peo-ple into the store and create community goodwill. Marketing efforts are coor-dinated with buyers in each merchandising area. Marketing has its limits, however; it is ultimately the consumer who accepts or rejects fashion.

■ *CHAPTER REVIEW*

Terms and Concepts

Briefly identify and discuss the following terms and concepts:

1. Marketing
2. Advertising
3. Publicity
4. Special events
5. Visual merchandising
6. Life-style displays
7. Image advertising
8. Merchandise or promotional advertising

9. Media
10. Radio and television spots
11. Direct-mail advertising
12. Cooperative advertising
13. Layouts

14. Copy
15. Ad production
16. Advertising agencies
17. Press release
18. Editorial credits

19. Inserts
20. Display packages
21. Standards manuals
22. Trunk shows

Questions for Review

1. What is the purpose of fashion marketing?
2. Explain the difference between advertising and publicity.
3. Discuss the types of media used in advertising and give examples of how each type reaches target groups.
4. Explain how cooperative advertising works.
5. Why is it essential for a buyer to be involved in marketing?
6. Why is visual merchandising important?
7. Explain how a store's fashion image is conveyed to consumer groups.

Projects for Additional Learning

1. Find and clip five examples of co-op advertising from your fashion magazine collection. Find the names and/or trademark symbols of the fiber producer, fabric producer (if mentioned), manufacturer, and stores.
2. Analyze the advertising campaign of a large chain store. Search through newspapers covering a one-month period and clip the store's advertisements. Are they always on the same page of the newspaper? Do they have a high-fashion image or popular appeal? Do they show the merchandise to good advantage? Do you think that the advertisements are effective? What other types of advertisement do they use? Magazines? Television? Billboards? Web sites?
3. Attend a special event at a local store. What is the purpose of the event? To draw people into the store? To create community goodwill? Describe the event and add your own photographs, if possible. Do you think the event was carried out successfully?
4. Visit a local department or specialty store and evaluate its visual merchandising. Do the displays carry out a theme throughout the store? Describe the decor and display techniques, both in windows and in interiors. Is lighting used effectively? Is merchandise attractively arranged? Do you believe that the total image of the store successfully relates to the merchandise offered?

■ NOTES

[1] As quoted in "Ferragamo Today," *Women's Wear Daily*, February 11, 1991, p. 7.

[2] As quoted in "Lauren at 25," *Women's Wear Daily*, January 15, 1992, p. 7.

[3] Rachael Arnold, director, corporate visual merchandising, Bloomingdale's, interview, May 4, 2000.

[4] Virginia Meyer, vice president, marketing, Cato Corporation, interview, June 2, 2000.

[5] Peter Connolly, executive vice president, marketing, Tommy Hilfiger, as quoted in "Media Maze," *Women's Wear Daily*, May 28, 1999, p. 6.

[6] As quoted by Dianne Pogoda, "Spruce Up to Stir Sales," *Women's Wear Daily*, February 1, 1993, p. 8.

Appendix

Career Guidelines

How will you fit into the fashion business? Choosing a career, not just a job, but work that you will enjoy and build on for the future, is one of the most important decisions of your life. I hope that this book will help you to make that decision.

This appendix tries to give a realistic picture of fashion career possibilities. It surveys job opportunities in textiles, fashion design, marketing, production, retailing, and promotion. In planning for your career, you should first understand yourself, your talents, and your ambitions. Then apply those abilities and interests to the field that offers you the best employment opportunities.

■ *THE TEXTILE INDUSTRY*

If you enjoy working with fabrics, you will find several possibilities for interesting employment in the textile industry. A wide variety of skilled and talented people is needed, including artists to create new designs, scientists to develop fibers and finishes, technicians to develop and work knitting and weaving processes, and marketing specialists to market fibers to mills and fabrics to manufacturers.

Fiber and Fabric Development

Research

Science and chemical engineering students may be interested in a career in the laboratories of the large chemical corporations that develop new fibers or at fabric companies or fiber associations that experiment with new treatments and finishes for fabrics.

Textile Design and Merchandising

Textile designers and stylists need a combination of specialized art and technical training. For print design, designers have to be able to apply their skills to two-dimensional design, yet with the understanding that the end use will be in a three-dimensional garment. Fabric stylists have to know the technical aspects of fiber and fabric production so that they are able to create interesting new blends of yarns, as well as new knit and woven constructions. Computer knowledge is also essential.

Production

The technical skills needed to work in a textile plant must be obtained in an engineering, textile, or vocational college. There are positions in the textile plant for project and process engineers, technicians, supervisors, and managers.

Marketing

For the extrovert, marketing provides a variety of interesting careers, including product development, public relations, advertising, and sales. Marketers work with both manufacturing and retail customers. Entry-level junior sales representatives can advance to sales, account, and marketing manager positions.

Training and Advancement

Because most textile firms are located in the South, location in that part of the country is necessary for most technical positions. Some marketing and styling positions are available in New York City and Los Angeles. Sales representatives may be located wherever there are manufacturing centers.

It is important to try to get some experience through a summer job or an internship before graduation. Some textile producers offer training programs that offer new employees an opportunity to rotate jobs and get an overview of the company. Experienced and able people from both the technical and the marketing sides of the business may advance to management.

■ *APPAREL MANUFACTURING*

Career opportunities for young people entering the apparel industry vary widely. The most interesting aspect of manufacturing is its diversification. Each person within the company must know something about all areas so that the company operations run harmoniously. Each area of manufacturing, product development, production, and marketing calls for different abilities.

Design and Merchandising

If you have creative abilities, consider becoming a fashion designer. The prospective fashion designer must be artistically creative, yet understand the technical and marketing aspects of the business as well. Besides being responsible for the original ideas for garments, designers must have a thorough knowledge of fabrics, must be able to make patterns, and must un-

derstand how a garment is put together. In some companies, designers are involved in every step of the production of the line, from concept to completed product.

Fashion designing is highly competitive. The better prepared aspiring designers are, the broader their opportunities will be. Graduation from a good design college is essential. Upon graduation, the budding designer might start as an assistant in the design or sample department. Any entry-level job will provide useful experience.

Merchandising offers the opportunity to mesh business acumen with a design sense. Retailing experience is very helpful as background training. The merchandiser works together with the designer so that the line will fit into company financial and sales goals. The merchandiser usually starts as an assistant merchandiser.

If you are interested in fashion design or merchandising, take every opportunity to observe and analyze new trends at fashion shows, visit manufacturers, and learn to objectively critique apparel and accessories that you see in stores. Also, designer Richard Tyler pointed out, sewing experience is very important for design students.[1]

Pattern-making

You might enjoy a career as a pattern-maker if you are technically oriented. Pattern-makers have an important function in the production process: they translate the design idea into a pattern for the actual garment. A pattern-maker must understand basic mathematics, have a good eye for proportion and line, and be able to achieve a perfect fit.

To prepare for a career as a pattern-maker, you must learn how to drape a pattern on a dress form, how to draft perfect flat patterns, and know how to create patterns by computer. Your first job may be as an assistant or as a sample cutter or pattern grader.

Production

There are opportunities for both men and women as supervisors or managers in fashion production. Production managers must plan and monitor production to ensure that delivery dates are met. Therefore, a well-organized person is best suited for a career in fashion production. Besides technical knowledge, a production manager needs the ability both to manage and to motivate people to get the job done.

An engineering or business education is an excellent background for a career in this area. Only a few large manufacturers have management training programs, so a graduate desiring a career in production should seek any entry-level position available, such as shipping or quality control, just to get a start in the field.

Marketing

If you are outgoing and enjoy working with people, you may like marketing, a career field that involves working directly with customers. You might begin a career as a showroom assistant or junior sales representative in New York or Los Angeles or traveling within a selling territory. A college education in fashion merchandising or marketing and retailing experience is recommended.

Training and Advancement

For the most part, fashion manufacturers are located in large cities. Students interested in design positions must be prepared, in most cases, to relocate to New York, Los Angeles, or wherever there is an opening.

As most manufacturers do not have training programs, you may try to arrange an internship with a manufacturer on your own. Your ingenuity will be appreciated. Initially, it is a good idea to get experience in a small company where you can observe the entire operation. Later, opportunities for advancement are better in large companies that promote from within.

■ RETAILING

Approximately one of every eight employed persons in the United States works in retailing in some capacity. It is absolutely necessary to get retail selling experience while getting a college education. Unless a person has dealt with customers and heard their comments, questions, and complaints, he or she cannot understand the basis of retailing. Working part-time as a salesperson at a store near your school or during the holidays, in the summer, on Saturdays, or after school may provide your initial opportunity and experience.

A few large stores offer summer internship programs for college students that are excellent opportunities for experience. An internship gives the college student a better chance at employment after graduation. Because most stores do not offer this program, you may need to ask permission to work as an intern for no pay. Creating this kind of situation for yourself demonstrates your motivation and initiative. Use this time to ask questions and learn as much as you can about all aspects of running the store.

A college degree or junior college diploma is necessary for a retail management career. Retailers like the creative thinking of the merchandising majors as well as the business skills of the retailing majors. Many students are also getting MBA degrees to round out their education and give them an edge in the job market.

Training

After college graduation, a fortunate few are able to get into a retail management training program at large stores such as Macy's. A typical program consists of work experience in a variety of departments and formal classes conducted by senior executives and training department personnel. Training programs are followed by the opportunity to become an executive.

In large stores, there are usually two main tracks to management: one is through the buying line (merchandising), the other through the store line (operations). Most department stores' training programs combine both tracks, providing a well-rounded experience. Every store has its unique organization structure and job opportunities.

Buying Line or Merchandising Track

After a training program, the first executive position is that of assistant buyer. They spend much of their time maintaining sales and inventory records.

With experience, the assistant may become an associate or single-vendor buyer and, later, a buyer or a planner/distributor. A buyer might advance to the position of group buyer, divisional merchandise manager, or general

merchandise manager. The general merchandise manager is part of senior management and sets merchandising policies for the entire store.

Store Line Track

The second career track in retailing is in store line operations. The department manager is responsible for having the goods on the selling floor; keeping current records of stock; and, in a branch store, ordering replenishments of stock from the main store. This person needs a background in sales and management training. The department manager is the role model for sales staff and the liaison between sales associates, customers, and buyers.

The department manager may advance to section manager, floor manager, assistant store manager, operations manager, or manager of a branch store. The operations manager oversees building maintenance, overhead, receiving, and the movement of goods within the store. The store manager is responsible for merchandising, sales, employees, and the general success of the store.

Alternate Training

Most stores now offer flexible career paths from the merchandising track to the operations track and back again. For example, a trainee may begin work as a sales associate, then an assistant department manager, assistant buyer, department manager, associate buyer, and so on. Able performers from both merchandising and operations might successfully work their way up to senior management. Senior management is responsible for the administration and organization of the store, establishing store policies and controlling operations. These managers need a solid background in the ranks of lower management as support.

■ MARKETING

Fashion marketing is another creative career. Fashion marketers communicate a fashion message to the public to boost sales.

Copywriters

Copywriters work on advertising and publicity for all levels of the industry. They may work directly for producers, manufacturers, and retailers or for agencies. Fashion writers and editors also work for trade and consumer fashion publications. The job requires a college journalism major and some experience, perhaps on a college newspaper.

Artists

Artists design advertising and catalog layouts and/or direct photo shoots. They might work for the in-house advertising department or for advertising agencies. Their artistic skills must be technically perfect. Naturally, advertising or graphic design training is necessary. Fluency with computer design programs is mandatory.

Visual Merchandising Designers

Visual merchandising stylists work for the store, where they decorate store windows and arrange interior presentations of merchandise to attract customers. Advancement opportunities include positions as store design man-

agers and corporate design directors. A college art or merchandising major is a prerequisite.

Special Events Director

Imagination and ingenuity are also needed to create special events. A fashion merchandising degree and experience in staging shows or running school publicity events is a good background.

■ FINDING A JOB

Research

After determining how your interests and abilities fit into the fashion business, you should investigate the companies that could be prospective employers. There are many different types of companies, both large and small. The advantage of working for a large company is that there is usually opportunity for promotion. In a small company, you can more easily learn every phase of the business.

Read about companies that interest you. Fashion and business libraries have directories, such as *The Fashion Guide, Standard & Poor's Register of Corporations,* or *Dun's Million Dollar Directory,* which list addresses and information on national and international companies. Local trade associations also have names and addresses of textile, fashion, and retail companies. You can write to these companies for annual reports or for other available information. Some retailers, such as Federated Department Stores <www.retailology.com>, now have recruiting via the Internet.

Meet professionals at lectures, fashion shows, Fashion Group meetings, and career seminars. Interview them at their offices for class projects. Continually read trade periodicals to keep abreast of industry news so that you will be able to answer questions intelligently at an interview. You should know as much about the company as your interviewer!

Preparations for an Interview

Graduating students often feel defeated before they start. However, it is necessary to be persistent and work at getting a job—prospective employers admire people with drive and enthusiasm. Tommy Hilfiger says, "Young people entering the business need both drive and persistence."[2]

Résumé

First, you need a *résumé* listing the appropriate highlights of your education, experience, and activities. List only the courses, experience, and activities that relate directly to your chosen career. Part-time or summer fashion retailing experience is very important.

Your résumé should be typed on a computer and printed. The professional look of your résumé should demonstrate your knowledge of visual presentation as well as your familiarity with computers. Do not list a job objective; that should go in your cover letter.

Each résumé must be accompanied by a *letter of introduction,* asking for an interview, stating where you can be reached by phone, your job objective, and the reason you want to work for that company.

You may need to send out as many as 100 résumés to land a job, but don't be discouraged, this is normal. If the company asks for *recommendation letters,* then you need to have a list of teachers and professionals who may be contacted.

Be sure to follow up the letter and résumé with phone calls, or your letters may be ignored. Try to get interviews even if there are no positions open with the excuse that you want to ask them some questions about their company. Most often, an applicant's enthusiasm and persistence can convince an employer that the applicant would be an asset to the company.

Portfolio

If you are seeking a creative position, you will need a portfolio in addition to a résumé. The portfolio should look professional, exhibiting only the best examples of your work. Include any projects that won awards or prizes. A design major might include sketches of new ideas (simple technical sketches on graph paper are fine) with fabric swatches and 8- by 10-inch photographs of completed garments worn by professional-looking models.

The Interview

Be sure to read a book on interview preparation! When you finally have obtained an interview, make the most of it. Each interview is good practice for the next one.

A professional appearance is absolutely essential for a job interview in the fashion field. You are making a visual statement of what you know about fashion and about your own self-perception.

Your fashion and company research will be useful during the interview. Brush up on fashion terminology and read current trade periodicals and the *Wall Street Journal* beforehand.

The interviewer may ask questions such as "Why do you want to become a buyer (designer, etc.)?" and "Why do you want to work for this company?" Obviously, without proper research, you could not specifically answer these questions. Also, beware of trick questions, such as "Tell me the worst experience you've had with a boss." You should also be prepared to ask interesting questions that show your interest in the job or the company. The fashion industry looks for sharp, focused minds.

No matter what your training or college major, companies will be looking for the following:

- Good skills learned in college and on the job;
- A well-developed résumé;
- A professional-looking portfolio (in design or communications);
- A fashionable, professional appearance;
- The ability to express oneself clearly (except possibly for technical positions);
- A pleasant personality and positive attitude to demonstrate that you will get along with your colleagues;
- Enthusiasm, self-motivation, and a high energy level;
- Awareness and an eagerness to learn;
- A willingness to take responsibility.

■ THE FIRST JOB

Your first job after school or college should be considered an *apprentice-ship,* a period of learning on the job. If your employer has no training program, try to set up your own apprenticeship or internship so that you can move around and learn all aspects of the business. You may want to try to set up an unpaid internship during a summer vacation. Try to learn as much as possible. Think of your first job as a free education. Never stop learning, and your career will always be rewarding. Odile Laugier, former vice-president of design at Adrienne Vittadini told me, "I've been here thirteen years and I'm still learning."[3]

The important thing is to obtain experience. Then, demonstrate how efficient and talented you are by doing a good job. Companies are always looking for responsible people to promote to better positions. If you are not promoted, at least you have gained experience for moving on to something else. Contacts that you make on the job will be valuable later. For example, fabric sales representatives often hear of job openings with apparel manufacturers and spread the word.

Be flexible and pleasant with your co-workers. A little humor and diplomacy go a long way toward promoting positive working relationships. Changes in fashion make the business exciting, but the creative people involved make it even more interesting.

Students often talk of opening their own businesses after graduation, and it seems that working for one's self would be easy. However, most small-company failures are caused by lack of experience. Before opening your own business, get as much experience as possible, both in a large company and in a successful small one to see how they are run. Working for yourself is actually more difficult than working for someone else because you must be self-disciplined. There are rewards, of course, for those who have ambition and creativity and are willing to work long and hard.

If you want to move up in the fashion field, give your education, training, and work all the effort and enthusiasm you can. Make the most of each situation. You get out of life what you put into it. Best wishes for a successful and rewarding career.

■ PREPARATIONS FOR A JOB INTERVIEW

1. Write your résumé. Include information on education, awards, experience, and interests that directly relate to your chosen field.

2. What fashion career do you think would bring you the greatest satisfaction? List the positive and negative aspects of this career in two columns on a sheet of paper. Analyze why you think you will do well and be happy in this career. What attributes do you have that you could bring to the job? How is your education preparing you? How will you enter the field, and what are your advancement expectations?

3. If you are a design or communication major, outline what you plan to include in your portfolio. Ask your teachers to help you select your best work. Develop an overall graphic theme for your portfolio.

4. Arrange to interview a professional in your chosen field (designer, retailer, sales representative, etc.). Ask about all aspects of the job.

What does he or she like and not like about it? What makes it interesting? How did he or she start out and advance? What valuable advice can this professional give you? College interviews and contacts often lead to jobs.

5. Research a company that interests you. Write to them for an annual report or other information that might be available. Check out the *Guide to Periodical Literature* for articles about the company in publications. Read the material and make notes of important information that you need to remember for an interview.

■ *NOTES*

[1] *Vogue,* February 1995, p. 244.

[2] Interview, September 1994.

[3] Interview, April 30, 1992.

Fashion Industry Terminology

Learning the terminology of the fashion industry is an important part of a fashion education. By using correct terminology, you show that you are familiar with the business. Many fashion terms are from the French language, because France has long been the capital of fashion innovation. For further clarification, check the index and refer to the text to see how the term was used.

accessories Articles worn or carried to complete a fashion look, such as jewelry, scarves, hats, handbags, or shoes.

acetate A manmade fiber of cellulose chains.

acrylic A manmade fiber made of long-chain synthetic polymer.

advertising Any paid message in the media used to increase sales.

advertising director The person in charge of the personnel and activities of the advertising department.

alta moda The Italian couture.

apparel Clothing, not necessarily fashionable.

apparel industry The manufacturers, jobbers, and contractors engaged in the manufacture of clothing (also called the garment business, the needle trades, the rag trade).

artisans People who do skilled work with their hands.

atelier (ah-tel-yay') French word for designer workshop. Ateliers are classified as *flou* (for soft dressmaking) or *tailleur* (for tailoring suits and coats).

automatic replenishment When a store allows a manufacturer to restock basics without a purchase order; continuous open-to-buy.

balance Visual weight in design.

balance of trade Difference in value between a country's exports and imports.

base goods The solid fabric used as the basis for a group of sportswear.

bespoke English term for made-to-measure men's suits.

bodies Garment silhouettes.

book inventory The dollar value of inventory, as stated in accounting records.

boutique (boo-teek') French word for a small shop with unusual clothing and atmosphere.

branch store A store owned and operated by a parent store; generally located in a suburban area under the name of the parent store.

brand name A trade name that identifies a certain product made by a particular producer.

brick and click An industry "buzz word" to describe retail stores that have web sites.

bridge fashion The style and price range between designer and better.

buyer A merchandising executive responsible for planning, buying, and selling merchandise.

buying office An independent or store-owned office that is located at a market center and buys for one chain or for many stores.

buying plan A general description of the types and quantities of merchandise that a buyer expects to purchase for delivery within a specific period.

chain store organization A group of stores that sell essentially the same merchandise and are centrally owned, operated, and merchandised.

classic A fashion that is long-lasting.

classification An assortment of related merchandise grouped together within a department of a store.

collection A group of garments designed for a specific season.

commissionaire (ko-me-see-ohn-air') Store representative in foreign cities.

commodity merchandise Standard basic merchandise.

computer-aided design (CAD) An integrated computer system that aids in designing and pattern-making, used in both textile and apparel design.

computer-aided manufacturing (CAM) Computerized pattern-making, grading, marker making, cutting, and sewing machines.

computer-integrated manufacturing (CIM) Computer connection to integrate computer-aided design and manufacturing systems.

consumer Someone who buys merchandise.

consumer demand The effect consumers have on the marketplace.

consumer obsolescence The rejection of merchandise in favor of something newer, even though the "old" still has utility.

contemporary styling Sophisticated, updated styling; originally designed for the age group that grew out of juniors.

contractor An independent producer who does the sewing (sometimes the cutting) for manufacturers; an outside shop.

converter A textile producer that buys greige goods from mills and dyes, prints, and finishes it before selling it to a manufacturer.

cooperative advertising Advertising costs shared by a textile producer and/or a manufacturer and/or a retailer.

coordinated sportswear Sportswear designed to mix and match interchangeably.

corporate selling Selling management to management; without the use of sales representatives.

cotton A vegetable fiber from the boll of the cotton plant; the world's major textile fiber.

couture (koo-tour') French word for dressmaking; applied to fashion businesses that make clothes to order.

croquis Original paintings of textile designs.

custom-made Apparel made to a customer's special order; cut and fitted to individual measurements; opposite of ready-to-wear.

cutter The person who cuts material during the manufacturing process.

cutting order Order of quantity to cut, how to cut, and what fabric to use.

cut-to-order Cut and produce only against orders.

cut-to-stock Cut and produce based on projected estimates of sales.

database marketing Using information about customers gathered from credit cards and other sources to plan marketing strategies.

demographics Statistical studies of population characteristics such as birth rate, age distribution, or income.

department store General merchandise store, including apparel, household goods, and furniture.

designer A person employed to create ideas for garments or accessories in the fashion industry.

design resource Any resource from which a designer obtains ideas; can be trade newspapers, design reports, fashion magazines, museums, historic-costume books, nature, theater, films, fabrics, and so on.

design services Reports and ideas available by subscription to manufacturers and retailers; predictives.

direct-mail advertising Any printed advertising distributed directly to specific prospects by mail.

discount retailing Low-margin retailing; retailers able to offer inexpensive merchandise by buying in quantity and keeping operating costs low.

discretionary income Income left after basic necessities have been paid for.

display Visual presentation of merchandise or ideas.

disposable income Income minus taxes; a person's purchasing power.

divisional merchandise manager A person in the middle management of a retail store; executive responsible for merchandising activities of a related group of departments; supervises buyers and assistants.

doors Fashion industry jargon for the number of retail stores at which a particular product is sold.

draping A method of making a pattern by draping fabric on a dress form.

electronic data interchange (EDI) The exchange of business data between two parties by means of computer.

electronic retailing Shop-by-computer retailing.

elements of design Design ingredients: color, fabric, line, and shape.

ergonomics The development of workplace equipment and standards designed to improve the safety, health, and efficiency of workers.

E-tailing An industry buzz word signifying electronic retailing.

ethnic or folk costume Traditional national or regional dress; often inspiration for fashion design.

fabrication Selection of the appropriate fabric for a garment.

factory outlet stores Stores that sell manufacturer's overruns directly to the consumer.

fad A short-lived fashion.

fashion The prevailing style of any given time; implies change in style.

fashion cycle Fashion change; refers to the introduction, acceptance, and decline of a fashion.

fashion director The fashion expert of an organization, who keeps it current with fashion developments and works with designers or buyers to form the fashion image of the company.

fashion editor The head fashion reporter at a magazine or newspaper, who analyzes the fashion scene and interprets it for readers.

fashion forecast A prediction of fashion trends.

Fashion Group An international association of professional women in the fashion business; founded in 1931, now called the International Fashion Group.

fashion merchandising The planning required to have the right fashion merchandise available in the proper quantities and place at the right time and price to meet consumer demand.

fashion press Reporters of fashion news for magazines and newspapers.

fashion retailing The business of buying fashion merchandise from a variety of resources and reselling it to ultimate consumers at a convenient location or via the Internet, television, or catalogs.

fashion trend New directions in fashion styling.

Fédération Française de la Couture French couture trade association composed of three main membership classifications (each called a Chambre Syndicale) and associated groups of manufacturers and artisans.

fibers Natural or synthetic strands from which yarns are made.

filament A continuous strand of fiber.

finishing The last treatments given to fabrics; the final handwork or final touches done to a garment.

first pattern Trial pattern made in the design department for the sample garment.

flagship store Largest and most representative store in a chain organization.

flax A natural fiber made from the stem of the flax plant and used to make linen.

flexible manufacturing A combination of methods used to make manufacturing most effective.

floor-ready standards When retailers require manufacturers to have merchandise pre-ticketed and on hangers, ready to be put on the selling floor.

franchising When a manufacturer sells the rights to retail its merchandise.

full-fashioned knits Knit garments with pieces shaped on the knitting machine.

furnishings Men's clothing category, including shirts, accessories, and item sportswear.

garment packages Apparel manufacturing done by textile producers.

General Agreement on Tariffs and Trade (GATT) A former contract between governments to provide a secure international trading environment, now replaced by the World Trade Organization.

generic name Family name given to each type of fiber.

globalization The trend for manufacturers and retailers (and all businesses) to expand throughout the world.

grading Process of making a sample size pattern larger or smaller to make up a complete size range.

greige goods (gray goods) Unbleached, unfinished fabrics bought by converters.

gross margin The difference in dollars between net sales and the net cost of merchandise during a given period.

haute couture Those dressmaking houses in Paris that belong to the Chambre Syndicale of the Federation Française de la Couture and meet the criteria to be on its Couture-Creation list (see Chapter 8).

Ideacomo Italian fabric producers' trade fair, held each November and May in Como, Italy, followed by presentations in New York.

imports Goods made in a foreign country.

issue plan Production schedule.

items Garments sold on an individual basis.

Jacquard loom (jah-kard') A loom invented by Joseph Jacquard in France in 1801 that weaves an elaborate pattern (such as damask, brocade, or tapestry) by controlling each warp thread separately.

jersey Basic construction of all weft knits.

jobber A middleman between the producer and the commercial consumer.

junior Size range of female apparel; in odd numbers, 3 to 15.

knockoff A copy of a higher-priced style.

leased department Within a store, a department run by an outside company.

licensing Giving a manufacturer permission to use a designer's name or designs in return for a fee or percentage of sales.

line An apparel manufacturer's collection of styles; also, visual direction in a design caused by seams, details, or trimming.

line buying Buying lines from reliable manufacturers.

linen A vegetable fiber from the woody stalk of the flax plant.

loss leader An item sold at less than the regular wholesale price for the purpose of attracting retail buyers to other merchandise.

lyocell New type of solvent-spun cellulosic fiber.

MAGIC Men's Apparel Guild in California, the world's largest men's apparel trade show, held each February and August in Las Vegas.

manmade fibers Fibers made from cellulose in plants or from chemicals derived from petroleum, gas, and coal.

markdown The difference between the original retail price and a reduced price.

marker A pattern layout put on top of the fabric for the cutter to follow.

market A group of potential customers, or the place, area, or time at which buyers and sellers meet to transact business.

market driven Responding to market or consumer needs.

marketing The process of planning, promoting, and selling merchandise.

marketing chain The flow of product development, production, and distribution from concept to consumer.

markup Difference between cost price and selling price.

mass production The production of merchandise in quantity.

media Means of communication: newspapers, magazines, radio, TV, and direct mail.

merchandise plan A budget or projection of the sales goals of a merchandise classification, a department, or an entire store for a certain period, including the amount of stock required to achieve those sales.

merchandise representatives Consultants trained by manufacturers to train sales associates in the stores.

missy Size range in feminine apparel in even numbers, 6 to 16.

moda pronta Italian ready-to-wear.

mode or moda Synonym for fashion; used mainly in Europe.

modular manufacturing A manufacturing method utilizing a small group of people who work together to produce a finished garment.

Multifiber Arrangement (MFA) A bilateral agreement among exporting and importing nations that provides the framework to prevent import surges.

national brands Manufacturers' brands that are available nationwide.

natural fibers Fibers that nature provides: cotton, wool, silk, flax, and ramie.

North American Free Trade Agreement (NAFTA) Trade agreement, implemented in 1994, creating a free market between the United States, Canada, and Mexico.

nylon A durable manmade fiber made of long-chain synthetic polymer.

off-price A price lower than the original wholesale price or below the normal wholesale price; usually special purchases, closeouts, or overruns.

offshore assembly Fabric purchased and cut in the United States but sent to Mexico or the Caribbean countries for sewing.

open-to-buy The amount of money a buyer can spend on merchandise to be delivered within a given period, minus the amount allocated to merchandise on order.

operations Steps in production; activities of running a business.

overhead The costs of operating the store or company.

overlock machine A machine with needle and loopers that creates an edge finish while sewing a seam.

performance fabrics High tech fabrics, using interesting fiber blends and finishes, to create durable and flexible fabrics.

physical inventory A physical count of stock on hand.

piece goods The trade term for fabrics.

piecework Rate by which many factory workers are paid.

plant capacity The quantity of garments that can be made in a factory at a certain time.

polyester The most widely used manmade fiber, made of long-chain synthetic polymer.

Premier-Vision French term for "first look"; international fabric trade fair held each March and October in Paris.

prêt-à-porter French for ready-to-wear; literally, "ready to carry."

preticketing Ticketing of merchandise by the manufacturer so the merchandise is ready for prompt distribution at the retail store.

price line A specific price point at which an assortment of merchandise is offered for sale.

price range The range between the lowest and highest price lines carried.

private label A store's own brand.

product data management systems (PDM) Computer software systems used to organize and edit a line.

production pattern The final pattern made to company size standards.

progressive bundle system A manufacturing system requiring one operator to repeat one assembly task and grouping operators to follow the order of production; section work.

promotion Products offered at special prices.

promotional stores Stores that stress special sales, bargains, and price reductions.

proportion The relation of one part of a design to another; an important principle of garment design.

psychographics The use of psychological, sociological, and anthropological factors to construct market segments.

publicity Messages about a company and its policies, personnel, activities, or services used without payment to the media.

quotas A means of regulating exports and imports.

ramie A natural vegetable fiber from the stem of a nettle-like shrub.

rayon A manmade fiber made from rejuvenated cellulose.

ready-to-wear Apparel that is mass-produced (opposite of custom made).

receiving The area of the store where packages are opened, checked, and marked.

repeat The repetition of a print in fabric design.

resource Term used by retailers for a manufacturer, wholesaler, vendor, or distributor; or a source for ideas or information.

retailing The business of buying goods at wholesale markets or producing goods and selling them to the ultimate consumer.

retail price The wholesale price plus a markup covering the retailer's operating costs and a profit.

sales per square foot Amount sold per square foot of store floor space; measure of productivity.

sample The trial garment or prototype.

sample cut A 3- to 10-yard length of fabric used by the design department to make up a trial sample garment.

Savile Row Street in London famous for its men's tailors.

selected distribution Limiting the number of stores that may buy merchandise to maintain exclusivity.

sell through The ability of a line to sell regularly and steadily at full price.

Seventh Avenue The main street of New York City's garment district; the term is used to represent the whole district.

showroom A place where sales representatives or management show a line of merchandise to potential buyers; called *salon de presentations* in France.

silhouette Outline of a garment.

silk The only natural fiber in filament form; obtained from the cocoons spun by silkworms.

soft goods Fashion and textile merchandise.

sourcing Worldwide search for the best available fabrics or garment production at the best price.

spandex A man-made fiber of long-chain synthetic polymer comprised of stretchable segmented polyurethane; known best by the DuPont brand name of Lycra.

special events Activities set up to attract customers to a selling place.

specialty store A retail establishment that handles narrow categories of goods, such as men's apparel, female apparel, or shoes.

spinning The process of extruding and hardening manmade fibers; the process of drawing and twisting staple fibers together into yarn or thread.

standard allowed hours The time it takes to complete each assembly operation or garment.

stock turnover The number of times a store's merchandise stock is sold and replaced in a given period.

store image The character or personality that a store presents to the public.

style Certain characteristics that distinguish a garment from other garments; a particular look in fashion.

style ranges Categories of styles that appeal to different consumers.

stylist A fashion expert; generally selects colors, prints, or styles for presentation or prepares fashion merchandise for photographic presentation in an advertisement or catalog.

tanning The process of transforming animal skins into leather.

target market The group of consumers to whom a producer, manufacturer, or retailer aims products, services, and advertising.

textile fabrics Cloth made from textile fibers by weaving, knitting, felting, crocheting, laminating, or bonding.

texture The surface interest in a fabric.

texturing The process of crimping or otherwise modifying continuous filament yarn to increase cover, abrasion resistance, warmth, resiliency, and moisture absorption or to provide a different surface texture.

toile (twahl) French word for a muslin sample garment.

trademark Company's individual registered mark and name for a product.

trend buying Retailers buy from new resources to obtain fashion newness.

trendsetter A designer or fashion leader who sets a fashion direction that others follow.

trunk show A show of designer clothes that moves from store to store, often accompanied by a personal appearance by the designer.

unit control Systems for recording the number of units of merchandise bought, sold, in stock, or on order.

UNITE Union of Needletrades, Industrial and Textile Employees.

unit production systems (UPS) Computer-guided conveyors that move garments automatically from one work station to the next; automatic progressive-bundle system.

universal product codes (UPC) Standard codes that identify style, color, size, price, fabrication, and vendor on price tags and enable this information to be fed through an electronic data interchange system.

variants Modifications of basic generic fiber compositions for special applications.

vendor A seller, resource, manufacturer, or supplier.

vendor analysis Statistical analysis of the profits made on merchandise from individual vendors.

vertical integration The joining of companies at different levels of production and marketing, such as a fiber producer with a fabric mill.

virtual showrooms Showing a manufacturer's line on the Internet.

visual merchandising Making merchandise visually attractive to customers.

warp knitting When fabric is knit in loops running vertically.

weaving The process of forming fabric by interlacing yarns on looms.

weft knitting When fabric is knit in loops horizontally or in a circle.

wholesale market A market where commercial consumers buy from producers.

wholesale price The price paid by commercial consumers for supplies and products.

Women's Wear Daily Trade publication of the women's fashion industry.

wool A natural fiber from animal fleece.

World Trade Organization (WTO) The governing body for international trade, which replaced GATT.

yarn A continuous thread produced by twisting or spinning fibers together.

Index